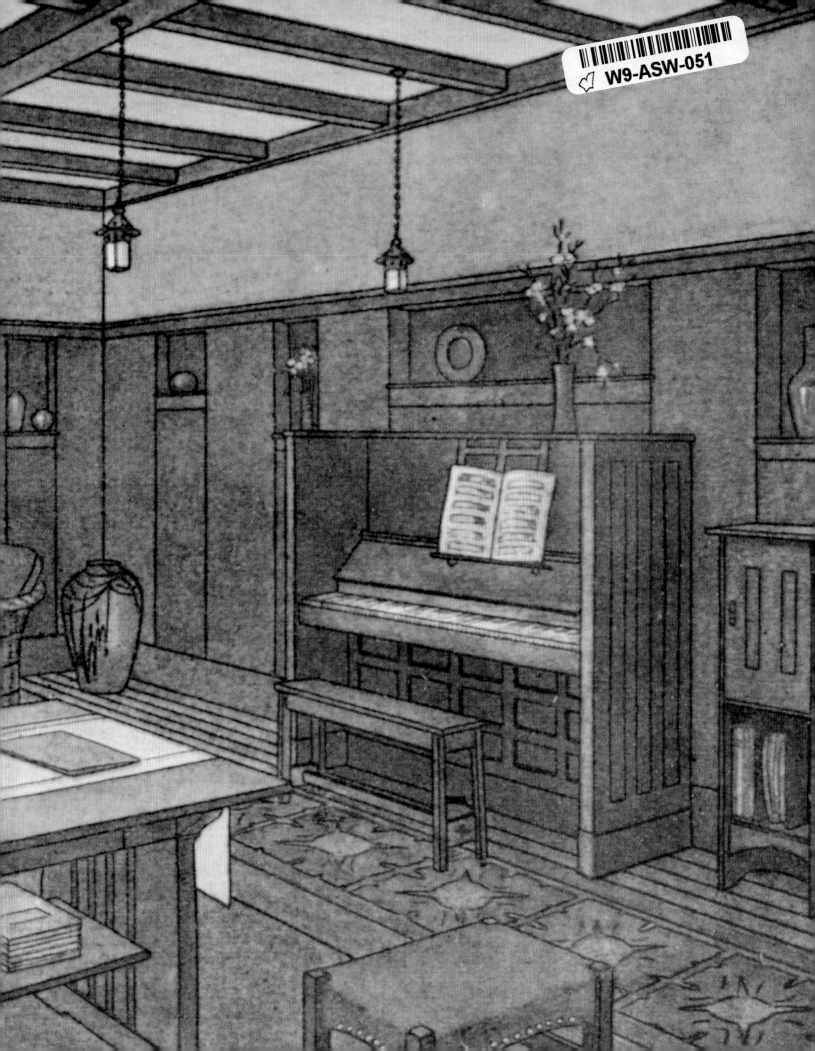
W9-ASW-051

"We have set before ourselves the ideals of honesty of materials, solidity of construction, utility, adaptability to place, and aesthetic effect...."

Gustav Stickley

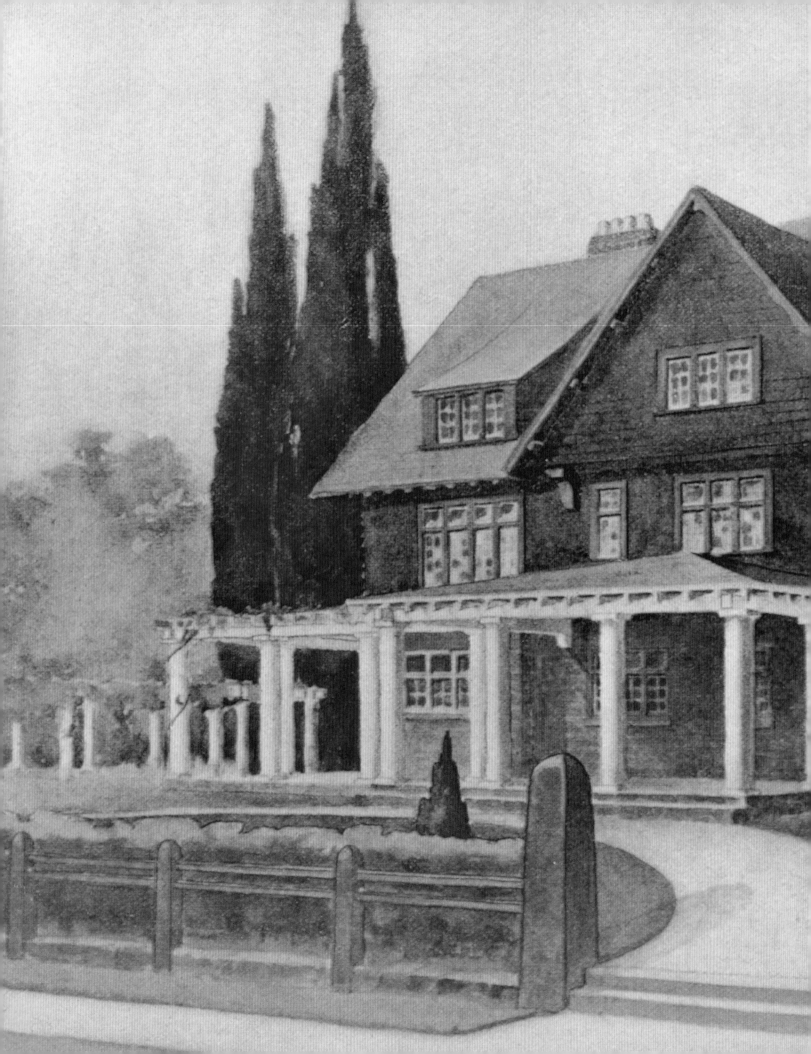

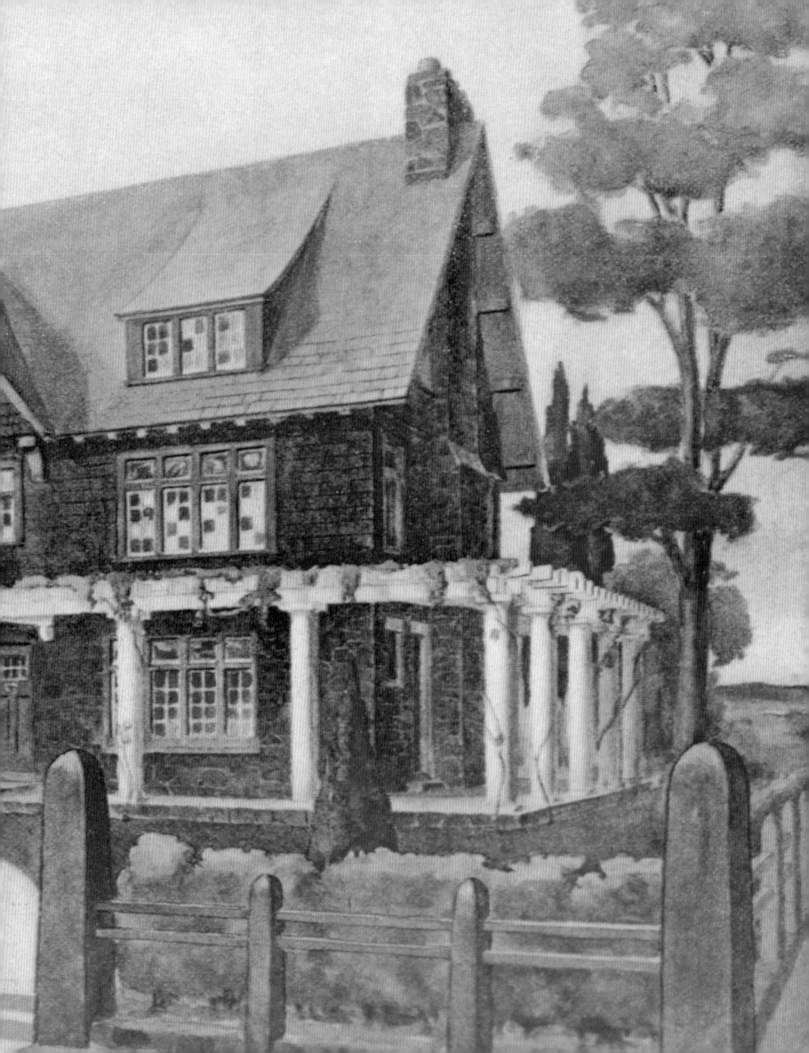

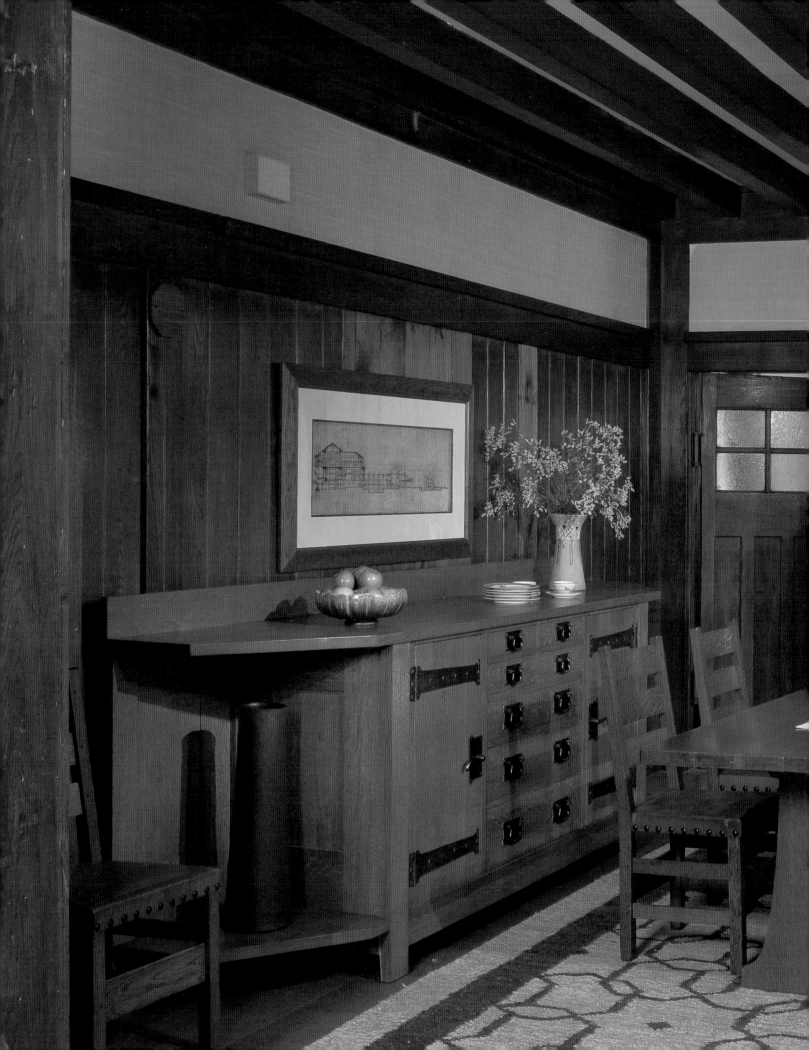

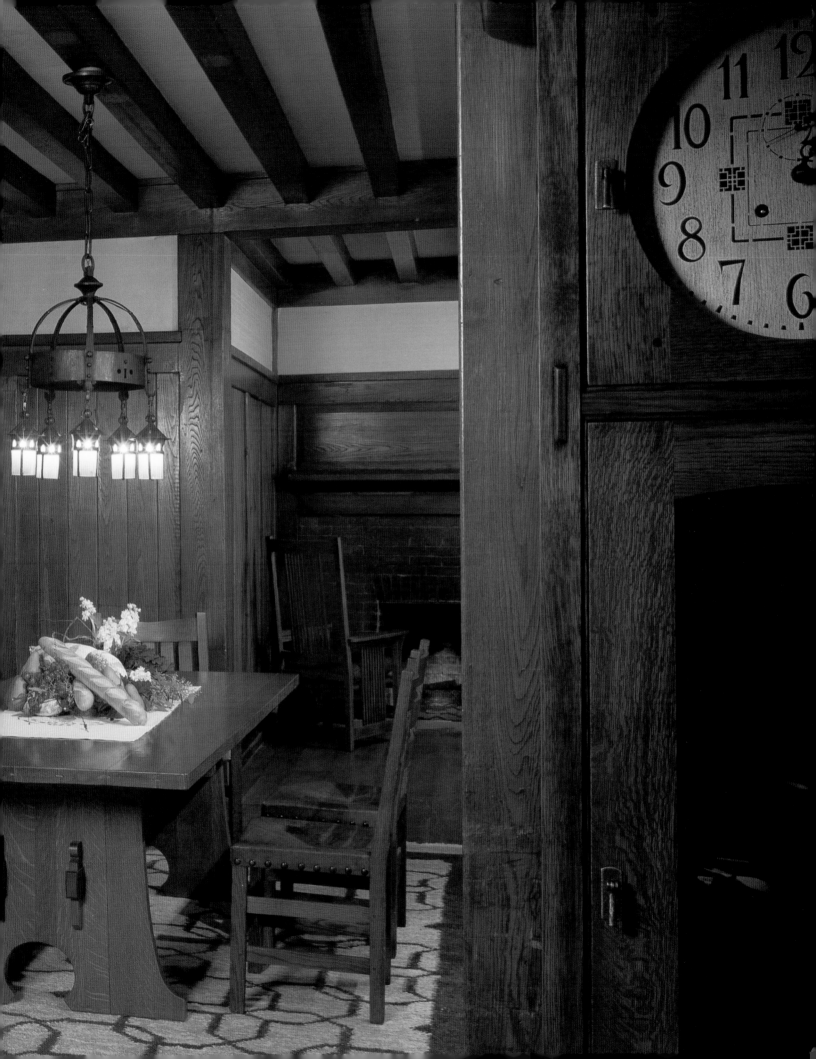

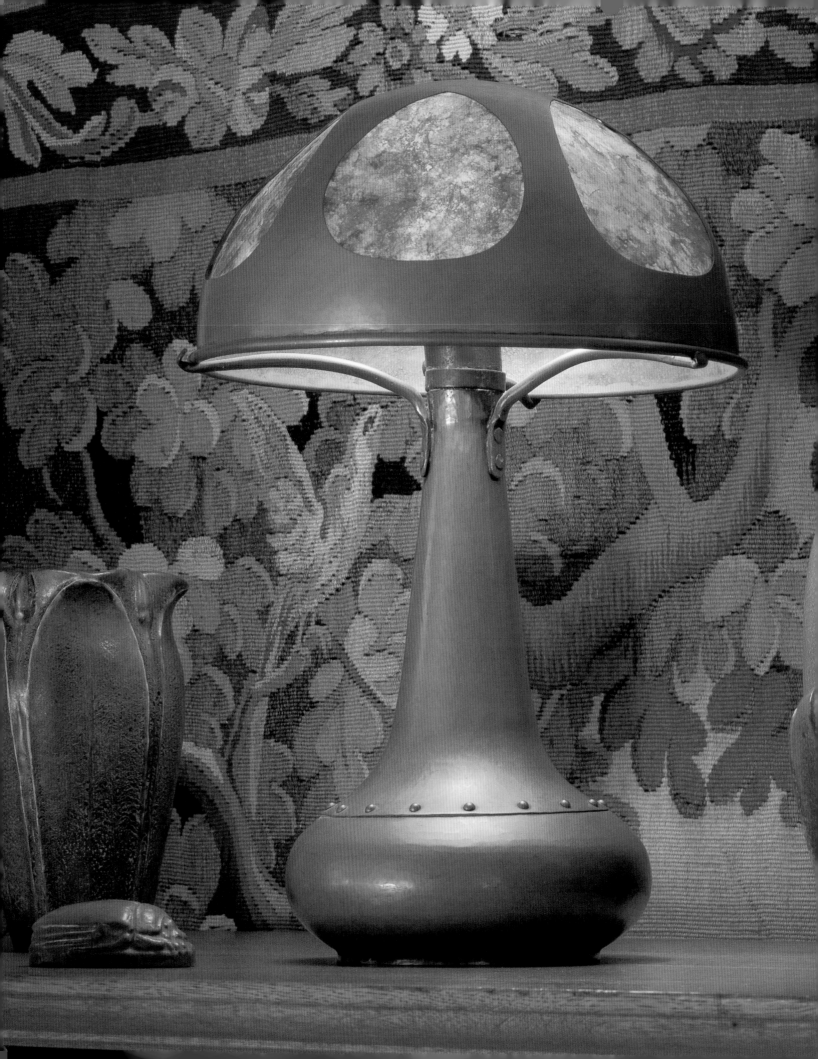

STICKLEY STYLE

ARTS AND CRAFTS HOMES IN THE CRAFTSMAN TRADITION

Text by David Cathers
Photographs by Alexander Vertikoff

An Archetype Press Book

SIMON & SCHUSTER

INTRODUCTION

STICKLEY STYLE

Contents

CONTINUING THE CRAFTSMAN TRADITION

STICKLEY AT HOME

That is why we have from the first planned
principles of honesty, simplicity and usefu
rejoice all their lives to remember as "home
to tired men who go back to them when th
the health that which
of-doors, ouses wi
sleeping r s to let in
examinat en in this
tical effec ouse, wh
free space essary pa
have mad s as larg
from the h more fr
one big l ne steps
small ves ands such
the place pleasure
And we l ks and c
privacy a ay shut
arrangement has always seemed to us symb
big hospitable fireplace is almost a necessit
true home life, and the very spirit of home s
tries ineffectually to take the place of a glo
☾Then too we believe that the staircase, i

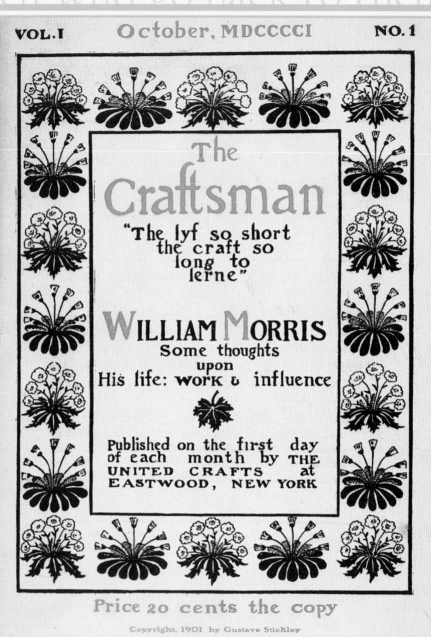

VOL. I October, MDCCCCI NO. 1

The Craftsman

"The lyf so short
the craft so
long to
lerne"

WILLIAM MORRIS
Some thoughts
upon
His life: work & influence

Published on the first day
of each month by THE
UNITED CRAFTS at
EASTWOOD, NEW YORK

Price 20 cents the copy

Copyright, 1901 by Gustave Stickley

INTRODUCTION

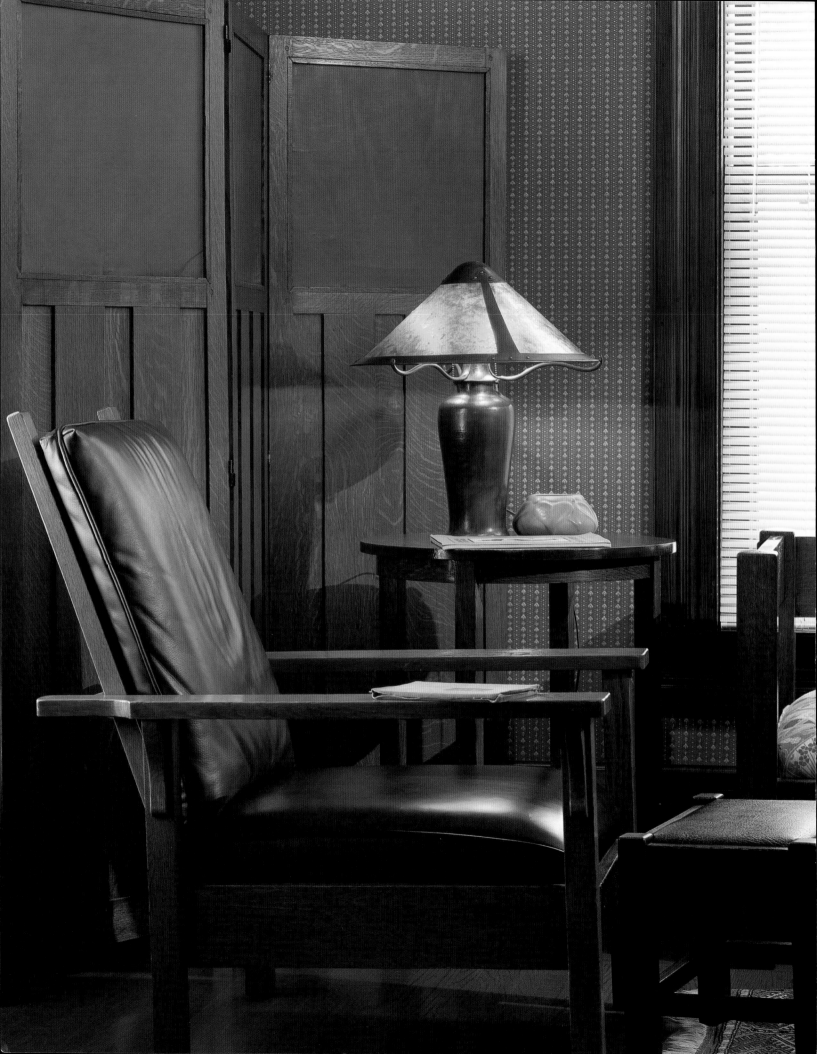

GUSTAV STICKLEY LOVED MUSIC, ESPECIALLY OPERA. HE WAS STIRRED BY THE BEAUTY of gardens and came to relish working in the soil. He cherished his wife and children, even though the demands of his career often kept them apart. In later life, opening his blue tin of Edgeworth tobacco and filling his corncob pipe, he delighted in telling vivid tales to enraptured grandchildren. But his greatest passion was wood. As his grandson Gustav Stickley III recalled, "He would caress a piece of wood. As burly and as big as he was … when he touched a piece of wood it was like a caress. … Even as a boy I could see this." ▦ A maker of furniture and decorative household

Gustav Stickley and the Craftsmanship of Life

objects and later also a publisher, Stickley (1858–1942) became a central figure of the American Arts and Crafts movement that flourished at the beginning of the twentieth century. Members of the movement, which arose in England, were distressed by the era's spreading industrialization and criticized factory goods cheaply produced and superficially decorated with garish machine-made ornament that often masked flimsy construction and inferior wood. To them, the new manufacturing system treated workers as little more than machines themselves. The movement bravely sought to remedy these ills by reviving the handicrafts of earlier times, stressing the

Gustav Stickley built to last. Today the simple lines of one of his oak-and-leather armchairs, framed by a Stickley screen beside a Dirk van Erp copper lamp, feel at home anywhere (opposite). Stickley reached the height of his success in 1910 (right).

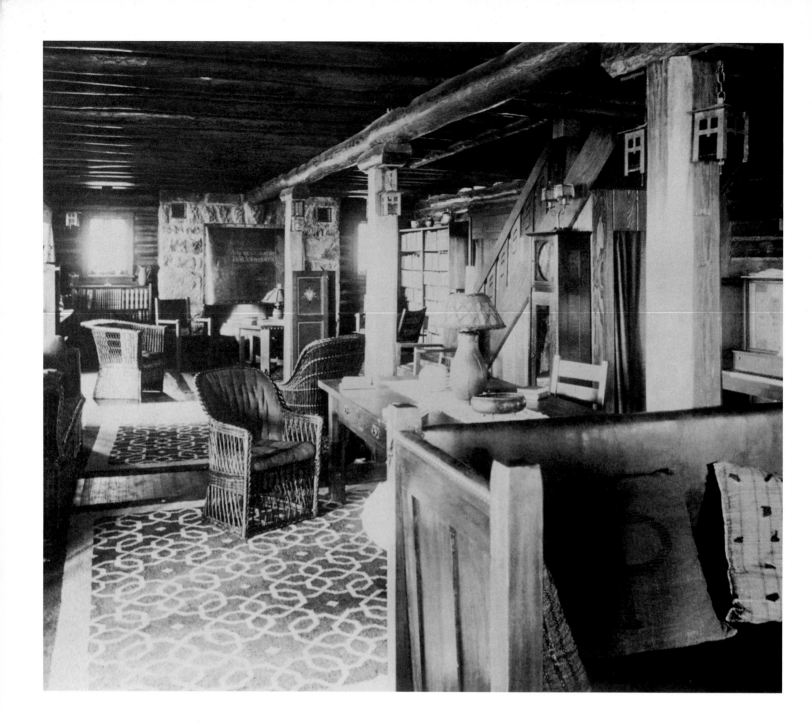

In the long living room at Craftsman Farms, Stickley's rustic log home in Parsippany, New Jersey, he mixed massive hardwood furniture with willow pieces, all Craftsman.

value of good workmanship, simple design, and the life-enhancing pleasures of honest hand labor.

In the United States Stickley gathered together many of the movement's shared beliefs and called them the "Craftsman idea." He advocated his version of the Arts and Crafts philosophy in his influential *Craftsman* magazine beginning in 1901, and in his Craftsman Workshops he produced moderately priced furnishings consistent with its principles and sold them widely. Through his publications and his products, Stickley brought Arts and Crafts ideals into people's daily lives, giving the movement meaning for a large national audience. This has proved to be his unique and lasting achievement.

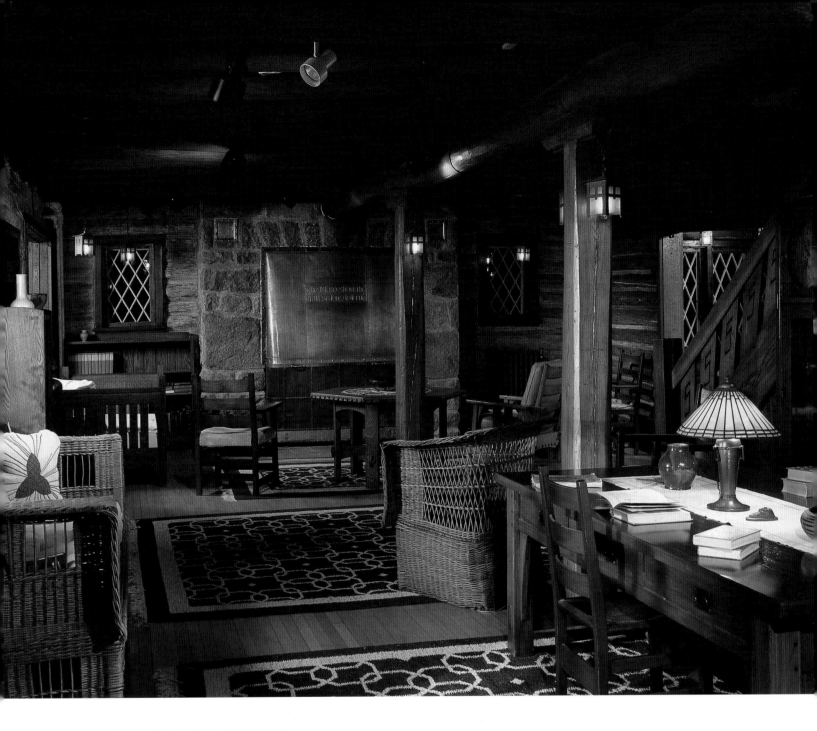

CLEARING THE CLUTTER

Stickley and his Arts and Crafts contemporaries on both sides of the Atlantic set out to reform popular taste. They wanted to clear away the clutter of furniture and decorative objects found in the typical Victorian interior and replace it with something simpler. This idea had been suggested earlier in *The House Beautiful*, a series of articles on domestic decoration by the American writer and art critic Clarence Cook. Published in book form in 1878, it went through several editions. Simple and structurally frank furniture designs had appeared in another popular primer, *Hints on Household Taste*, by the English designer and writer Charles Lock Eastlake. Many editions followed its 1868 publication, and Stickley was still recommending it to his *Craftsman* readers in 1915.

Today the copper fireplace hood at Craftsman Farms still wears its Chaucerian embossing: "The lyf so short / the craft so long to lerne." Sturdy balusters carry Stickley's S upstairs.

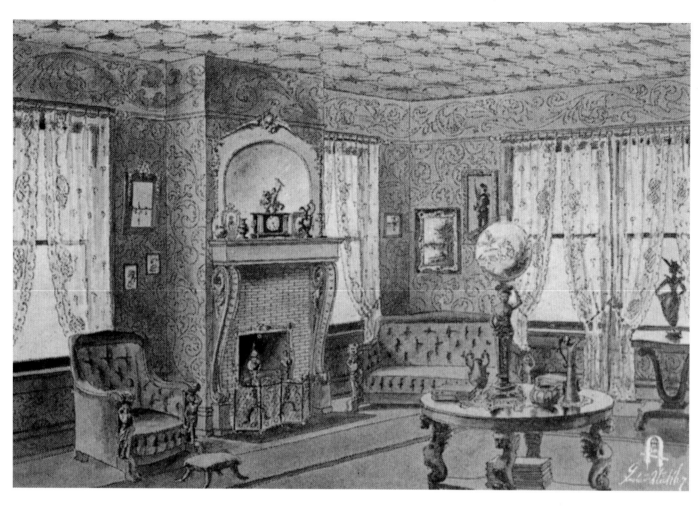

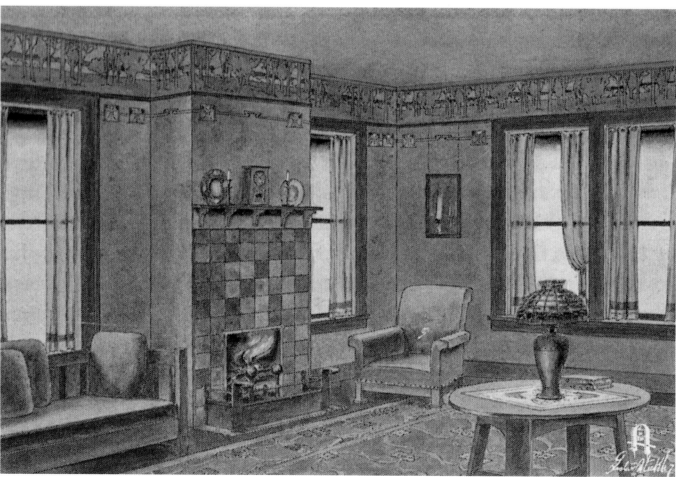

The December 1904 issue of *The Craftsman* magazine presented a lesson in interior design. In "before" and "after" drawings, the article "From Ugliness to Beauty" set forth the faults of a conventional crowded parlor, described as "a jangling complexity of curves ... [and a] cramped confusion of gilt flourishes and crowded bric-a-brac." Radical simplification was recommended.

In England, similarly, the Arts and Crafts architect M. H. Baillie Scott's book *Houses and Gardens* (1906) dramatized the dilemma of the densely furnished dining room that often doubled as a sitting room: "The dining-table is usually unnecessarily large, and the available floor space is reduced to a narrow strip round this table, and this, again, is further restricted by the sideboard and the chairs ... [driving] the unfortunate owner of the suburban house to spend his evenings inexorably wedged between the dining-table and the fire ... pushed into a corner by insistent and triumphant furniture. ..."

FOUND: A LOVE FOR WOOD AND CRAFTSMANSHIP

Stickley was born into an unprosperous farm family in Osceola, Wisconsin. His father earned a living as a stone mason, and as the oldest son Gustav was sent out to work alongside him. It was hard, tedious labor. In 1876, when he was about eighteen years old, he took a job in his uncle's furniture factory in the small rural town of Brandt, Pennsylvania, and there, amid the deafening whir and clatter of steam-powered woodworking machinery, he found his life's vocation. "It was the most commonplace ... work," he later wrote, "but from it I can date my love for working in wood and the beauty ... to be found in its natural color, texture and grain. ..."

By 1883 Stickley and two of his brothers, Charles and Albert, had formed Stickley Brothers & Company, a furniture manufacturing and retailing firm located in Binghamton, New York. Unable to afford sophisticated machinery, the firm relied on the few available power tools and a great deal of demanding physical labor. Stickley began making basic Shaker-like chairs, as well as reproductions of simple colonial, Windsor, and other plain chairs. He formed a new partnership with a seasoned furniture man, Elgin Simonds, in 1888. Leopold Stickley, another brother who later founded the L. & J. G. Stickley Company and made Arts and Crafts furniture of his own, also took part in this venture. The firm of Stickley & Simonds built a new factory in Syracuse, New York, in 1893 and manufactured chairs in various historic styles—Chippendale, Hepplewhite, and Empire—and combinations of patterns. The firm catered to the Victorian taste for novelty and embellishment, and its elaborately decorated designs were little different from those of hundreds of other furniture factories operating at the time.

Stickley showed readers how and how not to design a harmonious room in the December 1904 *Craftsman* magazine. A stuffy, formal parlor (opposite top) is crowded with fussy furniture encrusted with machine-carved decoration and dust-gathering bric-a-brac. Stripped of its excesses, the space (opposite bottom) is transformed into a comfortable Craftsman room with durable furniture simply arranged.

By the mid-1890s, with almost two decades' experience in the furniture manufacturing industry, Stickley was becoming prosperous. And yet he began to have doubts about the products being turned out by his factory. In later life he acknowledged supplying the demand for historic styles, "but always under silent protest: my opposition developing out of a course of reading, largely from Ruskin and Emerson."

Like many self-educated people, Stickley was an unceasing reader, and as a young man he had discovered the seminal writings of the English design critic and social theorist John Ruskin (1819-1900). For Ruskin, factory goods were inherently inferior to works of skilled craftsmanship, and he called for a return to the practices of the medieval craft guilds. His idealized medieval craftsman was freer, more creative, and happier than the nineteenth-century factory drudge, and these satisfactions improved his life and work while enhancing the whole of society. Ruskin helped spur the handicrafts revival of the late nineteenth century, and in his writings design, production, and morality were firmly linked.

Ruskin's reformist ideas were put into practice by William Morris (1834-96), who speeded the process of redefining art to include architecture, design, and traditional handicrafts. In 1861 he founded the London firm eventually known as Morris & Company to produce well-designed and largely handmade textiles, wallpapers, stained glass, furniture, and other decorative goods. His magnetic personality attracted many adherents, and he set an inspiring example as a designer, master craftsman, and crafts revival advocate. Largely because of Morris's influence on young designers and architects, the Arts and Crafts movement coalesced in England in the 1880s.

By the 1890s the lessons of Ruskin and Morris had attracted many American followers. Like their English counterparts, they rejected the ornate, mass-produced wares of the era in favor of the simple and handmade. Across the country Arts and Crafts societies were organized, made up of artisans who worked in wood, metal, clay, leather, textiles, paper, and other media, and who held exhibitions to present their work to the public. Commercial Arts and Crafts enterprises were also starting up: Elbert Hubbard's Roycroft community in East Aurora, New York; Charles Rohlfs's cabinetmaking shop in Buffalo, New York; the Grueby, Newcomb College, and Dedham Potteries; and other crafts-based firms. During this decade new journals devoted to art and design began publication in England, Germany, Austria, and America, carrying Arts and Crafts ideas to a growing international audience.

Wood was the heart and soul of Stickley's kinship with the Arts and Crafts movement. With its unvarnished wood, clear joinery, and no-nonsense forms, Stickley's furniture projected the beauty of integrity. As the details opposite testify, he favored careful construction made visible (top left), exposed joinery such as double dovetail joints in benches and floors (top right), Wright-like squared spindles that defined space without enclosing it (bottom left), and subtle finishes emphasizing the natural color, texture, and grain patterns of the wood (bottom right).

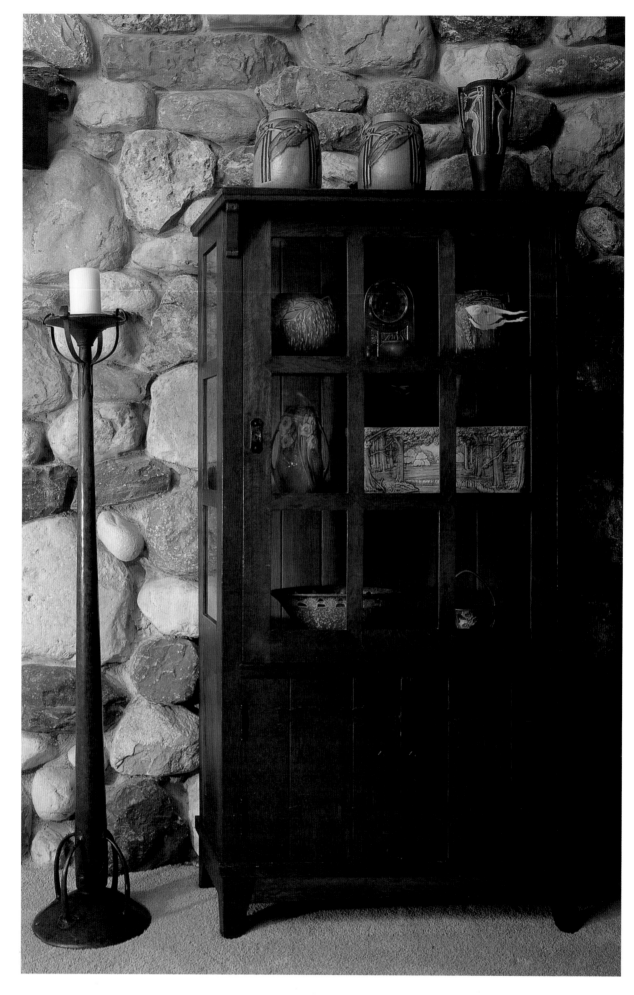

A year after Stickley launched his Arts and Crafts furniture line in 1900, his wares had taken on the straightforward character still recognized a century later. Among his pieces was this 1901 china cabinet, now owned by collectors who live in a Wright-style house. Chamfered panels at the back reinforce the strong vertical lines, which the owners have emphasized by pairing it with a rare tall candleholder of copper, made about 1907 by L. & J. G. Stickley, the firm started by Gustav's brothers.

THE CRAFTSMAN IDEA

This was an era of great ferment in the decorative arts, and Stickley felt its irresistible pull. In 1898 he established his own firm, the Gustave Stickley Company (he later dropped the *e* from his first name), which for the first two years continued to produce revivalist furniture. Stickley had a factory payroll to meet and a family to support, and these responsibilities apparently took priority: he was not yet able to act on the ideas forming in his mind. At the same time he began to experiment with Arts and Crafts design in his shop.

In the summer of 1900 Stickley introduced his first Arts and Crafts furniture to the trade at the Grand Rapids Furniture Exposition. Some of these early designs seem to have been inspired by Charles Rohlfs, the innovative Arts and Crafts furniture designer and maker whose workshop turned out intricately detailed and often exotic pieces expressing his unique and highly personal aesthetic. Other Stickley designs exhibited at this show suggested his awareness of contemporary European trends written about regularly in the international art journals. Stickley's offerings "met with instant favor," reported the trade magazine *Furniture Journal,* but his firm apparently made only one significant sale at this show: George Clingman, manager of the Tobey Company, a large Chicago retailer, ordered more than eight hundred pieces of Stickley's new furniture and arranged to market it exclusively under the Tobey name. Within a year the dealings between the two men ended in mutual disaffection, but Stickley's career as an Arts and Crafts furniture maker had begun.

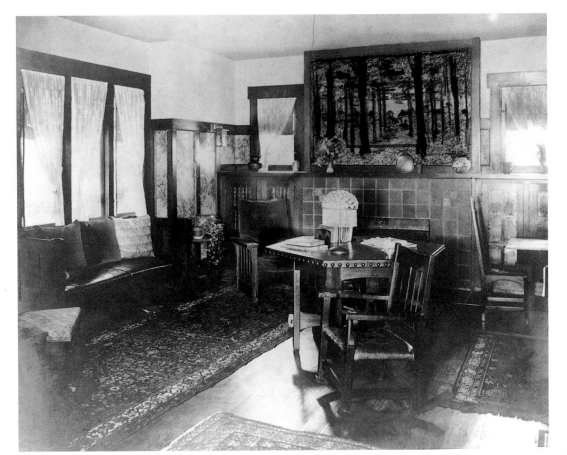

In addition to having Craftsman furniture, the Bronxville, New York, home of one of Stickley's designers, LaMont Warner, exemplified many Craftsman ideas: built-in bookcases flanking a tiled fireplace, casement windows framed in quartersawn fumed oak, paneled walls, and a mural by Warner himself.

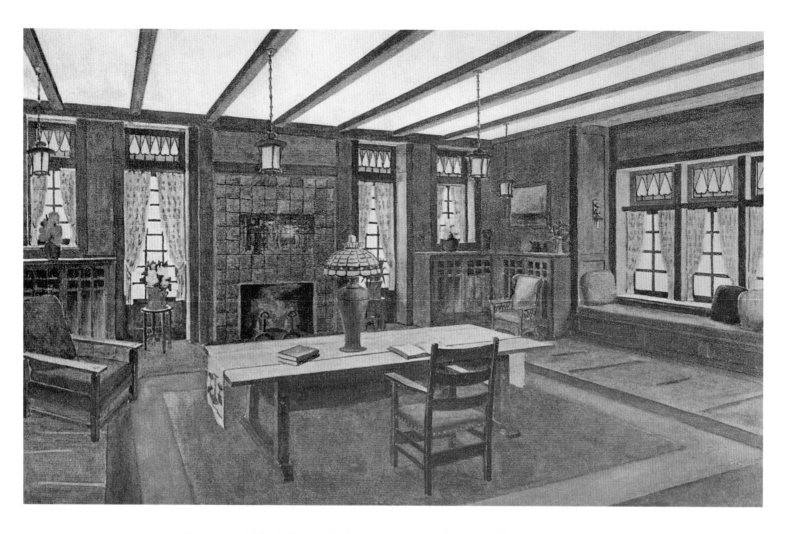

By 1901 Stickley's designs had grown more confident and had taken on the robust, structural quality that would characterize Craftsman furniture from then on. That same year, with a staff of writers and editors, he began publication of *The Craftsman*, a monthly magazine intended to publicize his furniture and spread Arts and Crafts ideals. The first issue, in October 1901, was devoted to William Morris, the second to John Ruskin, and the third to medieval guilds (for a time Stickley publicly referred to his firm as a guild).

Stickley's Craftsman idea, as he defined it in his 1901 catalogue, arose from established Arts and Crafts principles: "... the ideals of honesty of materials, solidity of construction, utility, adaptability to place, and aesthetic effect...." These handicraft-based precepts emphasized plain, functional form, good workmanship, decorative structure, and a respect for natural materials. Stickley applied his newly awakened beliefs to the furniture made in his workshops and, within a few years, to interior design, metalwork, textiles, and the design and construction of houses.

"HONESTY OF MATERIALS." Stickley valued honesty, by which he meant two things. First, the purpose of a piece of furniture should be immediately apparent in its design. He believed, for instance, that a chair should be "first, last and all the time a *chair*, and not an imitation of a

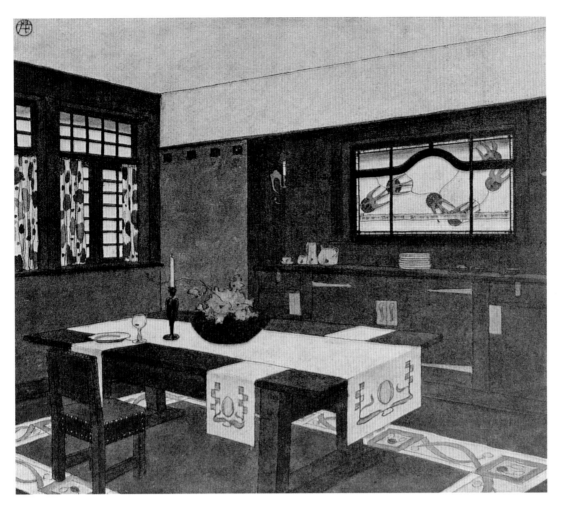

Color drawings of perfect rooms communicated the Craftsman idea to Stickley's readers. The October 1904 magazine showed a living room (opposite) turned toward a substantial fireplace and dressed in nature's colors. Prominent beams spoke of honest construction. A more avant-garde dining room in the November 1905 *Craftsman* (above) was sketched out two years earlier by Harvey Ellis, Stickley's foremost designer. His fascination with British Arts and Crafts design, particularly the work of the Glasgow architect Charles Rennie Mackintosh, is quite clear.

throne, nor an exhibit of snakes and dragons in a wild riot of mis-applied wood carving." Second, the designer and the artisan should appreciate the nature of their materials and create objects that honestly express that nature. For Stickley, like Frank Lloyd Wright, wood was not meant to be molded or bent into elaborate shapes or encased within thick layers of highly polished varnish that obscured its inborn beauty. It should be cut in straight lines to emphasize the dramatic patterns of its grain, its plain surfaces finished to enhance their natural colors and texture.

"SOLIDITY OF CONSTRUCTION." The careful construction of Craftsman furniture reproached the inferior factory wares of the day. As evidence of his furniture's substantial structure, Stickley created designs that made use of tenon-and-key joints, through-tenons pinned with visible dowels, double dovetails, and other forms of exposed joinery. These emphatic functional joints added visual interest to Stickley's pure, plain forms, while making clear exactly how everything was held together. Here was solid construction made visible, designed to be beautiful.

"UTILITY." Stickley was an early advocate of what he described as utility. His sturdy, unadorned Craftsman furniture was durable and functional and intended for daily use. It was not designed to be admired solely for its beauty or the status it conferred on its owner.

"ADAPTABILITY TO PLACE." The word *adaptability* appears in Stickley's writings again and again, and the idea of harmony was a leading theme of his work. Good taste for the Victorians had meant assembling and mixing a miscellany of exotic objects. Stickley sought to replace this kaleidoscopic approach to design with a unified, harmonious whole: the organic, he believed, must replace the eclectic.

"AESTHETIC EFFECT." Stickley always wanted his designs to be beautiful. Because he typically worked with plain forms, the aesthetic effects of his furniture relied on honesty, utility, harmony, and frankly revealed structure. The integrity of Craftsman furniture created beauty.

PROPORTION. The heart of Craftsman design, however, is Stickley's mastery of proportion, the relationship of the parts to the whole. The arms of a Craftsman chair, for instance, are placed to ensure the sitter's comfort and brace the frame, but they are also at the right height and of the right depth, width, thickness, and shape to accord visually with all the other elements of the chair. Stickley adjusted such details with rigorous empirical experimentation on the workshop floor, not according to any prescribed formulas: "[E]very model we produce," he wrote, "is studied and tested and modified until The Craftsman finds it thoroughly satisfactory."

COLOR. Stickley cared about color as well. Year after year he experimented with finishing methods that would enhance the natural color, grain, and texture of quartersawn American white oak, his favorite cabinet wood. He worked in matte browns, greens, and silver grays, applying wax or a thin coat of shellac to give the wood a soft, lustrous glow. To complement his furniture he created household objects of hand-worked copper or iron. The copper was given a rich warm brown patina, the iron a dull sheen that Stickley called "armor bright," and all the metalwork was hammered by hand to create irregular, light-catching surfaces that brought gleams of color into a room. He also made Craftsman curtains, wall hangings, and table runners with simple, subtly tinted patterns worked on loose-weave fabrics. With wood, metal, and textiles he recreated the colors and textures of nature and brought them into the home.

For visual interest, Stickley added simple inlays to his furniture. This inlay on the top of a veneered maple chest is based on a Harvey Ellis motif.

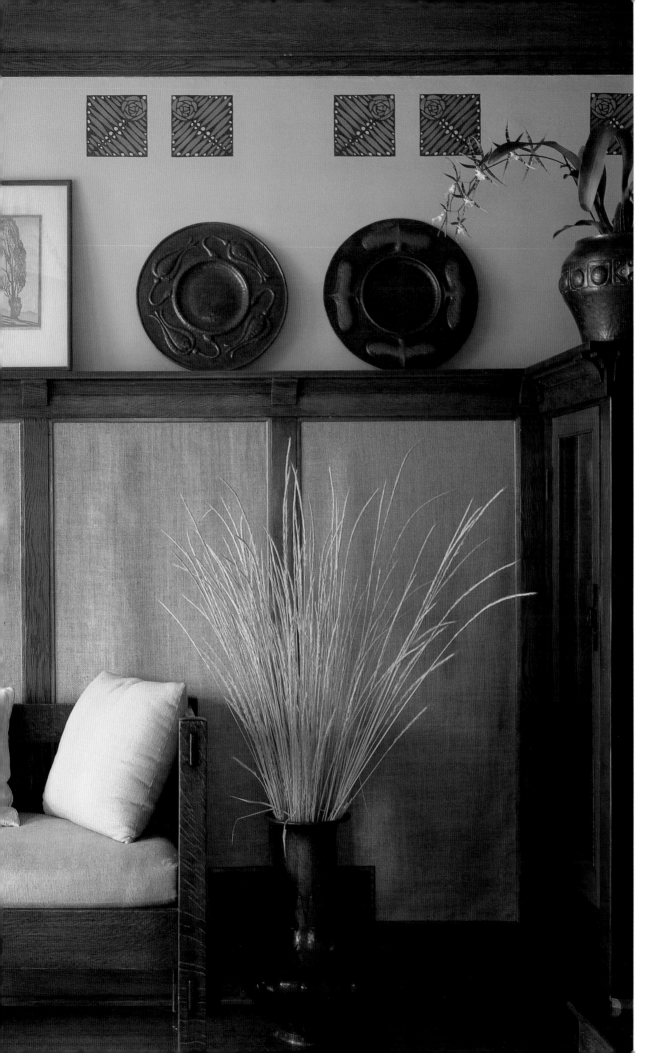

Scott Goldstein and Lauren Gabor have furnished their California bungalow in the Craftsman spirit. The coppery tones that enchanted Stickley warm a corner of their breakfast room. Above a hammered floor vase that catches the light, two Stickley copper plaques rest on a redwood plate rail that frames a wall paneled in burlap. The geometric rose stencil pattern is based on a motif created by Dard Hunter, an artist for Elbert Hubbard's Roycroft community in East Aurora, New York.

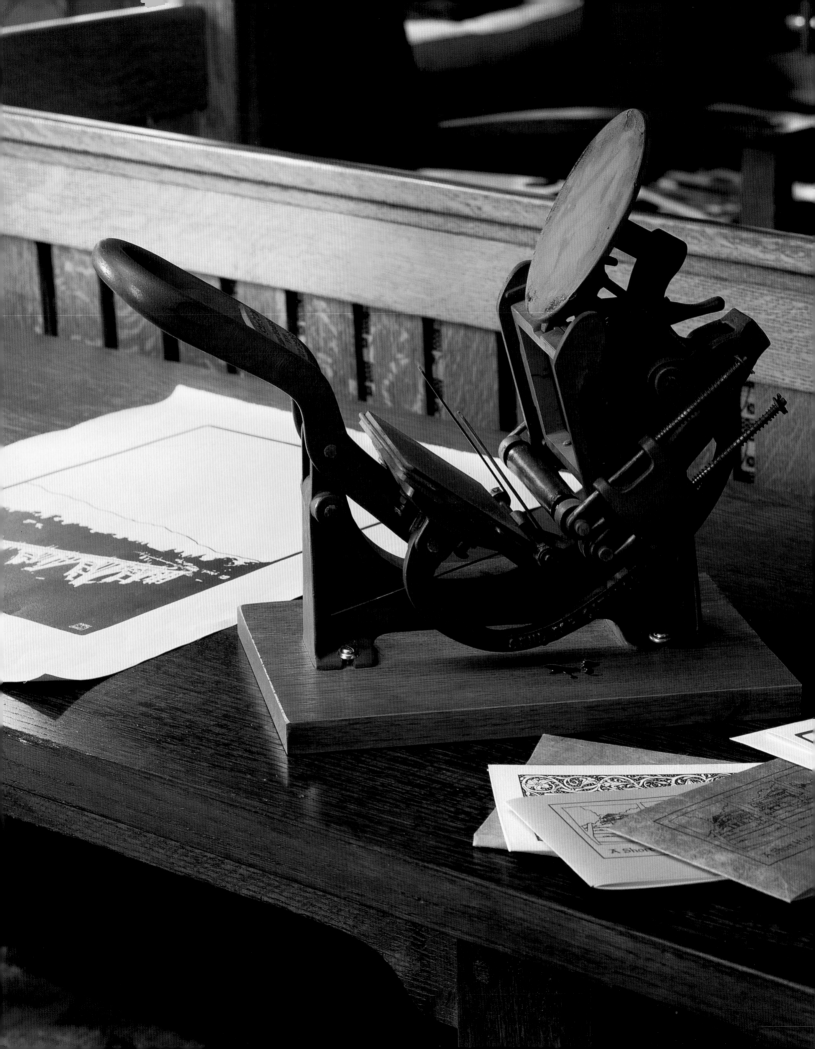

Stickley's thinking quickly evolved, and he began to move away from the idealization of the handmade object that had become a widely accepted Arts and Crafts belief. He recognized that he could produce wares affordable to a middle-class market only by combining skilled hand craftsmanship with an enlightened harnessing of the power of machines, an idea advocated by *The Craftsman* as early as 1902. From the first, Stickley's Arts and Crafts furniture, with its straight lines and flat surfaces, had relied to some extent on machine processes, and his public embrace of the machine acknowledged the realities of Craftsman production. A year earlier Frank Lloyd Wright had argued this case in his famous lecture "The Art and Craft of the Machine," and it seems likely that Wright's thoughts influenced Stickley. Yet as he pragmatically accepted shifting Arts and Crafts ideologies and took advantage of improving machine technologies, the Craftsman idea remained a central theme in all that Stickley did.

In time the Craftsman idea grew to include what Stickley defined as the craftsmanship of life—a moral dimension that he believed should guide the life and work of the individual, the family, the nation. His ideas about the simplification of design led to thoughts about the simplification of life and precepts for moral living. He spoke out against the materialism of his age in a way that continues to resonate today: he was a manufacturer with wares to sell, a capitalist in pursuit of profits, but he urged moderation. Such cautions later led to his eloquent essays on the need to protect the natural environment.

Stickley shared the Arts and Crafts belief in the moral influence of the built environment and emphasized the critical role the home and its furnishings played in shaping character. He thought that poorly made, poorly designed furniture was destructive of good taste, but this was its lesser evil: "Its moral effect," he insisted, "is still more perilous." When Stickley spoke of "the strong-fibered and sturdy oak" from which he built his furniture, he had more than furniture in mind. He was thinking, too, of the moral fiber of the American people.

A SIMPLER LIFE

Stickley's Craftsman enterprises achieved considerable success, and by 1902 his factory employed about two hundred workers. That year he completely remodeled much of the interior of a well-known Syracuse structure, the lavish Crouse Stables, and dubbed it the Craftsman Building. Here he had exhibit space for Craftsman wares as well as his business and editorial offices, a lecture hall, his design department, and, in an adjacent single-story building, his new metal workshop. In late 1905 he left this building and moved his offices to Manhattan, dividing his time between Syracuse and New York City.

Stickley considered well-made tools essential for successful and pleasurable craft work, a belief shared by many of his admirers today. André Chaves, who owns an "ultimate bungalow" designed by Charles and Henry Greene, keeps a small parlor or "hobby" press as a token of the hand-printing he practices. It rests on a rare Roycroft library table in the living room (opposite). Stickley's May 1904 magazine (below) featured another artisan toiling in his workshop.

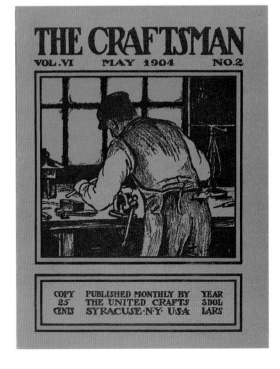

THE CRAFTSMAN

VOL. VI MAY 1904 NO. 2

COPY 25 CENTS PUBLISHED MONTHLY BY THE UNITED CRAFTS SYRACUSE·N·Y· U·S·A YEAR 3 DOLLARS

THE CRAFTSMAN BUILDING
38TH & 39TH STREETS
EAST OF FIFTH AVE.

Craftsman Farms supplied Stickley's restaurant with spring water, eggs, cheese, and milk. On the menu (above) was Stickley's Craftsman motto, tucked into a joiner's compass: *"Als ik kan,"* meaning "If I can" or "As I can." Visiting his daughter Barbara in Skaneateles, New York, in 1930, Stickley relaxed by the lake with his granddaughter Edith Wiles and his perpetual corncob pipe (opposite).

A few years later in the gentle, green hills of rural New Jersey he began building Craftsman Farms, an ambitious project meant to combine a crafts colony, a school, and a demonstration farm. He called it his Garden of Eden. Stickley's plans for the 650-acre site were never fully realized, but he lived there happily for several years with his wife, Eda, and their six children. In 1913 he leased a newly completed twelve-story Manhattan office tower and opened it as the Craftsman Building, which encompassed eight floors of retail space, two floors of offices, a floor for club rooms, a library, a lecture hall, and the Craftsman Restaurant at the top.

Stickley's huge financial commitment to this multistory Arts and Crafts emporium was unluckily timed. The popularity of his Craftsman wares began to decline, and the qualities that had once made them so appealing—their frank composition, hand-wrought surface textures, and muted brown and green earth tones—now looked a little dated as popular taste shifted toward bright colors and formal design. His problems were compounded when war began in Europe in 1914 and the market for household goods waned. Caught between the high fixed costs of the Craftsman Building (its annual rent was $60,000) and failing retail sales, Stickley's firm was bankrupt by 1915. He published the last issue of *The Craftsman* in December 1916 and then closed down completely. In the years following the bankruptcy he worked briefly with his brothers Leopold, John George, and Albert as a vice president of their amalgamated manufacturing firm, Stickley Associated Cabinetmakers, and then tried unsuccessfully to start several business ventures of his own. In later life he made a few simple, Shaker-like chairs for members of his family, but his days as "The Craftsman" were over.

Stickley died forgotten in 1942, his designs by then considered irrelevant and without worth. Yet a prediction he made during his Craftsman years has turned out to be true: "Oak furniture that shows plainly what it is, and in which the design and construction harmonize with the wood . . . will in time become valuable . . . [and] will be treasured as heirlooms in this country. . . ."

Gustav Stickley's Craftsman idea—his personal, creative response to mainstream Arts and Crafts thinking—had found ever-widening expression in wood, metal, textiles, interior design, and complete homes that settled comfortably into their natural surroundings. In his *Craftsman* magazine, he had reached out to readers seeking a simpler, better way to live. Throughout his career the Craftsman idea continued to grow and branch out, its roots sunk deep into Stickley's fondness for music and harmony, his desire to live in nature, his idealization of home and family, his love of wood.

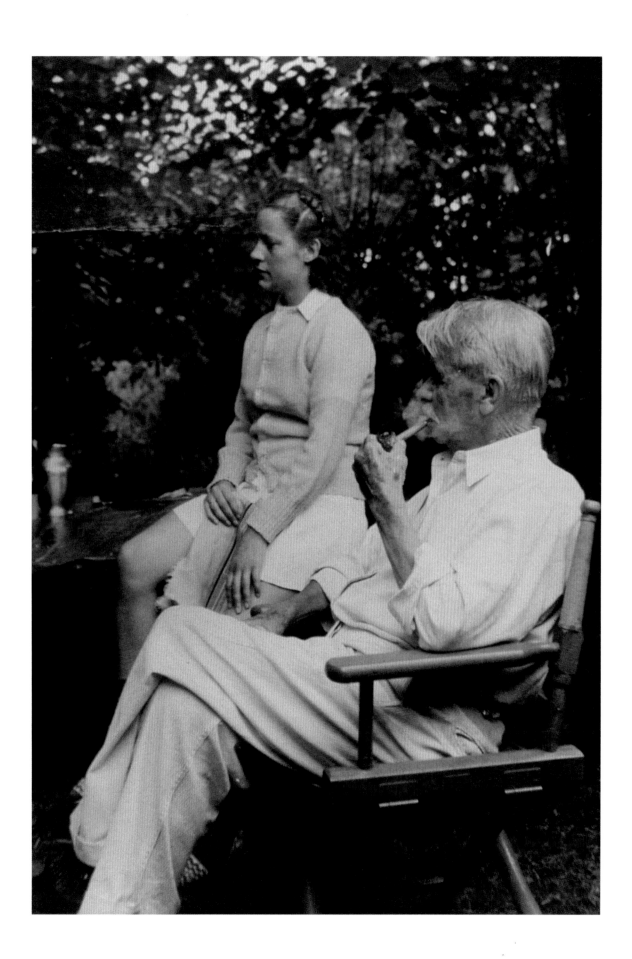

Take a house planned in this way, with a bi[g]
and beautiful with its great fireplace, open
cupboards, bookcases, sideboard and perh[aps]
which links the house with the garden; fill
upon the wood to[ne]
given fort mbroider[y]
house wh hall, re
den,—eac[h] ch one [of]
a-brac,—a[nd] hether o[r]
influence elopment
houses sh will see t[he]
central id d, althou[gh]
taste and r. This is
quite as v the more
woman d ready m
person's t hout feel
come bef[ore] a real h[ouse]
plans of the Craftsman houses that we hav[e]
arrangement of the kitchen. In these days o[f]
inexperienced help, more and more women
selves to keep the household machinery run[ning]
so, for woman is above all things the hom[e]

THE CRAFTSMAN

VOL. V JANUARY·1904 NO. 4

COPY 25 CENTS PUBLISHED MONTHLY BY THE UNITED CRAFTS SYRACUSE·N·Y·U·S·A· YEAR 3 DOLLARS

STICKLEY

STYLE

OUTSIDE~HOME MAKING

The Craftsman houses promoted by Stickley's *Craftsman* magazine came in many shapes and sizes, from rustic summer cottages and simple bungalows to substantial homes. Typically detached suburban residences meant for middle-class families, they were sturdy, unpretentious, and straightforwardly simple. All were designed to be in harmony with the natural landscape, an idea popularized in the mid-nineteenth century by Andrew Jackson Downing, whose book *Cottage Residences* (1842) offered house designs that "produced a harmonious union between the architecture and the landscape." ⠿ Along with Frank Lloyd Wright, Charles and Henry Greene, and other architects of the Arts and Crafts era, Stickley emphasized the use of natural materials, the relationship of the house to its site, and the belief that architectural beauty required good proportions and an adherence to the colors of nature. The exterior of the Craftsman house was not composed according to prescribed architectural formulas: it was not intended to look like a Greek temple or follow the rigid laws of symmetry. Rather, Stickley believed, it should rise from its natural surroundings "as a flower grows out of the soil." ⠿ The Craftsman house's reticent, rational design placed a high value on utility while avoiding elaborate display. Like Craftsman furniture, it was intended for people who desired plain living as well as good quality.

The Massachusetts house of Stickley's great-granddaughter, Cindy McGinn.

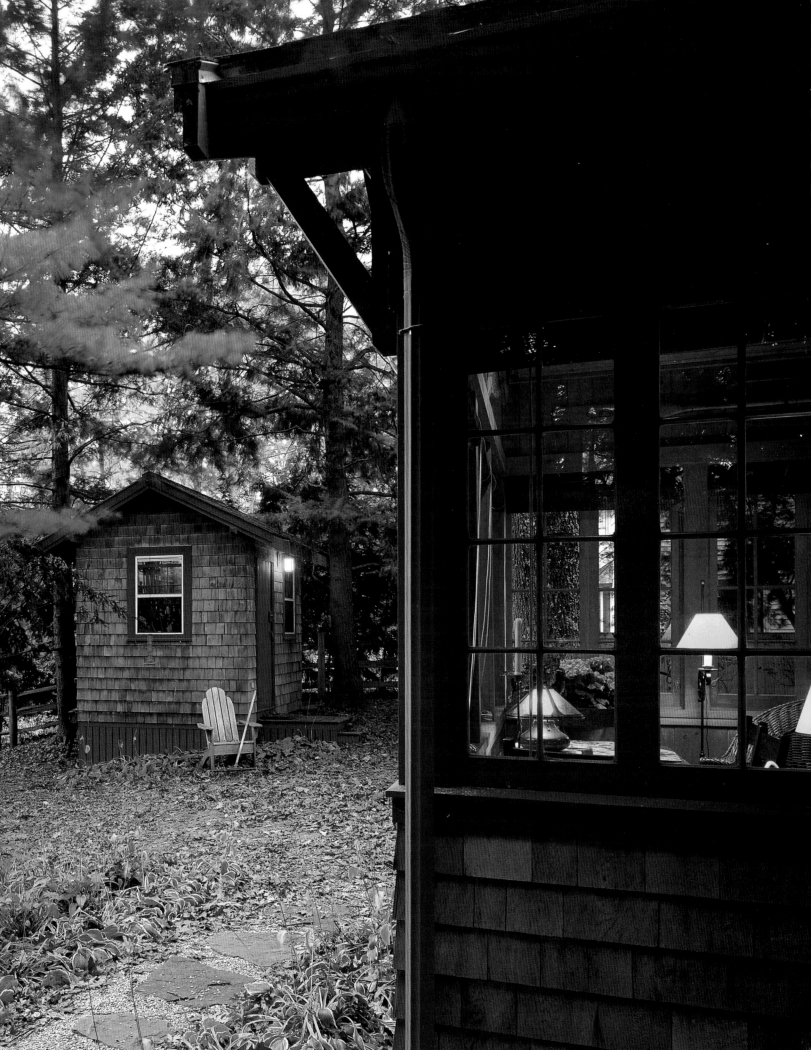

THE CRAFTSMAN HOUSE

"WE ... DO NOT BELIEVE IN LARGE HOUSES WITH MANY ROOMS ELABORATELY DECORATED and furnished, for the reason that these seem so essentially an outcome of the artificial conditions that lay such harassing burdens upon modern life and form such a serious menace to our ethical standards ...," declared Stickley in 1909. "That is why we have from the first planned houses that are based on the big fundamental principles of honesty, simplicity and usefulness—the kind of houses that children will rejoice all their lives to remember as home." With the Craftsman house, Stickley had found a new medium that could be shaped by the Craftsman idea. ▪▪ At the beginning of the twentieth century, popular magazines such as *House and Garden* and *Good Housekeeping* published plans for modestly priced houses, and in January 1904 *The Craftsman* began including plans for Craftsman houses as a regular feature. That same month Stickley founded the Craftsman Home-Builders Club, whose sole membership requirement was an annual $3 subscription to the magazine. Members were entitled to a free set of house plans as well as access to the expertise of Stickley's architecture department. For a minimal fee Stickley would modify these plans to suit individual needs; for a somewhat higher charge the company would design a complete house. ▪▪ Over a twelve-year period Stickley published plans for about two hundred Craftsman houses advertised as costing between $2,000 and $10,000 to construct; a few simple designs could be built for less than $1,000, while the most elaborate might require up to $15,000. By 1913 Stickley's firm claimed that several thousand Craftsman houses had been built, at a construction value of more than $20 million. The actual number, however, is unknown.

Today only about sixty Craftsman houses have been located, and nearly all of them have undergone remodeling that obscures their Craftsman heritage. ▪▪ Craftsman houses were designed by architects employed either full- or part-time by Stickley's firm; he is not known to have had any architectural training himself. In 1902 and 1903

"That Plainness Which Is Beauty"

Craftsman houses shown in Stickley's books (left and opposite) and magazine were unpretentiously plain but revered natural materials and careful proportions. These simple and affordable homes invited the family-centered life advocated regularly in the pages of *The Craftsman*.

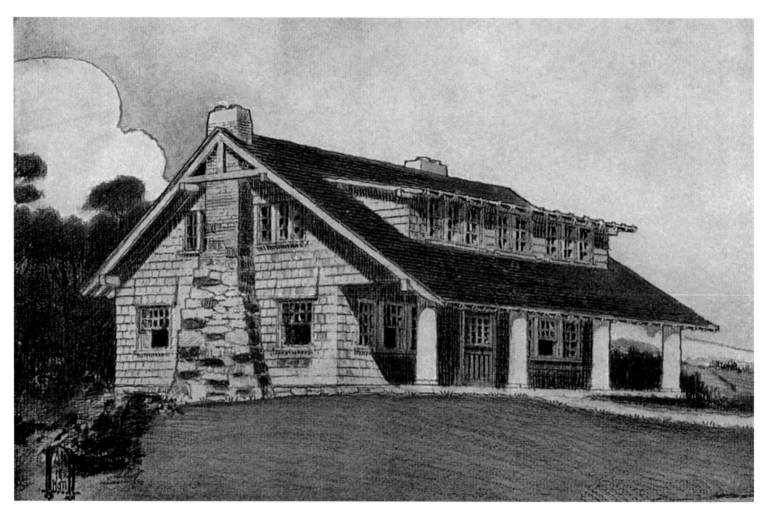

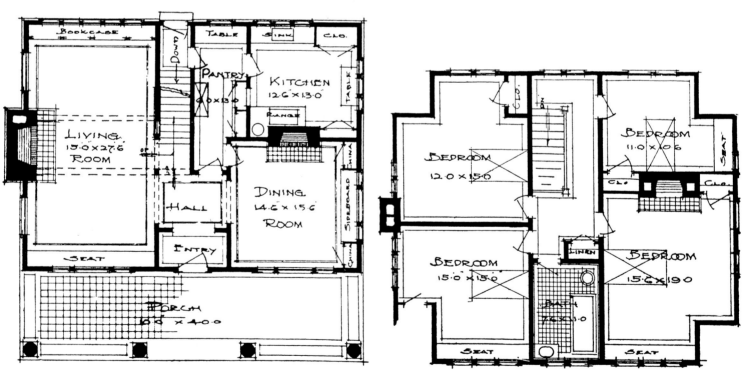

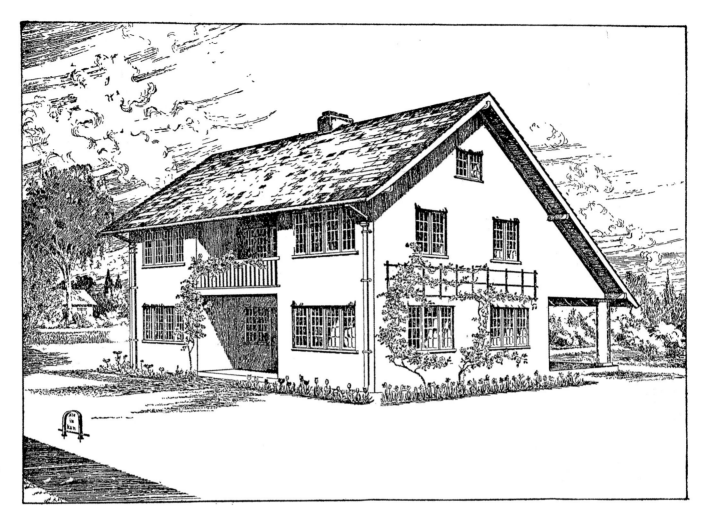

Henry Wilkinson, E. G. W. Dietrich, and Harvey Ellis designed houses for *The Craftsman* magazine. After Ellis's death in January 1904, Craftsman houses were published without attribution, but Stickley's surviving business papers record payments to the architects Harry Gardner, Oliver Story, George Nichols, Karl Sailer, and a "draughtsman," Ruth Anne Williams. ▪▪ The same broad principles that shaped Craftsman furniture largely determined Stickley's approach to domestic architecture: honesty of materials, solidity of construction, utility, adaptability to place, and aesthetic effect. He recommended the use of hand-hewn local materials left as much as possible in their natural state. Such good-quality materials were not inexpensive, but Craftsman houses were designed to keep maintenance costs low. ▪▪ Their exteriors frankly expressed the interior arrangements. By avoiding established styles, Stickley believed that he had liberated himself from fashion and made function a priority. A Craftsman house was designed not for effect but for the life that was to be lived in it. Wide porches, bands of windows, low-pitched roofs, and natural colors and textures tied the houses to the earth. Instead of leveling the land to make a smooth, neatly squared building lot, for example, Stickley advocated retaining as much of the natural landscape as possible. ▪▪ Although the designs—produced under the pressure of magazine deadlines— sometimes fell short of Stickley's ideals, his architecture, like his furniture, embodied "that plainness which is beauty," a simplicity he sought in everything he did.

Craftsman Houses: A Book for Home-Makers, published by Stickley in 1913, included houses meant to appeal to a wide middle-class audience. A "Comfortable Craftsman Cottage with Seven Rooms" (opposite) was called "as picturesque as it is practical." House no. 114 (above) was "planned for much outdoor life" with generous porches and sleeping balconies.

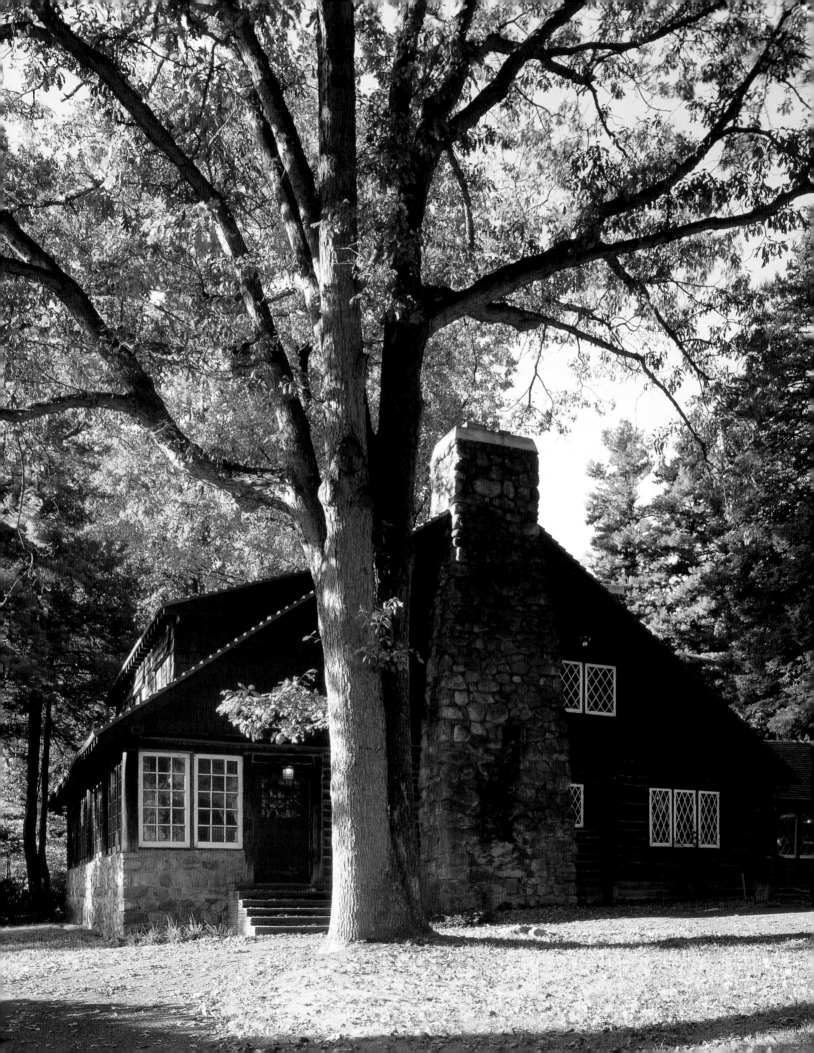

IN THE PAGES OF *THE CRAFTSMAN*, STICKLEY URGED HIS READERS TO THINK OF PORCHES, pergolas, and terraces as informal outdoor rooms rather than mere passageways. These structures blurred the distinction between outside and inside and created new and liberating opportunities for family life. As outdoor rooms they put family members into bracing contact with light-filled nature and at the same time offered secluded, shaded settings for quiet relaxation. ▪▪ The wholesome pleasure of vigorous outdoor living was a constant *Craftsman* theme. The inhabitants of a bungalow or Arts and Crafts–style house were able to work, play, rest, and eat in the open air because these houses were planned to provide space for as much outdoor life as possible. Porches, pergolas, and terraces, reconsidered as living or dining rooms, increased the usable area of the houses and created sturdy settings for lively outdoor play. ▪▪ They had a contemplative aspect as well. Similar to a fireplace inglenook, these sheltered, softly lighted spaces were meant to be restorative retreats

"Under Fragrant Bowers"

from the demands of daily life. They were domestic and withdrawn, protected by stone parapets, flower boxes, and luxuriant vines. *The Craftsman* declared that "there is a charm in . . . privacy." Pictured porches were often recessed to further enhance this enfolding sense of peace. ▪▪ Vines of all kinds climbed up porches and tumbled over pergolas, which each tied a house to the world outside. They created green and flowering corridors that led out of the house and into the garden, where members of the family refreshed themselves in the health-giving outdoors.

At Stickley's log home, Craftsman Farms in Parsippany, New Jersey (opposite), as well as in the pages of *The Craftsman* (left), enclosed and open porches allowed family members to read, relax, and eat in the fresh air, protected by a sheltering roof.

THE CRAFTSMAN GARDEN

STICKLEY BELIEVED THAT SURROUNDINGS SHAPED CHARACTER. FOR HIM, A GARDEN'S natural beauty had a positive moral influence. Spiritually, the garden was important for "the beauty it brings our eyes and the peace it lays upon our souls," noted the 1913 promotional booklet *Craftsman Houses*. It was a shady, fragrant refuge from the demands of daily life, a source of comfort and inspiration. Physically, gardening afforded relaxation and opportunities for work and play outdoors, providing pleasurable recreation and a productive use of leisure time. Architecturally, a garden linked a house to its surroundings, bringing it "into harmony with the landscape by connecting the craftsmanship of man with the work of Nature." ▪▪ The Craftsman idea found expression in the garden just as it did in the home. Honesty came from rejecting elaborately geometrical plantings, faultlessly trimmed walks, and neatly barbered bushes, in preference to

"That Green Eden"

natural patterns and groupings of shrubs and trees. Honesty also meant emphasizing a garden's utilitarian parts instead of concealing them. Colorful, orderly vegetable gardens were just as appropriate in the front of the house as in the back. "Getting down close to Mother earth and helping things to grow" was what really mattered, and a few weeds or an imperfect flower bed never diluted a garden's tranquillity. Adaptability to place suggested the use of native plants, right for the local climate and soil conditions, and garden structures built from local materials. Aesthetic harmony was to be achieved

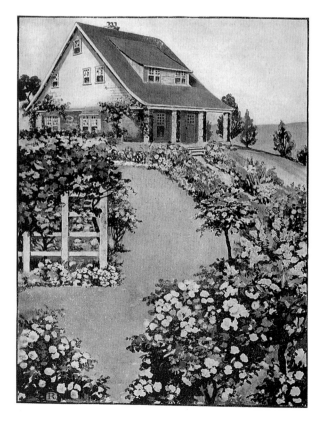

within the garden itself, with the site's existing natural features, and with the architecture of the house. ▪▪ The Craftsman garden had a rugged beauty, with "more of the feeling of free woods than of a primly kept enclosure," and symbolized the gardener's kinship with the open country. Stickley also encouraged rural, self-sufficient living. Like many other Arts and Crafts practitioners in England and the United States, he embraced what was known during his era as the "back to the land" movement, and this fueled his concern for progressive farming and the productive use of land. "We need [the garden]," exhorted *Craftsman Houses*, "because in practically all of us is a deep, distinctive longing to possess a little corner of that green Eden from which our modern and materialistic ways of living have made us exiles."

The April 1910 issue of *The Craftsman* (left) showed readers how to make a house blossom in summer. Stickley collectors in California (opposite) used a Japanesque gateway and lamps to recreate the aura of a Craftsman garden.

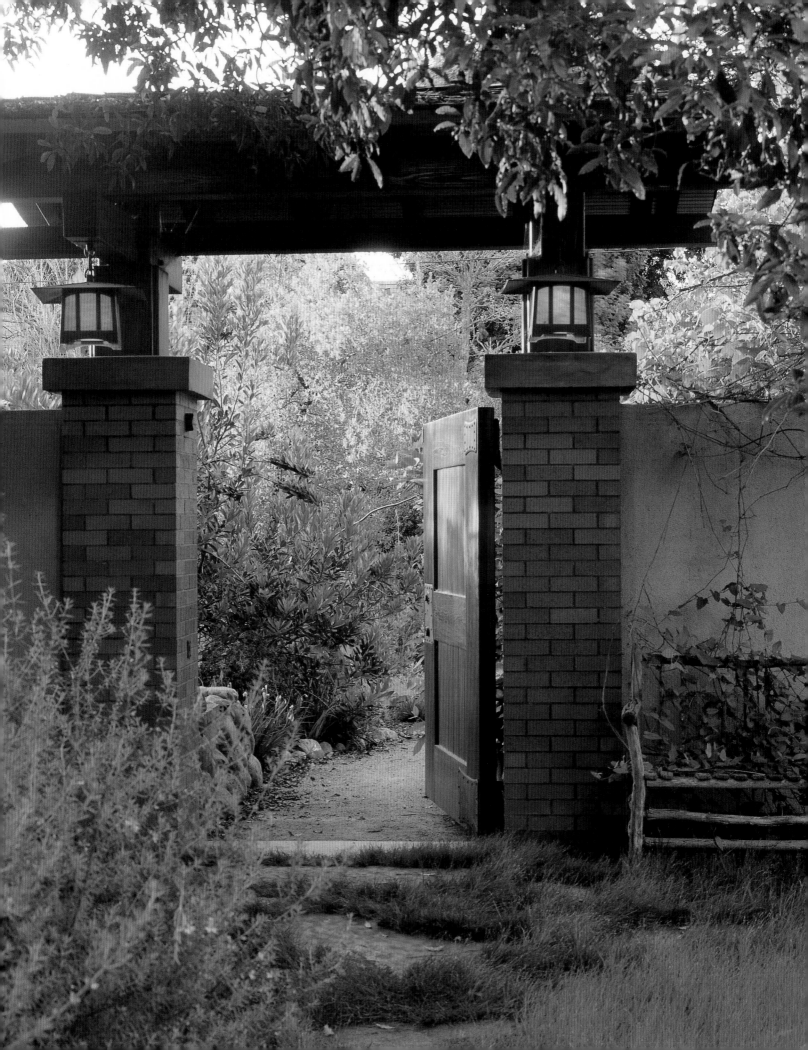

INSIDE~CRAFTSMAN IDEALS

Simplicity, honesty, and dignity—these were the attributes of Stickley's Craftsman interiors. Decorative effects relied on prominent structural features, such as ceiling beams and wainscoting, textured wall surfaces of rough plaster, and the natural colors of fumed oak or chestnut woodwork. Use and comfort were the goals, not expressions of status. ⠶ Stickley, of course, suggested Craftsman furniture to unify the interiors of the Craftsman house plans he sold, but he was equally committed to space-saving built-in bookcases, cabinets, and fireside seats. He lauded openness: large downstairs rooms separated by walls with wide, doorless entrances or defined by post-and-panel partitions that accentuated the horizontal flow of space. ⠶ Yet each room was meant to distinctly reflect its function, because Stickley believed that a room "is satisfying only when it completely fulfills the purpose for which it is intended. Its charm and individuality spring from its fitness to meet the needs of its occupants as simply and directly as possible . . . [and] to express honestly the life . . . and character of the people who live in it." While contributing to the beauty of the house as a whole, each room, he said, should be "contentment itself."

Silver from Stickley's restaurant and home, now at his great-granddaughter's.

LIVING ROOMS

THE MOST IMPORTANT ROOM IN THE HOUSE, STICKLEY BELIEVED, WAS THE LIVING ROOM, "a place where work is to be done, . . . the haven of rest . . . the place where children grow and thrive." Often the largest room in his Craftsman houses, it was informal and relaxed, unlike the stuffy, conventional Victorian parlor. Windows that let in sunlight and framed green vistas of the garden added cheer. Its decoration, the textures and colors of its woodwork and walls, and its simple furnishings set the tone for the whole house. :: Unconcealed posts, corbels, and ceiling beams made the room's structure visible, but its most important structural element was the fireplace. For Stickley, as for so many Arts and Crafts designers, this was the key symbol of domestic life. He liked a fieldstone fireplace (or one faced with tile) set in a cozy and picturesque inglenook, which gave a sense of intimacy to the hearth while allowing the fire's warmth to be enjoyed from the main room. Along with a few carefully chosen pieces of furniture, built-in window seats, bookcases, and cabinets unified the room while simplifying housework and freeing up space for expansive family living.

"Comfort and Beauty"

For the woodwork, Stickley preferred oak or chestnut for their strong, clearly defined grain patterns and because they took color well. His preferred browns, greens, and grays, achieved with fuming or stains, were restful and unobtrusive but strong enough to contrast pleasingly with the tints of a plaster- or fabric-covered wall. :: Harmonious and complete in itself, the living room did not need elaborate ornament. Yet its simplicity did not mean sparseness: the color and texture of pillows, the glinting surface of a hammered-copper bowl, and a vase filled with flowers were personal touches that brought the room to life. As the central family room, its greater significance was its benevolent influence on the shaping of character: "It is here," wrote Stickley, "that we should be at our best."

In October 1905 *The Craftsman* showed off Stickley's living room ideas in full color (right and opposite). These drawings captured the Craftsman idea: cozy built-ins, colors from nature, a tiled fireplace, paneled walls, sturdy furniture—and for the soul, music and flowers.

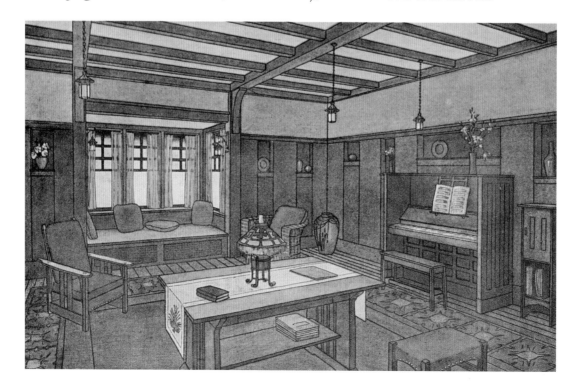

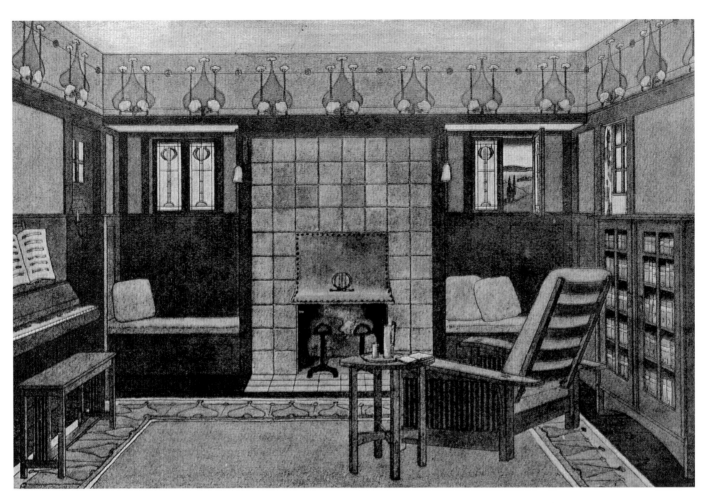

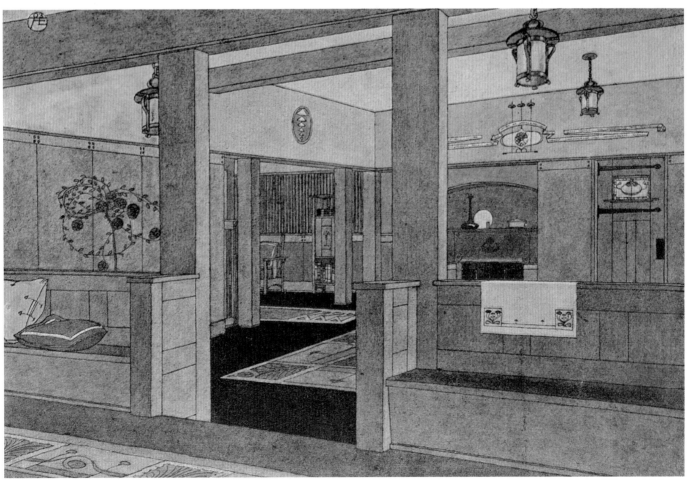

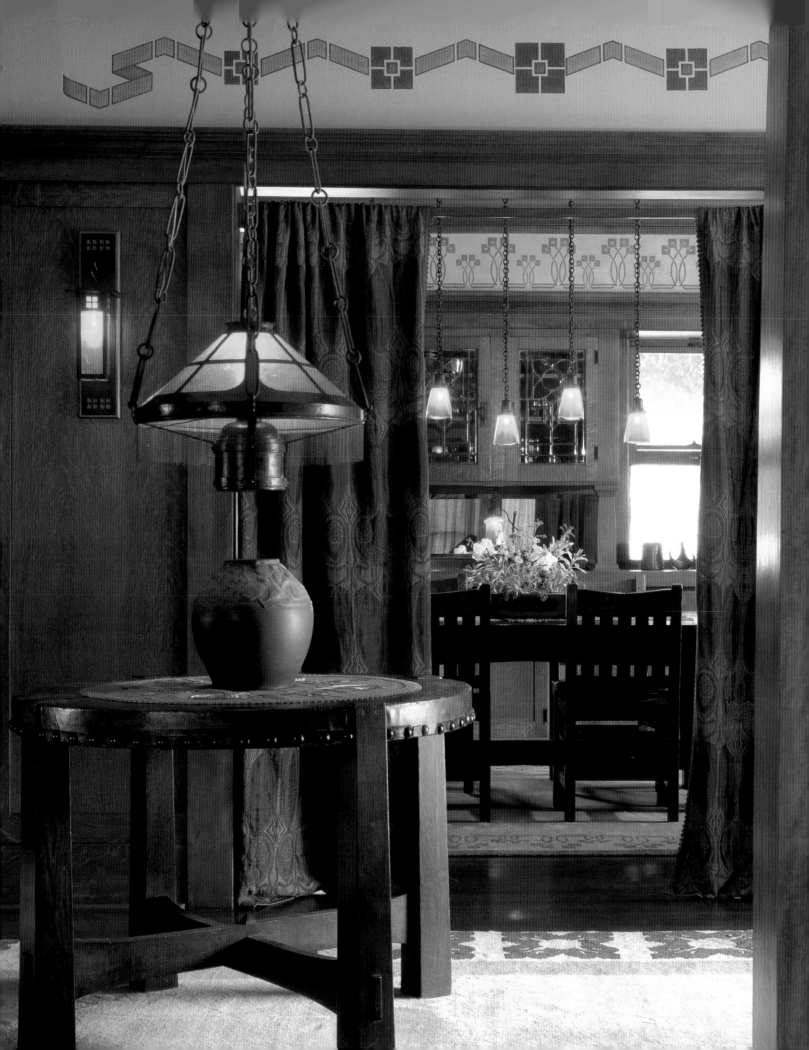

ENLIVENED BY RICH COLORS, BIG WINDOWS, AND HANDSOME STRUCTURAL FEATURES, Craftsman dining rooms were places of great charm. If separate, they were entered through wide doors that preserved the house's open floor plan. Alternatively, dining areas were set into a comfortable alcove along a living room wall or combined with the kitchen. ▪▪ As in other rooms, visible structure was important. Here again Stickley recommended wainscoting, ceiling beams, and large, well-placed windows with window seats or ledges for plants. He also suggested building in naturally finished sideboards, plate racks, and china cabinets with small-paned or leaded-glass doors. One wall was nearly always given over to a cheery fireplace. ▪▪ In contrast to the living room, Stickley believed that vibrant color was completely appropriate for the less frequently used dining room, as long as it harmonized with that of the adjacent rooms. Silver, glass, and china arrayed on a sideboard or plate rack gave the room all the decorative touches it needed. ▪▪ Kitchens combined the spotlessness and warmth of old-fashioned kitchens with the most modern ideas of convenience and efficiency. Stickley unsentimentally depicted this room as a kind of Arts and Crafts workshop, asserting that "the very first requisites are that it should be large enough for comfort, well-ventilated and full of sunshine, and that the equipment . . . should be ample, of good quality and, above all, intelligently selected. We all know the pleasure of working with good tools in congenial surroundings." ▪▪ Big built-in cupboards for storing china, cutlery, and table linens were central features. Walls were adorned with blue-and-white enameled kitchenware or copper cooking utensils, and surfaces were brightly colored and easy to clean. In its blend of the utilitarian with the visually appealing, a Craftsman kitchen was "as carefully finished as the rest of the house, and in its way . . . one of the most beautiful of the rooms."

"Centers of Hospitality and Good Cheer"

A California bungalow's owners heeded Stickley's advice to fill their dining room walls with rich color (opposite). While evoking the hominess of earlier kitchens, the Craftsman "workshop" was all business, as the September 1905 magazine illustrated (right).

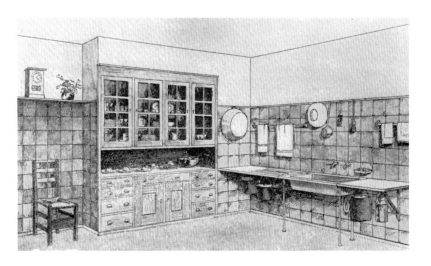

WALLS AND FLOORS

WALLS AND FLOORS, STICKLEY LIKED TO SAY, SHOULD EXPRESS THE FRIENDLINESS AND permanence of wood. Believing that generous woodwork was the best enrichment for any room, he recommended covering the lower portions of walls with wainscoted panels stained to bring out the natural grain and texture and give the surface a soft, mellow finish. Above the wainscoting, the wall was textured plaster, either plain or tinted, or covered with a fabric or wallpaper that harmonized with the woodwork. Color and individuality could be further heightened by stenciling a wall with a decorative frieze, although Stickley was careful to remind his readers to use this kind of ornamentation with great restraint. The wainscoting's rectangular motifs were repeated in well-proportioned, naturally finished doors, windows, and fireplaces that became part

"Complete and Satisfying"

of the wall's structural decoration. ▪▪ Floors were sturdy and made of durable hardwoods, their unobtrusive tones blending with the other woodwork in the house. Finished with a mixture of wax and varnish, their surfaces shone with a subtle gleam. Occasionally floors were embellished with inset geometric motifs of contrasting woods. These patterns were simple, structural, and subdued, and their ornamental value arose as much from skillful workmanship as from the modest designs themselves. ▪▪ With color, texture, and candid construction, the walls and floors brought a final touch of beauty and made each room "complete and satisfying" in itself.

The Craftsman advocated wainscoted walls with a plate rail (right). Framing around doors and windows helped define the structure of the room. Muted walls, oak floors, and a reproduction of a carpet design by the English Arts and Crafts architect C. F. A. Voysey (opposite) interpret Stickley's household advice today.

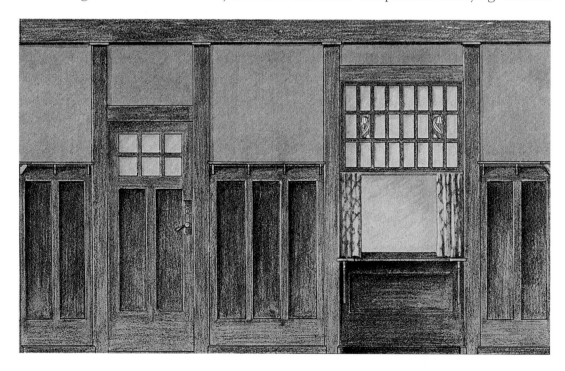

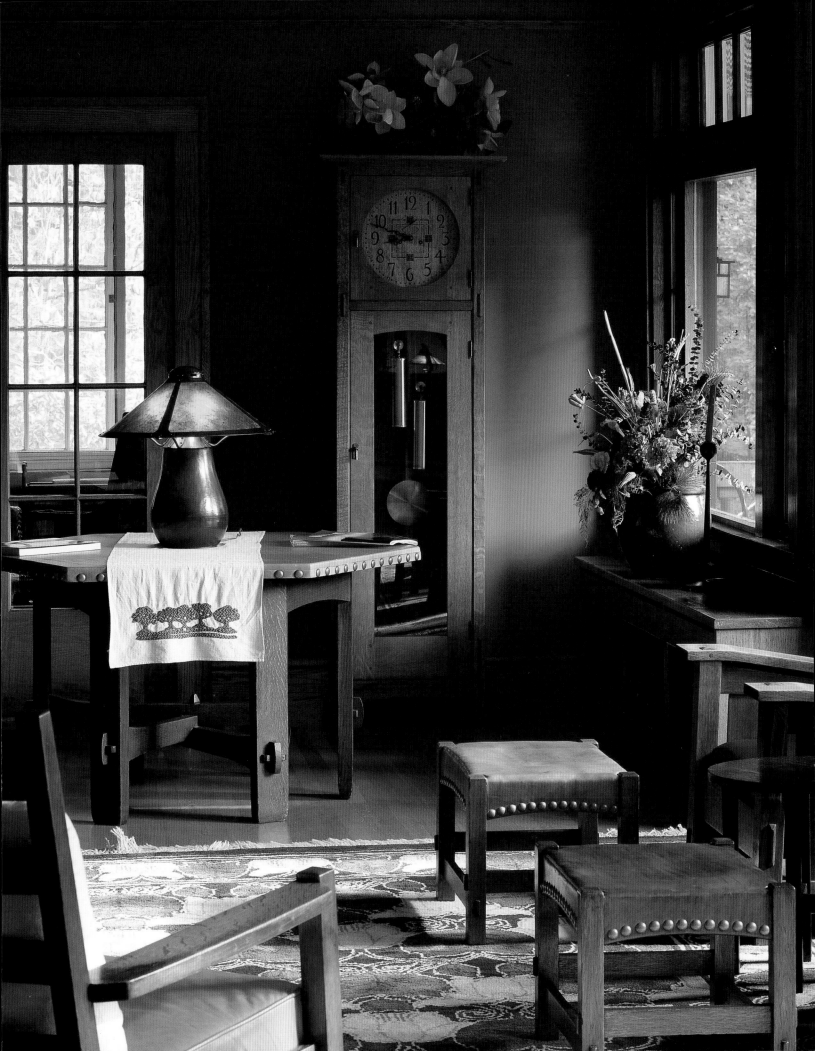

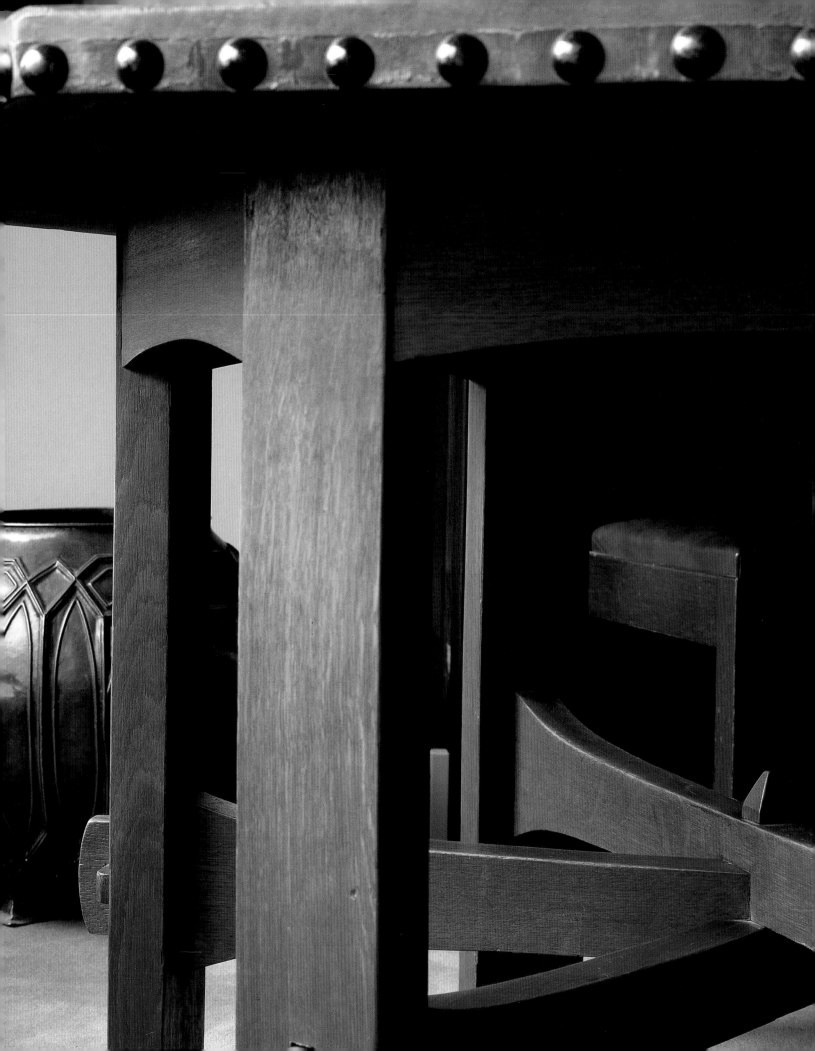

STICKLEY CALLED CRAFTSMAN FURNITURE THE CLEAREST EXPRESSION OF THE CRAFTSMAN idea. In response to the florid, machine-carved, skimpily constructed factory furniture of his day, he concluded that "the best way to get something better was to go directly back to plain principles of construction and apply them to the making of simple, strong, comfortable furniture." ▪▪ In 1900, the year he brought out his first Arts and Crafts designs, he began issuing furniture catalogues, and by the next year he was selling directly to retail customers as well as through Marshall Field and Company in Chicago, Gimbels in Philadelphia, and several other large depart-

ment stores. In early 1906 he opened a Craftsman retail store in New York City, later establishing similar outlets in Boston and Washington, D.C. ▪▪ Stickley's furniture was not inexpensive. His Morris chairs ranged from about $26 to $47, double-door bookcases from about $33 to $65, and round dining room extension

"Simple, Strong, Comfortable"

tables from about $33 to $82. Yet two of Stickley's upstate New York competitors—the Roycroft Shop and his brothers' firm, the L. & J. G. Stickley Company—sold comparable designs at somewhat higher prices. And similar pieces were available for considerably less money from the 148 American manufacturers who by 1908 were classifying themselves as

"Mission" furniture makers and from mass merchandisers such as Sears, Roebuck. ▪▪ Stickley liked to present himself as the sole creator of Craftsman furniture, but as the president and principal owner of a manufacturing, retailing, and publishing firm, it is unlikely that he would have had much time to spend designing at a drawing board. He did employ designers, but they worked anonymously. The one exception was Harvey Ellis, who created many graceful, elegant furniture designs for Stickley and signed his work in *The Craftsman* magazine. Craftsman furniture was also designed by LaMont Warner, Louise Shrimpton, and the architect Henry Wilkinson. Stickley's true talent seems to have been his ability to shape his designers and inspire their best work.

A New York collector displays one of Stickley's leather-topped hexagonal tables (opposite). The same model was listed in his company's 1909 furniture catalogue, *Some Chips from the Craftsman Workshops*, along with a desk, a reclining Morris chair, and a slatted settle (right).

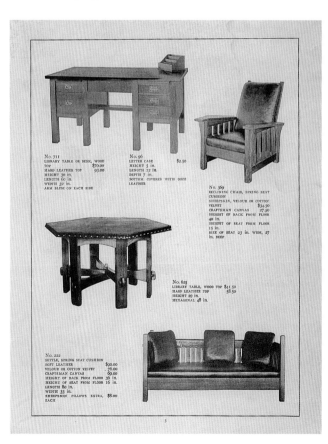

METALWORK AND LAMPS

WHEN STICKLEY AND HIS STAFF BEGAN TO DESIGN BOOKCASES, SIDEBOARDS, AND CABINETS, it must have been immediately clear that the shiny, elaborate stamped-metal hardware from standard suppliers would never do for Craftsman furniture. Stickley's earliest metalwork designs were for his 1901 furniture, although they were almost certainly executed by a subcontractor. In 1902 Stickley set up his own metal workshop to produce iron, copper, and brass hardware for his furniture. Craftsman hinges, key escutcheons, and drawer and door pulls were made "according to principle," their plain, rugged designs and matte finish harmonizing with the furniture's natural wood tones and unadorned forms. ⣿ The energetic Stickley soon conceived of a more ambitious undertaking. Within a short time his metalworkers were making handwrought lanterns, lamps, fire sets, jardinieres, umbrella stands, serving trays, wall plaques, and other handsome household articles. Although fashioned for everyday use, each piece of Craftsman metalware had "the quality of ornament and the marks of thorough craftsmanship." ⣿ Craftsman metal objects achieved their decorative effects primarily from their simple, structural forms. Skillful hand hammering enhanced these chaste shapes by creating varied, light-catching surfaces. Equally important were the soft, luminous color effects of Craftsman metal. The ironwork was finished by a process that brought out its black, gray, and silvery tones; the copper was given a deep warm brown patina that suggested the mellowing effects of age; and the brass, its surface untouched, took on a beautiful dull green shade. ⣿ Plain forms and glinting irregular surfaces gave Craftsman metalwork a unique beauty. Metal hinges and handles were appropriate adjuncts to Stickley's sturdy furniture, and his decorative, functional household articles brought the Craftsman interior to life.

"According to Principle"

Metal Craftsman lanterns (below) filled Stickley's 1909 catalogue. Rare bookends and hammered-copper plaques, poised on a rail above an L. & J. G. Stickley sideboard, are now at home in California (opposite).

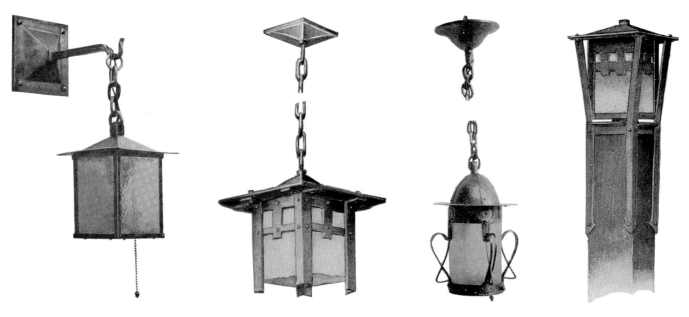

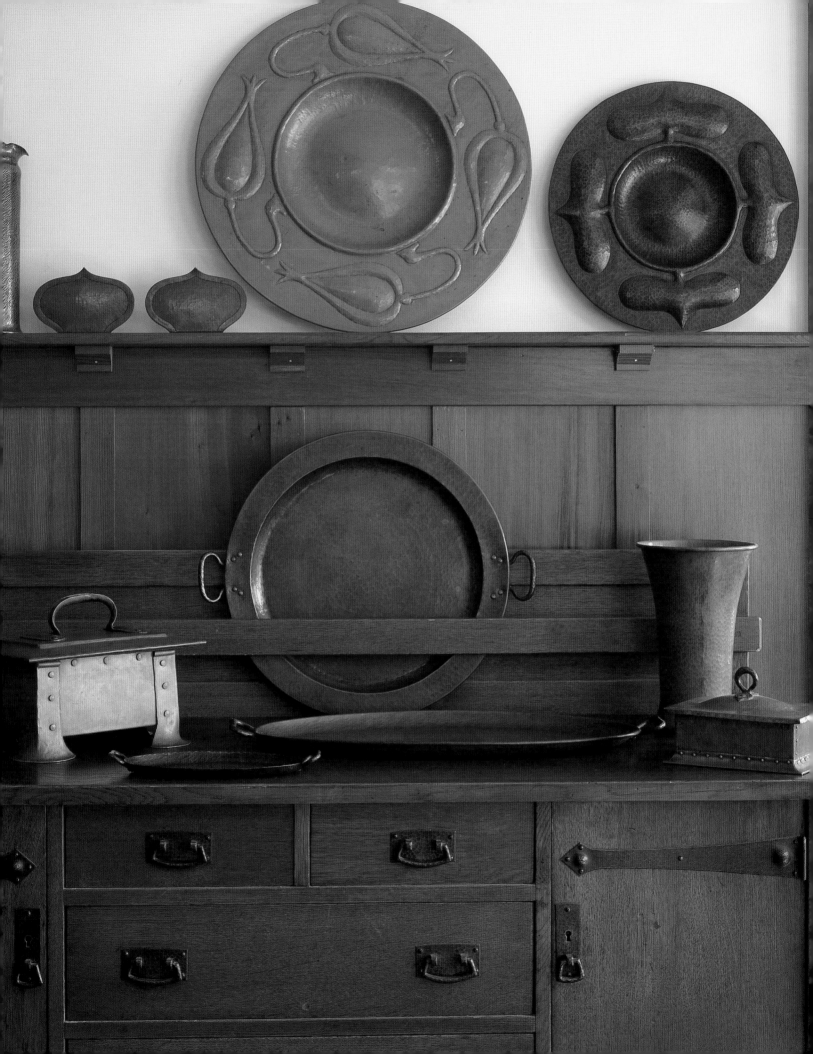

AFTER A EUROPEAN BUYING TRIP IN EARLY 1903, STICKLEY ESTABLISHED THE CRAFTSMAN textile department. His Craftsman Workshops were already making domestic objects of wood and metal, and now he sought fabrics to complement these sturdy, hand-wrought wares. Later that year he began offering Craftsman canvas, linen, homespun, and other textiles with rich coloring and irregular textures. Craftsman needleworkers, both salaried staff members and artisans working independently at home, fashioned them into pillows, door hangings, curtains, and table runners. These goods were sold through retail stores and catalogues, but Stickley also made materials available to home workers to encourage them to take up this craft themselves. ▪▪ Craftsman textiles added new ornamental possibilities of color, texture, and form to any home. They had warm, subtle tints as well as the brighter hues of crimson, yellow, and blue. The varied textures of these fabrics, roughly woven and made of loosely twisted threads, created an appealing play of color that shifted with the changing light. ▪▪ Most of Stickley's rugs had geometric Craftsman patterns and were woven of sturdy, durable wool in Scotland, Ireland, or India. The strength and simplicity of their unobtrusive designs and their soft, subdued coloring—oak-toned browns or light, golden browns, leaf greens, and dark blues—created a quiet and harmonious background for a Craftsman room. ▪▪ Needlework motifs worked on the pillows, table runners, and curtains were bold and uncomplicated and usually took the form of stylized leaves or flowers—ginkgoes, poppies, lotuses, wild roses—emphatically outlined with rows of heavy stitches. Craftsman needlework was skillfully done but retained slight imperfections to signify that it had been made by hand. ▪▪ In their blend of use and beauty, Stickley's fabrics, rugs, and embroideries expressed the Craftsman idea. Beyond that, their rich colors, pleasing textures, and simple designs softened the sometimes austere lines and sober tones of the furniture and brought a restful harmony to any room. Adding "the last note of grace and beauty," they completed the Craftsman interior.

"Homespun Harmony"

A homespun table scarf with Stickley's mark embroidered on it (opposite) now covers a chest in an Illinois Craftsman home. Readers of the 1909 catalogue could finish their own portieres (door hangings) with seed pods or ginkgoes (right).

To preserve these characteristics and to brin
constructive spirit which during the last ha
cial and industrial expansion, is, in a nut-sh
out our standards and to get rid of a lot of
our wealt acy. It is
ways we our energ
many of sources.
view tow eption r
which me g the case
a readjus it is on
would fo ves alon
only assu herefore g
but wou ance to
conduciv ental, m
regard it a ection of
to plan ar l simplif
some joy eady mac
in large houses with many rooms elaborate
these seem so essentially an outcome of th
burdens upon modern life and form such a se
as it does the spirit of extravagance and of
sweetness of home life, the desire for luxur

VOL. XVI, NO. 1 APRIL, 1909 25 CENTS

THE CRAFTSMAN

CRAFTSMAN ARCHITECTURAL NUMBER: WILLIAM L. PRICE WRITES OF MURAL PAINTING IN RELATION TO ARCHITECTURE, AND TEN OTHER ARTICLES ON THE SUBJECT DEAL WITH THE SEVERAL PHASES OF THE BUILDING ART IN THIS COUNTRY

THE ART OF SOROLLA, A MODERN SPANISH MASTER

·FORTY-ONE·WEST·THIRTY-FOURTH·STREET·NEW·YORK·

CONTINUING THE CRAFTSMAN TRADITION

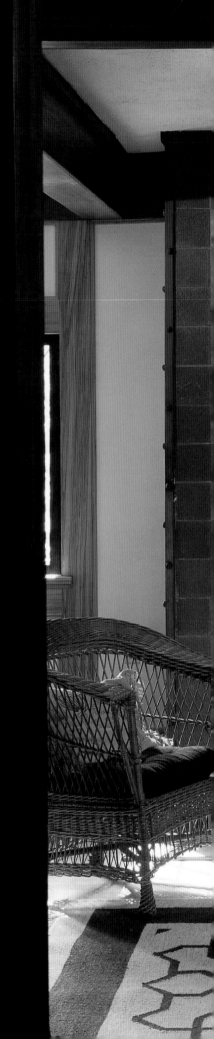

STICKLEY PURE AND SIMPLE

Homes filled with just Stickley furniture, metalwork, and textiles are a rarity, but a few such pristine collections do exist. Stickley style in its purest form includes, of course, the interior of Gustav Stickley's own home in Syracuse, New York, and his log house at Craftsman Farms in Parsippany, New Jersey. Homes built from plans first published in *The Craftsman* magazine also clearly express the Craftsman idea, as do the Craftsman furniture pieces prized by collectors. Stickley's descendants, including a great-granddaughter in Massachusetts, still treasure as family heirlooms objects he produced in the early years of the twentieth century. And the Stickley spirit lives on in the furniture manufactured by L. & J. G. Stickley, the firm run by two of Gustav's brothers, and in authentic reproduction pieces now available. ⁕⁕ Even within Stickley's output, interesting variations can be found. His first Arts and Crafts furniture, made in 1900, carried traces of the Art Nouveau style then popular in Europe. The following year he introduced his simple, massive, structural furniture, bristling with visible elements of construction such as tenon-and-key joints and exposed tenons. Stickley's 1902 furniture became increasingly clean-cut and crisp—almost completely rectilinear. In 1903 the architect Harvey Ellis brought gentle curves, lightness, and colorful inlays to Craftsman furniture. In later years Stickley produced many other highly regarded designs, such as his Frank Lloyd Wright–influenced spindle settles and chairs. Stickley's style constantly evolved, driven forward by the restless, energetic, and never-quite-satisfied Gustav Stickley.

A fireplace at Gustav Stickley's Craftsman Farms, Parsippany, New Jersey.

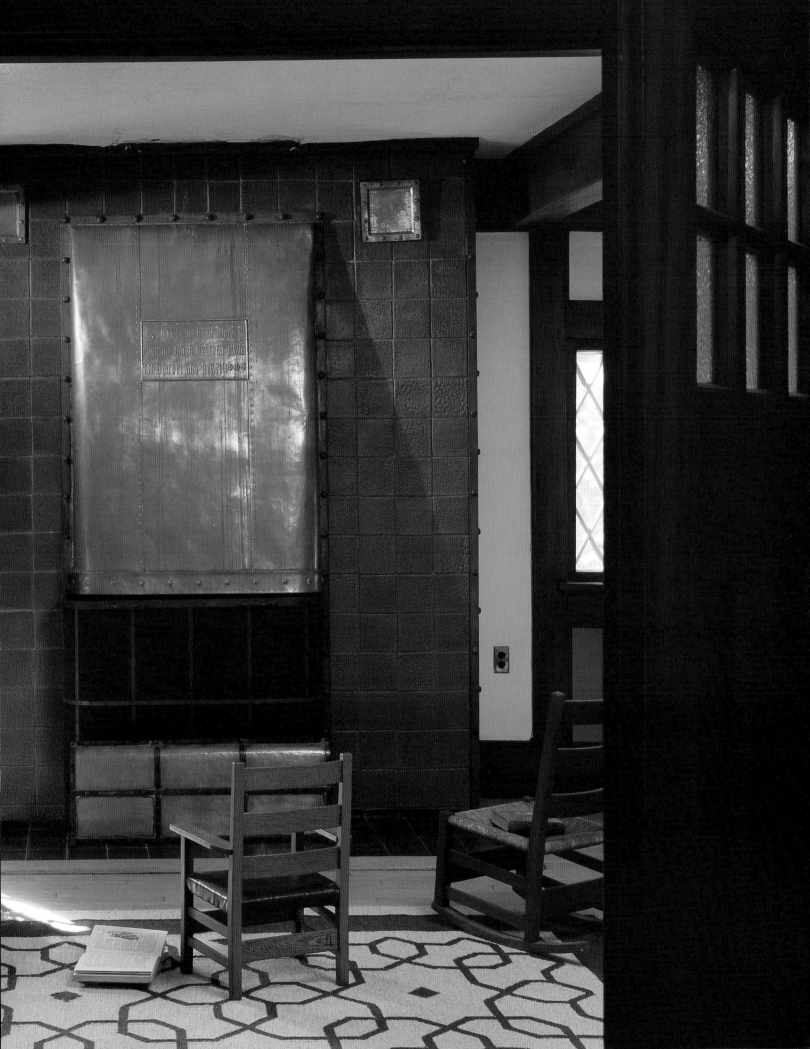

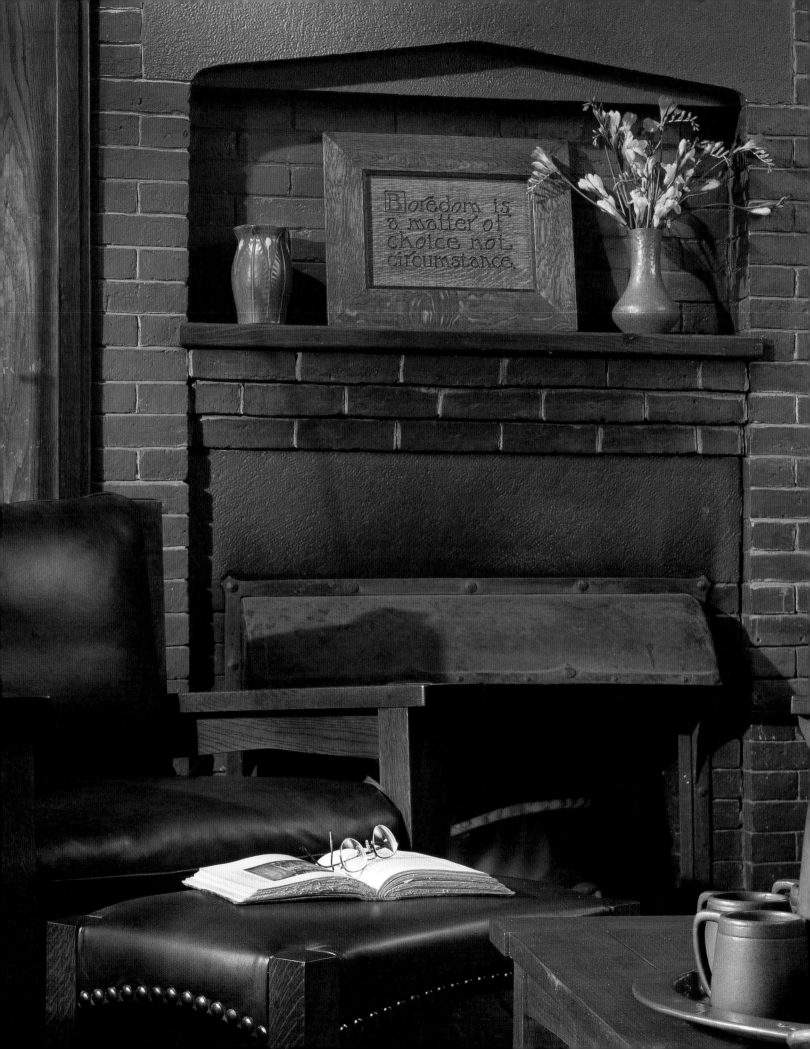

ON CHRISTMAS EVE, 1901, A FIRE BROKE OUT IN GUSTAV STICKLEY'S COLONIAL Revival house in Syracuse, New York, where the family had lived for only about one year. Most of the interior was destroyed. The Stickleys were able to save some valuable furniture, silverware, and rugs, but everything else was lost. Looking over the burned-out shell, Stickley decided to rebuild. His restoration left the classical details of the facade intact, but the inside was completely remodeled. Stickley had created the first Craftsman residential interior. ▪▪ A year later *The Craftsman* magazine published "A Visit to the House of Mr. Stickley," describing this transformed interior and introducing readers to the defining Craftsman virtues of simplicity, informality, and harmony. The formal parlor had vanished, and the downstairs had been redesigned as a large space divided by post-and-panel partitions. The new interior was dominated by oak and chestnut fumed with a potent solution of ammonia, resulting in a warm, rich brown tint that soon became Stickley's trademark color. New floors were laid with chestnut boards of varying widths, walls were paneled with oak planks rising to a rough-textured plaster frieze, and ceilings were heavily beamed. Seats and cabinets were now built in, and some of the original sash windows were replaced by casements organized into horizontal bands. Two fireplaces were remade of red brick with stone lintels, and at least one was faced with Grueby tile. These features would reappear in Craftsman houses to come. ▪▪ The Stickley family lived in this house for about eight more years, selling it, along with most of the furniture, when they moved to Craftsman Farms in New Jersey. But around 1919 Stickley's oldest daughter, Barbara, and her husband repurchased it and moved in with their five boisterous children. One day the following year the widowed Gustav, carrying his satchel, stopped by for a two-week visit and ended up taking over a third-floor bedroom, where he lived most of his remaining years. ▪▪ Much of what is known about Stickley's personal life comes from his grandchildren's memories. One indelible impression was his perpetually clean, bracing scent (a residue of the chemicals he used in his experiments to perfect new furniture finishes), which intermingled with the aromatic smoke of his pipe. Penniless in retirement, he cheerfully taught his grandchildren

The House of Mr. Stickley

As he remodeled the interior of his fire-gutted home, Stickley experimented with features that would define the Craftsman house. In the living room, he built a red brick fireplace with a hammered-iron hood and massive stone lintel (opposite). He also installed chestnut paneling and heavy posts rising to the beamed ceiling (pages 62–63). "Quiet harmony is the prevailing note of the composition," commented *The Craftsman*.

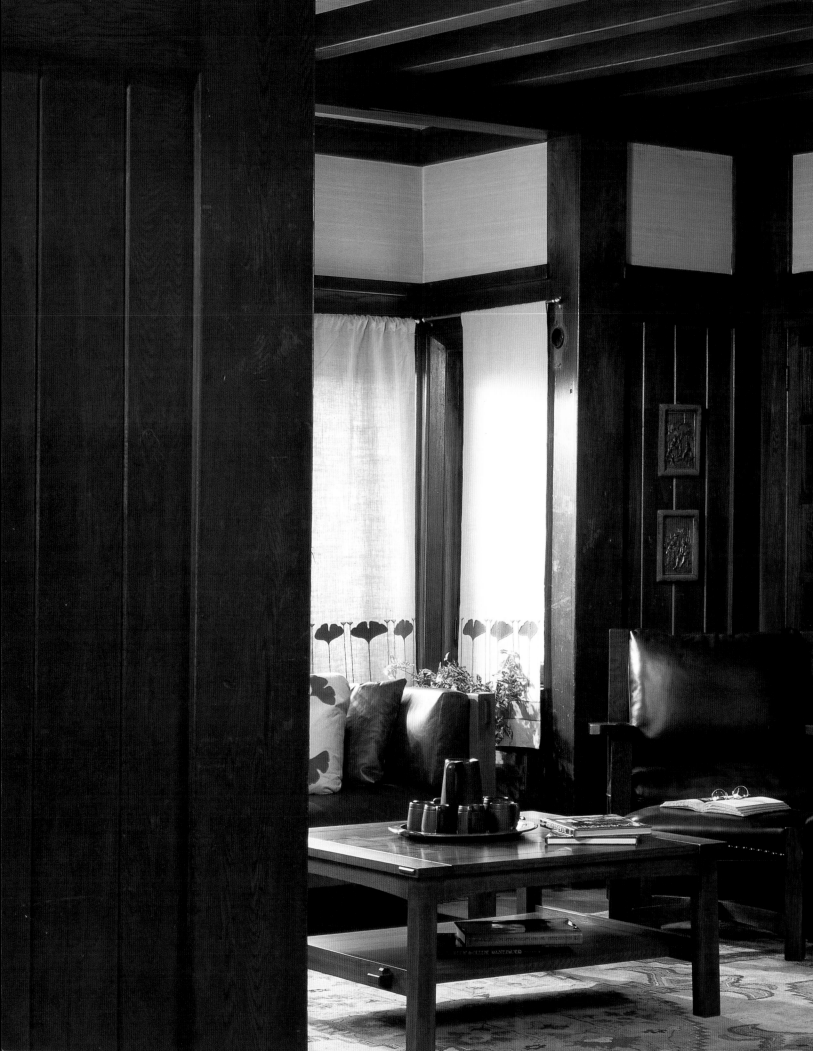

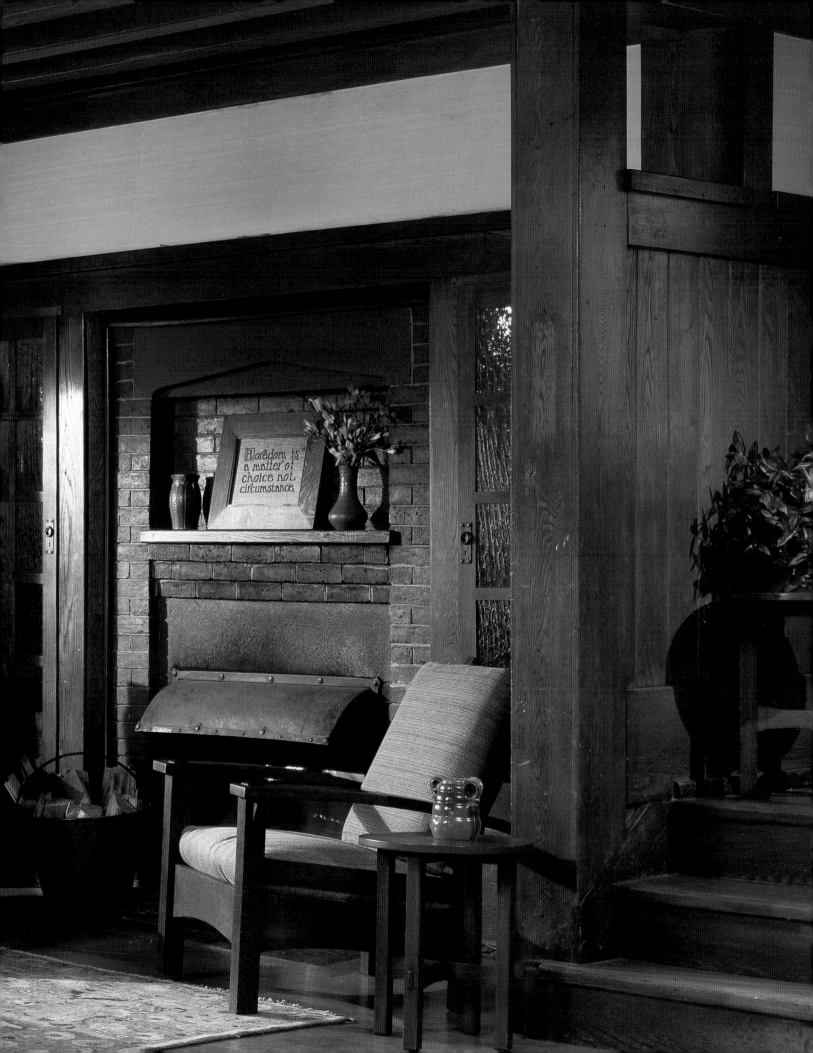

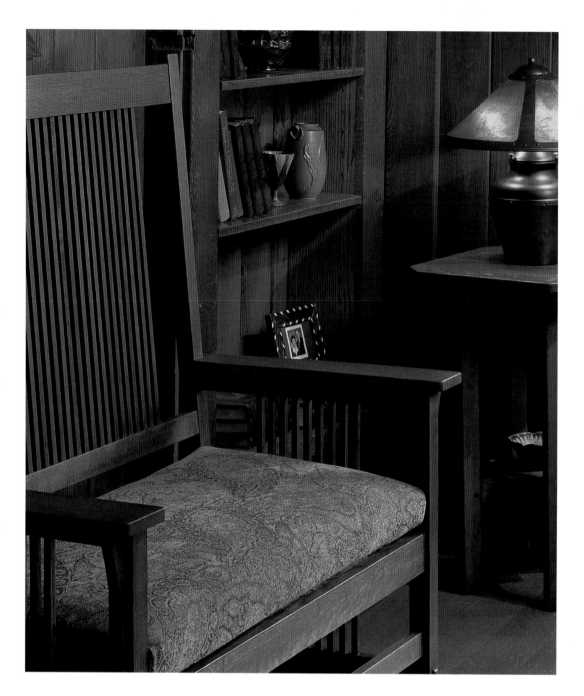

A reissued Stickley spindle settee and a modern lamp in the style of Dirk van Erp (right) complement the living room's original chestnut paneling. More rich chestnut woodwork in the dining room (opposite) carries out the living room's structural themes. Rows of beams along the ceiling "intensify the perspective," said *The Craftsman*. This open planning, simplicity, and structural frankness came to characterize Craftsman houses. The tall case clock is a reissue based on an original design by L. & J. G. Stickley.

about music and botany and puttered in the family garden. Years later they came to understand the true nature of his legacy: "He was," one grandchild has written, "almost an evangelist in bringing new thoughts and new appreciation of things artistic and new social thinking. That is something that doesn't go bankrupt and he, as an inspiring person, never did go bankrupt." ⁛

After Barbara's family moved on in the early 1950s, Stickley's house suffered neglect, although some of its original Craftsman furniture is preserved in private collections and museums. In the late 1990s local Arts and Crafts preservationists fought successfully to keep what remained of the house intact. It was subsequently bought by Alfred and Aminy Audi, the current owners of the L. & J. G. Stickley Company, who have stabilized the structure and plan eventually to resurrect this iconic Arts and Crafts site as a study center and museum.

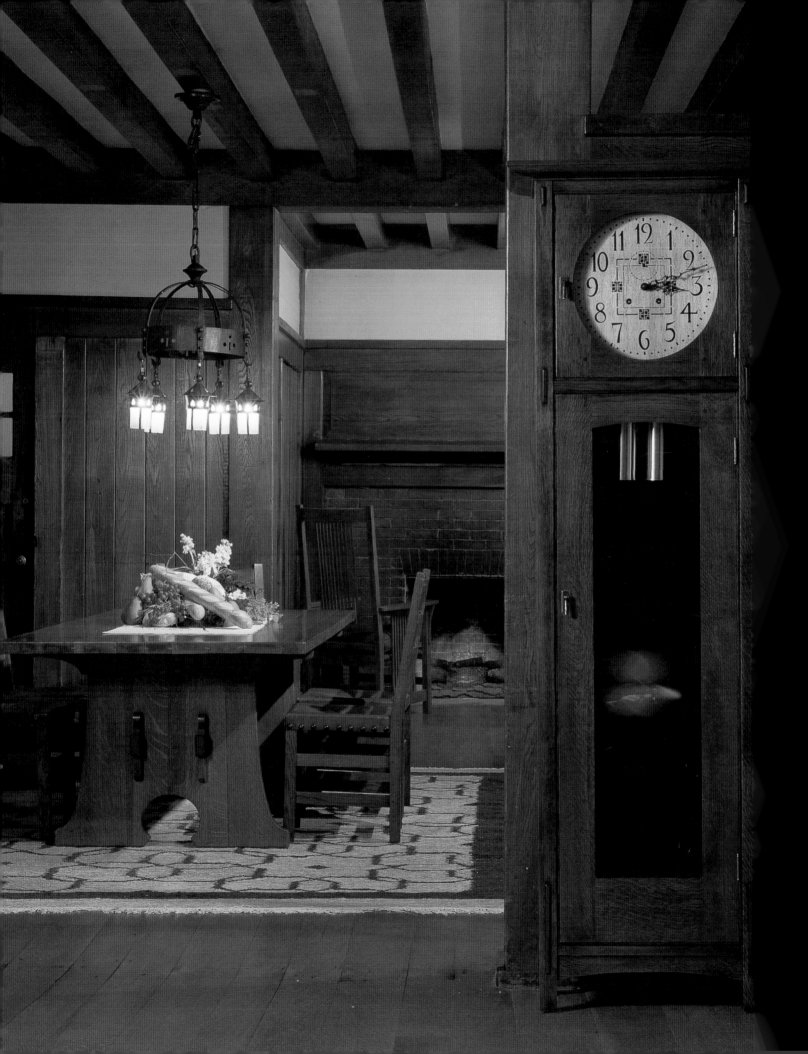

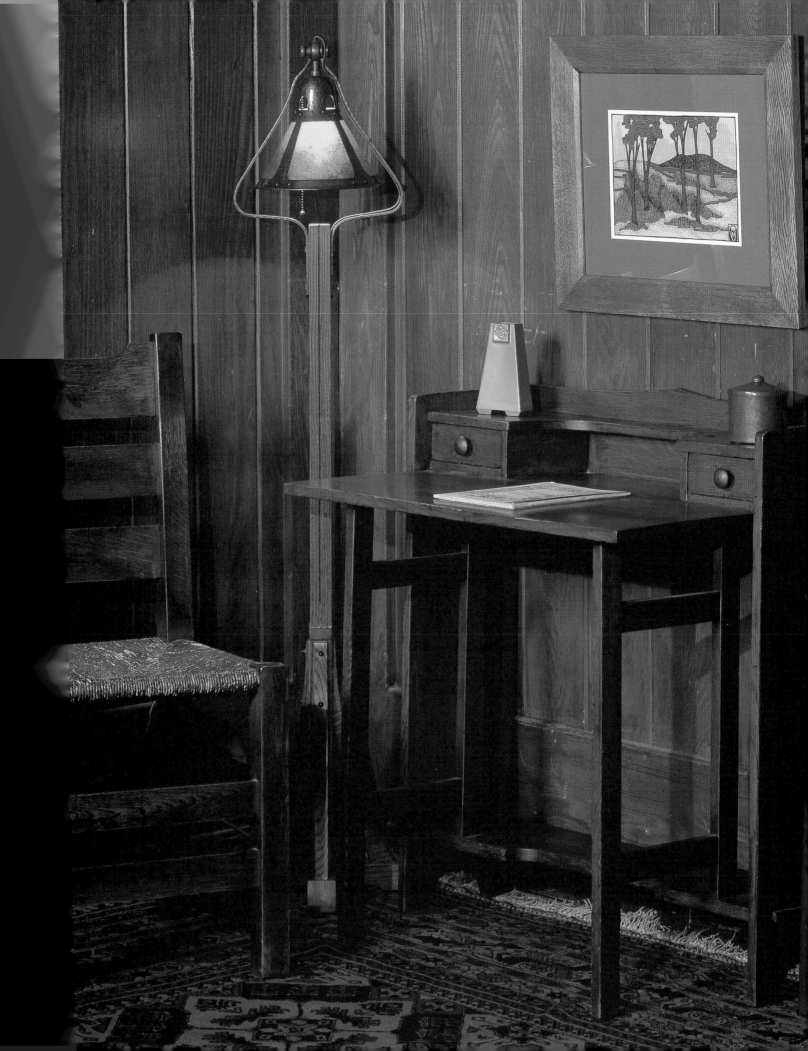

The warmth of the
wood in Stickley's
home is matched by
the warmth of the
furnishings. In one
corner of the downstairs
hall (opposite), against
a background of cham-
fered chestnut paneling,
a Stickley ladder-back
chair, its original rush
seat still intact, is pulled
up near a drop-leaf desk
by L. & J. G. Stickley.
The floor lamp is a
Craftsman reproduction.
An original Stickley desk
lamp with a glass-and-
copper shade and an
oak base (left) sheds
a glow over an inlaid
Stickley desk, designed
in 1903 by Harvey Ellis.

Stickley's
Rustic Vision

THE NEED TO LIVE CLOSE TO NATURE WAS A COMMONLY HELD ARTS AND CRAFTS IDEA. In the country village of East Aurora, New York, Elbert Hubbard established the Roycroft community, which eventually included three Roycroft farms. C. R. Ashbee, the English Arts and Crafts architect, designer, and writer, moved his Guild of Handicraft out of London and resettled in the bucolic Cotswold village of Chipping Campden. Frank Lloyd Wright's Taliesin, his home and studio in rural Spring Green, Wisconsin, was conceived as a largely self-supporting farm. ▦ Shortly after his fiftieth birthday Gustav Stickley began buying the New Jersey land where he would build Craftsman Farms—an artisan colony, a model farm, and a school. Stickley approached this undertaking as if it were a Utopian experiment. At first he referred to it not as a home but as a Craftsman village, "a farming community grouped around a central settlement," where "many people prominent in literature, art, nature study and the like will ... lecture or give informal talks." Although the decline of his business fortunes foiled the full realization of his vision, he did succeed in building a handsome log house as his residence and several cottages in a wooded setting and establishing a productive, 650-acre working farm. ▦ Stickley was drawn to the log cabin because the logs' stark beauty symbolized the structure's connection to the natural world. He admired its open architectural features. Perhaps most important, he saw the log cabin as uniquely American, "the pioneer of civilization, the sign of the determination to face the unknown and to conquer all obstacles." ▦ The big,

At Craftsman Farms, Stickley's daughters shared a bedroom (right) with a fireplace of matte blue Grueby tiles and a tall copper hood. *The Craftsman* approvingly noted that the room "has both delicacy and refinement and is thus appropriate to the ideal of the modern woman." The magazine called the house (opposite) "a log cabin idealized."

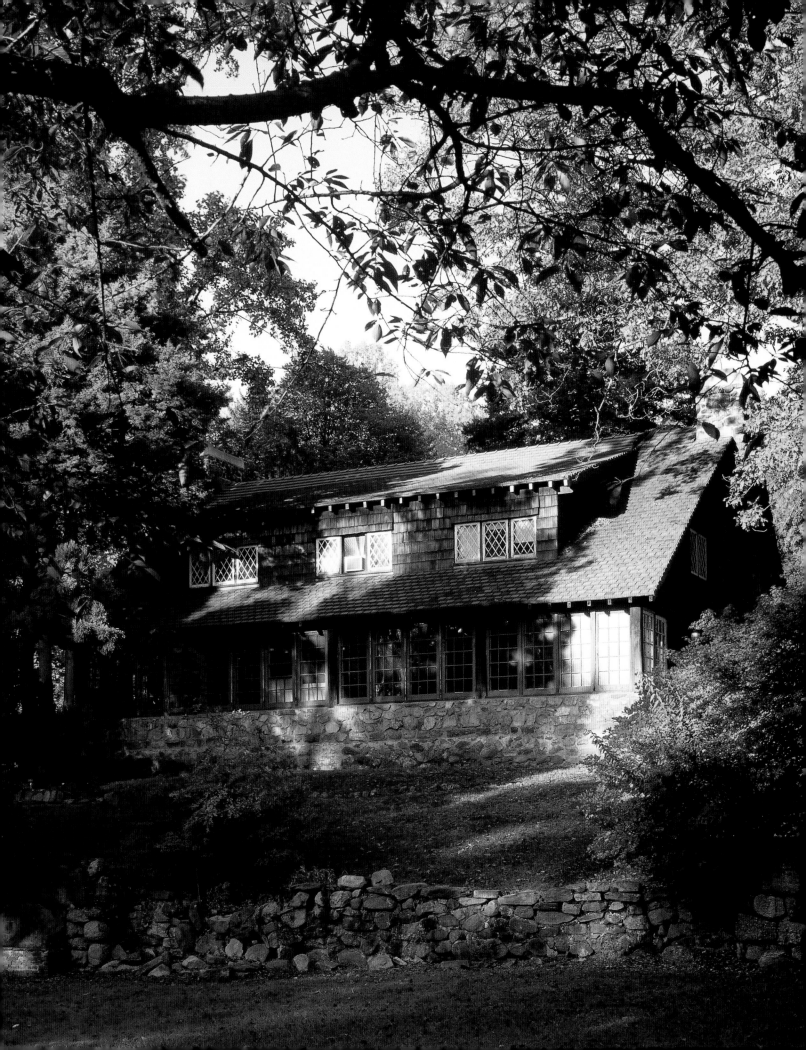

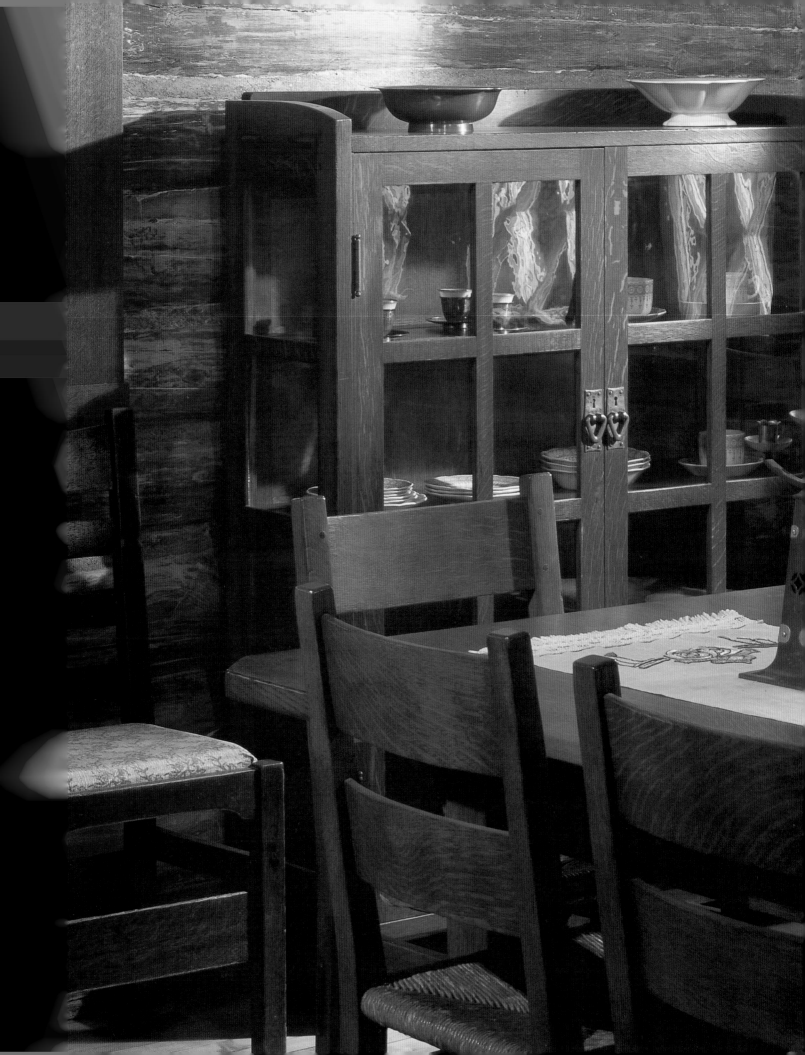

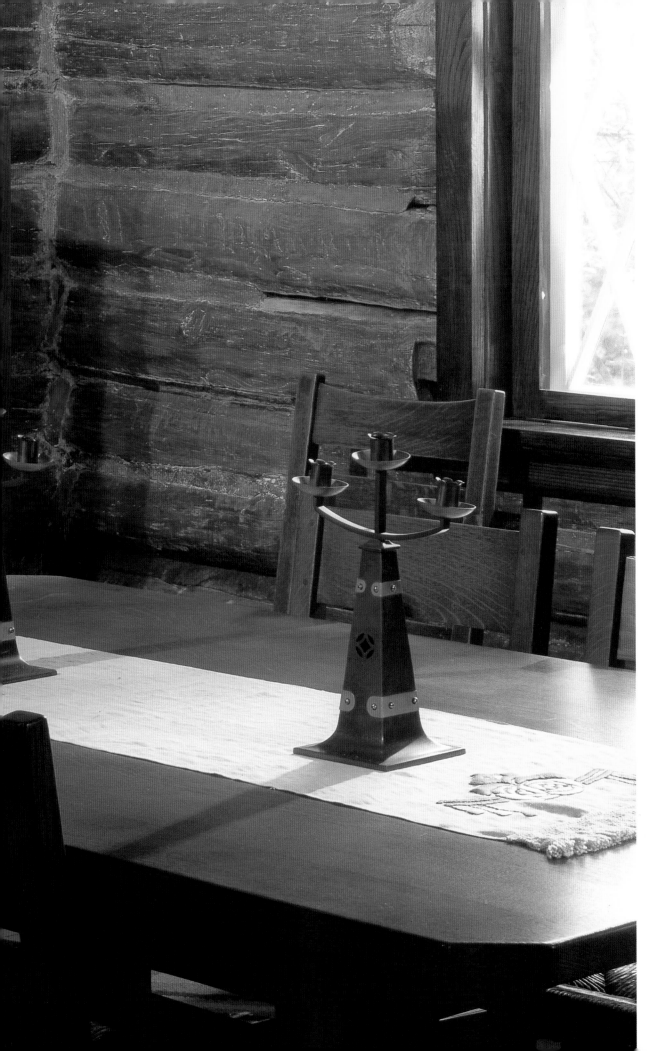

The Craftsman extolled the "bare beauty of the logs themselves" in the rooms at Craftsman Farms, but in the 1940s new owners, reflecting the taste of their day, covered the logs in chalk-white paint— now stripped off to reveal the walls as Stickley saw them. This Craftsman dining set is one of two in the dining room.

71

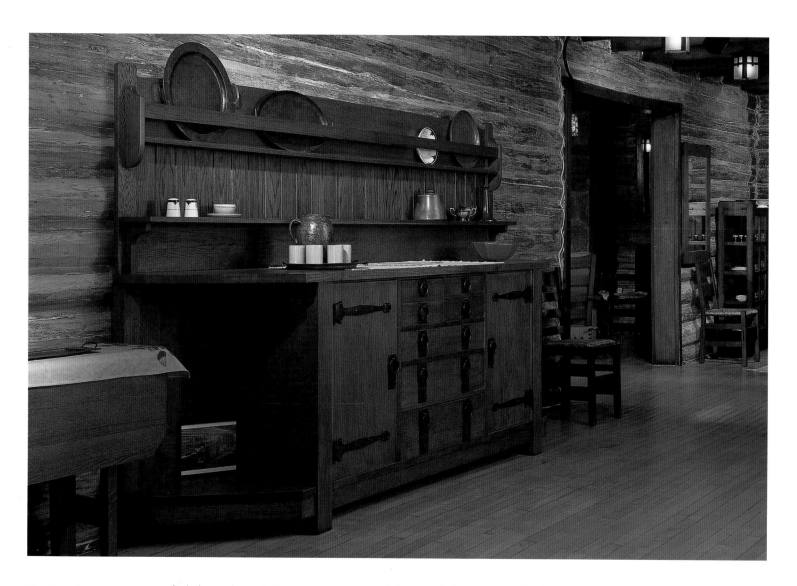

The long dining room sideboard (above), of oak and chestnut, was made to fit the space. A Craftsman sideboard, table, and chairs are placed at another end of the room (opposite), on a Donegal rug original to the house.

slightly awkward downstairs spaces of Stickley's log house—the long, narrow dining room, living room, and porch—have been criticized by some as ill-proportioned, but they were perfect for parties. In July 1911, shortly after the family moved in, the Stickley daughters invited sixty friends to the house for a dance, and there were many more celebrations after that. Three of the daughters were married at Craftsman Farms, and these ceremonies were followed by festive dinners and dancing late into the night. The first Stickley grandchild was born at the Farms in August 1912.
■■ Today the twenty-six remaining acres are owned by the township of Parsippany, and the nonprofit Craftsman Farms Foundation is gradually restoring the buildings, furnishings, and grounds of this National Historic Landmark. In time this irreplaceable Arts and Crafts house will again look as it did during the days when the Stickleys called Craftsman Farms their home.

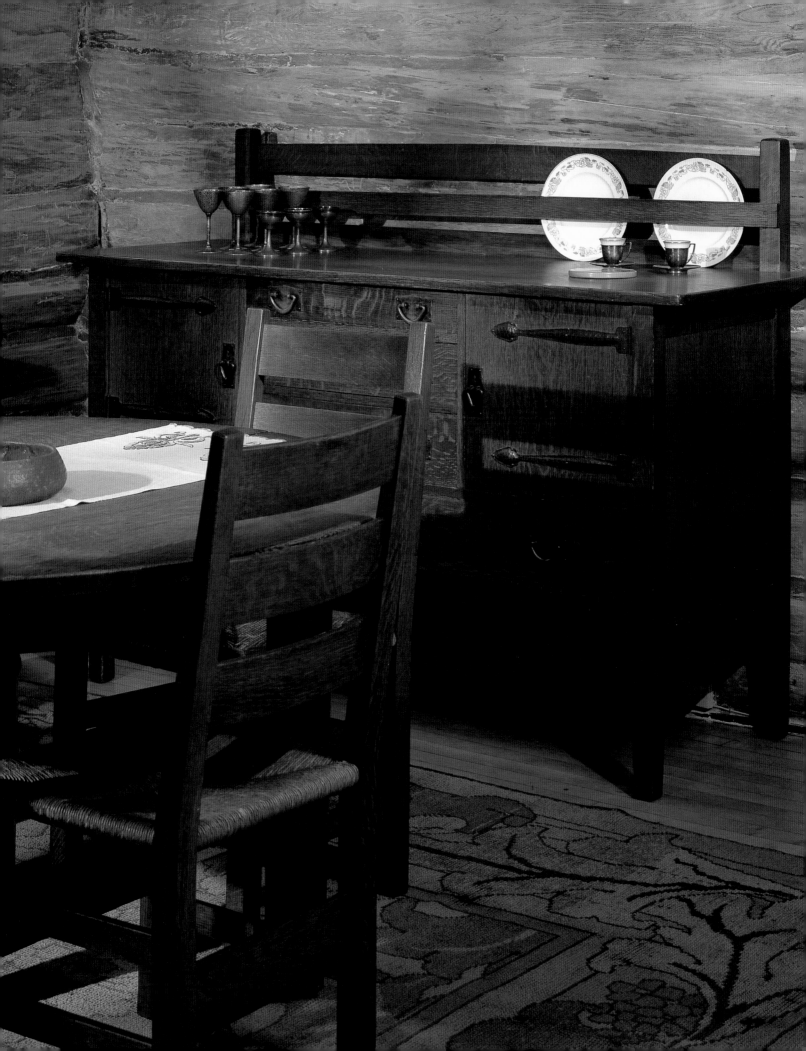

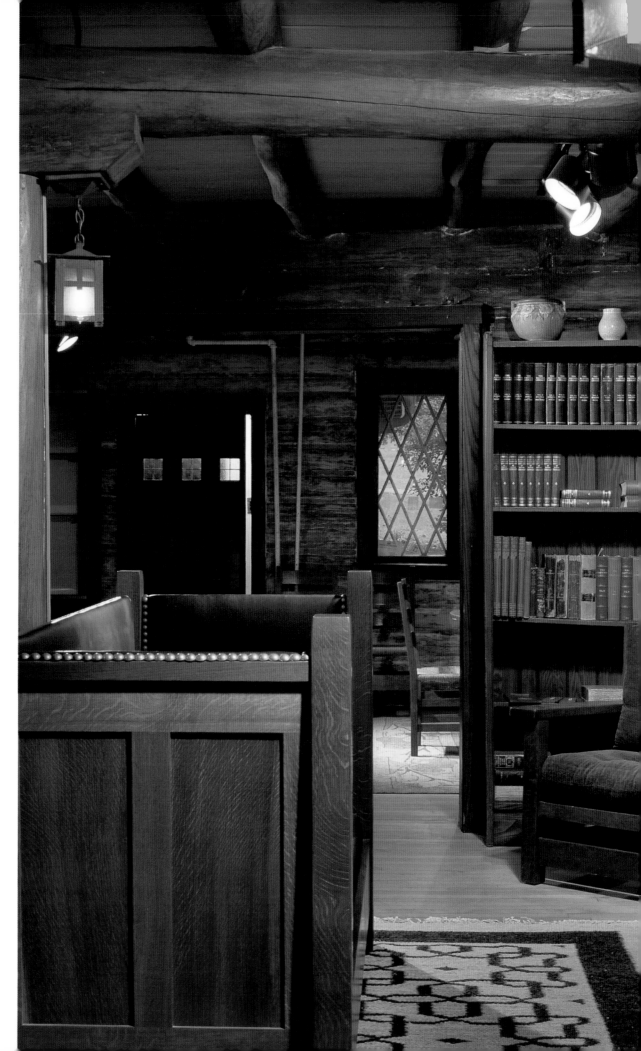

Stickley, whose formal
education ended when
he was ten or eleven,
in many ways typified
the self-taught, self-
made man. He lined
the walls of his living
room (right) with book-
cases filled with books
and, according to his
daughter Mildred, "read
all the while." It is easy
to imagine him reading
in the evening by the
fireplace, comfortable in
his capacious Eastwood
chair, made about 1902.
This chair is his signa-
ture piece, embodying
all the essentials of his
style—massiveness and
plain, pure form. (Origi-
nally Stickley named
his furniture Eastwood,
for the Syracuse suburb
where his factory was
located.) At the oppo-
site end of the living
room (pages 76–77)
rises another stone
fireplace, its keystone
supporting one end of
the enormous three-part
ceiling beam that runs
the length of the room.

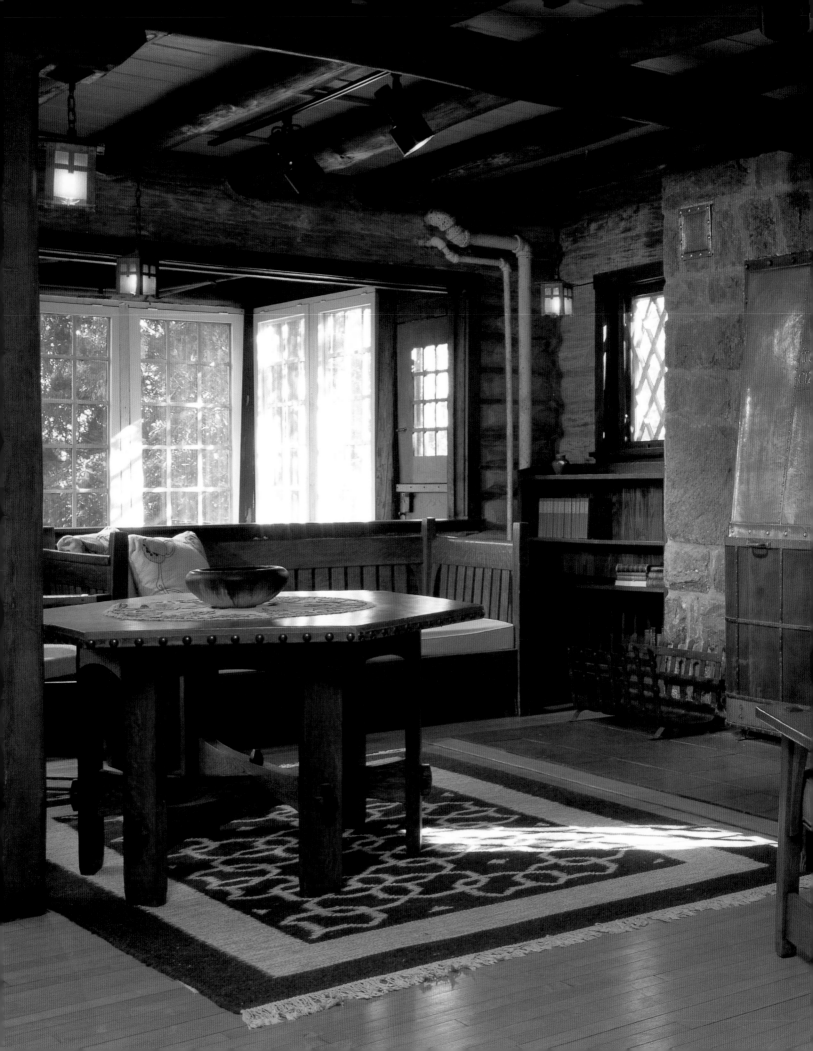

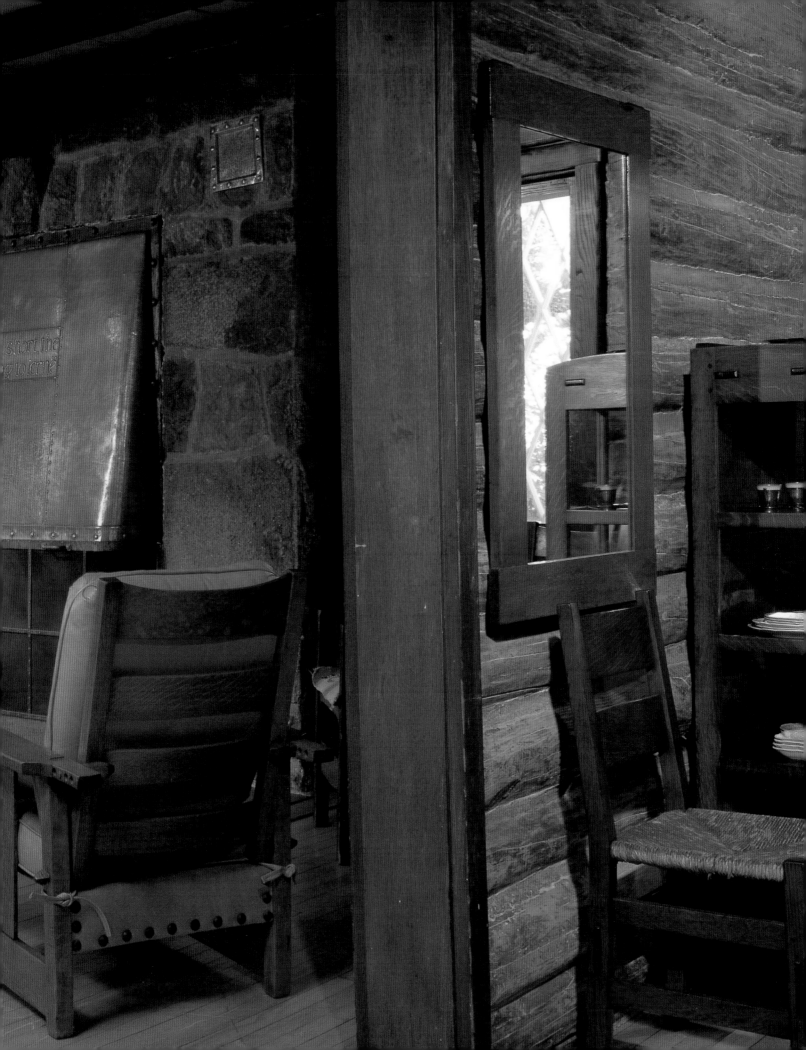

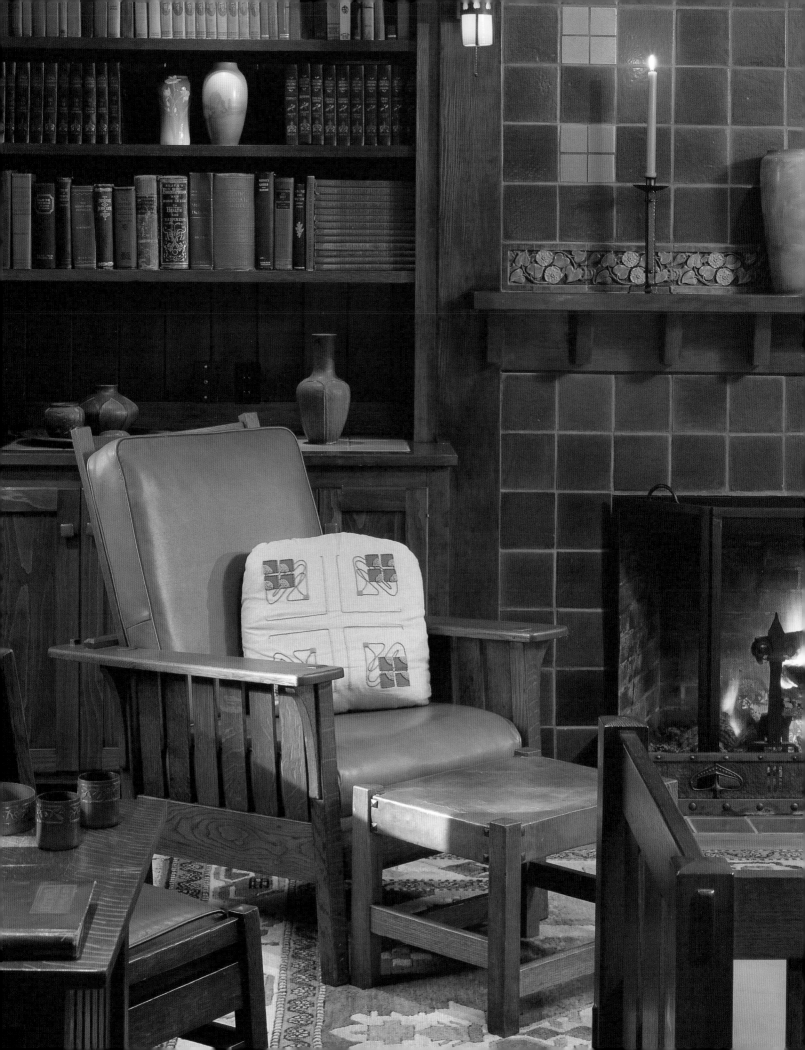

ON A PLEASANT SUBURBAN STREET NEAR BOSTON IS A LINE OF NEAT WHITE CLAPBOARD houses all about the same size and built close together. Standing slightly apart is a cedar shingle house framed by graceful hemlocks, its structural timbers clearly visible and its front walk lighted by Arts and Crafts-style lanterns set on fieldstone piers. This house belongs to Cindy and Tim McGinn, and its Craftsman-like appearance is a reminder of the life and work of Cindy's great-grandfather, Gustav Stickley. ▪▪ Before its imaginative remodeling into a Craftsman house, the McGinns' home was a tiny Cape Cod. "We needed more space and thought about moving to a bigger house," says Tim, "but we liked living here and decided we'd be happier enlarging our house instead of moving to a new one." They also wanted a more spacious and appropriate setting for their collection of Stickley furniture. Thus, the new living room was designed with furniture placement in mind and given Craftsman features: horizontal bands of windows, a built-in window seat, and built-in bookcases. The fireplace was faced with green Grueby tile salvaged from the fabled Arts and Crafts-period mansion Dreamwold in Cohasset, Massachu-

Family Matters

setts. ▪▪ Through the years the McGinns have bought many pieces of Craftsman furniture— a small sewing rocker, an eight-legged sideboard, and a fall-front desk from about 1902. But their great treasures are the heirlooms that have descended in the family. Their inlaid Craftsman piano, one of perhaps five known today, is probably the first Craftsman piano ever built. A bed that Cindy slept in as a child was originally from Craftsman Farms. ▪▪ As inspiration for the McGinns' remodeling, Tim first built a shingle Arts and Crafts-style garden shed in the back yard (pages 32-33). Many years earlier Stickley had constructed shingle cottages near his log house at Craftsman Farms, commenting, "I like the houses to be grouped together. It makes life simpler, more friendly." Today the home of his great-granddaughter and her husband recaptures the simplicity and friendliness of Craftsman Farms and keeps alive a bright chapter in Stickley family history.

Cindy McGinn's great-grandfather would have approved of her new living room (opposite), with its bookcases made with V-jointed boards and square wooden pulls and its tiled fireplace, built in true Arts and Crafts fashion by Tim McGinn. Family mementoes include an embroidered white table scarf from the Stickley home (right).

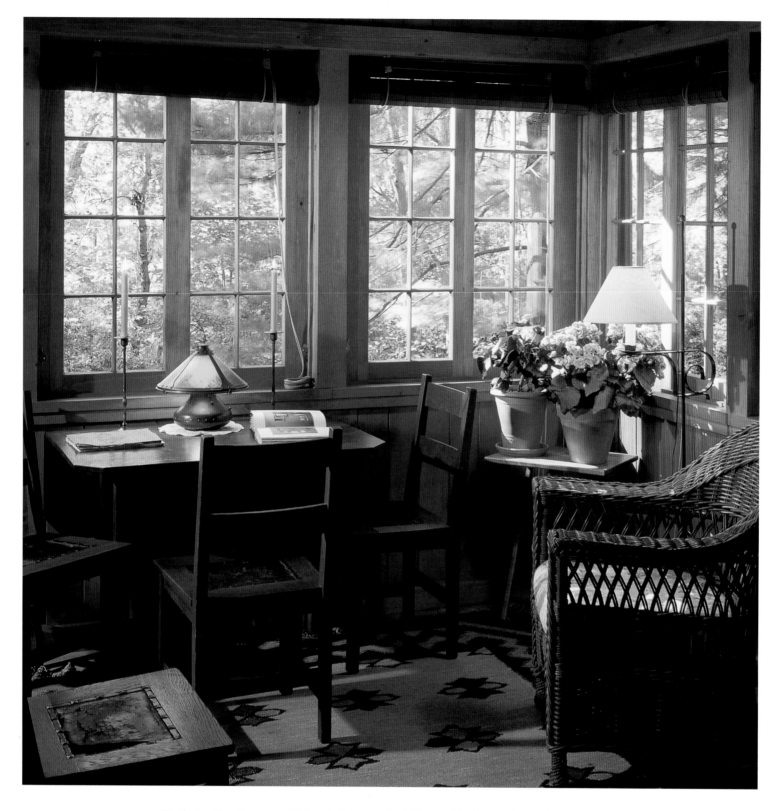

On the McGinns' new porch (above), Craftsman furnishings—side chairs, a drop-leaf table, and a rug (a family heirloom)—bask in the sun. With the addition of flat-roofed shed dormers, shingle siding, a diamond-paned window, and a front porch with grouped wooden posts, the McGinns have given their home (opposite) the attributes of a true Craftsman house. In the living room (pages 82–83), a Morris chair by L. & J. G. Stickley on the left and one by Gustav Stickley on the right flank the fireplace. Soft light comes from Craftsman wall sconces.

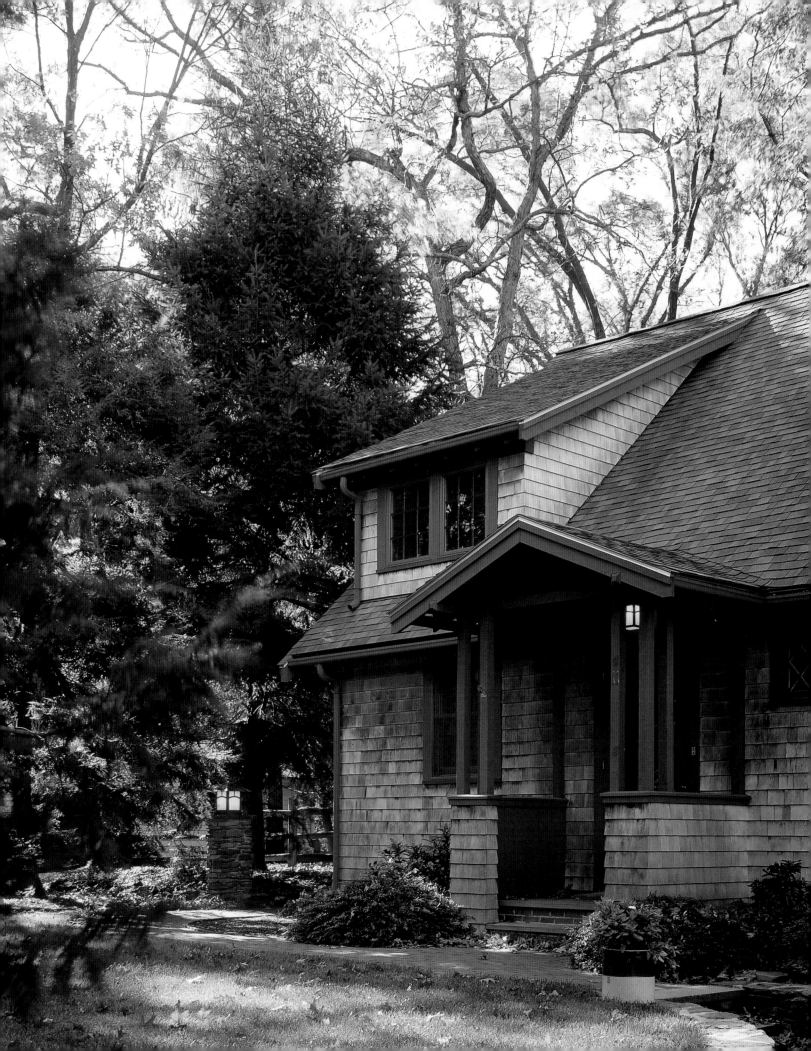

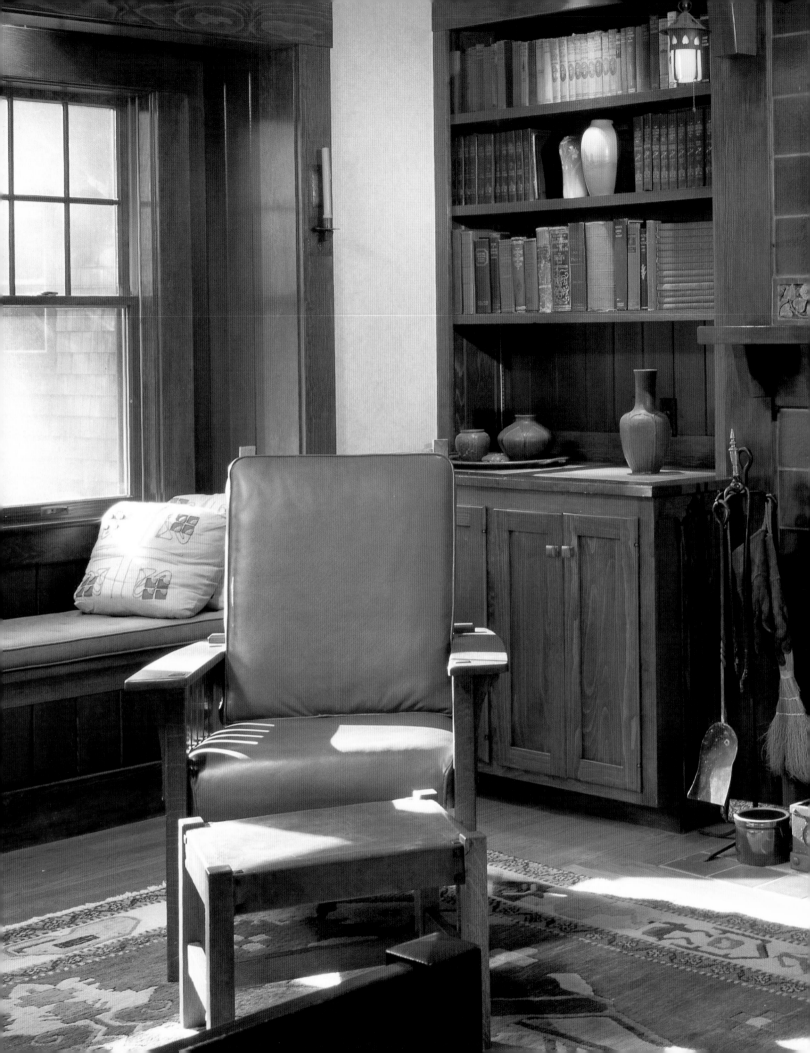

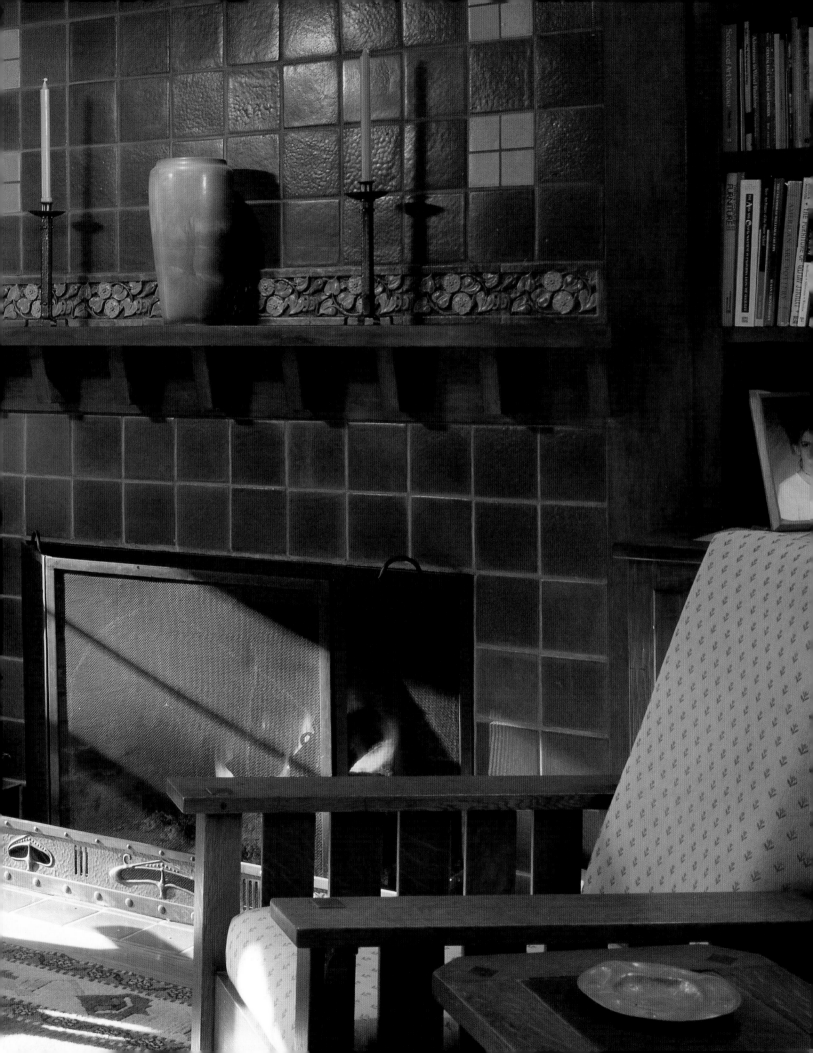

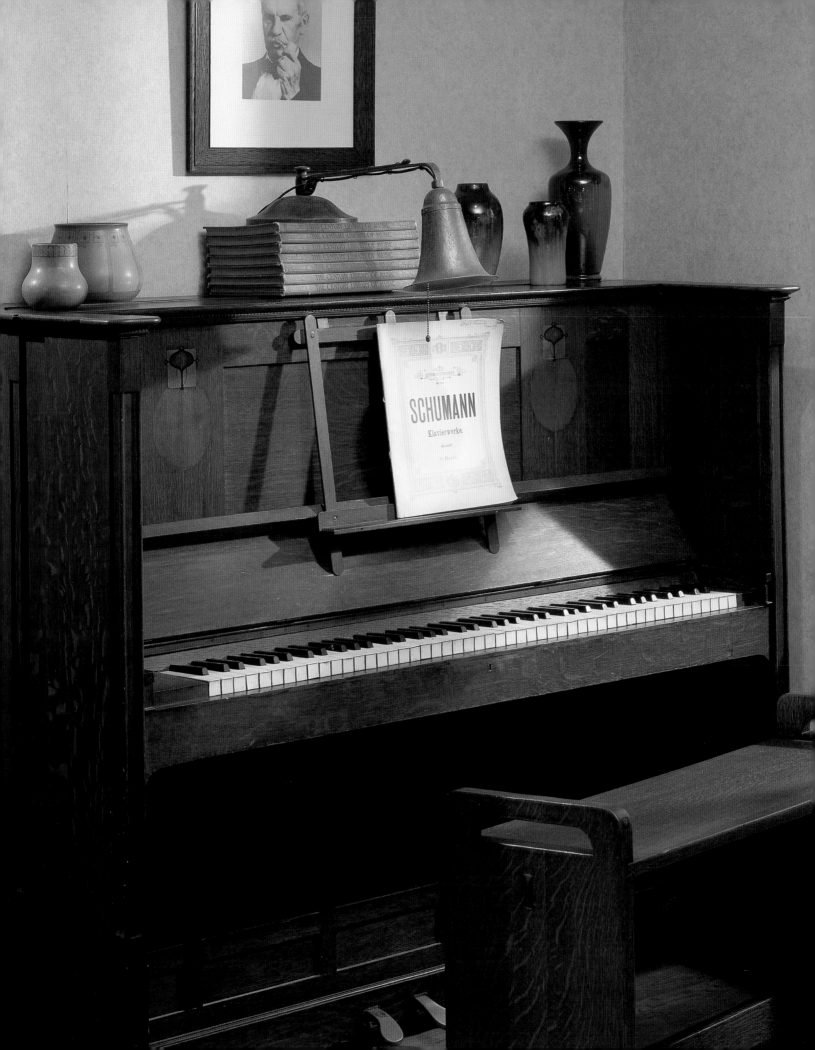

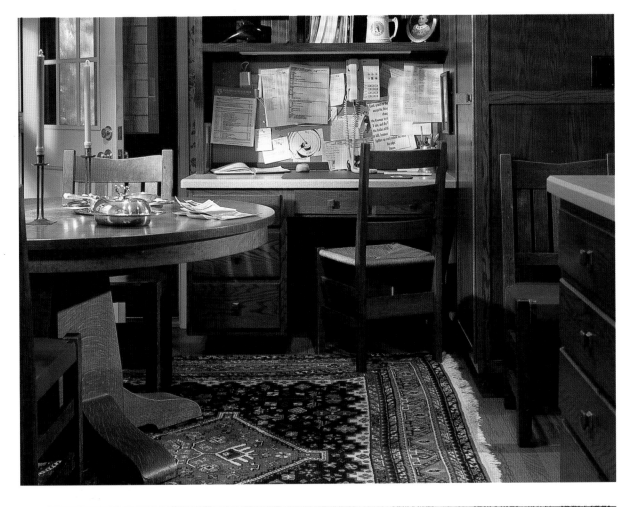

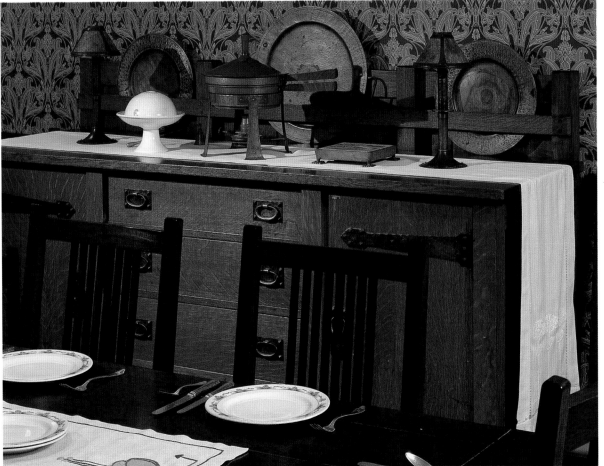

The McGinns' rare inlaid piano (opposite), designed by Harvey Ellis in 1903, occupied the large bedroom at Craftsman Farms where Stickley's daughters slept. After Cindy's grandmother, Mildred Stickley, was married in 1915, her parents gave her the piano. Mildred left it to her daughter Ruth, who in turn gave it to her daughter, Cindy, an accomplished musician. The Craftsman piano lamp is also a rarity. Above the piano is a photograph of Gustav Stickley taken a few months before his death. The expanded kitchen (left top) has a circular Craftsman table and V-back chairs. In the dining room (left bottom), Stickley and Roycroft copper pieces are displayed on an eight-legged Craftsman sideboard, which is topped with the heirloom Stickley scarf.

A DREAM HOUSE DESIGNED BY STICKLEY'S ARCHITECTS

WHEN THE CURRENT OWNERS OF THIS CRAFTSMAN HOUSE BOUGHT IT MORE THAN twenty years ago, they had never heard of Gustav Stickley. They were simply smitten with it the moment they walked through the front door. "We just loved the house," says the wife. "We loved the richness of the wood." They also appreciated the openness of the generous entry hall, which flowed into the living room on one side, into the dining room on the other, and through double doors at the back of the house onto a sheltered terrace. Their immediate emotional response would have pleased but not surprised Stickley. In September 1908, the year this house was built, *The Craftsman* published an article about it saying: "The ceilings of the hall, living room and dining room are beamed, and all the rooms are paneled high with quarter-sawn oak stained to a soft grayish tone, so that the friendly effect of the wood is felt as soon as one enters the house." ▪▪ The current owners set about filling the

From the Pages of *The Craftsman*

This house in a New York City suburb (left) was built from plans published in the September 1908 *Craftsman* (right). It retains its original front door and flanking sidelights of geometrically patterned leaded glass (opposite).

house with Victorian-era antiques. But one day an intrepid Stickley collector tracked down the house, knocked on the front door, and told them they were living in a Craftsman house. Since then most of the antique furniture has melted away, replaced by Arts and Crafts–style pieces reissued by the L. & J. G. Stickley Company. ▪▪ Today the fieldstone-and-shingle house, set high on a hill in a New York suburb, still evokes the same sense of friendly welcome. Nearly all the interior wood-work described in the *Craftsman* article remains intact. The leaded-glass windows are original, and most of the built-in furniture has survived. ▪▪ The owners have come to admire not just the beauty of their house but also, for reasons that go to the heart of the Craftsman architectural philosophy, Stickley's belief in open planning and functional design: "This is a holiday house," says the wife. "It's like one big room when it's decorated for the season, and so much fun for family visits."

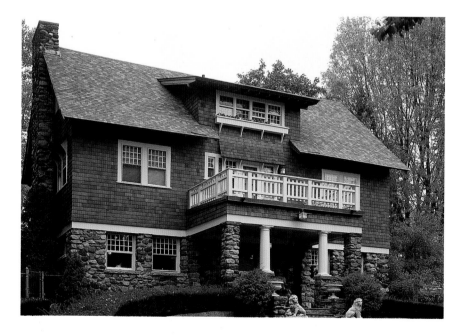

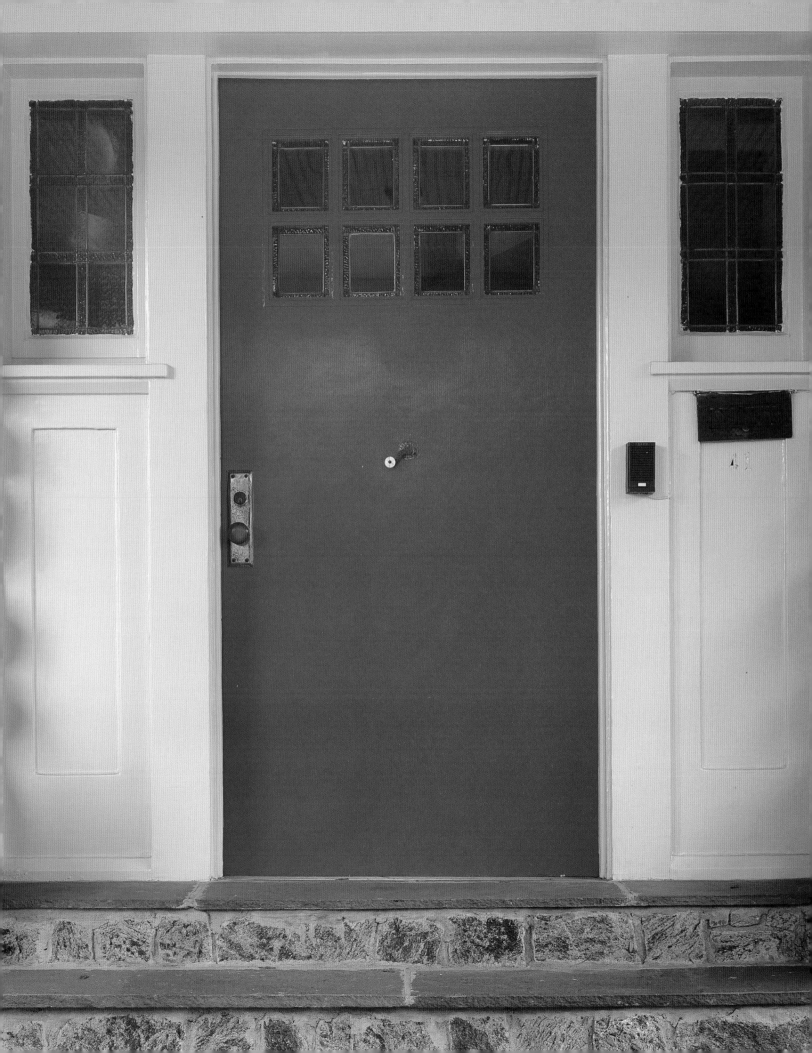

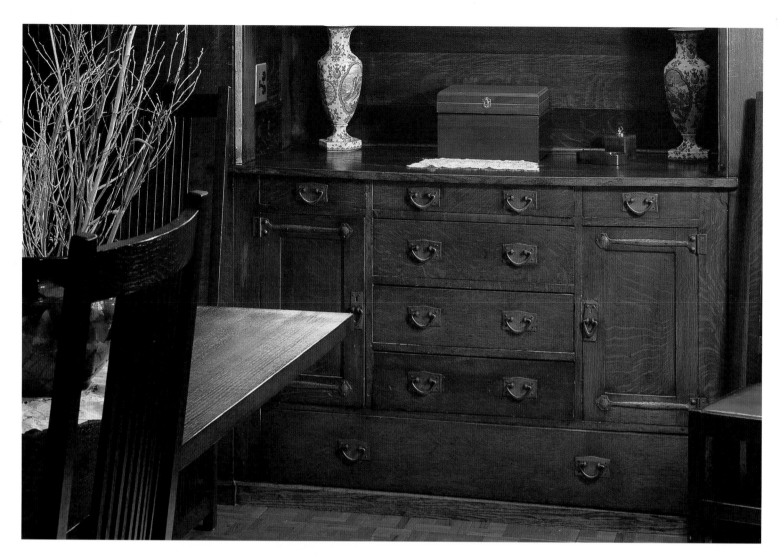

The dining room's built-in Craftsman sideboard (above) remains firmly in place. In the master bedroom, the hammered-copper trim of a fireplace edged with Grueby tile (right) looks almost as if it had just left Stickley's metal shop. The house's wainscoting is original (opposite), as are ceiling beams, post-and-panel partitions, and the living room's oak floors.

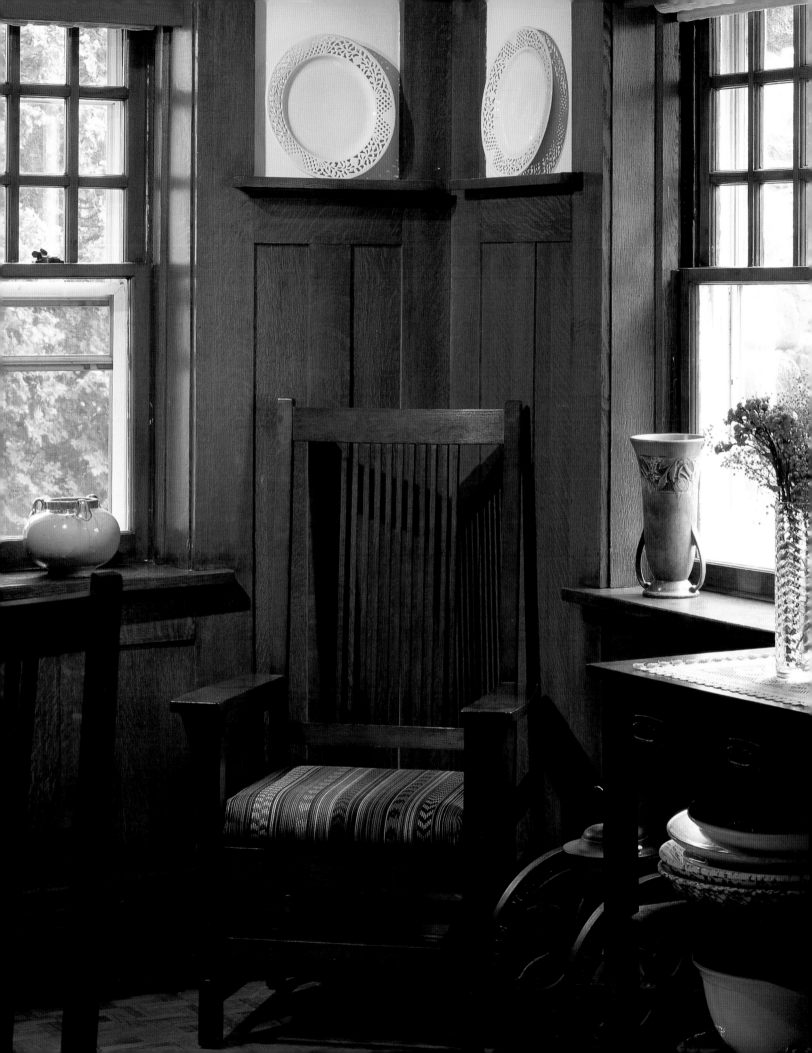

HARVEY ELLIS: MORE THAN A "PAPER" ARCHITECT

HARVEY ELLIS, ARCHITECT, WAS NOT A PROMINENT MEMBER OF HIS PROFESSION, but younger designers had always flocked to him, drawn by his keen wit and his almost magical abilities with line and color. His friends called him a genius, but with reservations. To them he was essentially a "paper" architect whose architectural fancies came to life on the drawing board but did not really lend themselves to three-dimensional form. In the spring of 1903, Stickley hired Ellis as an artist, designer, and writer for *The Craftsman* magazine. ▪▪ When he joined Stickley, only seven months remained of Ellis's life (he died of kidney disease on January 2, 1904, at the age of fifty-two). But in that brief, fertile period at the Craftsman Workshops he created beautifully assured designs for Craftsman furniture, textiles, metalwork, light fixtures, and stained glass. He supplied the magazine with exquisitely drawn covers and illustrations and designed five houses, the

How to Build a Bungalow

last appearing in December 1903 in an article entitled "How to Build a Bungalow." As far as is known, none of Ellis's Craftsman houses was built while he was alive. But in 1995 a private collector built Ellis's final house design at Crab Tree Farm near Chicago. ▪▪ His plans were incomplete, consisting only of a perspective view of the front, elevation drawings of the front and one side, floor plans for the first and second floors, and two partial views of the living room. Although Ellis's article was fairly specific about construction methods, colors, and materials and included some discussion of furnishings, the design had to be reimagined by people working long after it appeared in *The Craftsman*. ▪▪ Built of wood shingles and white-painted stucco, the house has a generous verandah that runs across the front and wraps around both sides. The low, sheltering roof,

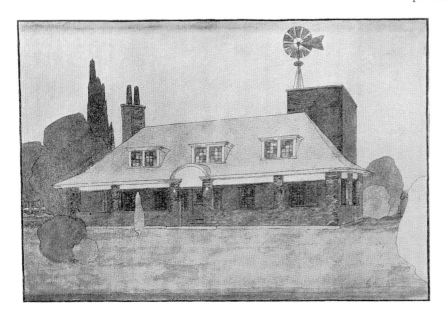

In Harvey Ellis's 1903 design for this bungalow (left), the windmill set off against the sky was more than a delightful architectural detail: it was to be fully functional, supplying the house with water. Ninety years later, Ellis's assured design, with a nonworking windmill, was finally realized (opposite). The living room (pages 92–93) is filled with Ellis-designed inlaid furniture made by the Craftsman Workshops. Rugs, tables, lamps, and the hammered-copper fireplace hood reflect British Arts and Crafts influence.

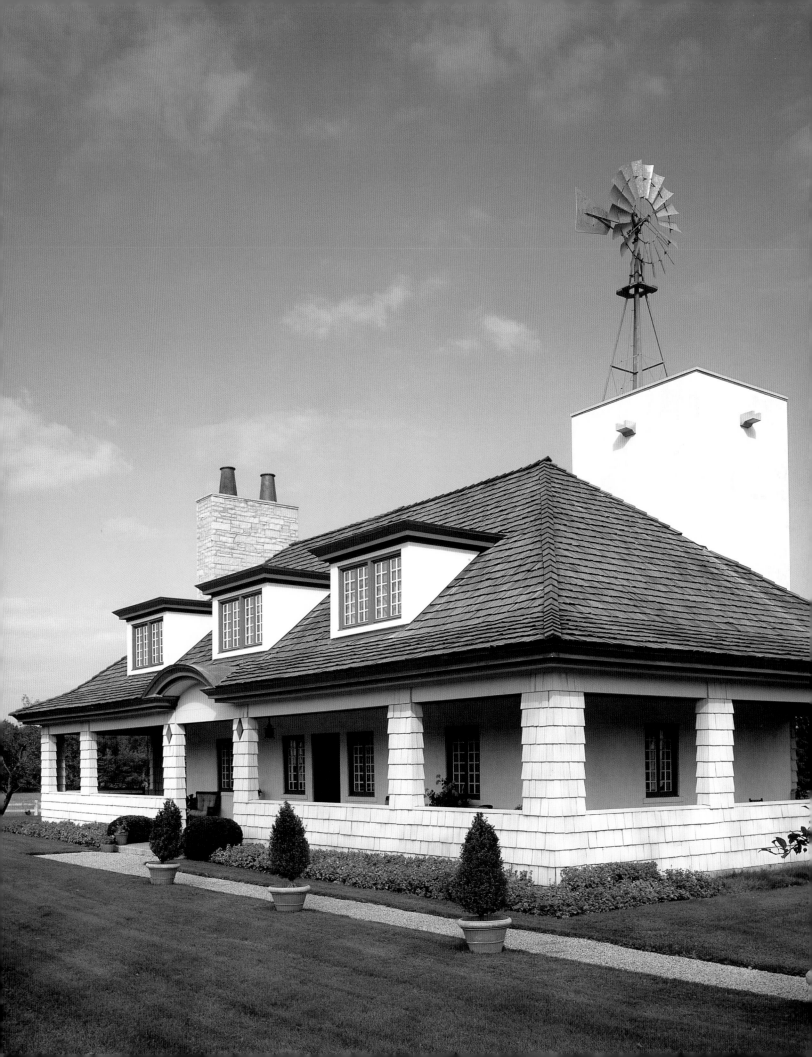

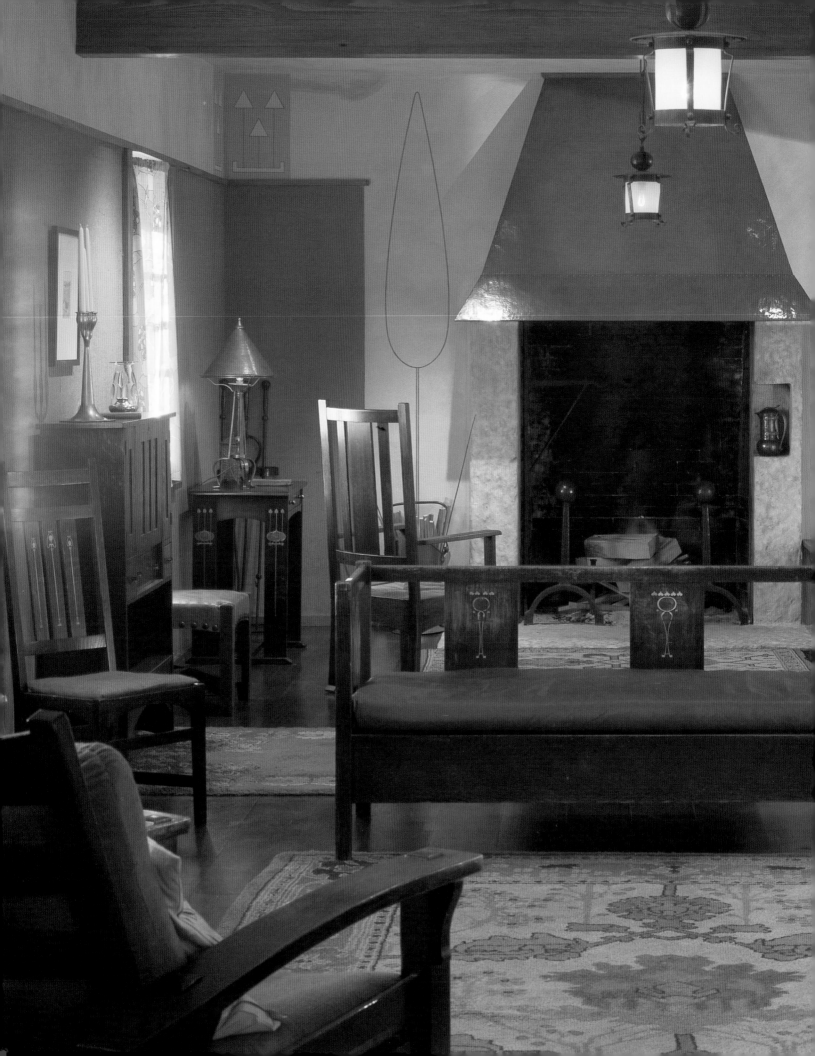

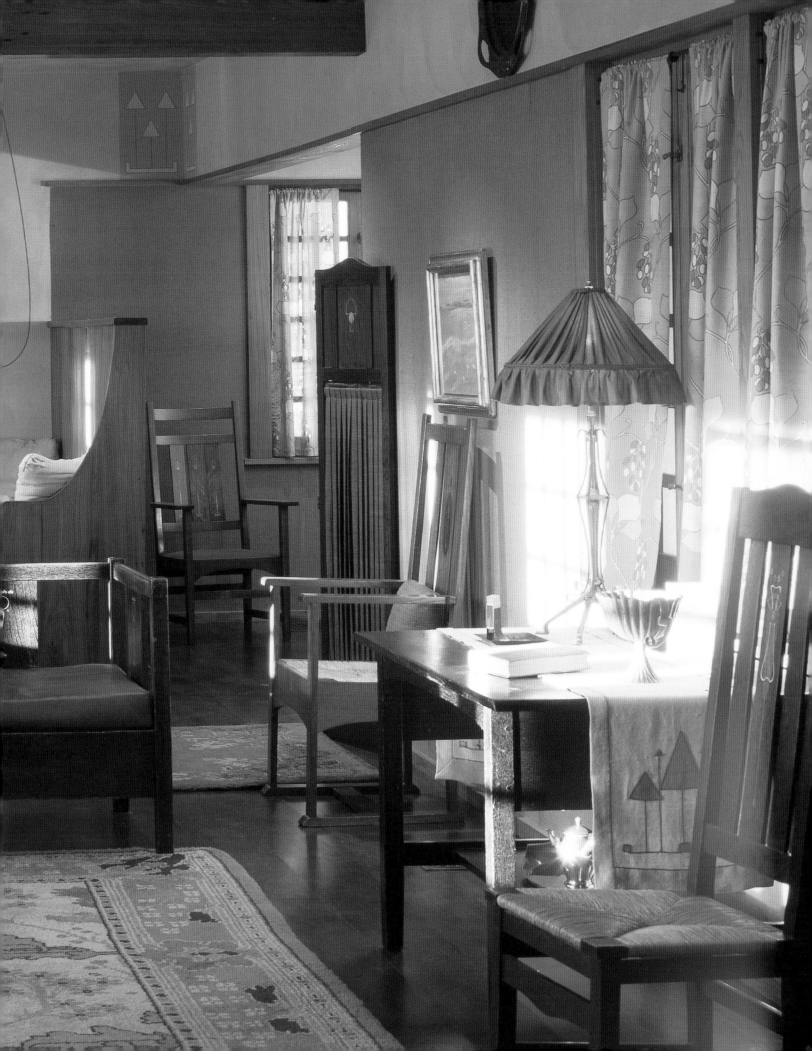

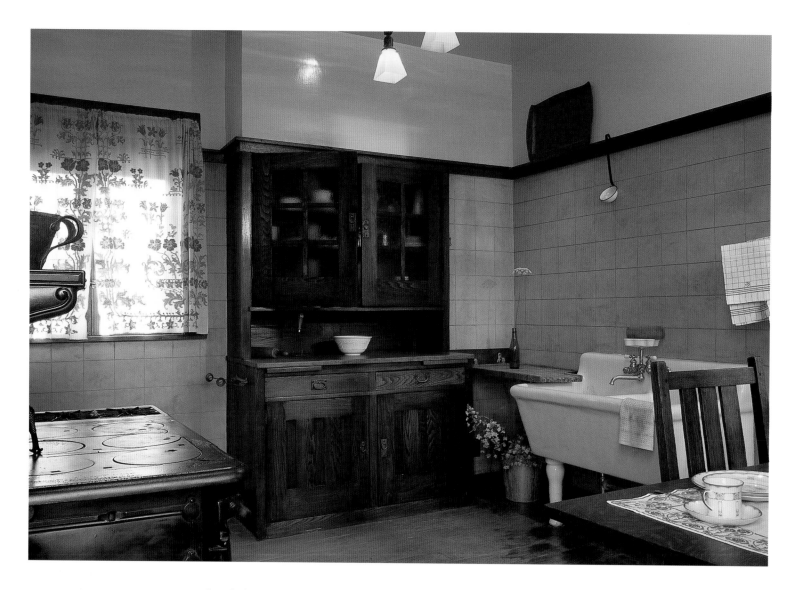

The kitchen boasts a rarity: a built-in Stickley chestnut cabinet. All the elements—the cast-iron wood-burning stove, the sink, and the china—are of the period. A Stickley chair is pulled up to a Stickley table.

covered in dark-stained shingles, is punctuated by three dormers, and the eaves line is broken only by a simple arch above the strap-hinged front door. Ellis varied the otherwise symmetrical facade by placing a modest stone chimney on the left and a tall, jaunty windmill tower on the right. "Not symmetry," he was fond of saying, "but balance." ▪▪ The interior has a Craftsman house's forthright openness while reflecting Ellis's subtler style and more refined grace. Here he drew freely on the British Arts and Crafts architects who inspired his Craftsman designs. The fireplace hood is inspired by M. H. Baillie Scott, the stylized poplar trees outlined on the wall by the fireplace recall similar motifs by C. F. A. Voysey, and the stenciled frieze above them echoes Charles Rennie Mackintosh. To underscore its international nature, the owner has filled the house with American and British Arts and Crafts objects, along with rare inlaid Craftsman furniture designed by Ellis. ▪▪ More than ninety years after Stickley published its design, this jewel-like house has at last claimed its place in the landscape. Constructed with perfect attention to details large and small, it reflects a profound understanding of Ellis's creative methods and some inspired improvisation. Here is proof in wood and stone that Harvey Ellis was more than a "paper" architect.

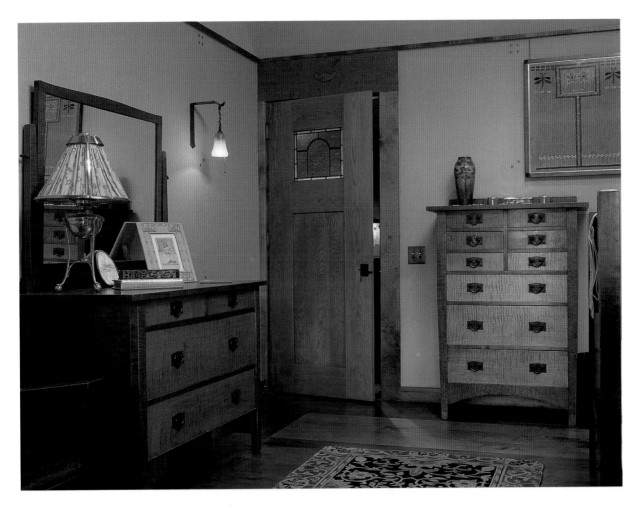

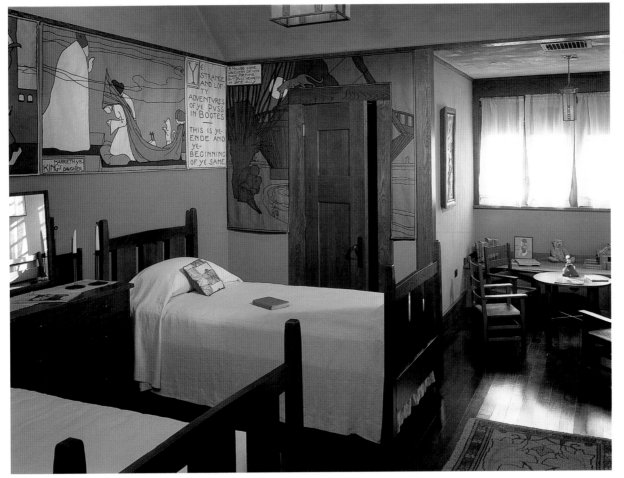

In 1903 Ellis designed Craftsman furniture featuring bowed sides and arched aprons at their bases, motifs reused by other Stickley designers after his death in 1904. These motifs appear in the house's maple bedroom furniture (left top), which Stickley offered in his catalogues from 1905 to 1907 and afterward by special order only. The delightful "Puss in Boots" wall hangings (left bottom) recreate Ellis's series of illustrations, published in the August 1903 *Craftsman*, which were intended to be made as embroidered and appliqued wall hangings.

ONE DAY IN 1978 DONALD DAVIDOFF WALKED INTO A NEW YORK GALLERY AND SAW a long, low oak-and-leather Prairie settle made by the L. & J. G. Stickley Company. He had never heard the name Stickley before, but that evening he told his wife, Susan Tarlow, that Stickley was what they were going to collect—after they finished graduate school! ▪▪ In the beginning they bought some of Gustav Stickley's Craftsman pieces but found themselves drawn to the more eclectic and somewhat less austere furniture made by the rival firm established by his brothers Leopold and John George. They especially admired the sleek, sophisticated designs created by L. & J. G. Stickley's designer Peter Hansen about 1910, when the firm was calling its Arts and Crafts furniture Handcraft. One of the couple's first Handcraft purchases was a rocking chair of honey-colored quartersawn oak that they still own. Another was a settle, listed in the company's catalogue simply as "#220 Settle" but called "Prairie" today because of its clear debt to the designs of Frank Lloyd Wright. ▪▪ Other L. & J. G. Stickley pieces in the Davidoff-Tarlow home near Boston recall the Prairie style—the tall-back Handcraft dining room chairs and two Wright-influenced L. & J. G. Stickley armchairs—but many of the best do not. The double-door Handcraft armoire in the main bedroom is probably one of a kind. In the dining room are two rare early L. & J. G. Stickley pieces: a massive china cabinet with long copper hinges and a cellarette (a small cabinet for wine bottles). The glass-and-copper Handcraft lanterns hanging above the dining room table were made for Leopold Stickley's house in Fayetteville, New York. ▪▪ During

Kindred Spirits

In a house filled with his brothers' work, a Gustav Stickley serving table (right) is lighted by a Dirk van Erp lamp, grouped with Grueby, Fulper, and Van Briggle ceramics and a pair of Jarvie candlesticks. The arms of this rocking chair (opposite) hooked Donald Davidoff and Susan Tarlow on L. & J. G. Stickley's Handcraft furniture: the flake pattern of the quartersawn oak, the rich honey color of the finish, the slightly rounded edges. Behind it is an open L. & J. G. Stickley bookcase and on the table a very rare oak-and-split-bamboo L. & J. G. Stickley lamp.

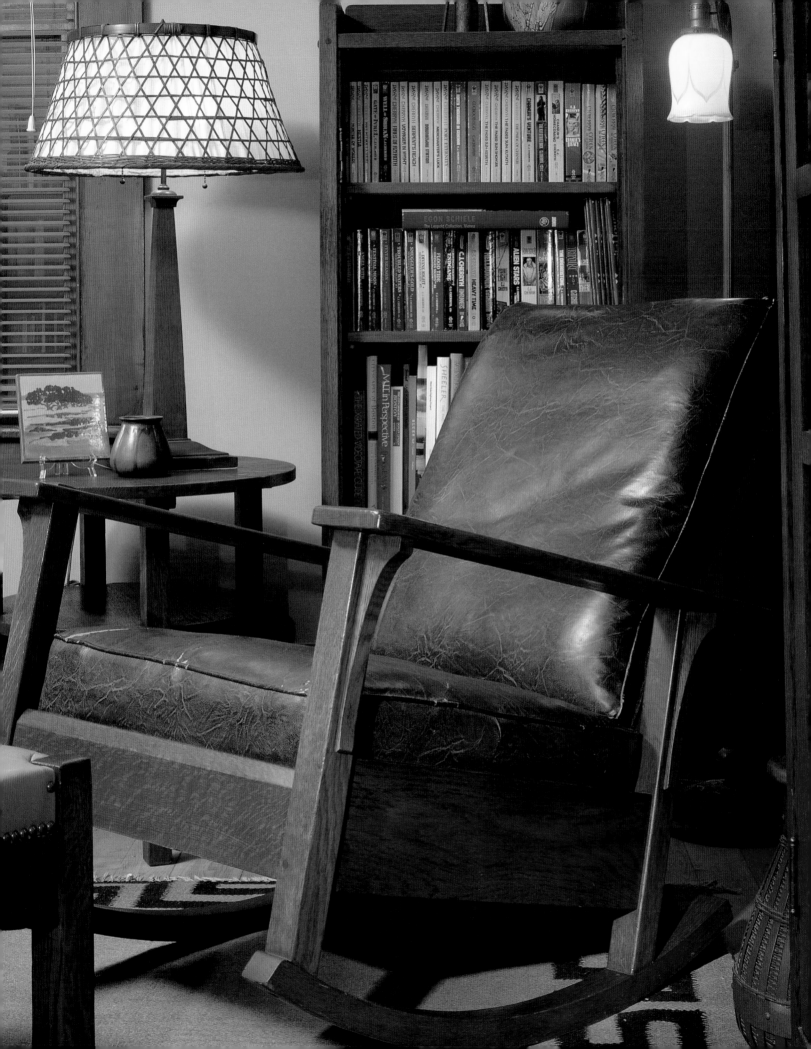

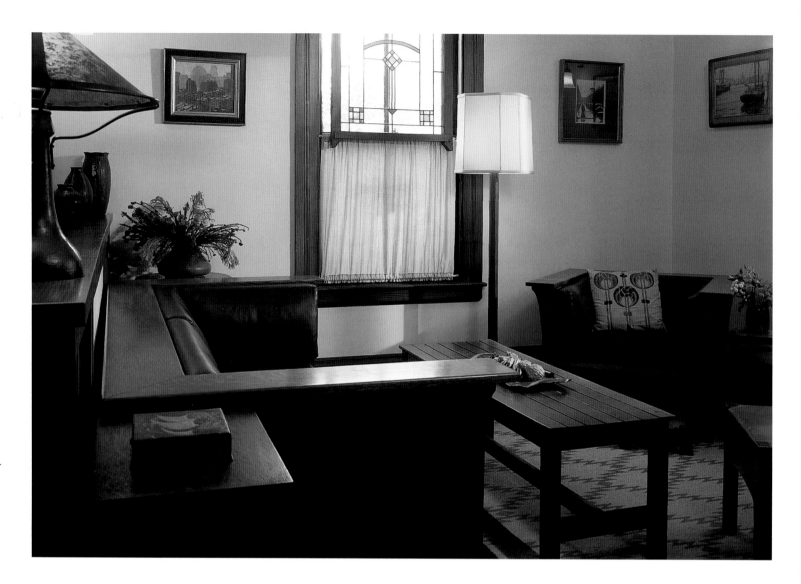

With its broad horizontal surfaces, an L. & J. G. Stickley Prairie settle (above) is a classic American Arts and Crafts design attributed to Peter Hansen, who also created the matching cube-shaped chair. An oak L. & J. G. Stickley cellarette (opposite) is simply but imaginatively designed.

Gustav Stickley's Craftsman years, he and his brothers kept their businesses separate, a fact lamented at least once by the industry. On Christmas day 1906, "The Tattler" column, a regular feature in the trade magazine *Furniture Journal,* was devoted to Gustav Stickley and included this report on his brothers: "Charlie is still in Binghamton, the manager of the Stickley & Brandt Chair Company; Albert made an advantageous connection out of which the Stickley Brothers Company, of Grand Rapids, has grown, and four or five years ago Leopold and J. G. Stickley ... launched out for themselves. It has always seemed a pity to me that these five brothers could not have combined their forces and worked together." According to family tradition, all the brothers were strong-willed and preferred to work independently, and it was not until Gustav's bankruptcy that, for about three years, they finally banded together. :: Today Leopold and John George Stickley rest somewhat in the shadow of their older, more famous brother. But the handsome, innovative L. & J. G. Stickley designs in the Davidoff-Tarlow collection show how accomplished their firm could be. In the serene interior of this Handcraft house, their work is seen at its best.

The tall, double-door china cabinet in the kitchen (right) was made during the first years of L. & J. G. Stickley's furniture production. Behind it, a Frank Lloyd Wright side chair sounds the Prairie theme. In the passage separating the kitchen from the dining room, Donald Davidoff and Susan Tarlow have installed clear, geometrically patterned leaded-glass doors designed by the Prairie School architect George W. Maher. The Prairie theme continues in the dining room (opposite), where tall-back Handcraft chairs grouped around a rectangular L. & J. G. Stickley table define the central space and create a sense of enclosure suggestive of Wright. The lanterns, only ten of which are known, come from Leopold Stickley's home in Fayetteville, New York.

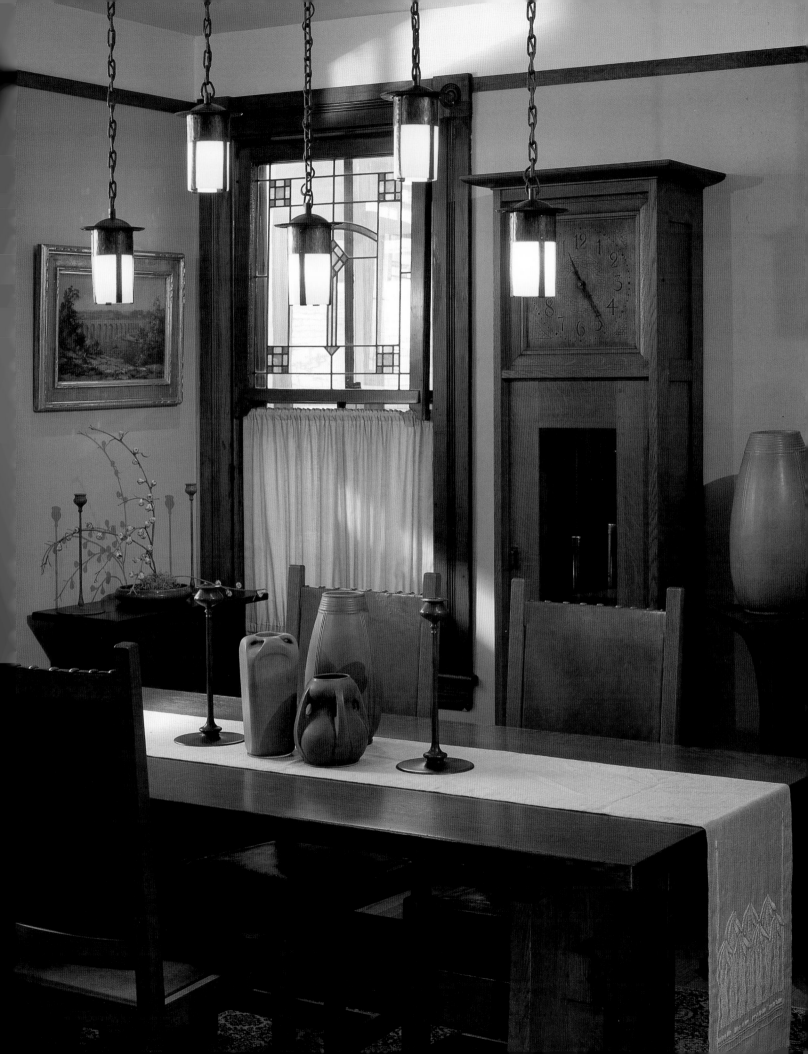

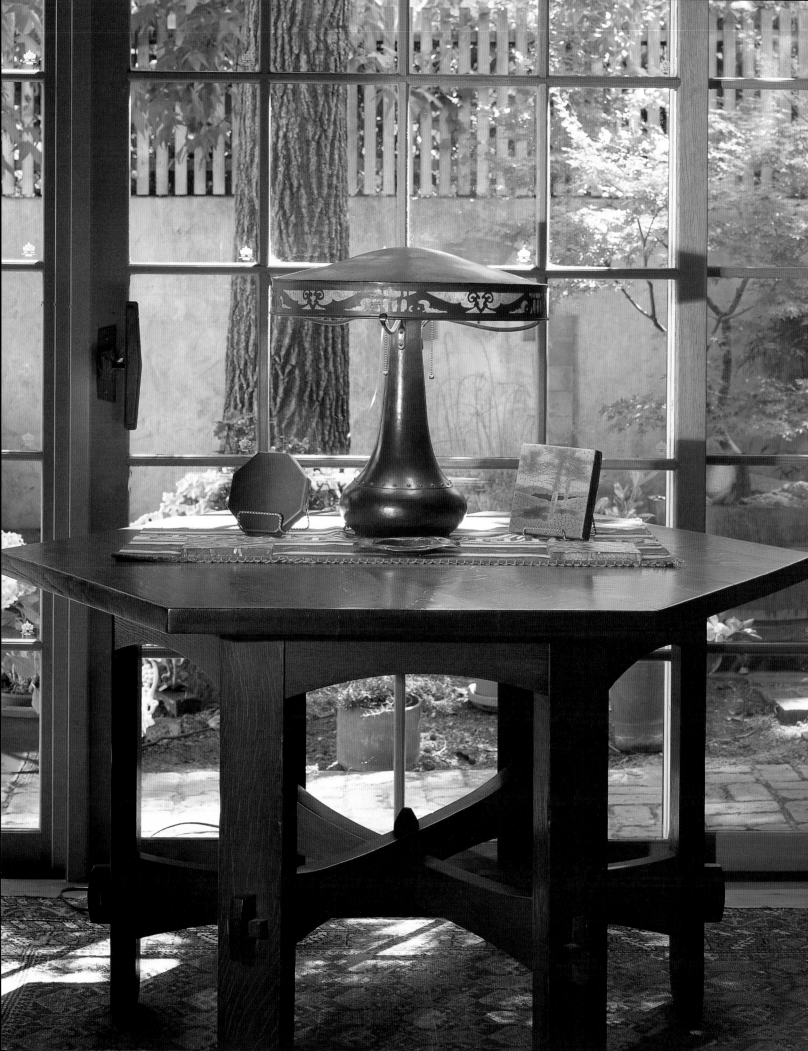

ALLEN AND VONDA BREED DID NOT SET OUT TO BE COLLECTORS: THEY JUST LIKED ARTS and Crafts architecture. When they began planning a new master bedroom for their northern California home, they decided to make it look like a room in a Craftsman house. Allen found design ideas by poring through *Craftsman* magazines at a local library and then constructed the room's wainscoting, plate rail, and ceiling beams himself. The Breeds added only one new piece of furniture—a handsome Arts and Crafts bed that was just the right height for the wainscoting. ▪▪ But what was meant to be the end of their furniture buying turned out to be the beginning. At an antiques show the Breeds came upon a display of Stickley furniture arranged in room settings. Seeing that furniture, says Allen, "was a revelation, a dream come true." They decided that their entire bedroom should be Stickley, and over the next few years they bought two Morris chairs,

Stickley by Serendipity

several library tables, a tall chest, and a sideboard to serve as a chest of drawers. ▪▪ Growing discontented with the other rooms of their house, the Breeds found themselves dreaming of filling them with Stickley furniture, too. Echoing a sentiment with which nearly all Stickley collectors would agree, Allen says, "When you start living with it, it really grows on you." The rest of the Breeds' house has been transformed by their collection, which now includes a rare seven-foot-long "knock-down" settle and a Stickley Eastwood chair, whose spacious seat and wide arms allow it to be used as a chair, a table for stacking books, or even, according to one Craftsman catalogue, a bed. ▪▪ Allen describes the joys of collecting Stickley furniture: "You have all the surprises and pleasures of looking at a picture in *The Craftsman*, and then finding the actual piece and seeing that it's even better than you had hoped. It's like discovering treasure."

Stickley's hexagonal library table, with its stacked cross-stretchers and big tenon-and-key joints, is as much a favorite with collectors today as it was with Stickley himself, who had one in his Syracuse home and later at Craftsman Farms. Other Arts and Crafts touches—a Dirk van Erp copper-and-mica lamp and Grueby tiles—accentuate the Arts and Crafts theme.

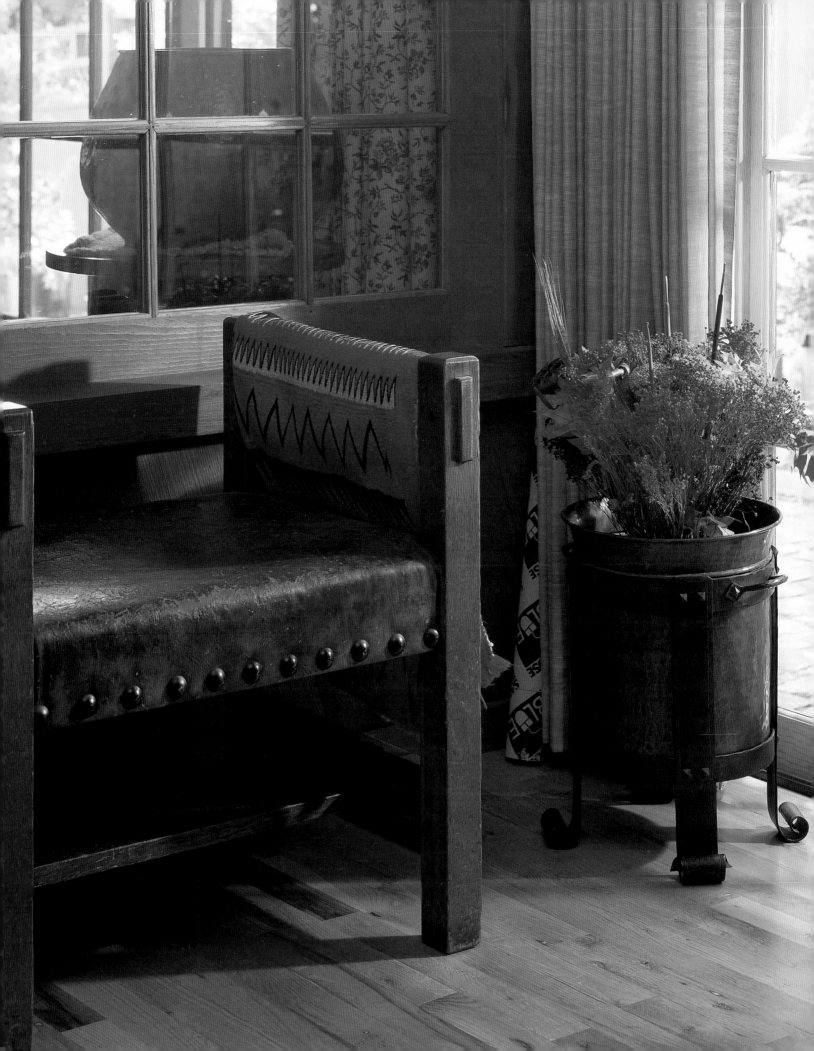

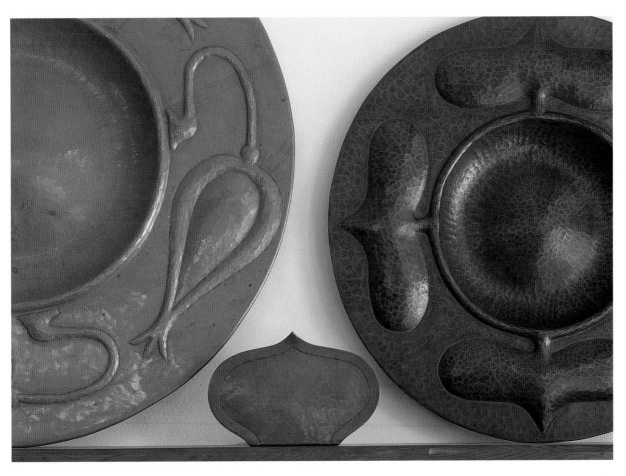

A leather-covered window seat and a copper-and-iron jardiniere (opposite), both Craftsman, grace the Breeds' sunroom. Today only a handful of Stickley's hammered-copper wall plaques are known (left). The virtues of Stickley's V-back armchair (below)—comfort, sturdiness, good proportions, and beauty—render it his most nearly perfect chair.

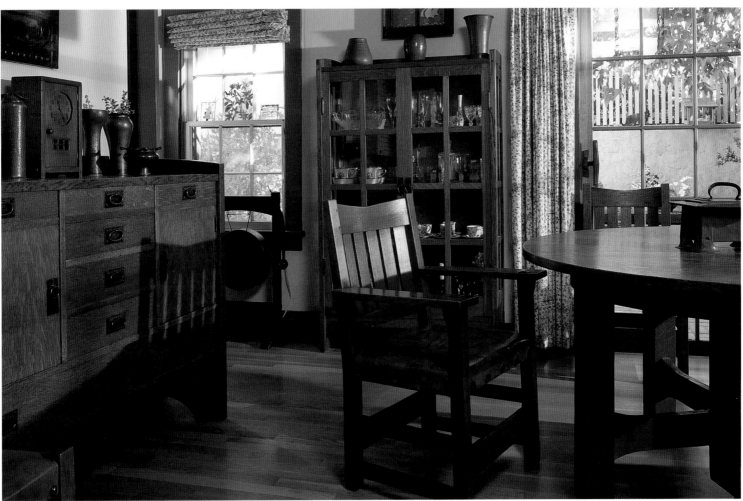

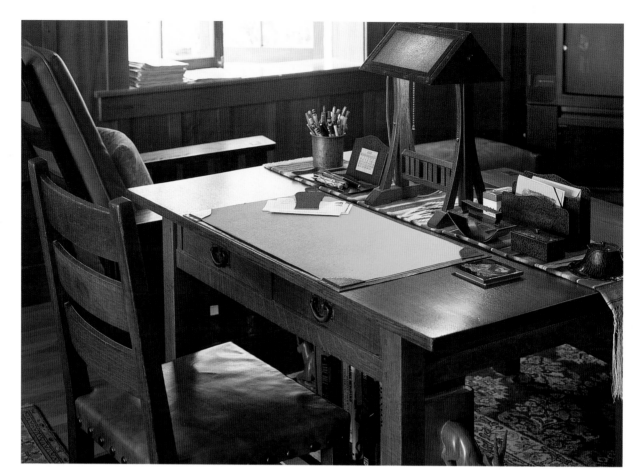

Allen Breed's hammered-copper Craftsman desk set and a Craftsman lamp complete his Craftsman desk (right). The room that started the collection (below): the Craftsman-like wainscoting sets off Craftsman furniture and lighting and a row of Grueby tiles. A pyramidal Roycroft magazine pedestal (opposite) looms above ladder-back Craftsman chairs.

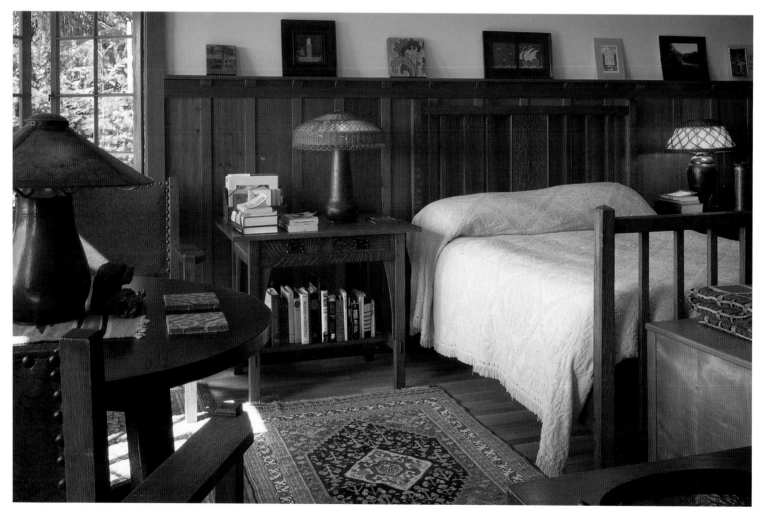

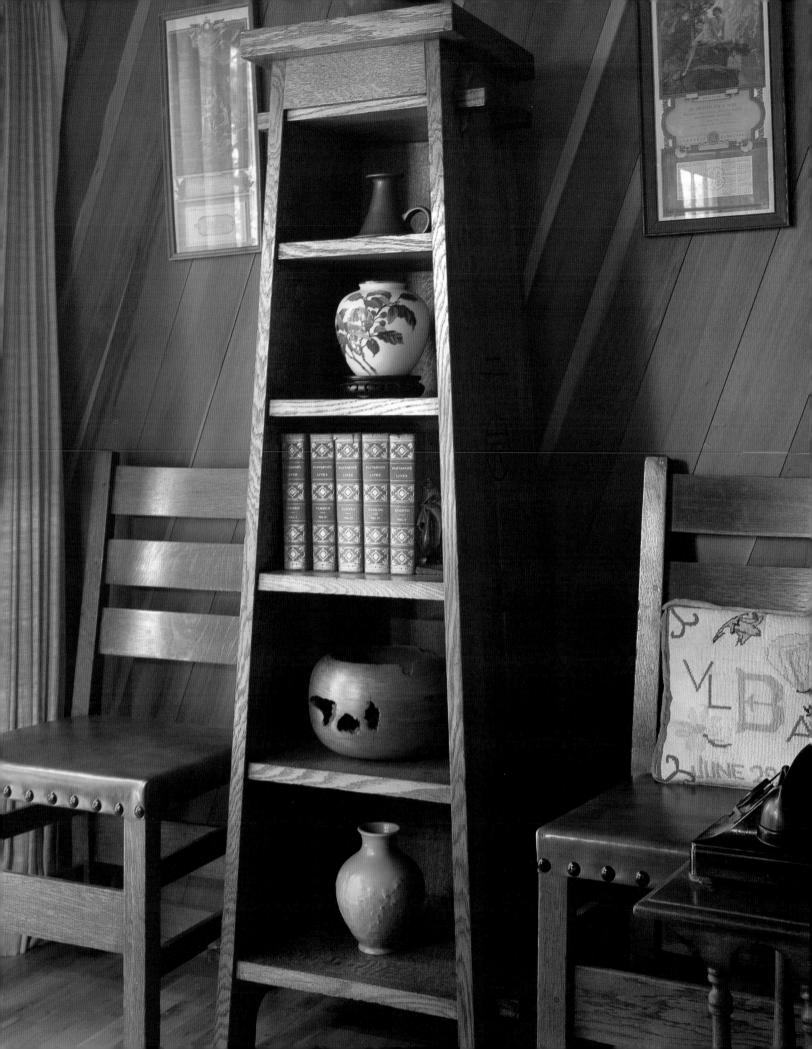

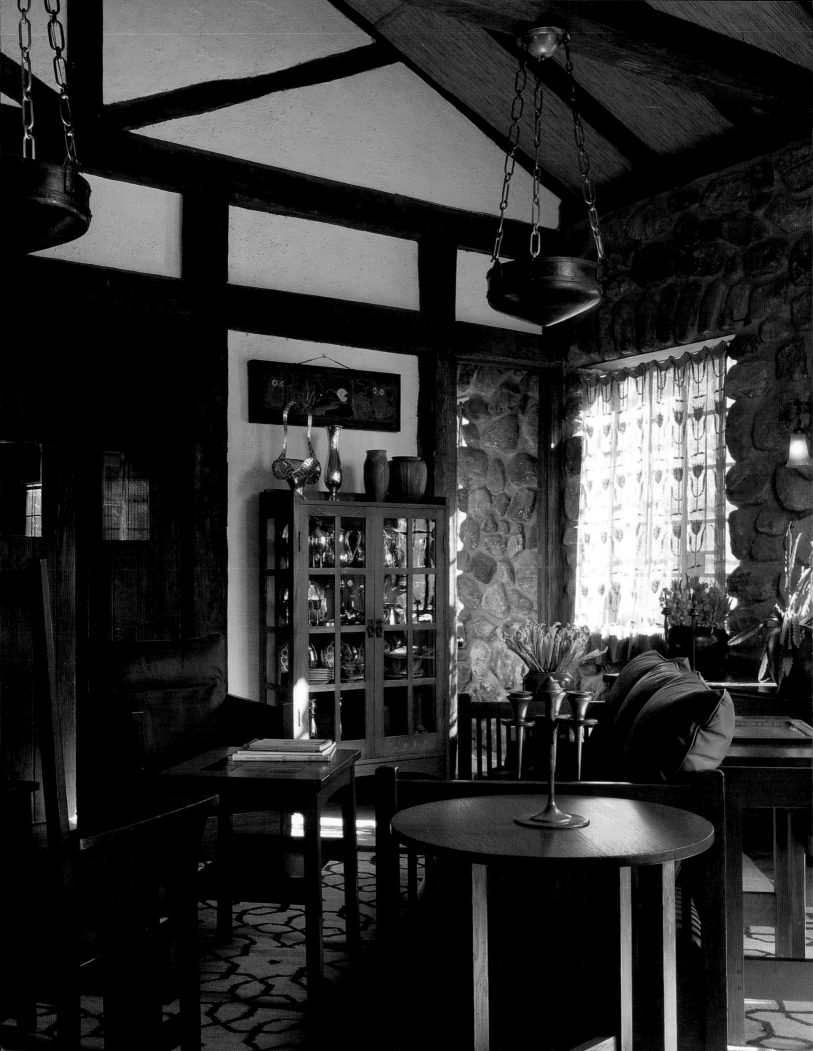

MORE THAN TWENTY-FIVE YEARS AGO ELAINE DILLOF, AN ANTIQUES DEALER, READ A BOOK entitled *The New Antiques,* which had a few things to say about Mission oak furniture: "The only way you can break it is to run over it with a tank.... As to the future of mission, it is hard to imagine as this is being written that anyone in their right mind will ever collect it." Dillof had never heard of Mission oak but decided it was just the thing to buy. Soon she was bringing home any pieces she could find and storing them in the attic. ■ This furniture has found a perfect setting in Elaine and Robert Dillof's 1920s stone house near New York City. Rising from its steep hillside site like an outcropping of rock, it is as dramatic inside as outside. The living room walls and fireplace, made of irregularly shaped fieldstone, contrast with the Craftsman-like rough-sawn wood ceiling beams and create a shifting play of light and dark. Sunlight floods through French doors at the front of the room and silhouettes a Stickley sideboard, made about 1901, holding an even greater rarity, a Craftsman wine cooler of hammered copper. ■ A winding staircase at the back of the living room leads up to the combined sitting–dining room. The natural stone walls of this spacious, sun-filled room support rugged wood beams and exposed rafters, just the kind of open construction Stickley favored.

A Good Eye
for Stickley

Complementing the Stickley furniture are some superb examples of furniture by the Roycroft community and Charles Rohlfs, as well as Grueby pottery, Stickley and Roycroft lighting, and warmly patinated copper pots by the Arts and Crafts metal master Dirk van Erp. ■ When the Dillofs learned the name Gustav Stickley after a few years of collecting, they looked for his mark on the pieces they owned and were excited to find it on many of them. One early purchase had been the tall Stickley spindle side chair now in their upstairs sitting room, discovered at a house sale for $5. The matching spindle armchair came along later for $100. Elaine Dillof clearly had a good eye.

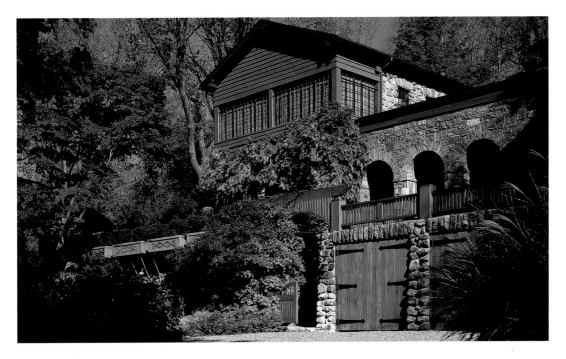

Craftsman spindle furniture fills the Dillofs' sitting–dining room (opposite), illuminated by Roycroft copper fixtures designed by Victor Toothaker. With its stone facade and band of casement windows, the house wears a Craftsman air (left).

109

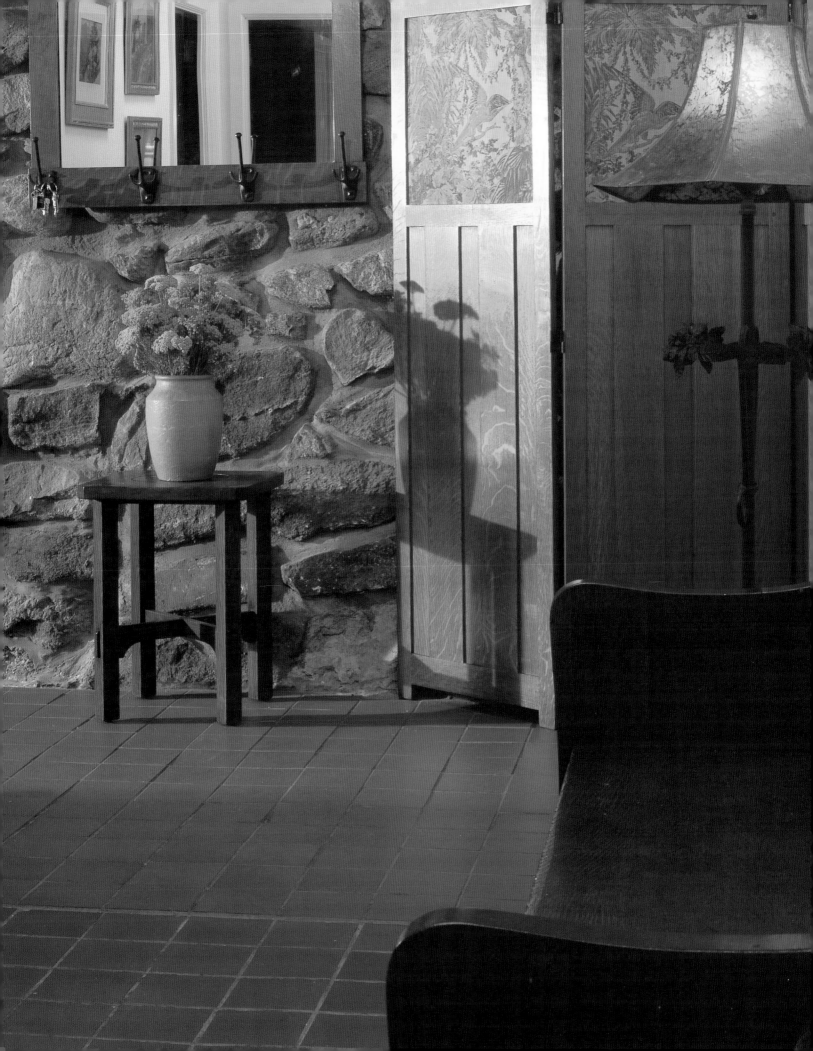

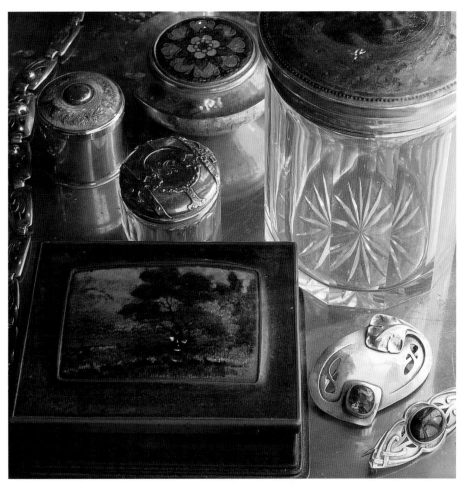

In the Dillofs' entry hall (opposite), a tall-back Stickley hall settle offers a welcoming seat. Adding its warm glow to the gleaming tile floors and sun-drenched stone walls is an iron-and-mica floor lamp by the Arts and Crafts metalworker Marie Zimmermann. Displayed on a copper-topped Craftsman table (left top) is Elaine Dillof's Arts and Crafts silver jewelry and colorful enamels. An early Craftsman sideboard with tenon-and-key joints at each end and double dovetails on the door fronts holds a rare Craftsman copper wine cooler (left bottom).

In the dining room (right top), a Roycroft table is surrounded by Craftsman ladder-back chairs. A band of casement windows wraps around three sides of this room, enlivened in one corner by a Craftsman copper-and-mica lamp. A Stickley Brothers bedroom set (right bottom), made by Albert Stickley's firm in Grand Rapids, Michigan, is exquisitely inlaid with stylized pewter roses reminiscent of the British Arts and Crafts. Covering the wall of another bedroom (opposite) is a woven English Arts and Crafts textile attributed to Samuel Rowe. A stylized rose, based on a design by the Roycrofter Dard Hunter, is stenciled onto the wall.

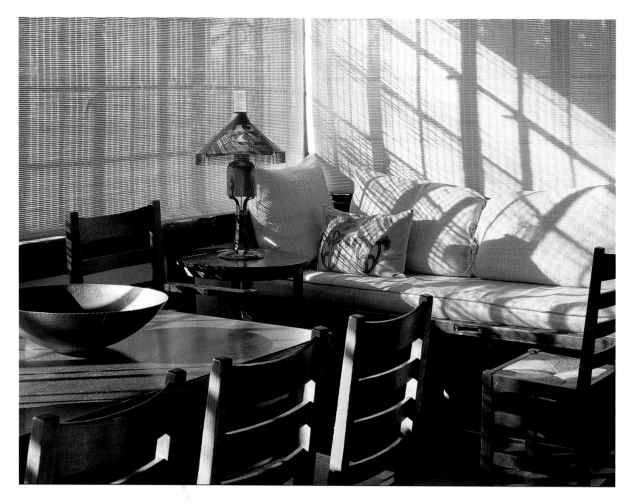

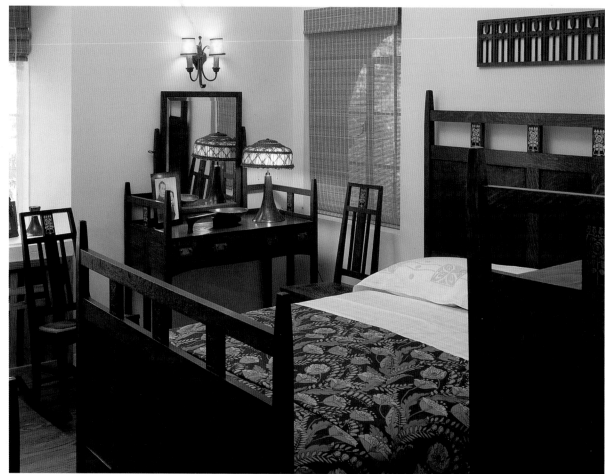

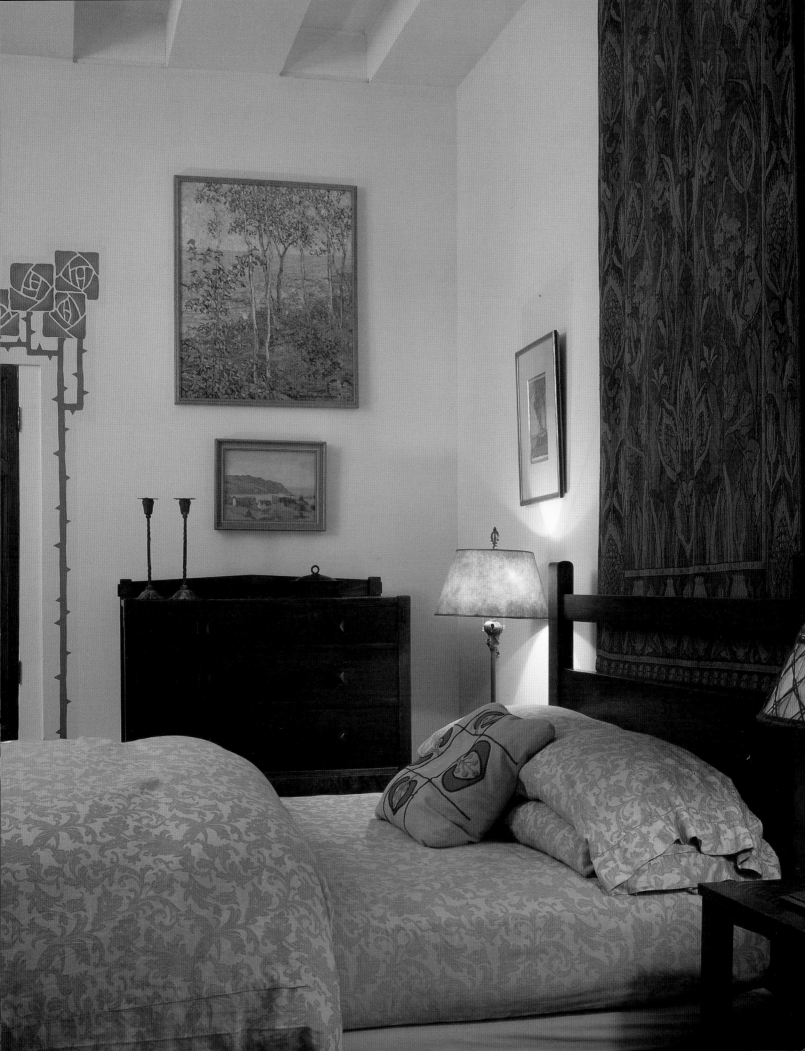

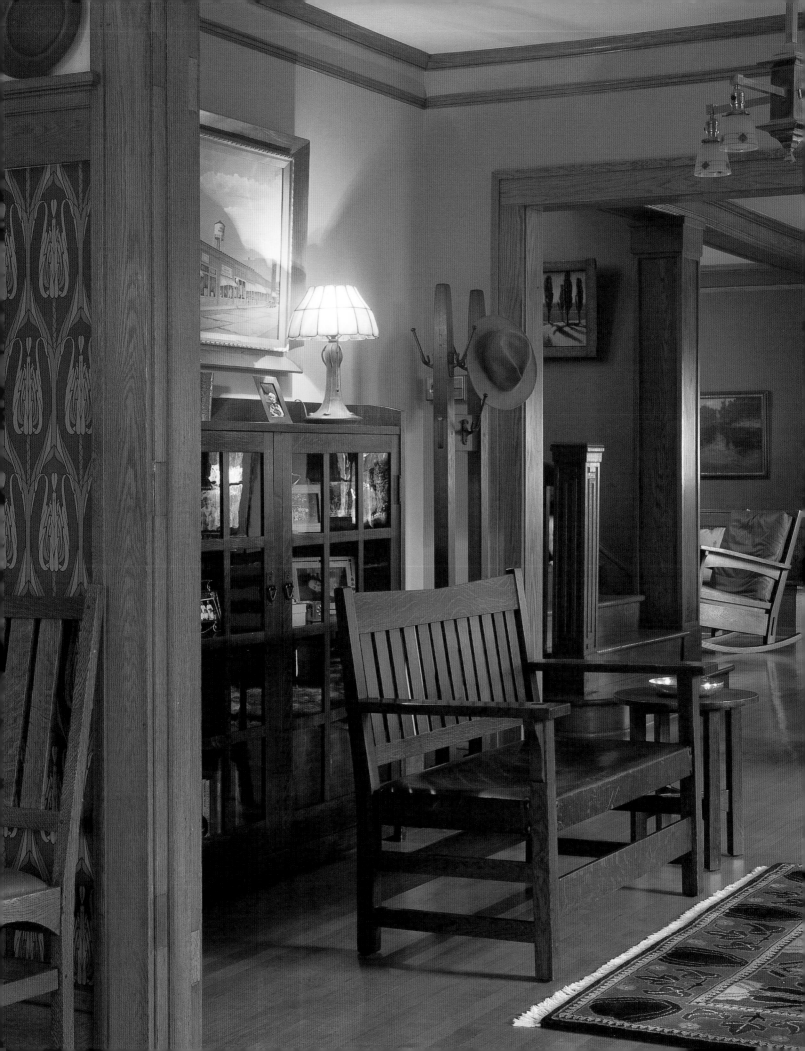

DURING HIS HIGH SCHOOL AND COLLEGE YEARS, BRUCE JOHNSON COLLECTED VICTORIAN oak furniture and after graduation began a dual career as an English teacher and a furniture refinisher who occasionally bought and sold antiques. One day in the late 1970s, when he was still teaching, he walked into the basement of a house in Iowa and happened upon twelve dark, tall-back Roycroft chairs. He was only vaguely aware of the Arts and Crafts movement and knew almost nothing about Roycroft, but instantly, he says, "I was hooked." After that he bought whatever Arts and Crafts furniture he could find. ▪▪ Today Johnson writes books and magazine articles on Arts and Crafts subjects, lectures frequently, and is a popular columnist for the Arts and Crafts magazine *Style 1900*. He is also the director of the annual Arts and Crafts Conference, held every February in Asheville, North Carolina, and attended by several thousand enthusiasts. The three-day weekend event, which includes lectures, an Arts and Crafts antiques show, and an exhibition and sale of Arts and Crafts–inspired wares made by modern crafters, takes place at the historic Grove Park Inn (1915), itself an Arts and Crafts icon. ▪▪ Johnson and his wife, Lydia Jeffries, also an avid Arts and Crafts collector, live in a three-story 1915 house in North Carolina whose original Arts and Crafts interior is largely intact. This they have filled with Stickley furniture, Roycroft copper, and sterling silver pieces by William Waldo Dodge, a North Carolina Arts and Crafts silversmith. But Johnson has learned that it is important to keep collecting in perspective. One day, as the family drove off to yet another antiques auction, his ten-year-old son turned to him and offered some advice: "Dad, you don't need to own *every* piece of Stickley!"

Hooked on Arts and Crafts

The music room (opposite), now a study, is furnished with a V-back settee, a bookcase, and a costumer, all Stickley pieces. Other Stickley items include a smoker's cabinet, with room for pipes and cigars (far left), now used as a table, and a round L. & J. G. Stickley table (left).

Filled with Craftsman furniture, the dining room claims one Roycroft prize: a hanging glass-and-copper light fixture (right). Designed by Victor Toothaker, who worked for both Stickley and Elbert Hubbard, it dates from about 1912. A Stickley ladder-back high chair (opposite), made of oak with a rush seat, stands before the Wrightian fireplace. All the furniture in the living room (pages 118–19) is Craftsman except for the tall clock (an L. & J. G. Stickley reissue) and the floor lamp between the two drop-arm Morris chairs. The lamp, based on a Stickley design, was made by the contemporary metalworker Michael Adams of Aurora Studios and the owner Bruce Johnson, who believes that the ideal collectors are also crafters themselves.

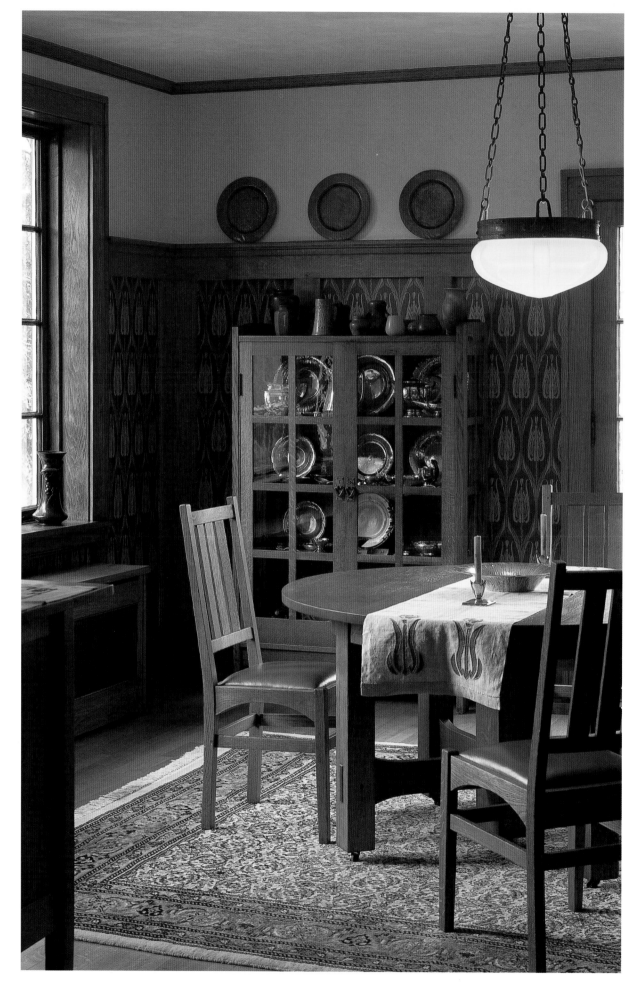

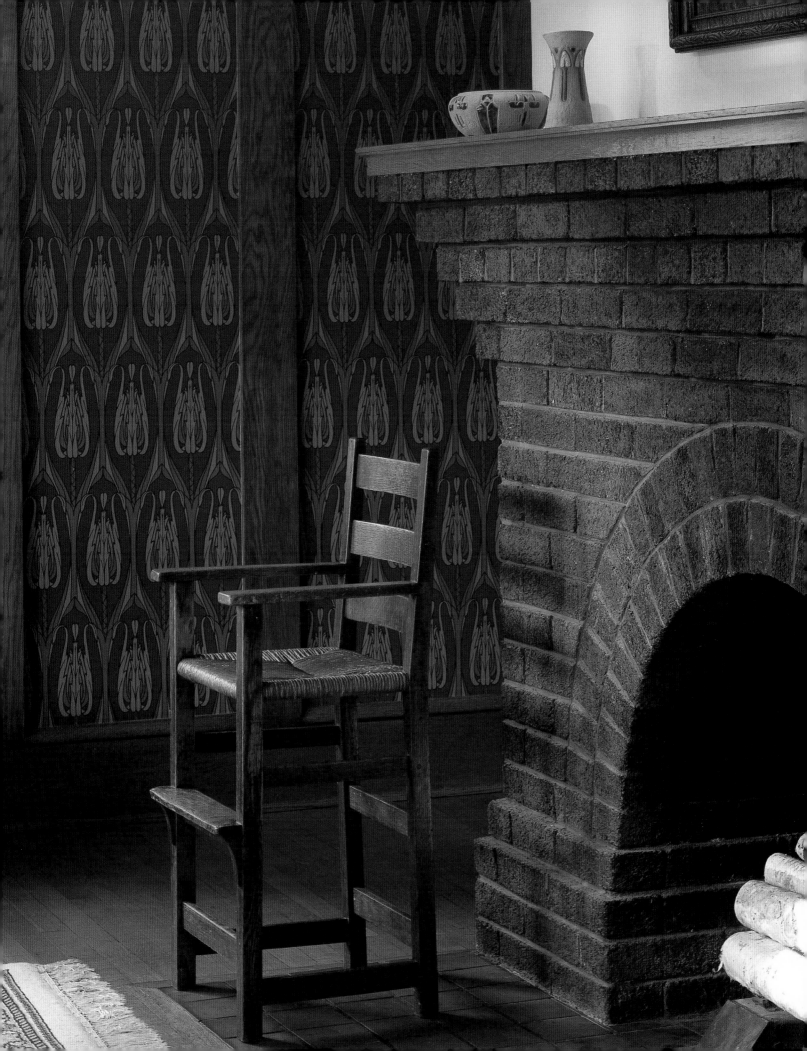

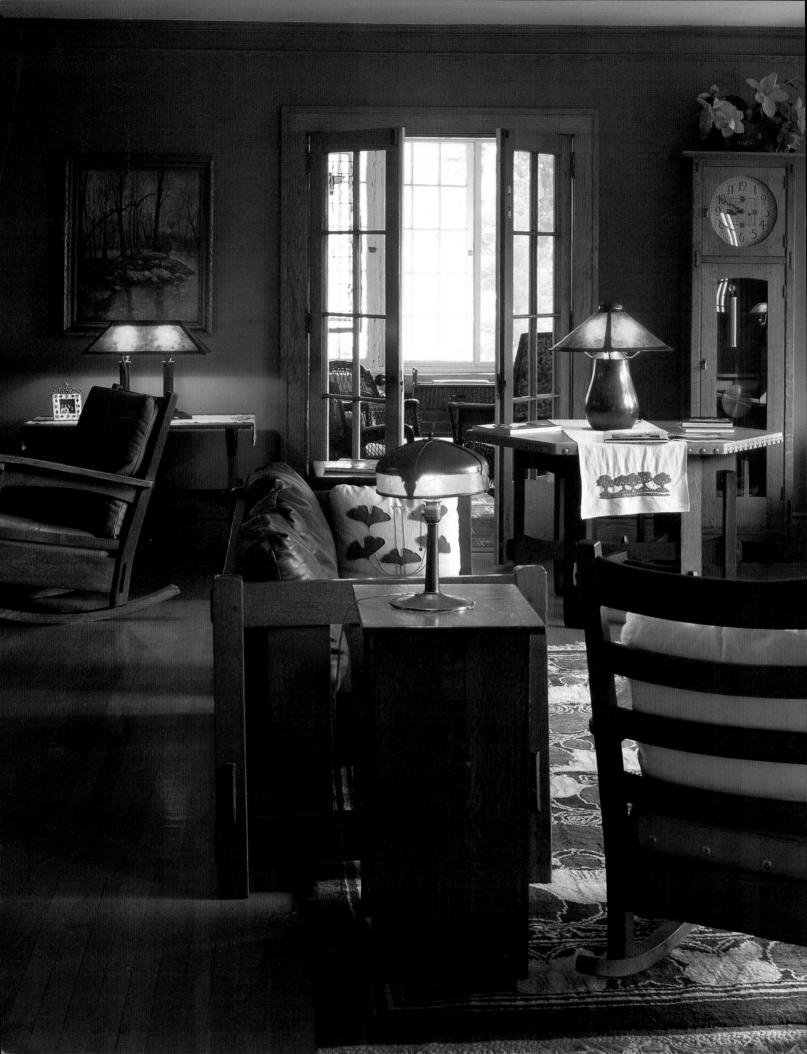

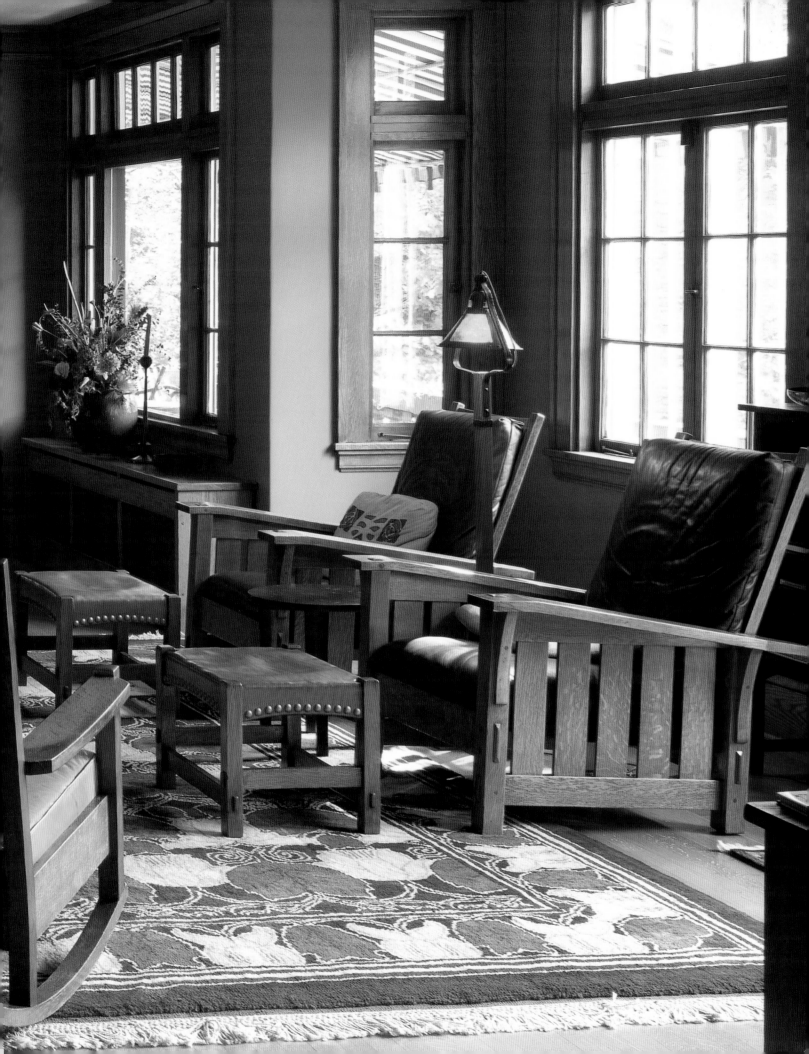

The view down the hall toward the living room (right) shows some of the house's distinctive woodwork, such as the Prairie-like geometric newel post and banister. The family who commissioned this house from the architect Richard Sharpe Smith in 1914 came to North Carolina from Chicago, which may explain the Wrightian influence. Among the Craftsman furnishings in the study (opposite), located between the living and dining rooms, are a Craftsman fall-front desk and a side chair. Roycroft copper is displayed around the room.

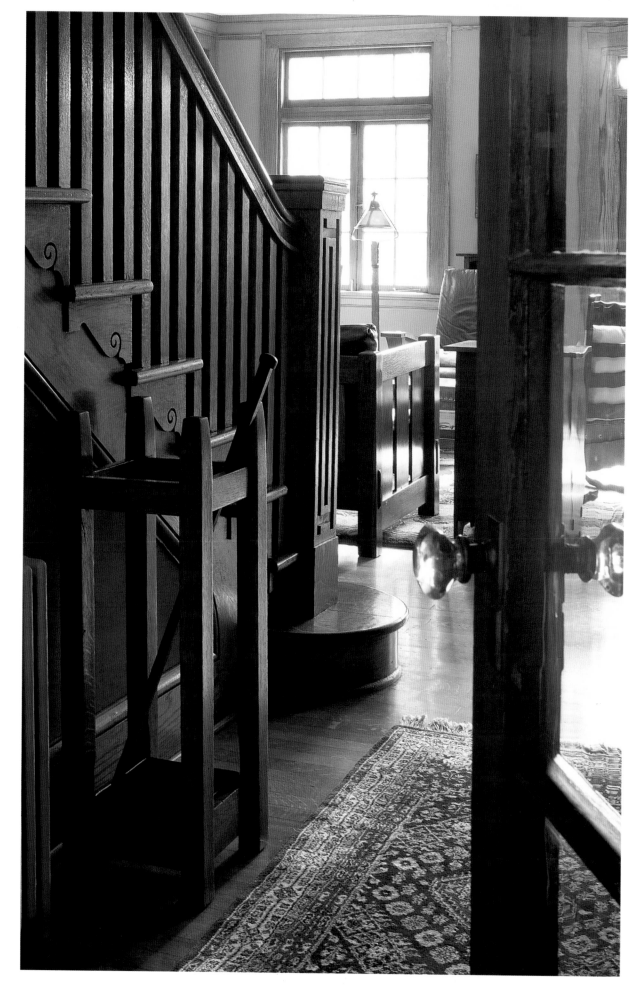

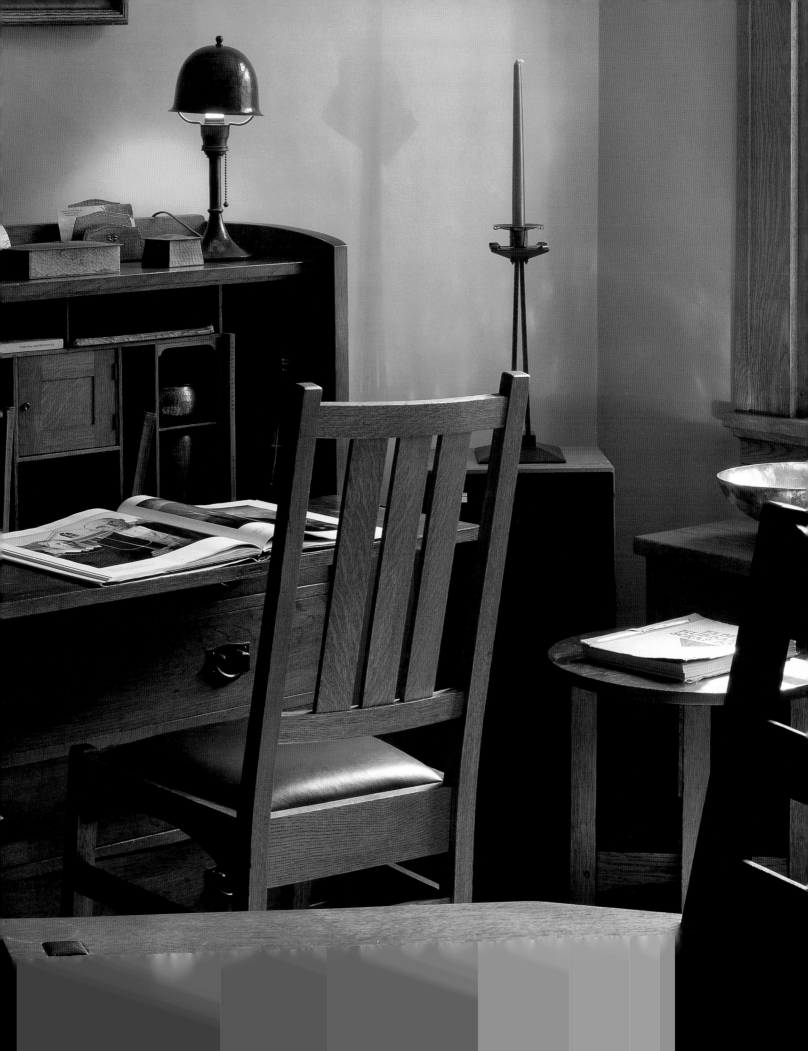

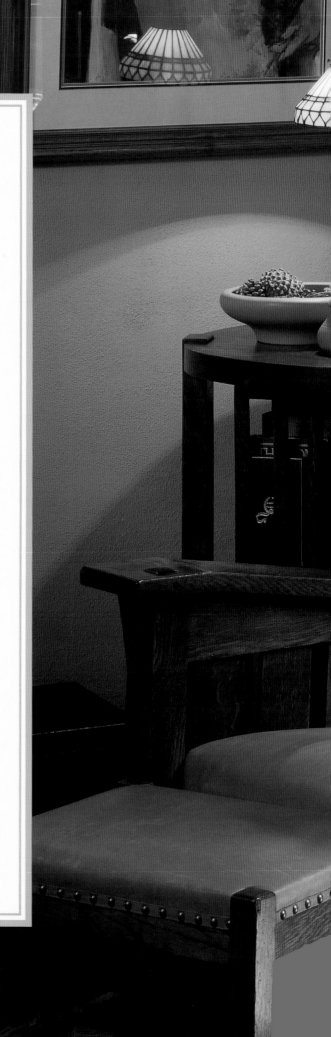

STICKLEY AND THEN SOME

Few if any Stickley collectors collect only Stickley. The result is wonderfully diverse collections in sometimes eclectic surroundings: Stickley pieces seem at home in a New York farmhouse and a Texas Victorian, a Manhattan apartment and a southwestern house recalling Frank Lloyd Wright. ▪▪ This diversity reflects the vitality and variety of the Arts and Crafts movement. Stickley's furniture was generally plain and sturdy, in contrast to the elaborate carved or sawn decoration and exaggerated structural details of that designed by Charles Rohlfs. Frank Lloyd Wright's straight-lined furniture was designed specifically for individual architectural commissions, as was the exquisitely crafted furniture of Charles and Henry Greene in California. In England M. H. Baillie Scott often designed furniture for his architectural clients as well as factory-made furniture produced by the manufacturer John P. White. In Glasgow the architect Charles Rennie Mackintosh created furniture with delicate detailing, subtle color, and almost fluid form for his domestic and commercial commissions. And in Austria, the Wiener Werkstätte (Vienna Workshop), a group of reformist designers and artisans inspired by British Arts and Crafts, created colorful, formal, geometric furniture and other decorative household wares. Although the Arts and Crafts objects produced in Britain, Austria, and America may not be stylistically similar—Arts and Crafts was not a style but a way of life—they arose from similar impulses. ▪▪ In contemporary collections Rohlfs chairs may be grouped around a rectangular Stickley table; a Wright chair may soar beside a knock-down Craftsman settle; and an L. & J. G. Stickley library table may stand near a sideboard designed by Baillie Scott. By intermingling Craftsman pieces with the work of other designers, many collectors have found that Stickley fits comfortably within the rich mosaic of the American and international Arts and Crafts.

A Stickley drop-arm Morris chair in a Pasadena, California, landmark.

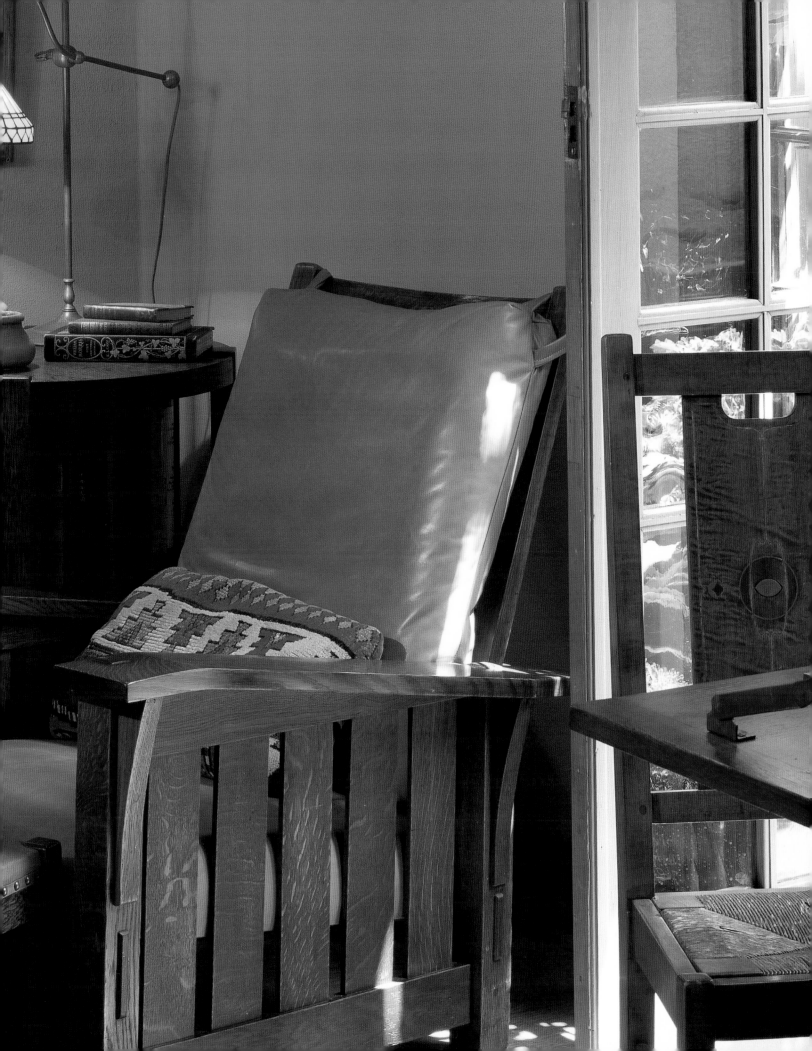

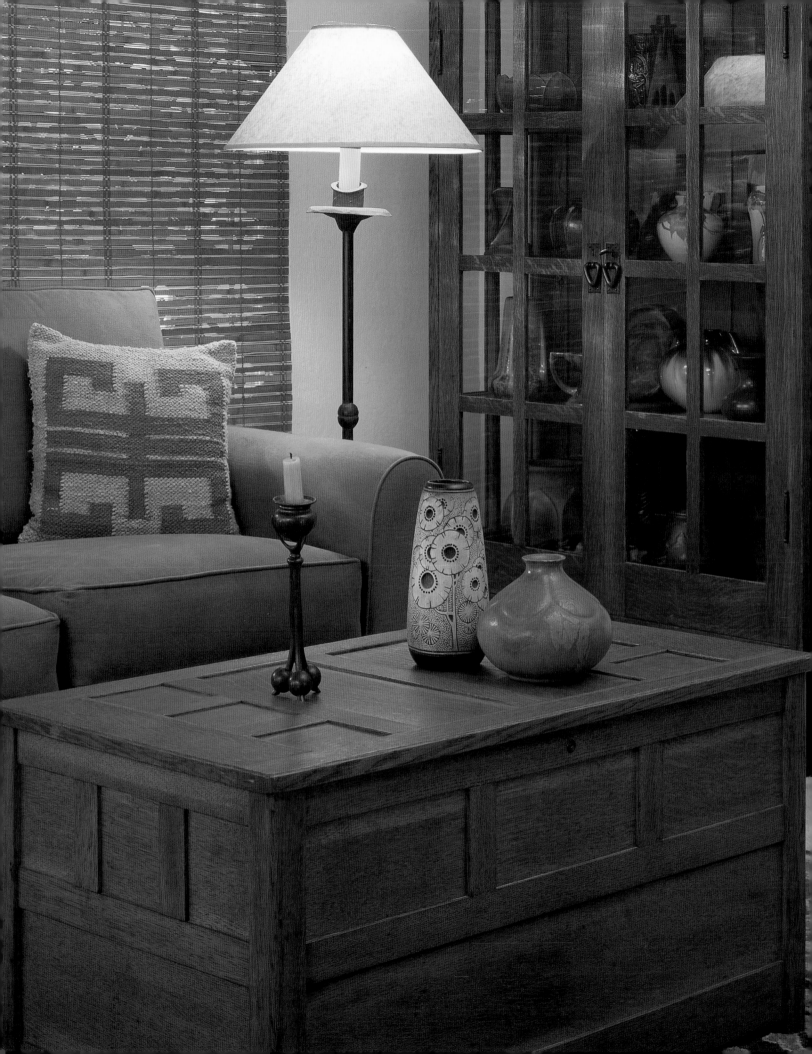

ON MARCH 22, 1960, A BERKELEY UNDERGRADUATE NAMED ROBERT JUDSON CLARK excitedly sent his sister a postcard about a new find: "Guess what!!! I looked at my chair last night—at a new angle—and it's a signed GUSTAV STICKLEY . . . am I happy!" This chair—bought not because of who had made it but just because Clark liked it—had cost him $5. ▪▪ While in college, Clark had begun researching the early-twentieth-century California architects Bernard Maybeck, Louis Christian Mullgardt, and Charles and Henry Greene. He tracked down turn-of-the-century books and periodicals and eventually found *The Craftsman* magazine, from which he learned what Stickley's furniture looked like and how it was marked. Soon after identifying Stickley's red decal underneath the seat of his new chair, he found a photograph of an identical chair in the January 1904 *Craftsman*. With that discovery he began collecting Arts and Crafts. ▪▪ In 1972, when he was an assistant professor at Princeton University, Clark created the landmark exhibition *The Arts and Crafts Movement in America 1876–1916* and edited its catalogue, both of which refocused attention on long-eclipsed Arts and Crafts furniture, ceramics, metalwork, lighting, textiles, and books. Some of the exhibited pieces were from Clark's own collection, and some still stand in his house near San Francisco (he is now professor emeritus): the Gustav Stickley chair, his original purchase, made about 1903; an L. & J. G. Stickley Morris chair; and a handsome storage chest from an oak bedroom suite made in 1910 by Jewett Johnson, a California manual arts teacher. ▪▪ Today, when collectors are so eager to seek out period Arts and Crafts objects and modern artisans work in the spirit of the movement, it is sometimes hard to realize that this revival is a relatively recent phenomenon. It may, in fact, have begun that day when a student handed $5 to a Pasadena antiques dealer and drove home with a mysterious chair.

ONE STICKLEY CHAIR LEADS TO A CLASSIC EXHIBITION

The First Collector

While in high school, Robert Judson Clark first saw this chest by Jewett Johnson (opposite) at the home of Johnson's widow. The tall frame-and-panel cabinet (far left and left), purchased from Leopold Stickley's widow, Louise, now holds Clark's archive of architectural drawings.

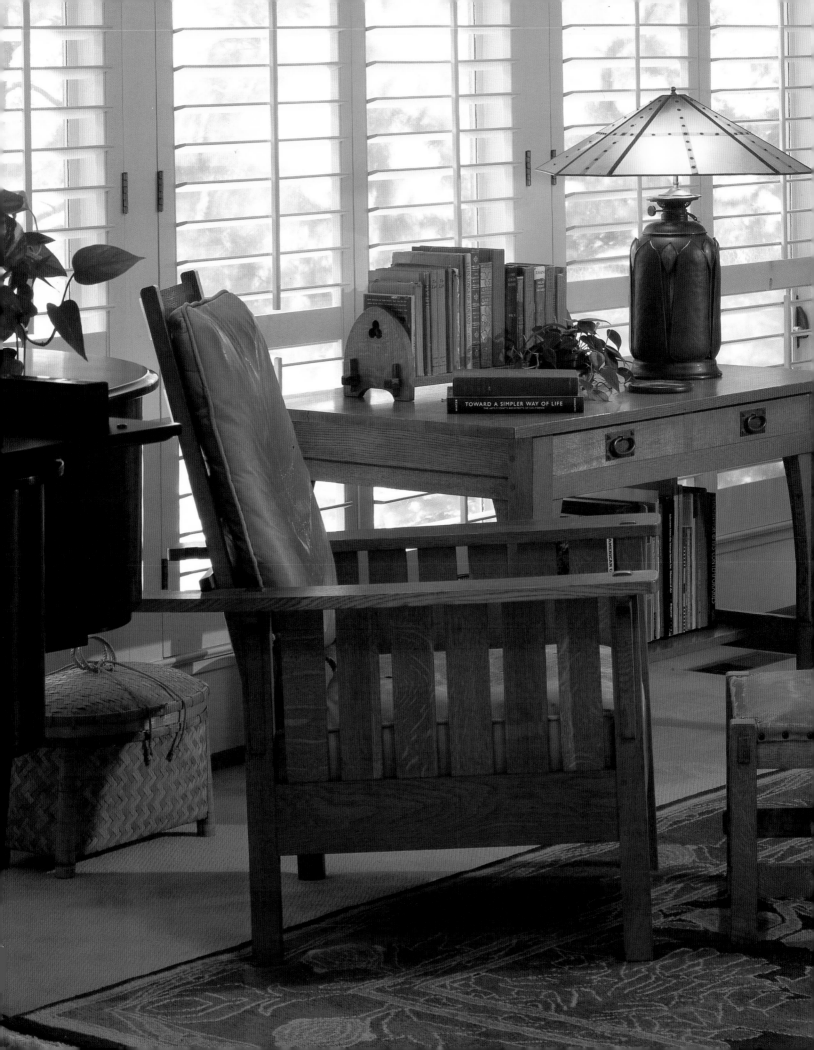

TOWARD A SIMPLER WAY OF LIFE
THE ARTS & CRAFTS ARCHITECTS OF CALIFORNIA

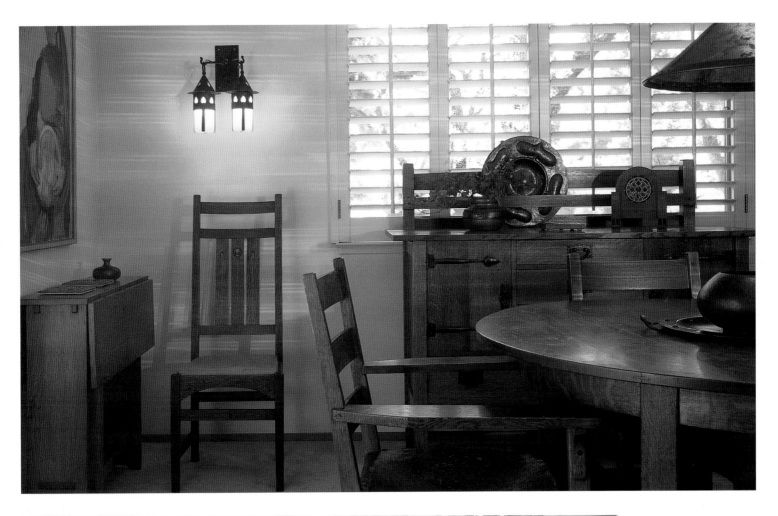

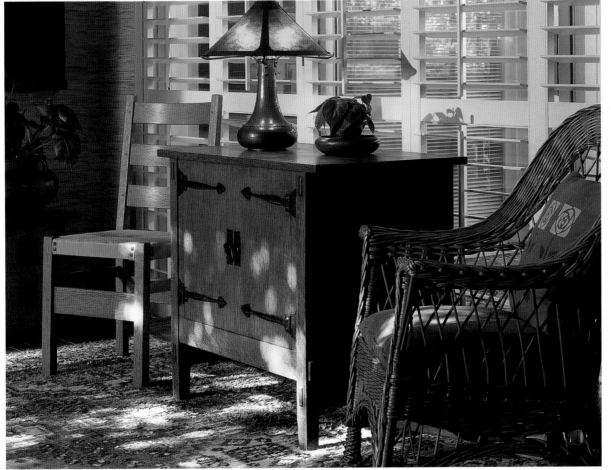

The second piece of Stickley furniture Clark ever bought was an L. & J. G. Stickley Morris chair (opposite), now in his living room. His first Craftsman piece, the inlaid chair purchased for $5 in 1960 (above), is surrounded by relatives in the dining room. A Craftsman cabinet with shapely strap hinges (left) takes pride of place in the collector's entry hall.

THIS BOOK WAS WRITTEN AT A LARGE, FLAT-TOPPED STICKLEY DESK IN A STUDY FILLED with Arts and Crafts ephemera. The papers on the desk are held down by Gustav Stickley's own leather-covered paperweight, his name impressed across its convex top, which he used on his desk in the Craftsman Building in New York City. On the walls in Roycroft frames are photographs of Stickley, Harvey Ellis, and Elbert Hubbard and two posters: an original and rare April 1908 *Craftsman* magazine poster and one from *The Arts and Crafts Movement in America 1876–1916*, the landmark 1972 Princeton exhibition undertaken by Robert Judson Clark. But the house itself predates Stickley by more than a century. ▪ David Cathers and his wife, Susan, live in a wood-frame farmhouse north of New York City, part of which dates to about 1797. Unlike a Craftsman house, it has a plain exterior of white clapboards and black shutters and stands aloof from its natural setting. The interior, remodeled in the late 1930s in what was then considered "early American," has been left largely intact. In this unlikely setting Stickley furniture is perfectly at home. ▪ The two-hundred-year-old dining room is surprisingly Craftsman-like in

An Unlikely Setting for Stickley

its plaster walls, dark-stained wood trim, and weight-bearing ceiling beams. The room's plainness and structural clarity, helped along with Stickley lanterns, are in complete harmony with its Craftsman furniture, including a large double-bay bookcase. In the living room, the vertical pine boards of the walls are echoed in the strong vertical lines of two Stickley spindle chairs. And while massive Arts and Crafts furniture might overwhelm the Federal-style master bedroom, its more delicate designs—a subtly curved nine-drawer Craftsman chest, a graceful Craftsman chair, and a rare music cabinet—fit in well. ▪ For this collector, inspired by the Princeton exhibition, the immediate appeal of Stickley furniture was that it seemed modern but was not made of modern materials: it had the admirable clean lines of a Mies van der Rohe chair, for instance, but not its impersonal steely surface. Stickley's brown quartersawn oak draws the eye but also makes a deeper, emotional connection that resists logical analysis.

Gustav Stickley's own leather-covered paperweight holds down some of his firm's surviving business correspondence (left). In the author's living room (opposite), the strong vertical geometry of a Stickley Morris chair and a spindle chair, made about 1905, fits comfortably with the whimsical geometry of a Frank Lloyd Wright textile from about 1955.

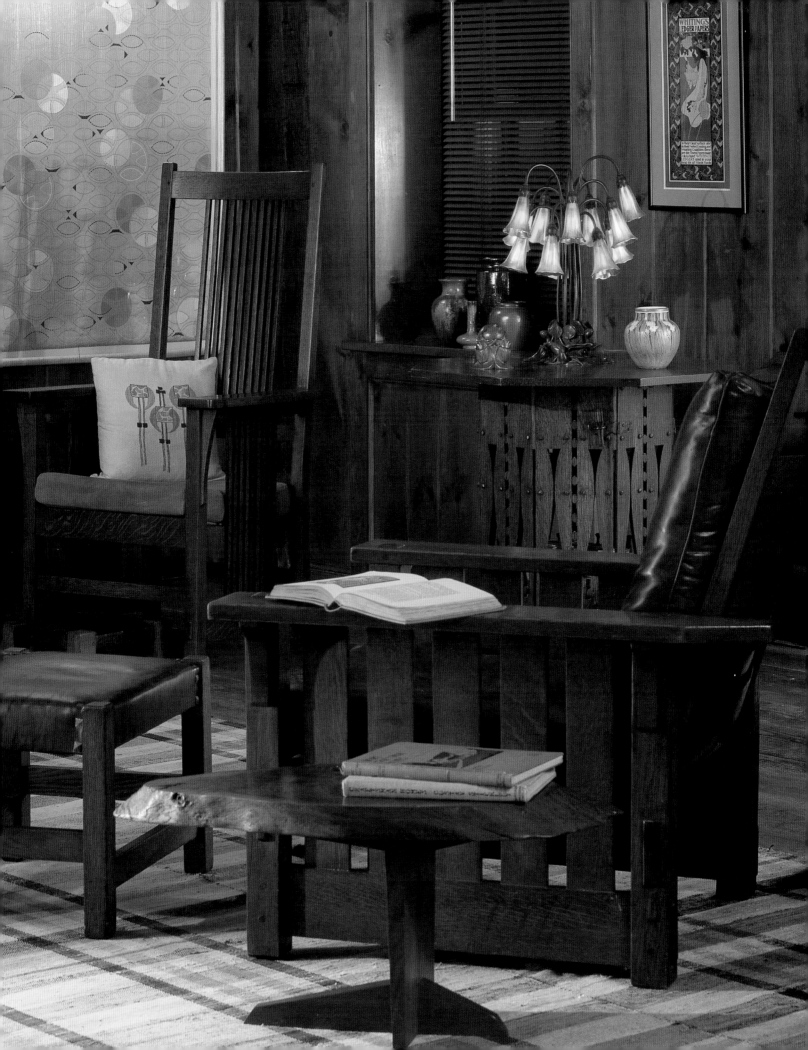

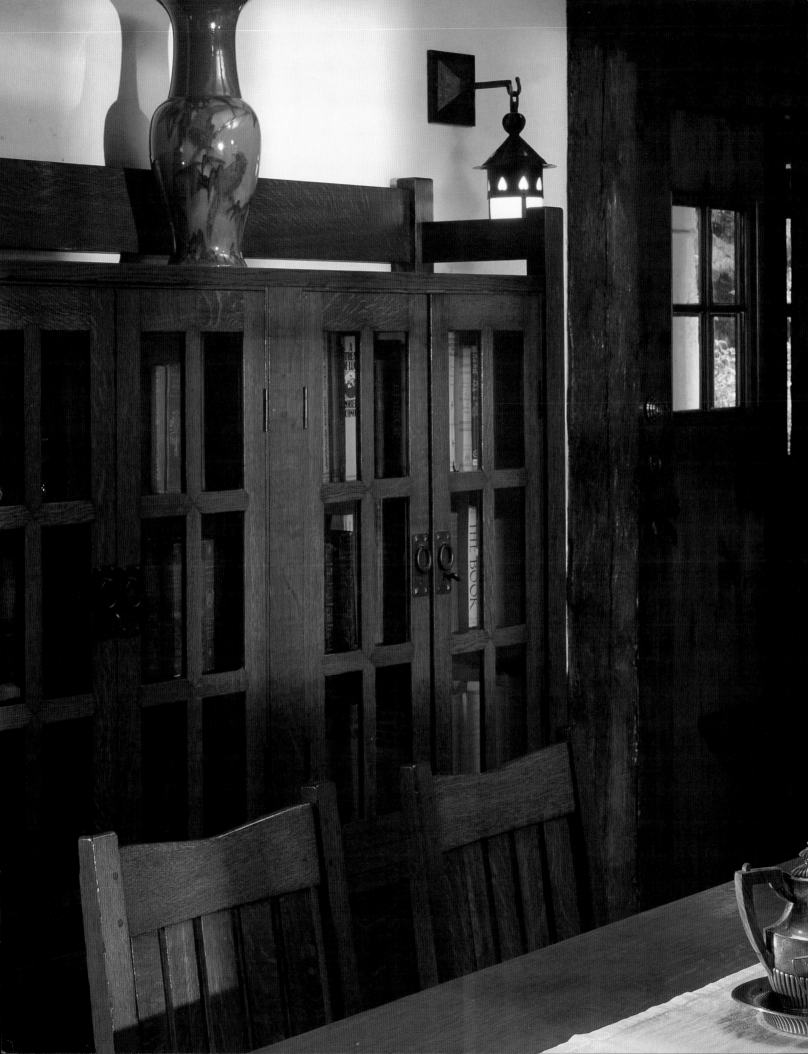

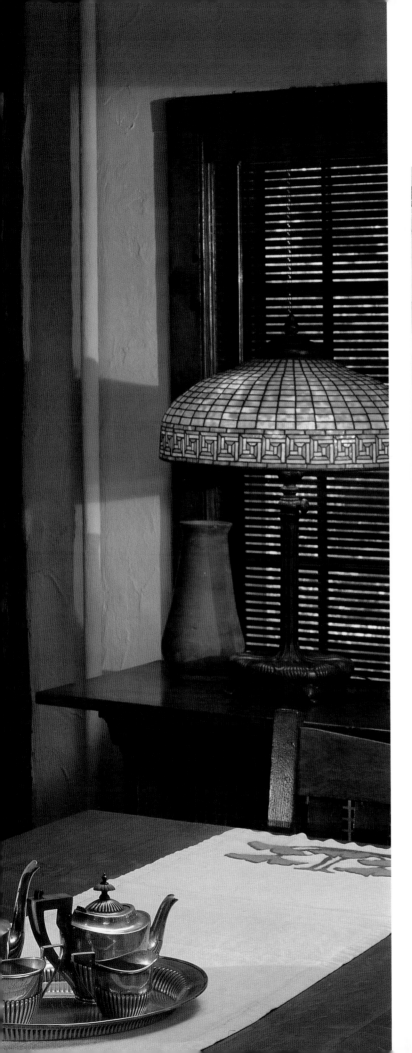

Typical of Stickley's 1902 designs, a big double-bay Craftsman bookcase (left) dominates one wall of the dining room. Each piece of the silver tea set is inscribed "Stickley 1896," possibly to commemorate the family's move to Syracuse. The plate rack (above) holds a plate marked with the joiner's compass from Stickley's Craftsman Restaurant, a plate from the Roycroft Inn, a Roycroft copper-and-pewter buttress vase, and Arts and Crafts pottery.

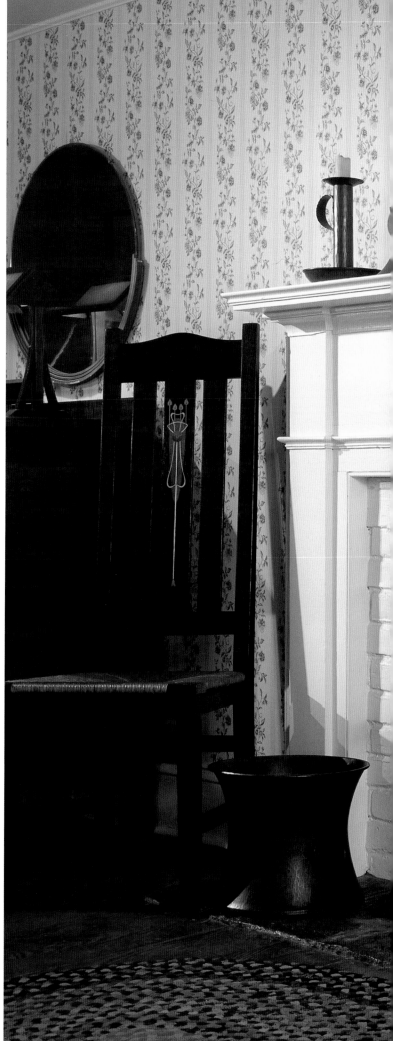

With its white-painted woodwork, Federal-period fireplace, and patterned wallpaper, the master bedroom is an unexpected setting for Stickley. In one corner (above), a nine-drawer Craftsman chest stands next to a Charles Rohlfs wastebasket. Roycroft seahorse andirons originally owned by Elbert Hubbard II enliven the hearth (right), flanked by a graceful Craftsman chair and a rare music cabinet designed by Harvey Ellis and inlaid with pewter and copper.

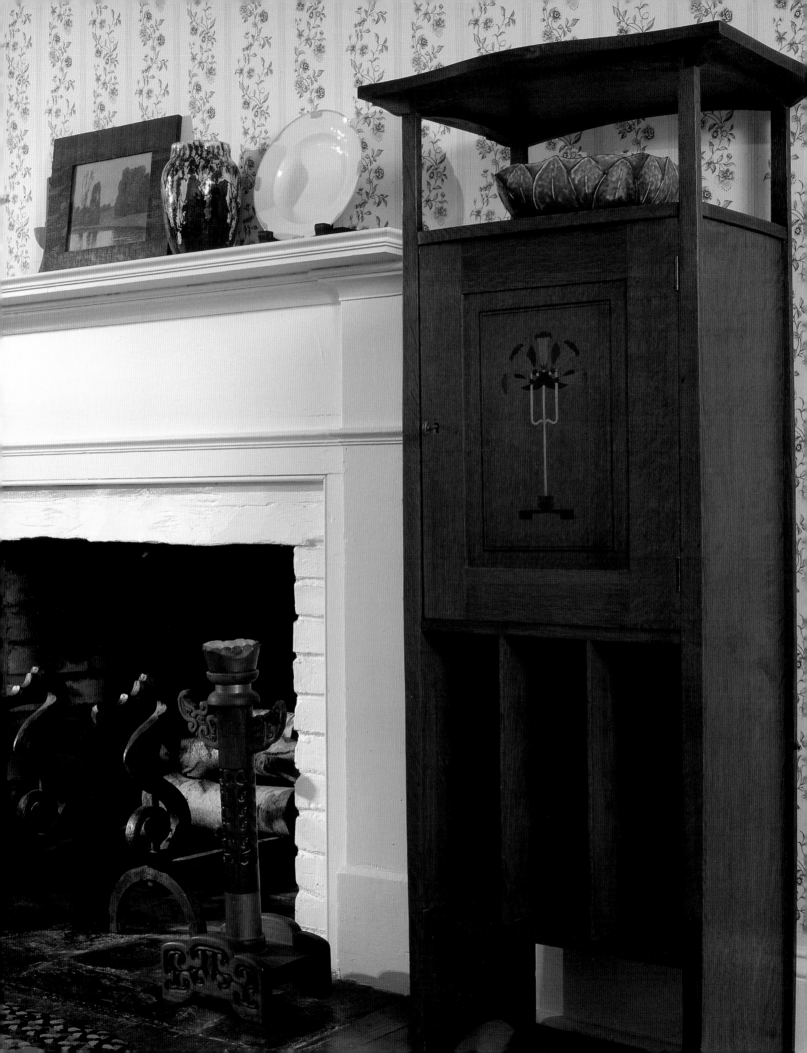

STICKLEY CLAIMED THAT HIS FIRM HAD ONLY ONE PARALLEL IN MODERN TIMES— that of William Morris in England. But just a few hundred miles away from him in East Aurora, New York, Elbert Hubbard, too, claimed the William Morris mantle. Hubbard's Roycroft, founded in 1895 to print his own writings and publish two monthly magazines, *The Philistine* and *Little Journeys,* quickly blossomed into a publishing and manufacturing firm, organized as a kind of crafts community with a campuslike setting. In addition to magazines and handsomely bound books, the Roycrofters produced simple furniture, metalwork, and modeled leather objects. ▪▪ Stickley and Hubbard shared more than an admiration for Morris: Stickley's Craftsman Workshops and Hubbard's Roycroft community also shared several designers. In 1902 Stickley hired away the Roycroft designer and metal artisan Jerome Connor, who became a Craftsman art director for about a year. Another gifted metalworker and illustrator, Victor Toothaker, worked for Stickley creating Craftsman metalwork and drawing Craftsman houses from about 1907 to 1910; he then moved to East Aurora and became a designer for the Roycroft copper shop. This artistic overlap may account for occasional similarities between Craftsman and Roycroft work. ▪▪ The Roycroft community eventually grew to have its own concert band, baseball team, savings bank, and at its peak perhaps as many as five hundred employees. One of these was George ScheideMantel, for three years the head of the Roycroft leather shop. He and his wife, Gladys, lived in a modest house—a two-story clapboard-and-shingle structure with a fieldstone foundation—that he designed in collaboration with a

SHARING WILLIAM MORRIS'S MANTLE

Comrades in Spirit, Rivals in Style

George ScheideMantel's workshop, complete with his tools, remains intact in the house (right). One of the few surviving examples of the Roycroft community's business is a specially made Roycroft filing cabinet (opposite), the concert band's bass drum perched on top.

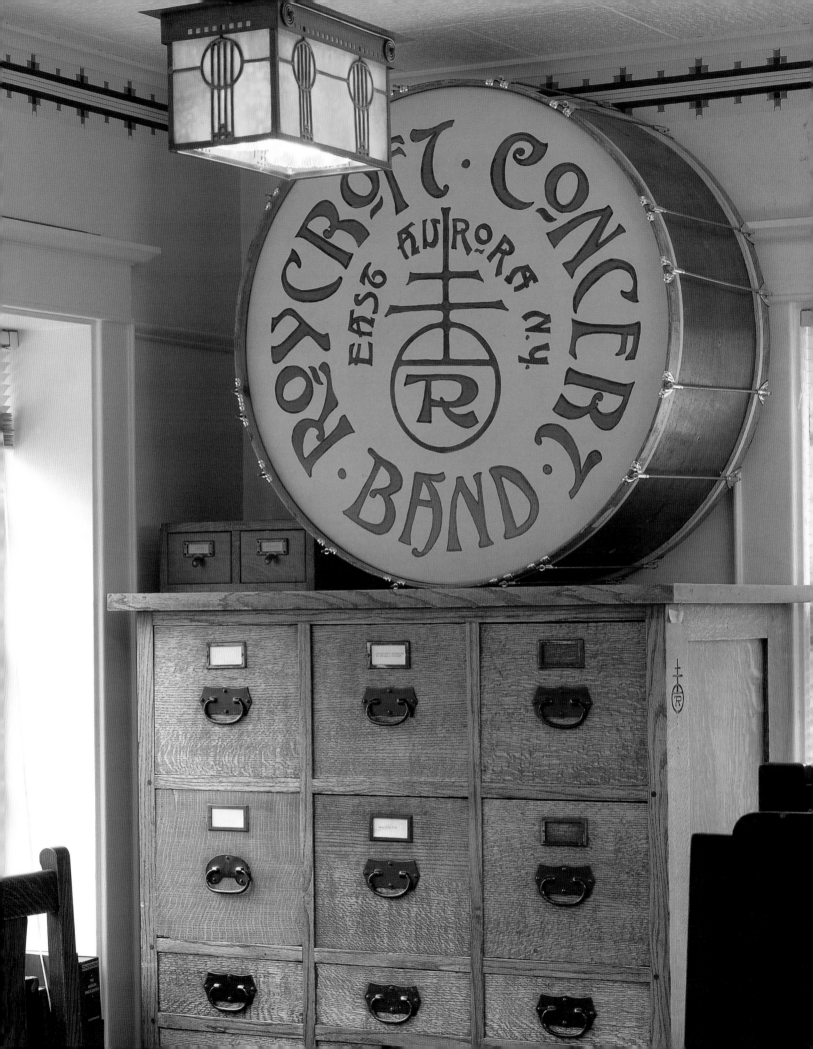

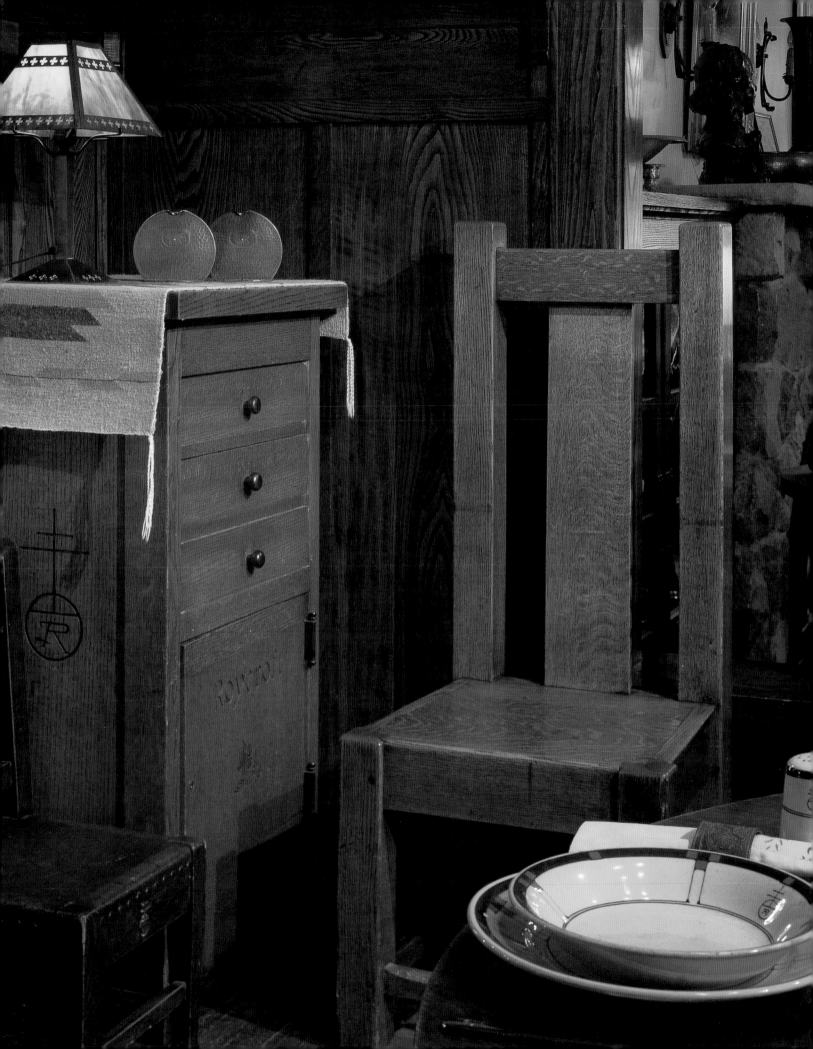

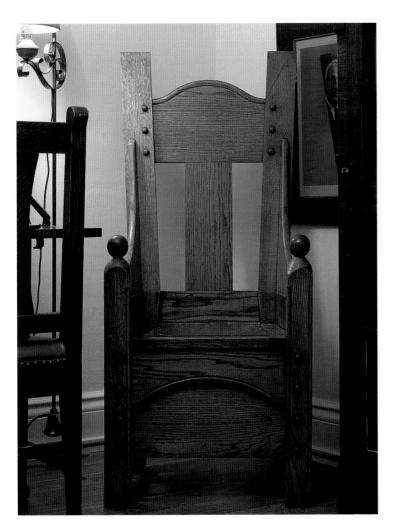

Roycroft architect, William Roth, and had built by Roycroft craftsmen. Like Stickley's Craftsman houses, it has a spacious front porch, a flat-roofed shed dormer, and wide overhanging eaves. The interior, too, shares some features of the Craftsman house. In the living room is a fieldstone fireplace flanked by built-in bookcases made of naturally finished chestnut. This room opens onto the dining room, which has chestnut wainscoting rising to a corbelled plate rail, a built-in chestnut sideboard with hand-wrought copper hardware, and floors of dark-stained oak. ▪▪ In 1985, at the age of 100, Gladys ScheideMantel gave this house to the Aurora Historical Society, which maintains it as a house museum. It is filled with rare Roycroft furniture, metalwork, modeled leather, and books and magazines. Preserved in the upstairs studio are George ScheideMantel's tools and patterns, along with examples of his superb leather-working skills; among the reference works still on his bookshelf is a handful of *Craftsman* magazines. In the dining room are the original Roycroft table and chairs bought by the ScheideMantels. ▪▪ East Aurora remains rich in Roycroft history, much of it rightly focused on the public achievements of Elbert Hubbard—an iconoclastic writer and public speaker who generated national publicity and money-making lectures that helped keep the Roycroft community afloat. Here in the ScheideMantel House it is still possible to find traces of day-to-day life the way it was once lived at the Roycroft.

Two Roycroft rarities (opposite): the dining room's silver cabinet and monumental hall chair, akin to Stickley's Eastwood chair in its plain, pure form. An unusual armchair (above left) is attributed to Elbert Hubbard II, who for several years was the head of the Roycroft furniture shop. In the entrance stand a dark-stained dressing table and chair (above right).

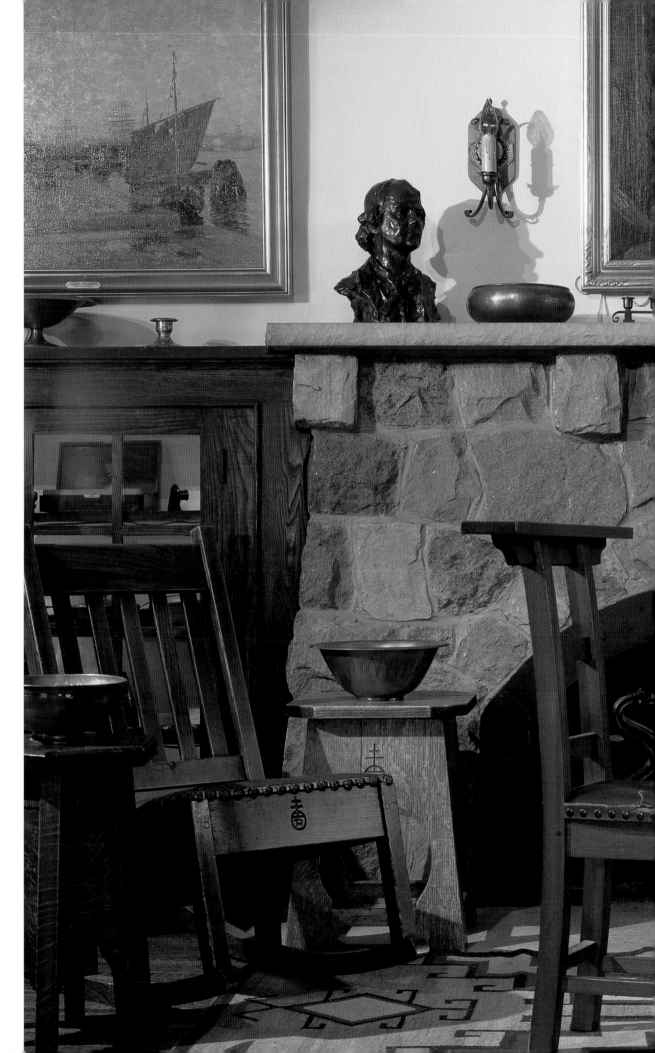

In the ScheideMantels'
living room, a portrait
of the Roycroft artist
Alexis Fournier hangs
above the split-stone
fireplace, two of his oil
paintings arrayed on
either side. In the center
of the room is a straddle
chair, a slightly eccen-
tric Roycroft design
that allows a person to
straddle it facing back-
wards, arms resting on
the flat surface of the
crest rail. After the
death of Elbert Hubbard
and his wife, Alice,
during the sinking of
the *Lusitania* in 1915, his
son Elbert II took charge
of the Roycroft, keeping
it running through the
Depression and up to
the eve of World War II.

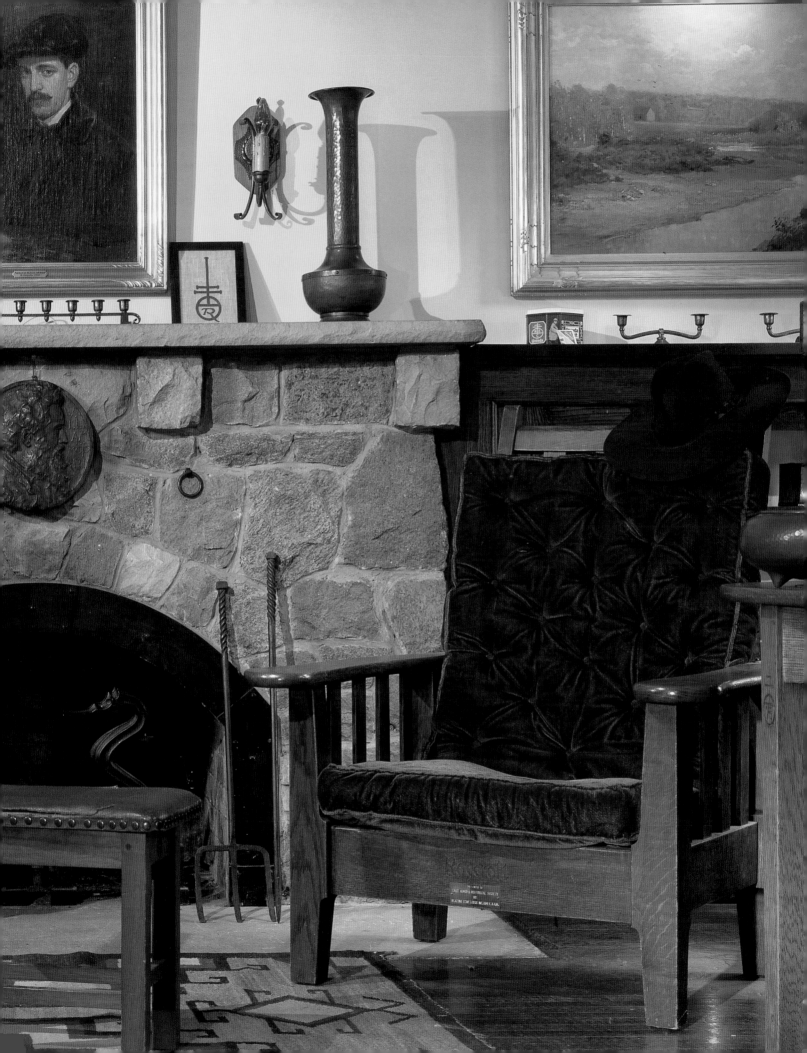

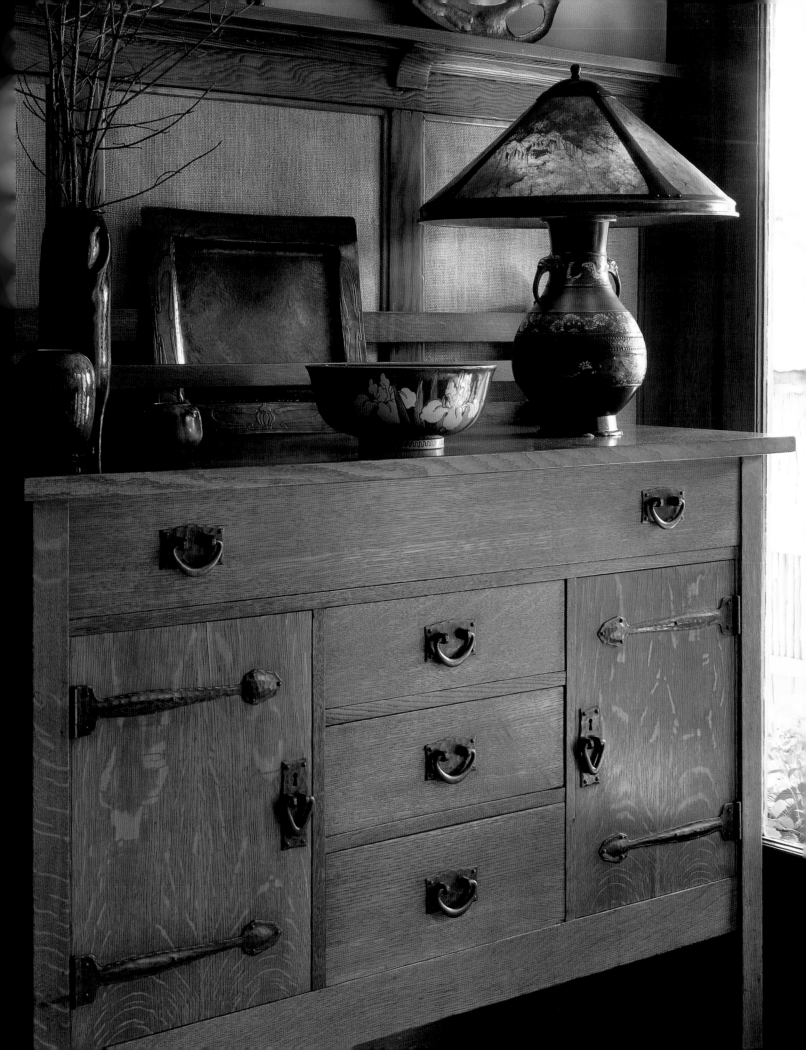

CALIFORNIA, TODAY AS WELL AS A CENTURY AGO, EXUDES A SPECIAL CREATIVE SPIRIT. "Painters were drawn by the light, ceramists by the soil, and the warming sun cast its rays on everyone," writes Scott Goldstein, West Coast editor of the Arts and Crafts journal *Style 1900*. In this "beguiling climate," he adds, "the California Arts and Crafts movement was born.... [creating] a fresh approach to decorative design and new indigenous architectures." ▪▪ During a visit to California in March 1904, Stickley admired its many new Arts and Crafts houses and visited crafts workers inspired by the movement's ideals. In an interview with a San Francisco newspaper, he spoke of starting a crafts community: "Here in California," he observed, "you have the ideal conditions for such a community. . . . the climate, the pure air, the scenery, the fruitfulness of the soil, the conditions which render outdoor life easy." Within a few years *The Craftsman* magazine was regularly publishing articles praising what it called the West Coast's "rustic free-hand architecture," a building type similar to the Craftsman house. ▪▪ The 1912 California bungalow owned by Goldstein and his wife, Lauren Gabor, is the kind of house *The Craftsman* magazine admired most. It has low-pitched roofs and wide eaves above stucco walls, grouped windows, and a deep, shaded front porch that leads to a leaded-glass front door. Inside, naturally finished woodwork gleams, and original built-in furniture remains in place. At the back of the house, doors lead outside to a terrace and a lush garden with Arts and Crafts–style garden structures. ▪▪ The uniquely Californian vitality that so appealed to Stickley is apparent in the furnishings:

In the Land of "Free-Hand Architecture"

In the breakfast room (opposite), a Stickley oak sideboard with hammered-copper hinges is set against a wall of fir and redwood with burlap panels. The bronze-and-cloisonné lamp was made in San Francisco about 1915 by Lillian Palmer. On the den mantel (left) is an L. & J. G. Stickley clock by Peter Hansen flanked by Dirk van Erp copper pots. The stained-glass-and-copper light fixtures were designed by Scott Goldstein in the style of Greene and Greene.

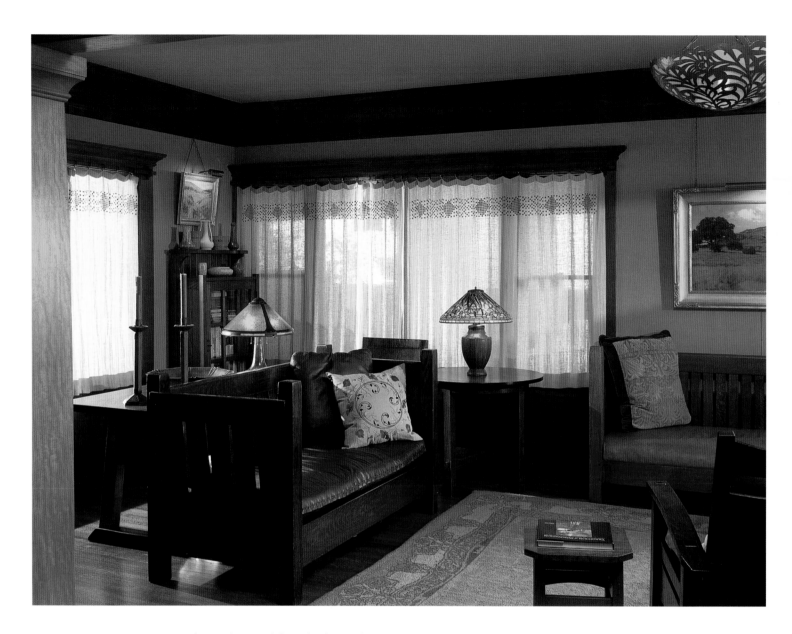

Behind the settle in the living room (above) is a small director's table, both Stickley. The entry (opposite) has Greene and Greene's oak-and-redwood cabinet, Batchelder lamp bases, and a van Erp copper pot.

a cabinet designed for Charles and Henry Greene's 1907 Blacker House in Pasadena; gleaming Dirk van Erp copper pots from northern California; ceramic tiles by the Pasadena teacher and tilemaker Ernest Batchelder; and rare ceramics, made in California of local clays, from the Alberhill, Arequipa, Grand Feu, Rhead, and Valentein Potteries. This collection, however, is not merely an assemblage of beautiful Arts and Crafts objects; it is part of a wholly unified interior. "The collection," says Goldstein, "has to serve the house. Everything works together. We are inspired by architects—like Greene and Greene and Frank Lloyd Wright—who designed not just houses but complete interiors as well." Everything here represents the creative California spirit that stirred Stickley so long ago as he traveled, enchanted, through the Golden State.

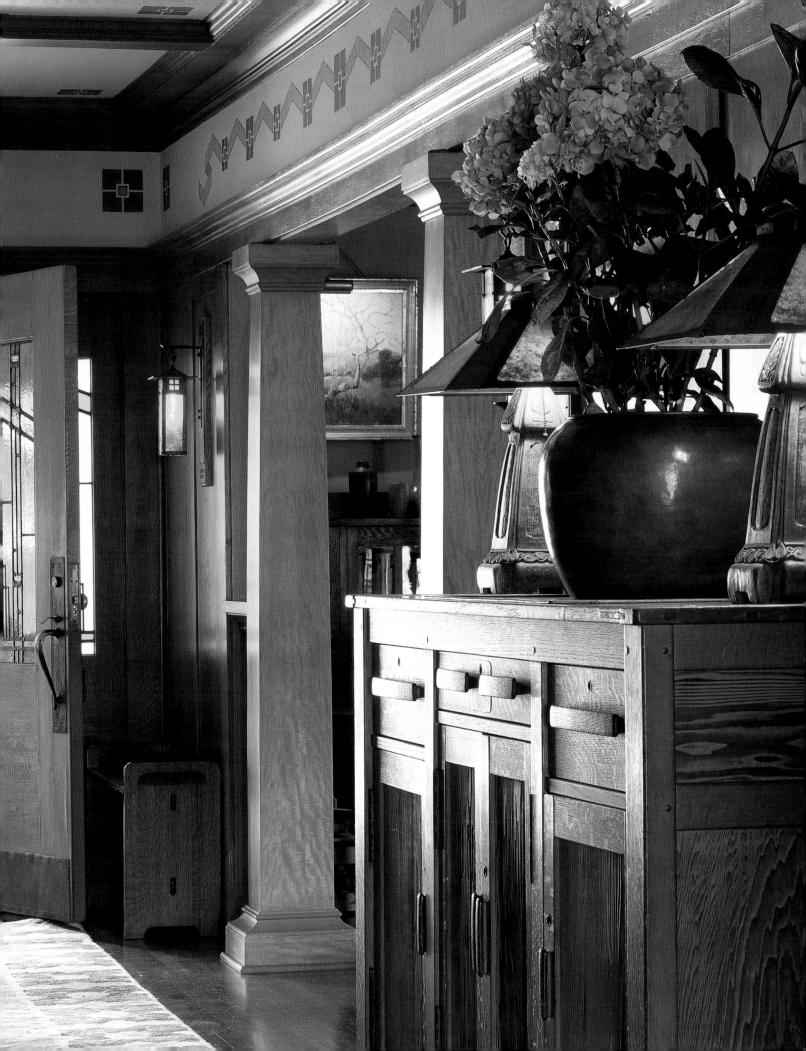

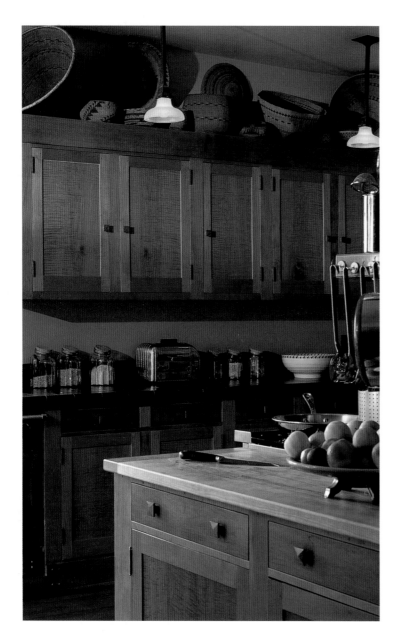

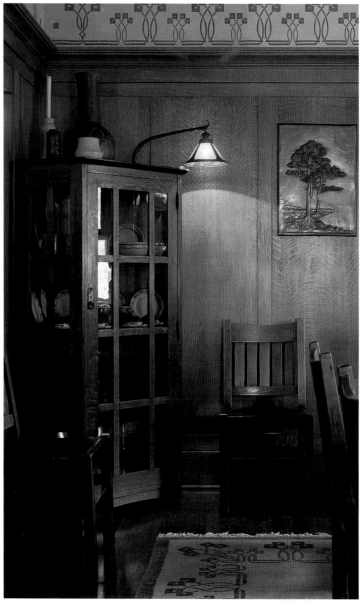

Baskets made by California Indians decorate the Arts and Crafts–style kitchen cabinets (above left). The paneling in the dining room (above right and opposite) is of quartersawn oak, as is the L. & J. G. Stickley corner cabinet. Scott Goldstein and Lauren Gabor designed the dining room table, which has a set of V-back Craftsman chairs around it, as well as the frieze pattern and matching rug, based on a Stickley design. The den (pages 146–47), with its scenic Batchelder tiles, Indian baskets, van Erp copper pots, and stained-glass windows depicting old missions, is pure California.

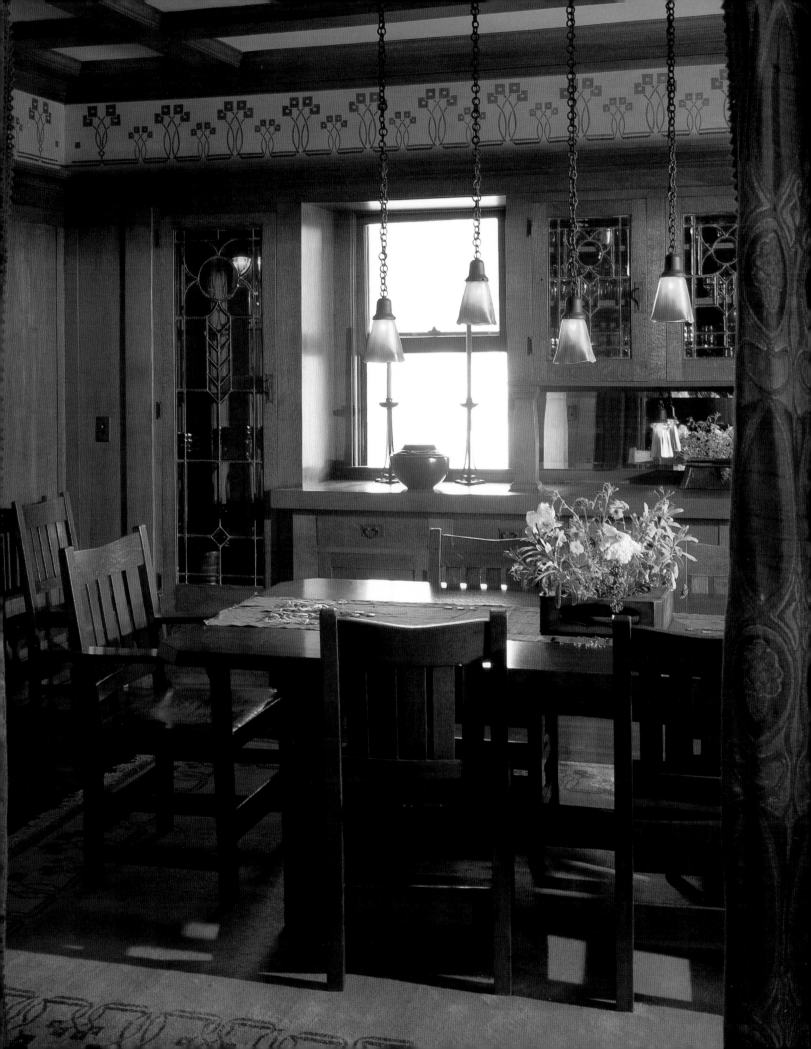

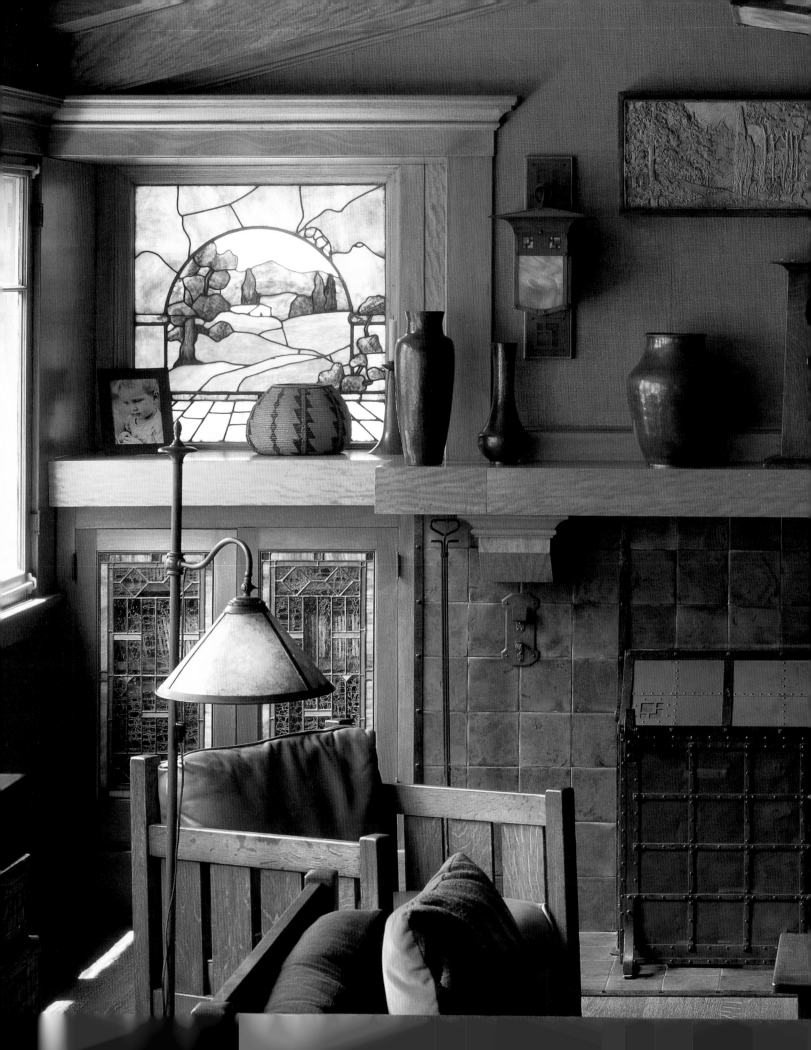

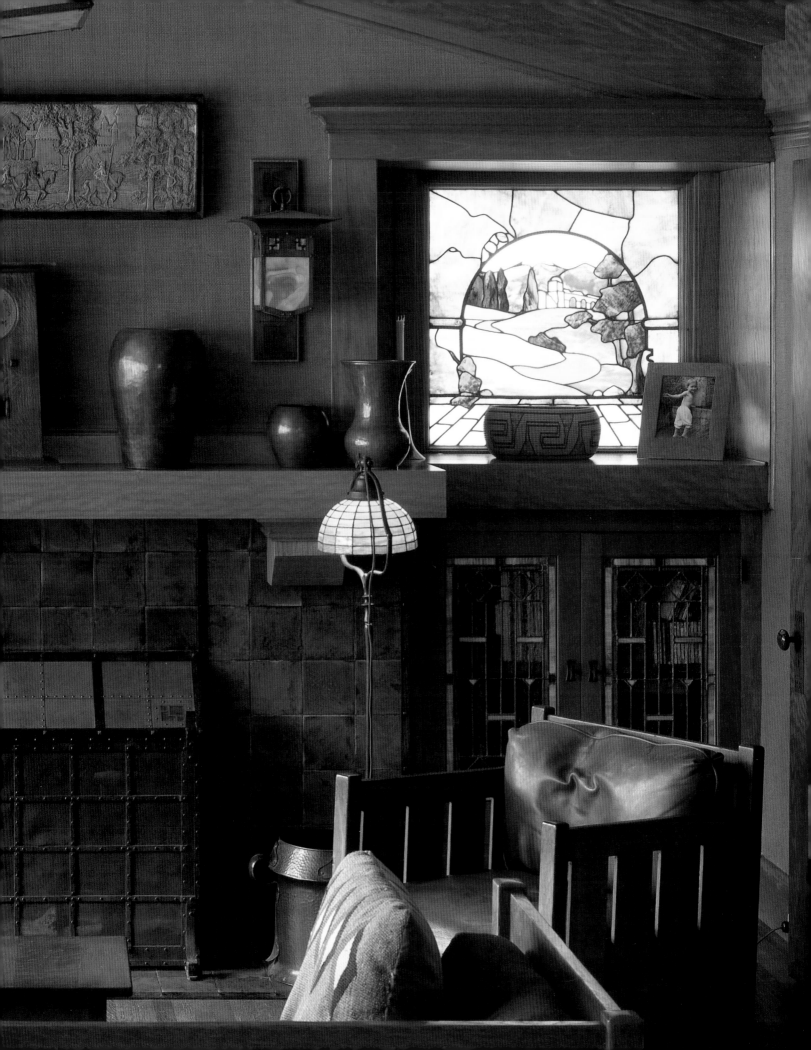

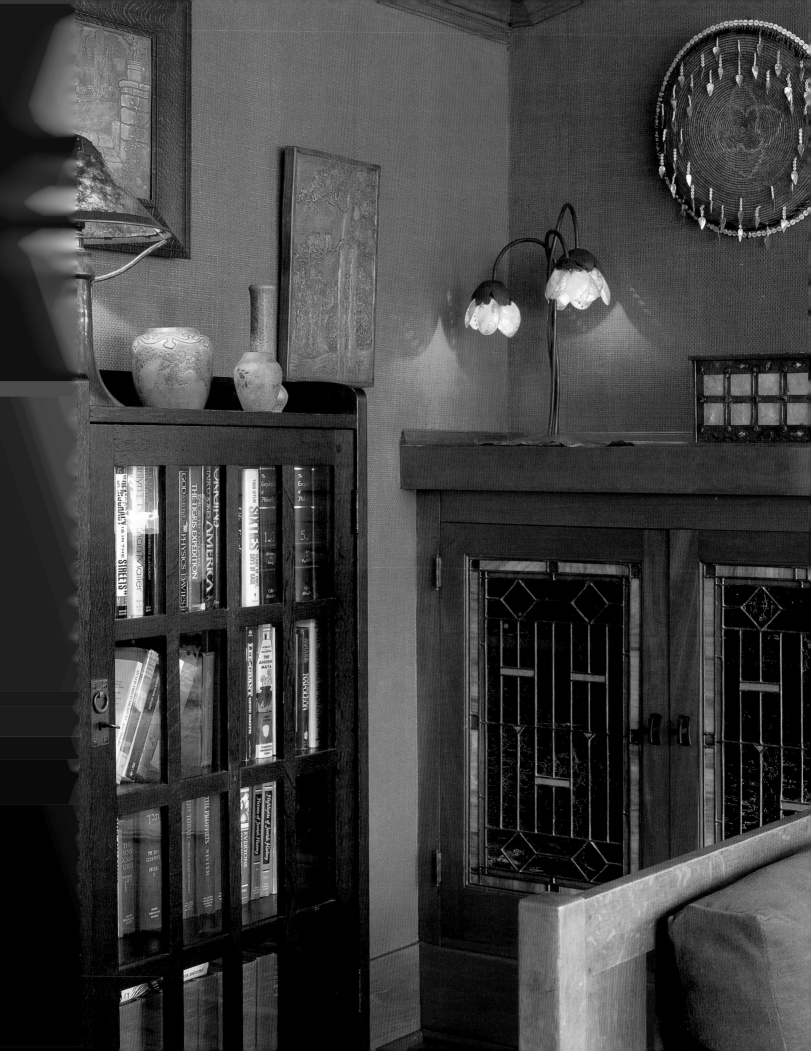

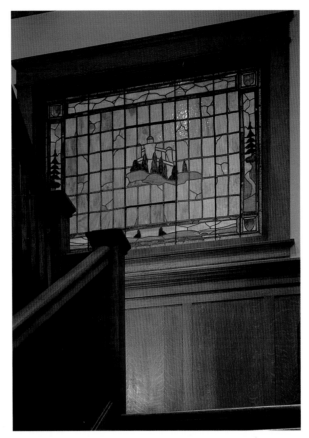

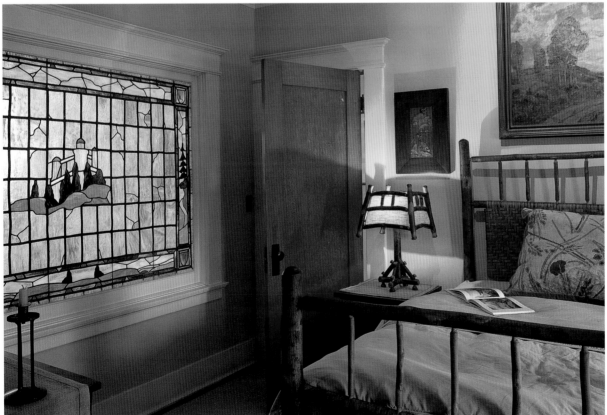

Burlap-covered walls (opposite) provide the perfect backdrop for both freestanding and built-in furniture and California-made decorative objects of clay, copper, and abalone. A Voysey portiere (top left) hangs in the doorway between the master bedroom and sitting room, furnished with a Stickley willow settle and armchair. At the top of the stairs (top right), a stained-glass panel original to the house achieves what *The Craftsman* called "a light effect as rich and subtle as that seen in some of the old cathedrals." The double bed and table lamp in the guest bedroom (bottom) were made by the Old Hickory Company. Its furniture, particularly popular during the Arts and Crafts era, is in keeping with the rustic streak evident in Stickley's log house at Craftsman Farms.

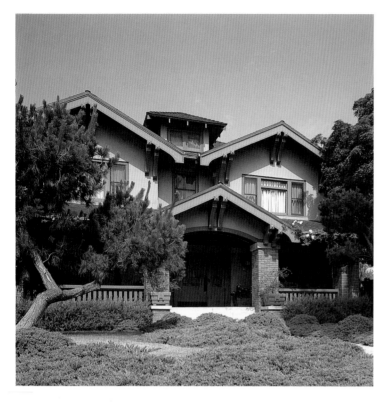

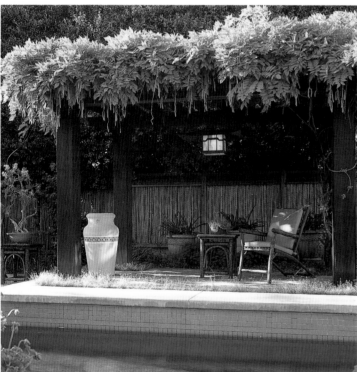

Scott Goldstein and Lauren Gabor's bungalow (top left)—with its bracketed gable ends, enclosing front porch, leaded-glass front door and sidelights, and earth-toned walls and trim—is classic California. The restful garden is graced by a fountain (top right), which incorporates tiles based on designs by Ernest Batchelder; other Arts and Crafts–style garden structures (bottom left and right); and a profusion of golden California poppies and other native flowering plants (opposite).

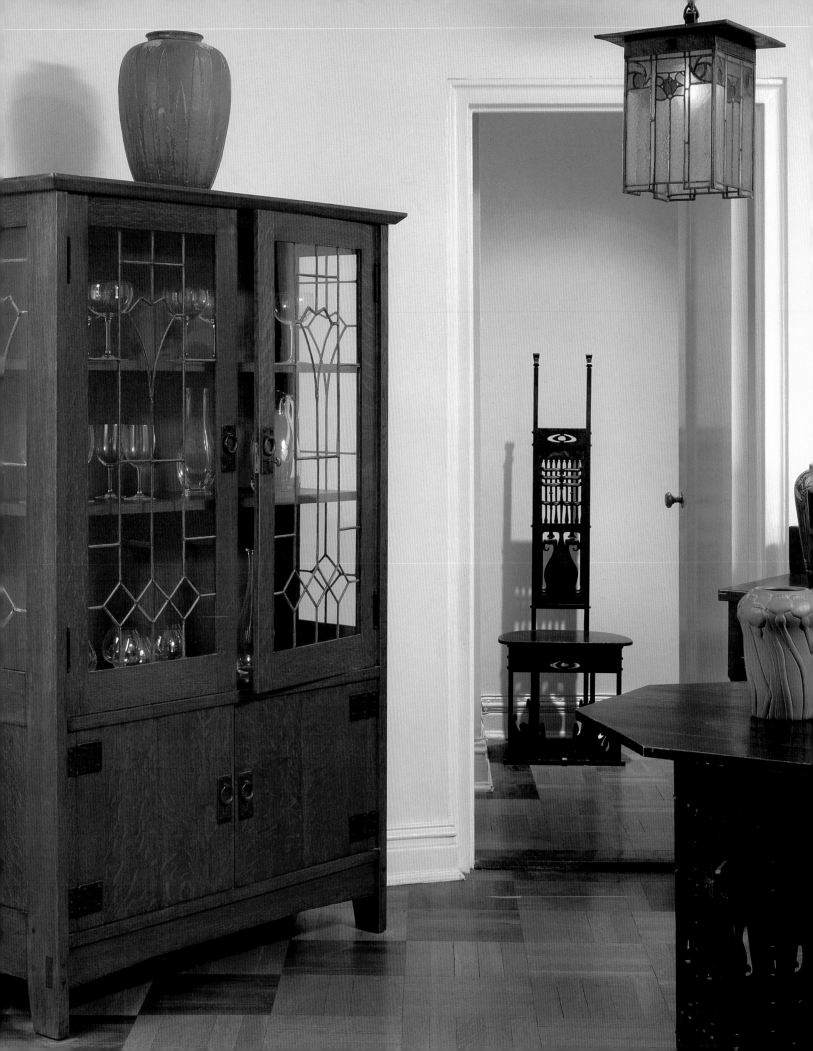

STICKLEY ADMIRED THE NORTH AMERICAN INDIANS: THEY LIVED SIMPLY, IN HARMONY with nature, and crafted beautiful, well-made objects from local natural materials, decorating them with stylized designs based on natural forms. Their traditional way of life, even then rapidly disappearing, seemed far removed from machine-driven American mercantilism, and Stickley saw them—from an Arts and Crafts perspective—as true artisans. ▪▪ A 1910 article in *The Craftsman* called Indian craft work the country's only real handicraft. It also pointed out how well Indian blankets harmonized with the plain shapes and natural wood tones of Craftsman furniture, because "they are simply another expression of the same idea . . . and are absolutely in keeping with the whole decorative scheme of [a Craftsman] house." ▪▪ The Indian blankets that appealed to Stickley were those made in the early twentieth century. Elbert Hubbard used them

throughout the Roycroft Inn in East Aurora, New York, and contemporary Stickley collections often include one or two. The examples in this private Manhattan collection, however, are rare Navajo wearing blankets of the mid-nineteenth century. Created between about 1840 and 1875, these

Craftsmen of a Different Stripe

geometric-patterned and striped blankets predate the American Arts and Crafts movement by several decades; they reflect a higher level of craft than the later blankets but a similar compatibility with Arts and Crafts design. ▪▪ Fascination with Native American culture is further evident in this collector's photographs—original prints in their original frames—by Edward Curtis, who in 1904 set out to make a lasting photographic record of traditional Indian life. Two years later *The Craftsman* published an article about this vast, ambitious project, praising Curtis

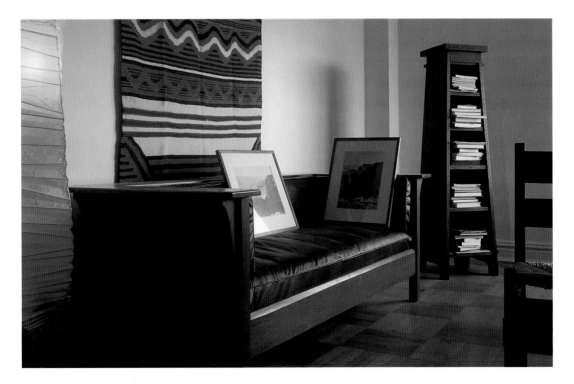

In the entry (opposite), a Craftsman lantern illuminates a 1902 Craftsman cabinet by LaMont Warner and an octagonal table and hall chair by Charles Rohlfs. An L. & J. G. Stickley Prairie settle in the study (left) draws together the Navajo blanket and Roycroft magazine pedestal.

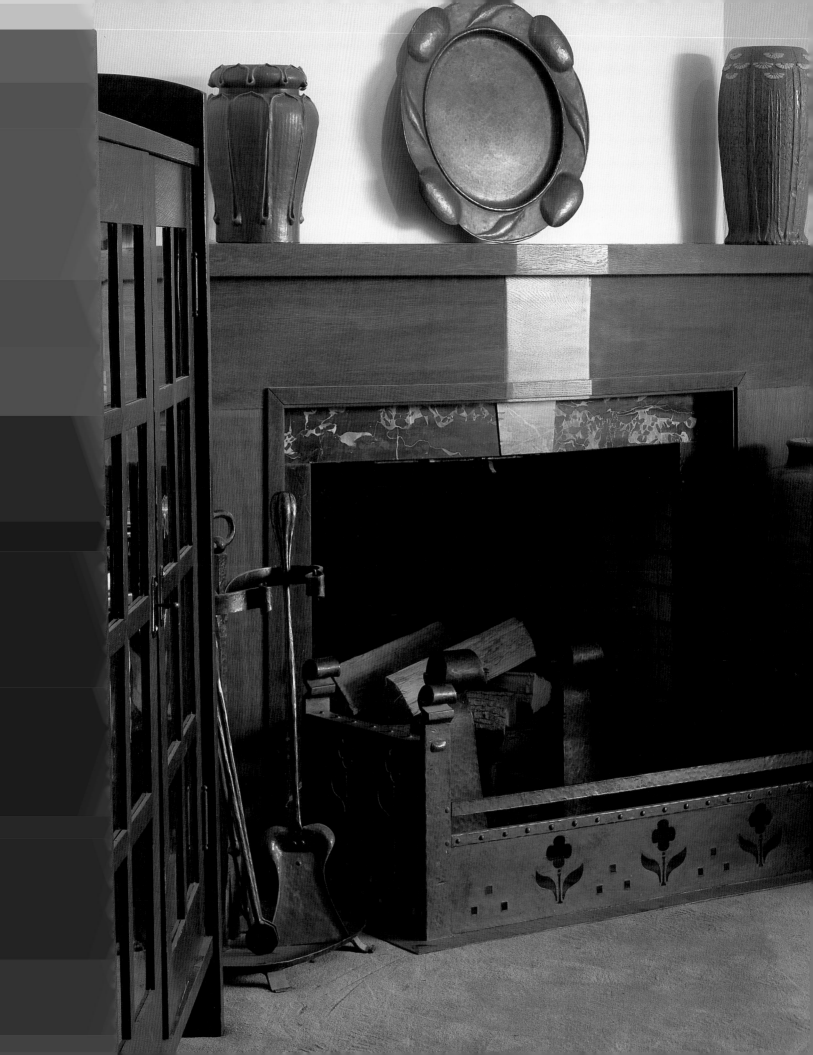

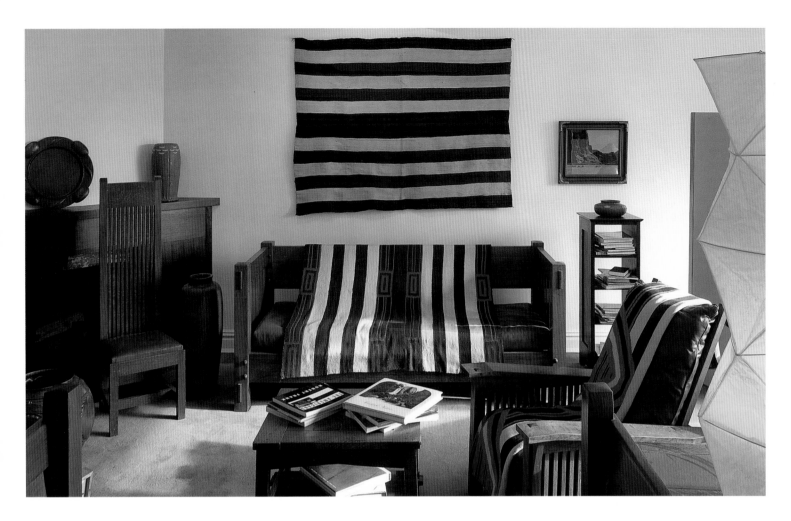

for his sympathetic, compelling photographs that depicted Indian legends, customs, and history, calling him "a craftsman ... a historian, a scientist, an artist." :: In this collection, native arti-facts are complemented by late-nineteenth- and early-twentieth-century American prints and photographs, furniture, metalware, and ceramics. Epic large-format photographs by Carlton Watkins, the great nineteenth-century landscape photographer, depict Yosemite in dramatic views. These grand vistas contrast with small, subtle, exquisitely colored woodblock prints of the Massachusetts landscape by one of the seminal figures of the American Arts and Crafts, Arthur Wesley Dow. Most of the furniture and metalwork are early Craftsman pieces, but there are also important examples by L. & J. G. Stickley, Roycroft, Charles Rohlfs, Greene and Greene, and Frank Lloyd Wright. Hand-thrown pots with bulbous, paper-thin clay bodies—dimpled, dented, pinched, folded, and vividly glazed—are the work of the eccentric, virtuoso Mississippi potter of the early twentieth century, George Ohr. :: "I was naturally drawn to Navajo blankets," says this collector, who began acquiring examples about twenty years ago. At the same time he was developing a taste for twentieth-century design. Seeing a photograph of a Craftsman sideboard in the *New York Times* got him started collecting Arts and Crafts furniture and decorative objects. Not until his collection was largely in place did he discover, in the pages of *The Craftsman,* that Gustav Stickley shared his admiration for Native American handicraft.

The living room hearth (opposite) is equipped with a fire set, andirons, and a hammered-iron fireplace fender deco-rated with cutouts—all Craftsman. Pristine Stickley pieces in the living room (above) include a knock-down settle, a drop-arm spindle Morris chair, and a table inset with twelve Grueby tiles.

155

A STICKLEY RARITY, UNITED AT LAST

ABOUT TWENTY YEARS AGO THE NEWLY MARRIED TED LYTWYN AND CARA CORBO set out to furnish a house. They decided to buy old furniture because it was affordable and sturdy, they liked the way it looked, and, besides, antiques auctions were so much fun. At one country auction they saw some Mission oak furniture and fell in love with it. From that moment they were no longer just a young couple decorating a home—they had become Arts and Crafts furniture collectors. Today Ted is the vice president of the Craftsman Farms Foundation, which manages Stickley's New Jersey home, and Cara is one of the foundation's legal advisers. ▪▪ Their house in suburban New Jersey is filled with Stickley and Roycroft furniture. Perhaps their rarest piece is a Stickley sideboard with open shelving on top, which they bought in two parts. They found the shelving in one dealer's shop and decided to buy it, even though they were not sure how they would use half a piece of furniture. After a few years of determined looking, they came across the

One True Passion

bottom part in another shop. The reuniting of the top and bottom halves of this sideboard, made about 1902, is a story of perseverance and amazing luck against very long odds: the sideboard is the only example of this Stickley design known to exist today. ▪▪ Cara and Ted are also avid collectors of Stickley and Roycroft metalwork and American art pottery. Their collection of rare ceramics focuses mostly on unorthodox, small-scale studio potters such as Theophilus Brouwer and William J. Walley. Walley was the archetypal, uncompromising Arts and Crafts potter who did everything by hand: he insisted that "there is more true art in a brick made and burnt by one man than there is in the best piece of molded pottery ever made." Walley was a truly passionate potter, just as Ted Lytwyn and Cara Corbo are truly passionate collectors. "Stake out your turf," Ted advises new collectors, "and go for it!"

Stickley furniture—settles, chairs, and a 1901 bookcase—surround a Roycroft bride's chest in the living room (right). The owners' two-part sideboard (opposite), now a perfect whole, is based on Stickley's eight-legged sideboards. The shelves, filled with Pewabic pottery by Mary Chase Perry and rare ceramics by Theophilus Brouwer and William Walley, exemplify Stickley's ideal of decorative construction in their exposed tenon ends.

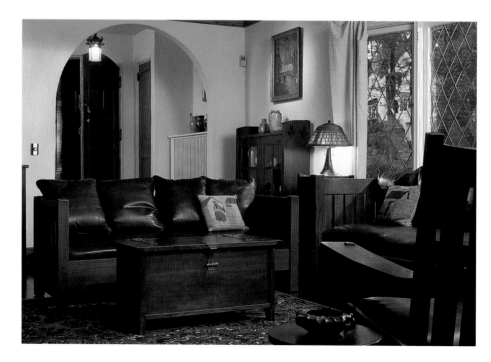

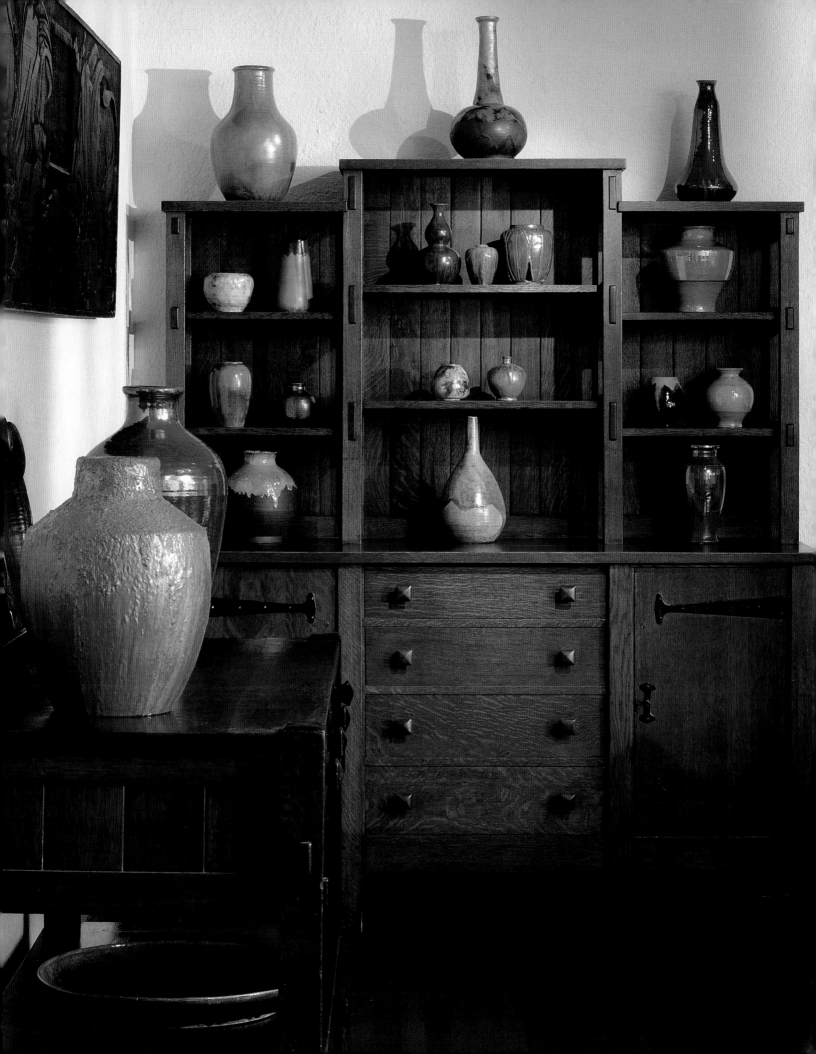

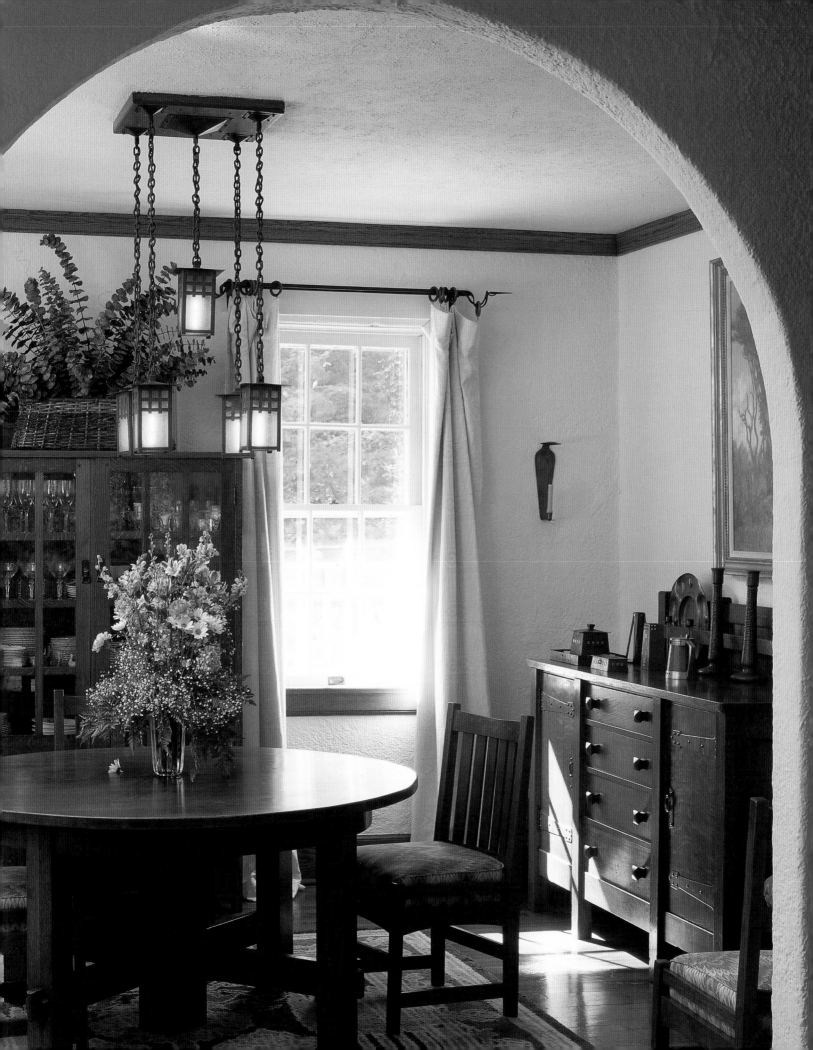

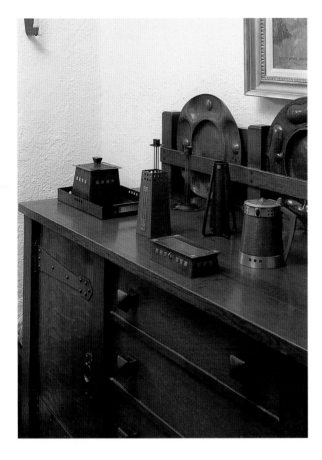

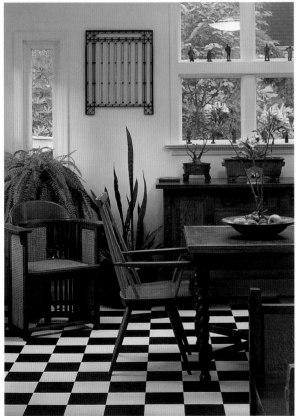

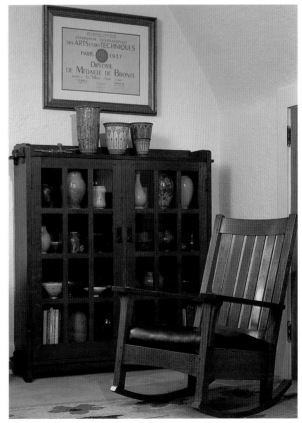

The dining room (opposite) is furnished with a Stickley table, a Stickley eight-legged sideboard, Craftsman lanterns hanging from their original ceiling plate, and an L. & J. G. Stickley china cabinet. On the sideboard (top left) is metalwork designed by the master Roycroft artisan Karl Kipp. An early Roycroft bookcase of oak, glass, and iron (top right) has the talismanic Roycroft name boldly incised above the door and two Roycroft orb-and-cross symbols cut into the face of the bottom drawer. A Mission oak-and-wicker barrel chair (bottom left) finds use in the kitchen. The L. & J. G. Stickley bookcase in the upstairs study (bottom right) is filled with Leon Volkmar's vibrant art pottery. The pots on top were displayed at a 1937 Paris exhibition, for which Volkmar was awarded the bronze medal and this diploma.

A MARRIAGE OF PRACTICAL COMFORT AND ART

Meeting of the Minds

SEVERAL YEARS AGO ANN AND ANDRÉ CHAVES BECAME THE NEW OWNERS OF THE Duncan-Irwin House in Pasadena, one of the architectural masterpieces of the Arts and Crafts movement, and filled it with Arts and Crafts objects. They instinctively saw that the interior woodwork's refined structural detailing and subtle lines were in complete sympathy with the more rigid geometric forms of their Stickley and Roycroft furniture. But when they examined photographs of the original interior, then in the possession of Theodore Irwin's granddaughter, they were astonished: they owned several Stickley pieces identical to his and had placed them exactly as he had. The Irwin dining room, for instance, had an eight-legged Craftsman sideboard and a Craftsman serving table just like the ones that grace the room today. ▪▪ The house's history reflects the cross-pollination of ideas that led to the flowering of the American Arts and Crafts movement. In 1906 the California architects Charles and Henry Greene completed an extensive reworking of a Pasadena house bought by their client Theodore Irwin from the original owner, Katherine Duncan. The remodeled structure was in perfect accord with the ideas that shaped the Craftsman house. Shaded porches, wide balconies, and a pergola-covered terrace created tranquil outdoor rooms. Interior spaces flowed freely, enriched with textured plaster walls contrasting with smooth hand-shaped woodwork, and were filled with Craftsman and Craftsman-like furniture. ▪▪ Charles Greene had visited the 1901 Pan-American Exposition in Buffalo, New York, and had seen its exhibit of Stickley furniture. Returning home, he began reading the newly launched *Craftsman* magazine, whose design philosophy echoed his own evolving architectural ideas. Stickley, for his part, admired the Duncan-Irwin

Mossy stone combined with burnt brick, redwood shingles, and massive timbers (right) all link this Greene and Greene landmark to Craftsman design principles. Natural colors and textures in the paving tiles, walls, and siding (opposite) anchor the house to its site.

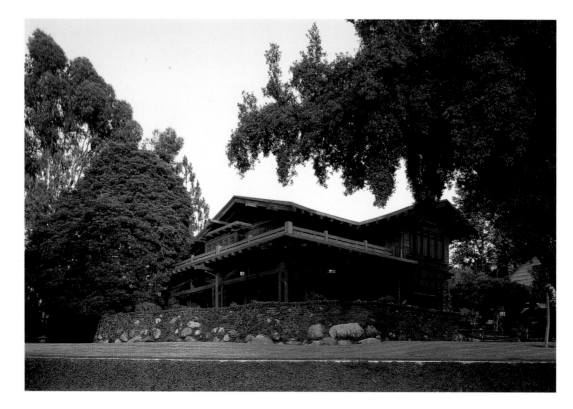

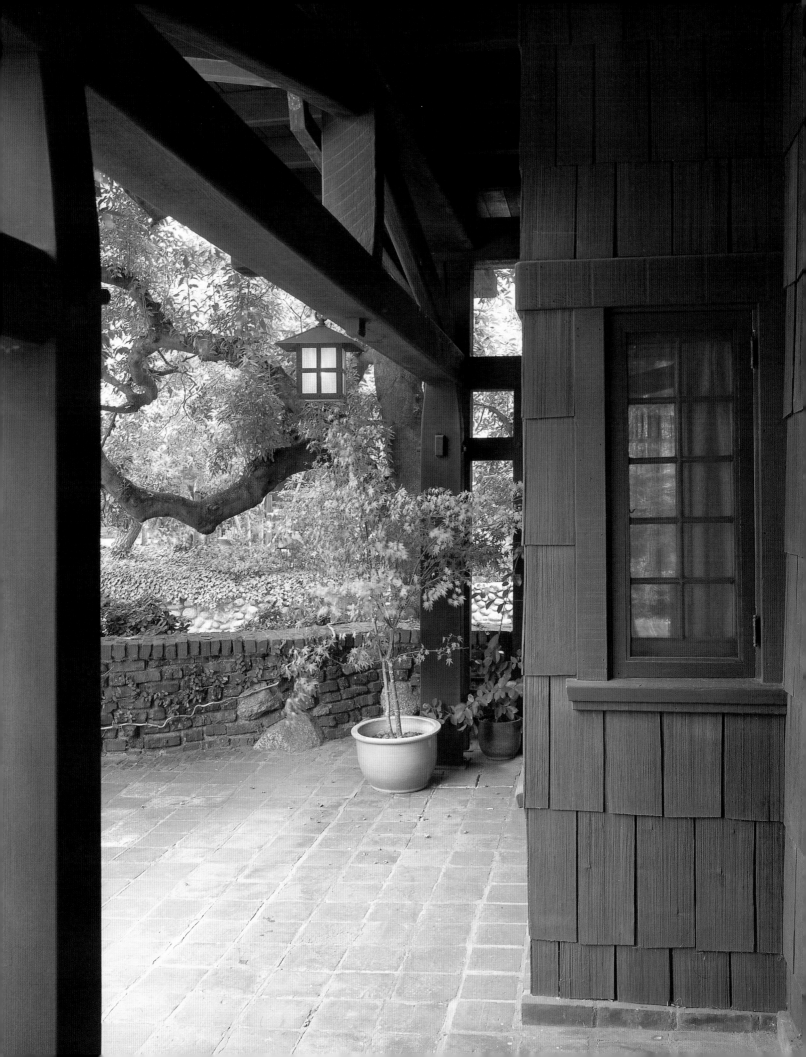

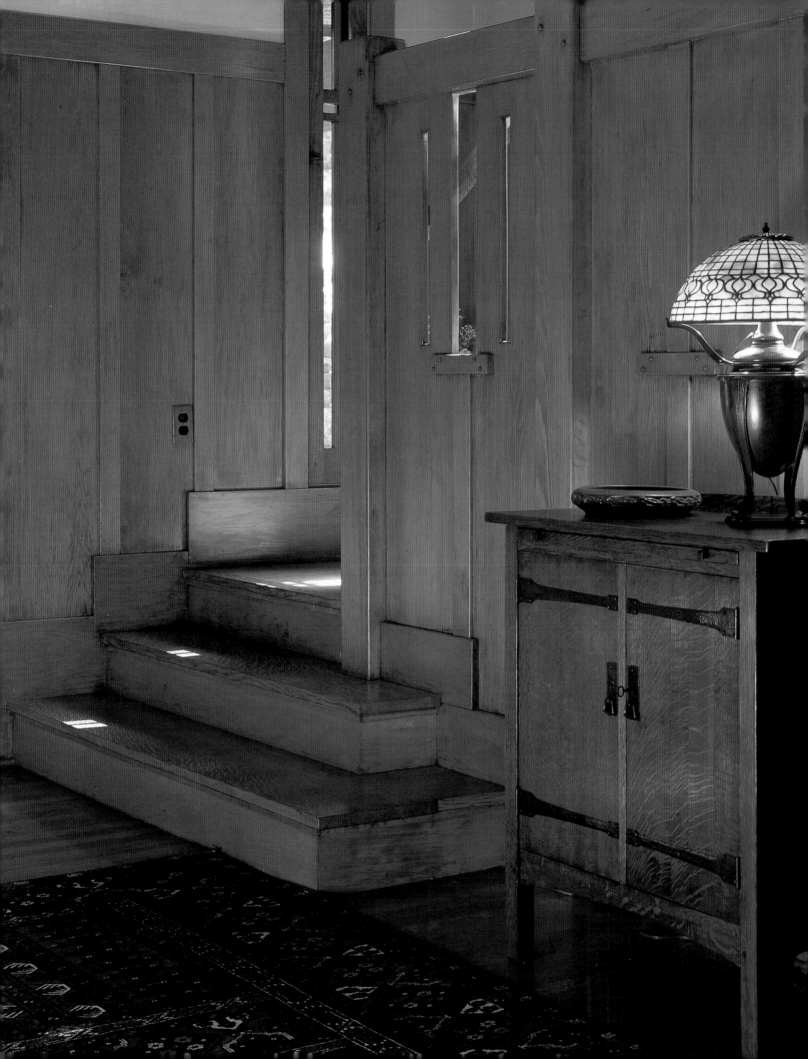

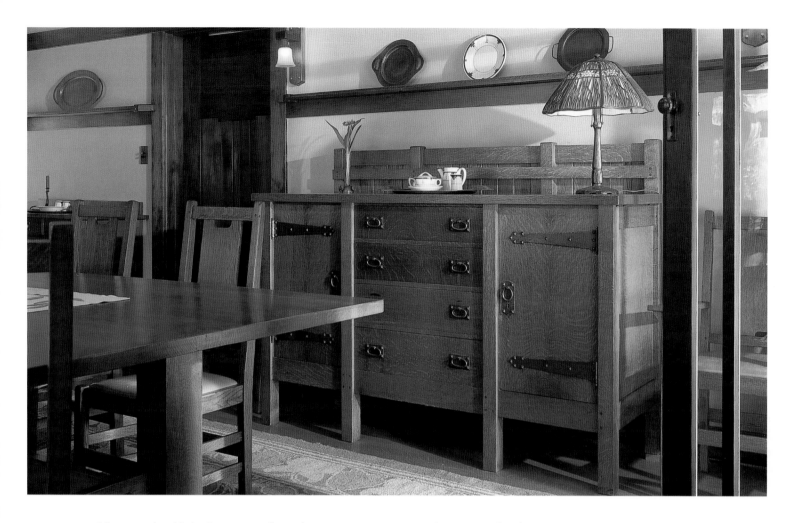

House and published pictures of it in his magazine, praising the Greenes for designing homes "in which practical comfort and art are skillfully wedded." At least three house designs published later in *The Craftsman* were inspired by Greene and Greene. However, while Stickley preached a sturdy and democratic architecture that he hoped to see scattered across the American landscape, the Greenes for the most part produced refined, artful masterworks for a few well-off California patrons. ▪▪ When the Chaveses were first married they bought modern Danish furniture, admiring its clean, spare lines and liberal use of wood. Then one day they passed an antiques store with a display of dark, plain furniture set against a white stucco wall. It seemed reminiscent of their modern pieces, and they stopped to look. This was Stickley furniture, they learned, and André particularly liked one of the rocking chairs. Ann gave him the rocker for his next birthday, and from then on they were confirmed collectors. Eventually they took perhaps the ultimate step, purchasing the superb Greene and Greene house where they now live. ▪▪ But it is not only the Arts and Crafts of the early 1900s that engages the Chaveses. They are also skilled crafts workers themselves. Ann, originally from East Aurora, New York, home of the Roycroft, is a weaver and textile artist, and André is a painter and handpress printer. Their home has stimulated their creativity: "Deeply tied to the collecting impulse," says André, "is an element of inspiration."

Wood tones radiate from the entrance hall (opposite) to the dining room (above), with its eight-legged Craftsman sideboard like the original and H-back Craftsman chairs. In the living room (pages 164–65), Craftsman bow-arm Morris chairs flank a Craftsman settle in front of the tile-faced fireplace. Roycroft seahorse andirons match a green Rookwood tile above.

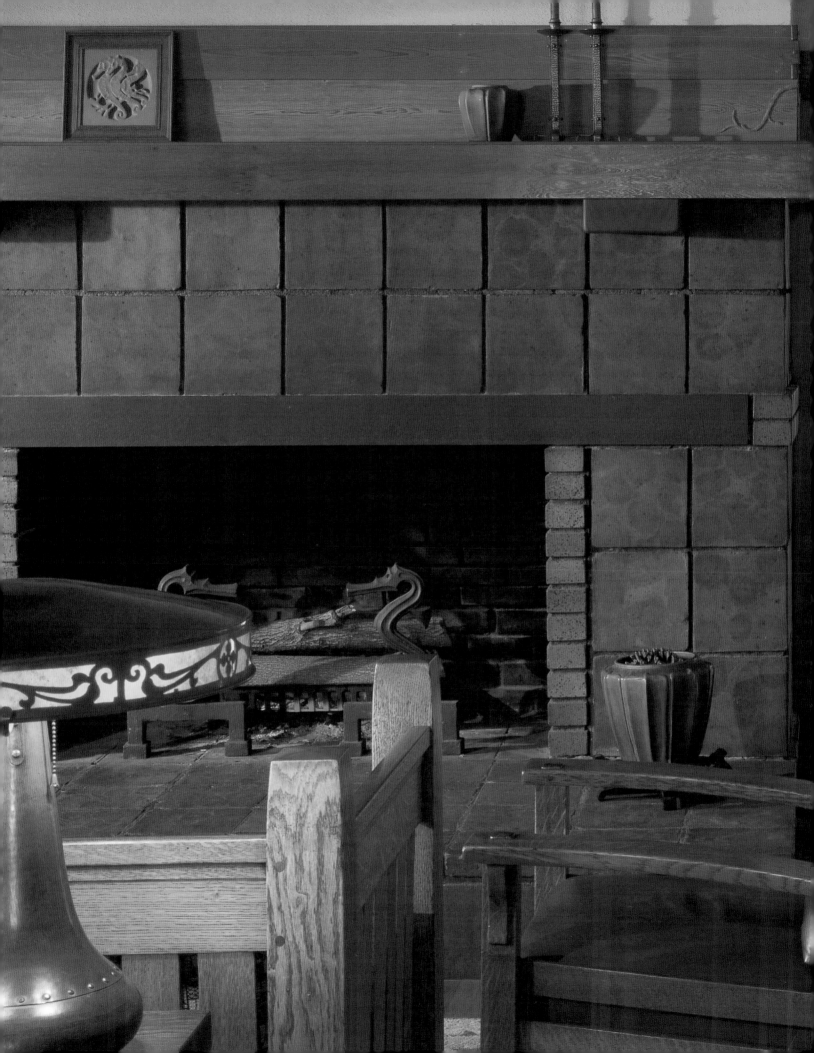

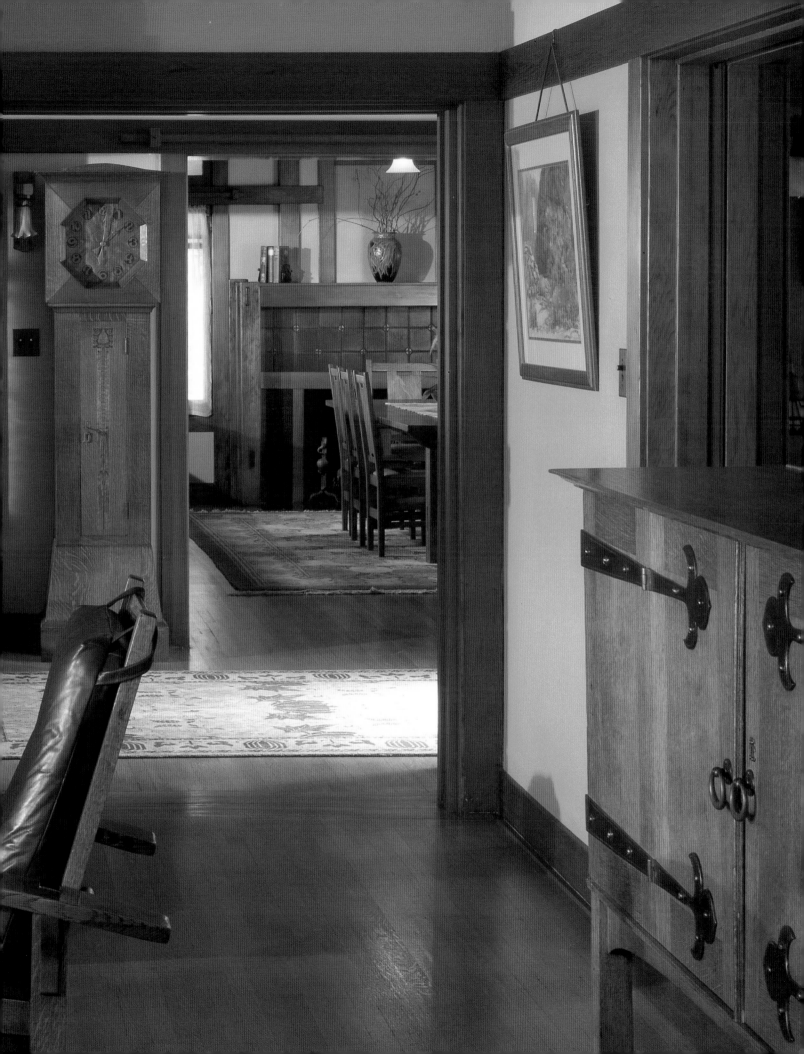

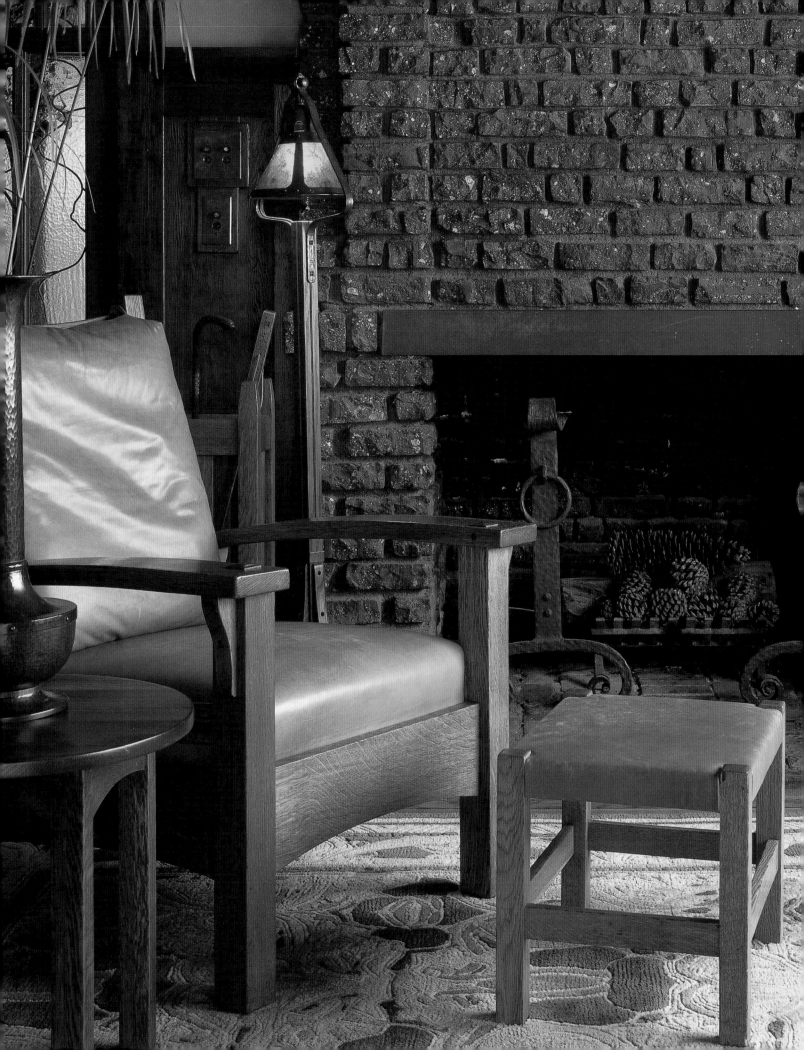

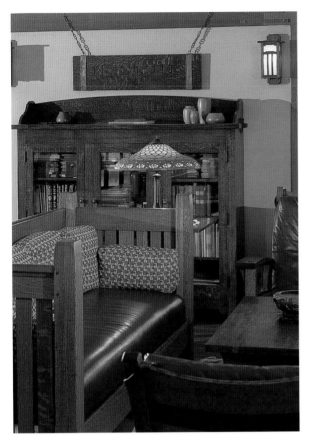

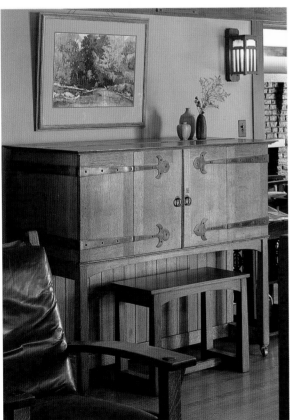

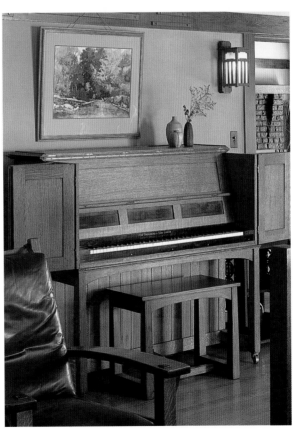

A Craftsman Morris chair (opposite) rests on a reproduction Voysey carpet, between a hammered-copper vase for long-stemmed roses, designed by Victor Toothaker, and a reproduction Stickley floor lamp. Next to the Craftsman settle in the living room (top left) is a Roycroft triple-door bookcase below one of Elbert Hubbard's hanging mottoes. The Chaveses' piano (top right and bottom left and right) is an unusual English piece, designed by the architect M. H. Baillie Scott. He disliked a projecting keyboard, so he fashioned this "Manxman" piano with its cupboardlike doors.

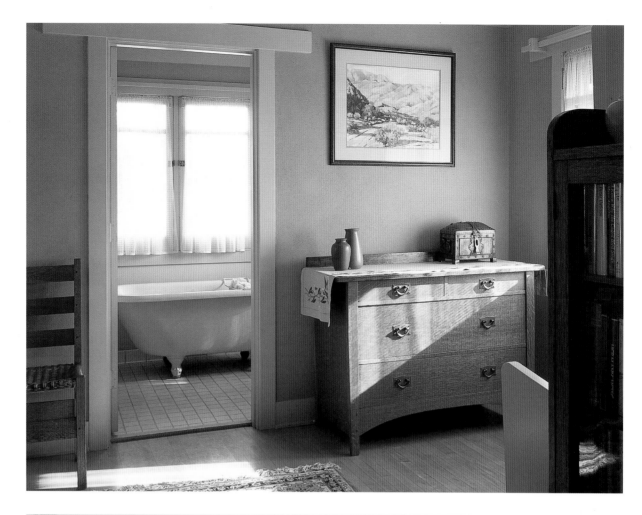

The arched apron and bowed sides of a Craftsman bedroom chest (right top) are design motifs first added to the Stickley line by Harvey Ellis. Ann Chaves, a weaver, made its embroidered scarf in her workspace in another bedroom (right bottom), where an eight-harness loom was installed. The table square at right is also an example of her embroidery, as is the wisteria cushion on a built-in settle-bookcase (opposite) in a different bedroom.

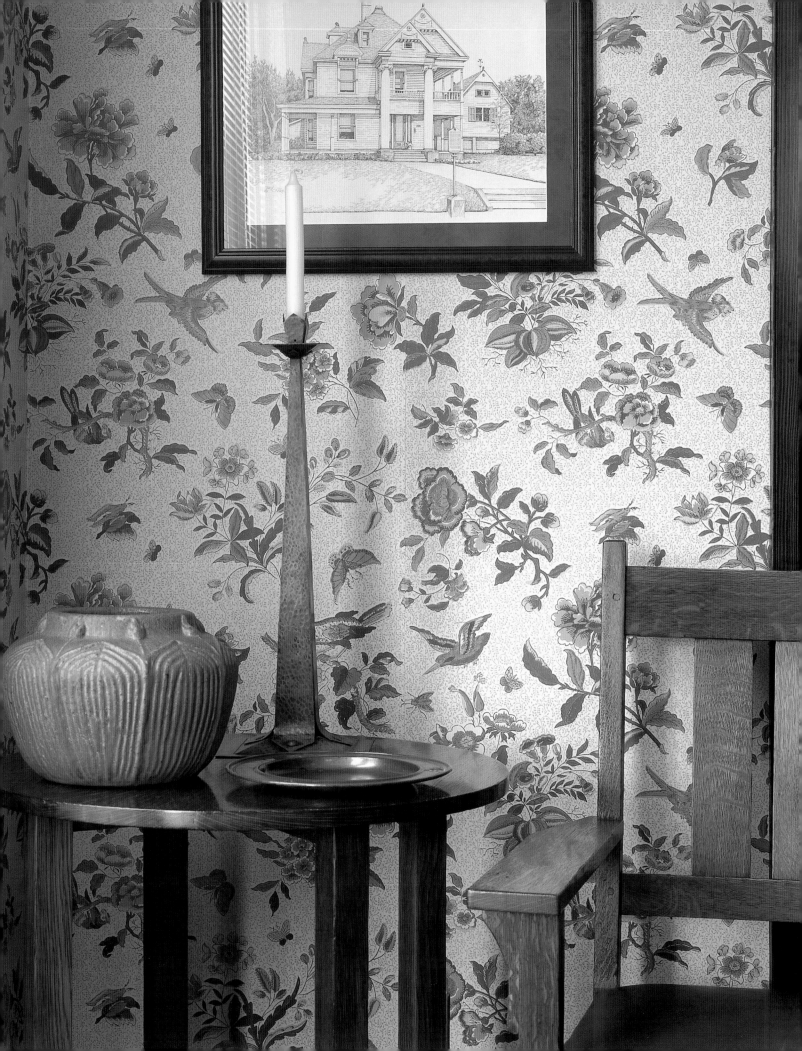

WHEN GEER AND DOROTHY McKEE BOUGHT THEIR RAMBLING THREE-STORY TEXAS house, built in 1896, it badly needed repair. Today, all its lost Victorian glory faithfully recreated, it is listed in the National Register of Historic Places. With the neoclassical detailing of its facade, its generally vertical proportions, and a floor plan that includes a formal parlor, the house might seem antithetical to Stickley's architectural ideas. Yet it offers an ample and compatible space for the McKees' Arts and Crafts collection, which was inspired by their previous house, a Craftsman-like bungalow. ▪▪ At first glance the entry hall seems typically Victorian. The fireplace, faced with white marble tiles, has a dark-stained wooden mantelpiece, and a flowered paper covers the walls. But the Stickley furniture, Roycroft metalwork, and Arts and Crafts ceramics displayed here are the first hint that the interior of this house does not match its exterior. ▪▪ Adding to the formal elegance of the parlor, a room Stickley wanted to banish, is a Craftsman settle covered with a printed William Morris textile and two examples of inlaid Craftsman furniture: a delicately scaled fall-front desk and a tall rush-seated chair. This is Stickley's special-occasion furniture, which is perfect for a

A Generous Welcome for Stickley

parlor. But there is a comfortable informality to this room as well. In one corner a Dirk van Erp copper-and-mica lamp casts its warm, glowing light on a three-paneled oak-and-leather Craftsman screen and an inviting Morris chair. ▪▪ In every room on all three floors, Stickley furniture fits comfortably with the late-nineteenth-century interiors. In the dining room, where the rich dark wood of the floor, fireplace, and ceiling beams contrasts vividly with the soft-hued flowered wallpaper, a Craftsman plate rack displays some of the McKees' Roycroft china. This blend of styles—Arts and Crafts objects against a Victorian background—seems to contradict nearly every tenet of the Craftsman idea, but it all works together nonetheless. The McKees plan to keep adding to their collection, and this large-hearted Victorian house will easily accommodate more.

Framed on floral Victorian wallpaper is a picture of the McKees' Texas landmark (opposite). Beneath are new occupants of the home: Stickley furniture, Roycroft copper, and a ceramic pot from the Wheatley Pottery. In the guest bedroom (right), a Roycroft lamp illuminates Stickley's 1909 *Craftsman Homes* atop a Craftsman desk.

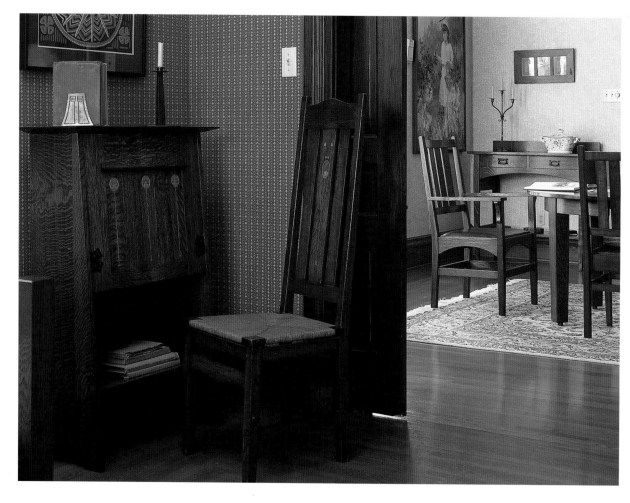

Made about 1903, the parlor's inlaid Stickley desk and inlaid tall-back Stickley chair (top and bottom left) add an appropriate note of formality to the McKees' historic house. The dining room's eccentric but ingenious adjustable wall sconce of oak and copper (bottom right) was designed by the Arts and Crafts furniture maker Charles Rohlfs. Stickley furniture fills the dining room (opposite), whose sideboard displays an oak, copper, and ceramic Craftsman chafing dish. Four Roycroft breakfast settings on the table were a rare find: the McKees bought them from a Texas woman whose father-in-law received them as a gift from Elbert Hubbard II in the late 1930s.

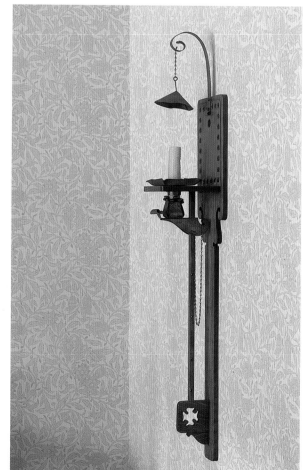

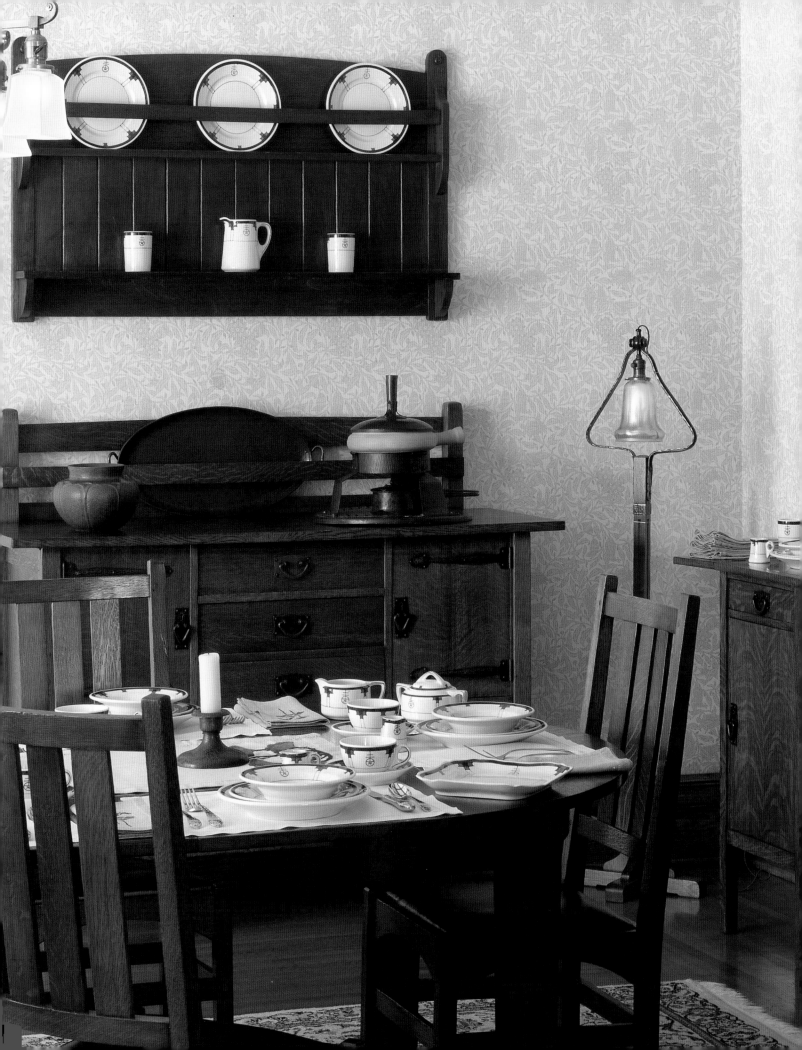

A Stickley fall-front oak desk from about 1902–3 (right) bears dramatic brass hinges that rise vertically on the front and horizontally on the cabinet doors. A slightly earlier bookcase to the right is rare. The living room fireplace (opposite), with its fluted oak columns and dentil molding, is Craftsman-like only in its current accoutrements: a Craftsman mantel clock and seven Grueby pots.

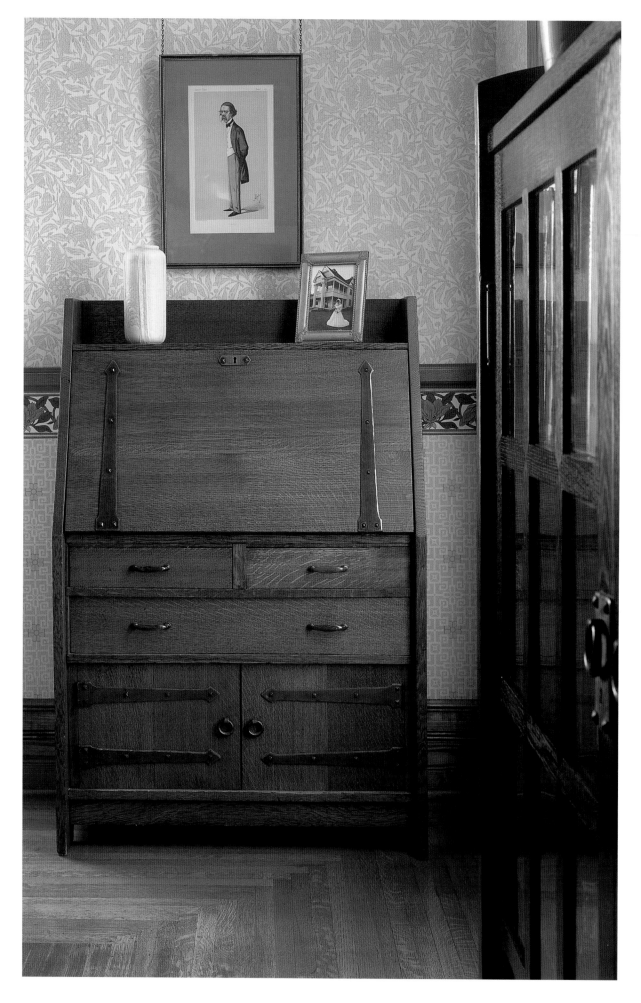

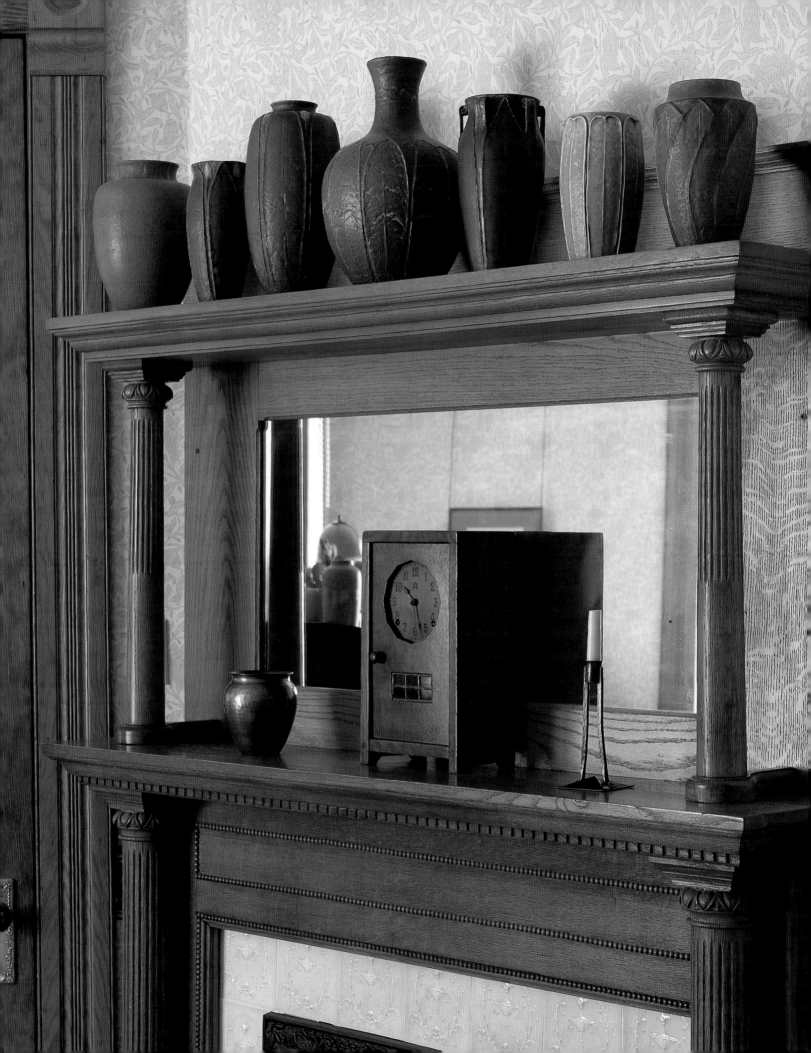

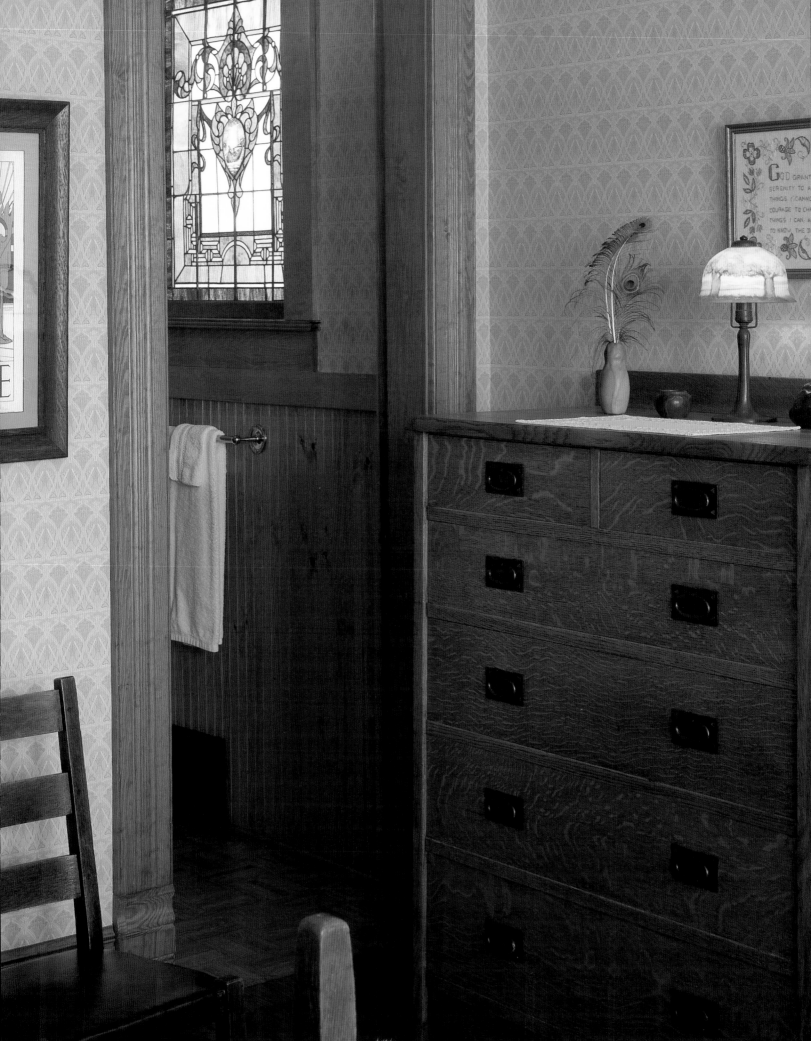

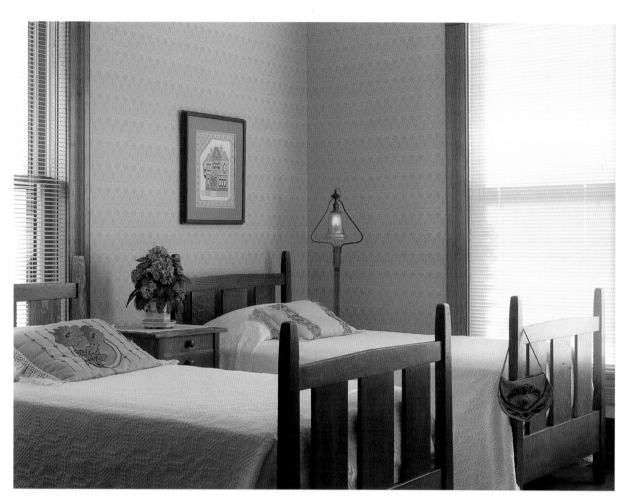

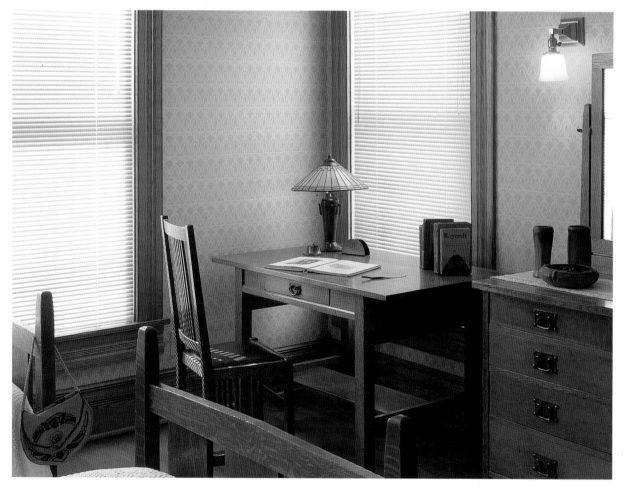

The master bath (opposite) retains its stained-glass window and original woodwork, but the bedroom furniture is all Stickley. On the dresser, peacock feathers rising out of a blue Van Briggle pot recall a favorite decorative motif of the period. Twin Craftsman beds in the guest room (left top) are finished with Arts and Crafts–era embroidered pillows. The single-drawer Craftsman desk with a wide top (left bottom) is lighted by a Roycroft lamp of copper and leaded glass.

177

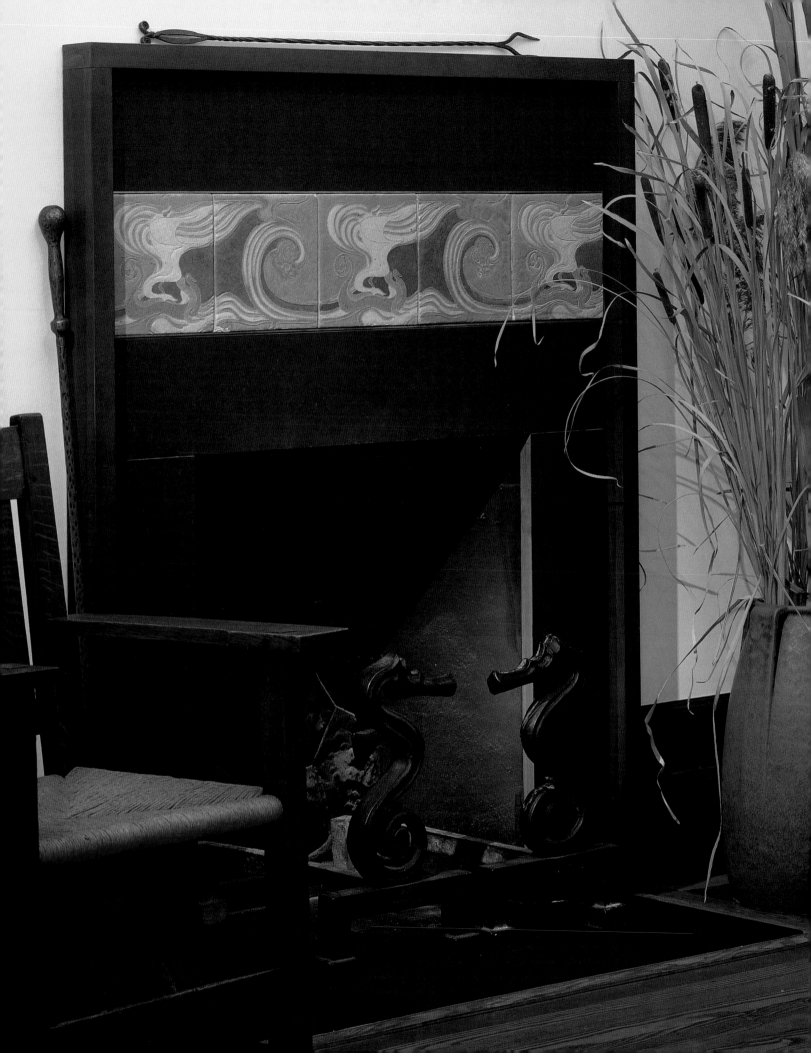

MANY COLLECTORS TODAY CONSIDER STICKLEY'S 1902 FURNITURE THE HIGH POINT of his production, but a *House Beautiful* writer that year grumbled that Stickley's massive furniture was "heavy to see and heavy to move." In response to such criticisms, Stickley introduced his graceful inlaid furniture in 1903 and his refined spindle furniture in 1905. In 1904 he began making a line of wicker ("willow"), which he said "affords exactly the relief that is necessary to lighten the general effect of the darker and heavier oak pieces." In this museumlike Manhattan apartment, Stickley's ideas about creating a harmonious interior by mixing heavy and light have been beautifully realized—although perhaps not in a way he could have foreseen. ▪▪ An oversized Morris chair, discovered in a New York antiques store, started off the Stickley collection. "It was big and gutsy," says the owner, "and I loved it." He was soon a committed collector of

Stickley's early, structural furniture of 1901 and 1902. But as much as he loved these pieces, he began to feel that by themselves they seemed a bit austere. His eye shifted toward the lighter, more decorative furniture of Charles Rohlfs. ▪▪ Rohlfs was a gradually acquired taste, but this collector came to appreciate the designer's unfettered originality—the quirky

A Harmony of Opposites

charm of the furniture's unorthodox proportions and its imaginatively carved and sawn motifs. To him Rohlfs's best work has an almost otherworldly quality; its shapes seem to come not so much from the natural world as from "an abstraction of an idea of something organic." ▪▪ His passion for Rohlfs led him to the whimsical ironwork of Samuel Yellin, the Philadelphia-based master blacksmith and designer. "The Yellin and Rohlfs are perfect together," he says. "They both have lots of flourishes, and the dark wood goes well with the color of the iron." In Yellin's work—for instance, the floor lamp standing beside the Morris chair—he admires the superb craftsmanship, attention to detail, and seemingly endless inventiveness of the designs. As this collector instinctively saw, the fanciful forms of Rohlfs and Yellin are ideal foils for the "fine plainness" of Stickley's early Craftsman furniture, here combined to create a unique and pleasing Arts and Crafts environment.

Fanciful furniture by Charles Rohlfs and decorative ironwork by Samuel Yellin intermingle in this apartment with Stickley's strong, superbly made Craftsman designs. Seahorse andirons designed by the Roycroft artist W. W. Denslow, illustrator of the *Wizard of Oz*, and fashioned by Jerome Connor about 1900 guard the hall's fireplace made of Grueby tiles.

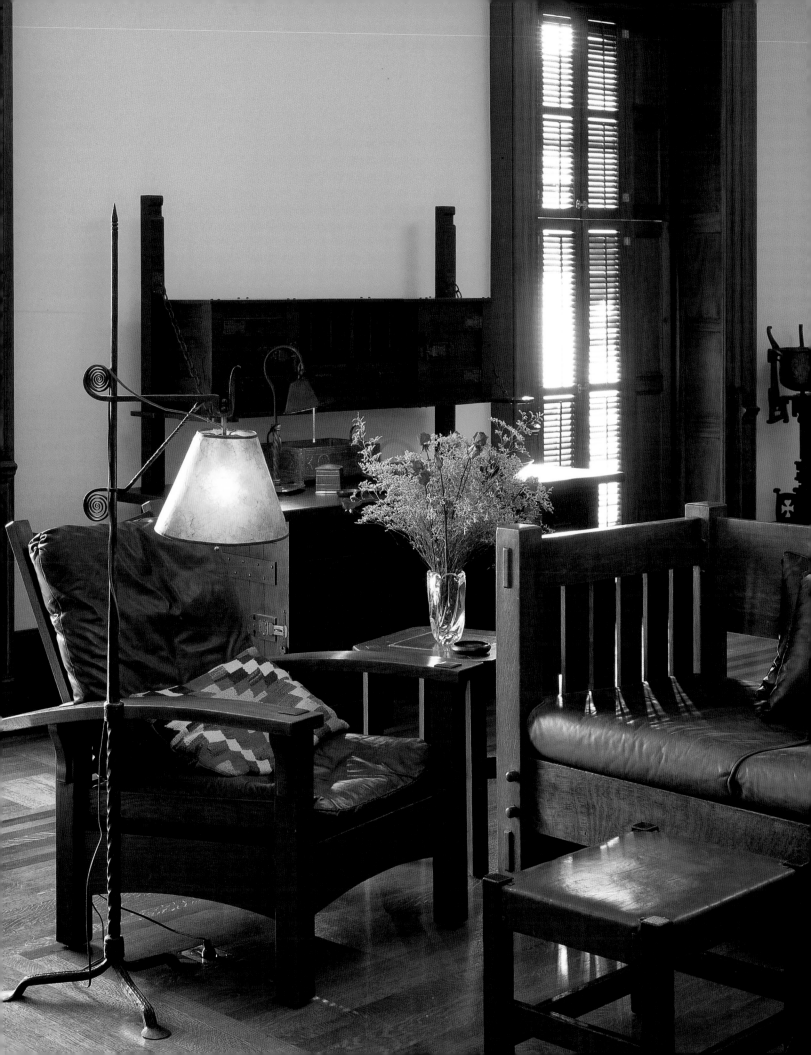

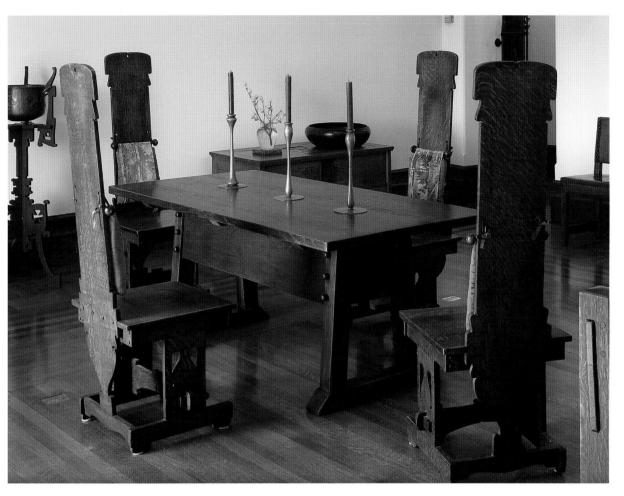

The Samuel Yellin iron floor lamp and the over-sized Charles Rohlfs desk (opposite) follow a more overtly decorative thread of American Arts and Crafts than do Stickley's spare shapes. Four tall chairs made for Rohlfs's own dining room (left) surround a Stickley director's table inspired by M. H. Baillie Scott. The owner's classic Eastwood chair (below) typifies the unornamented forms he sees as "protomodern."

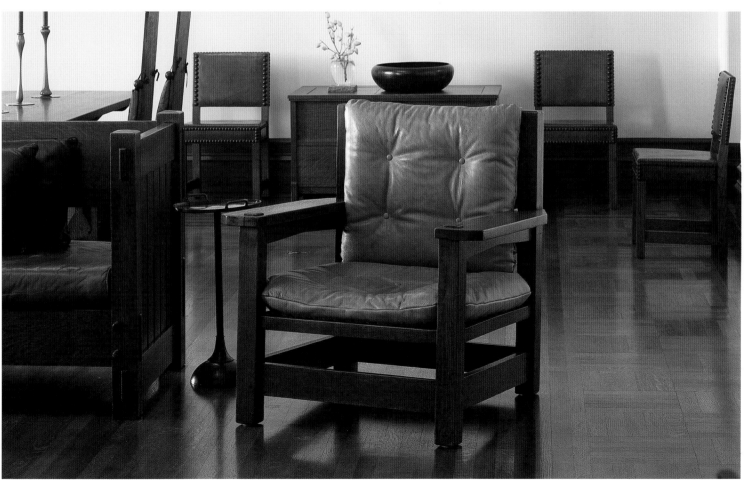

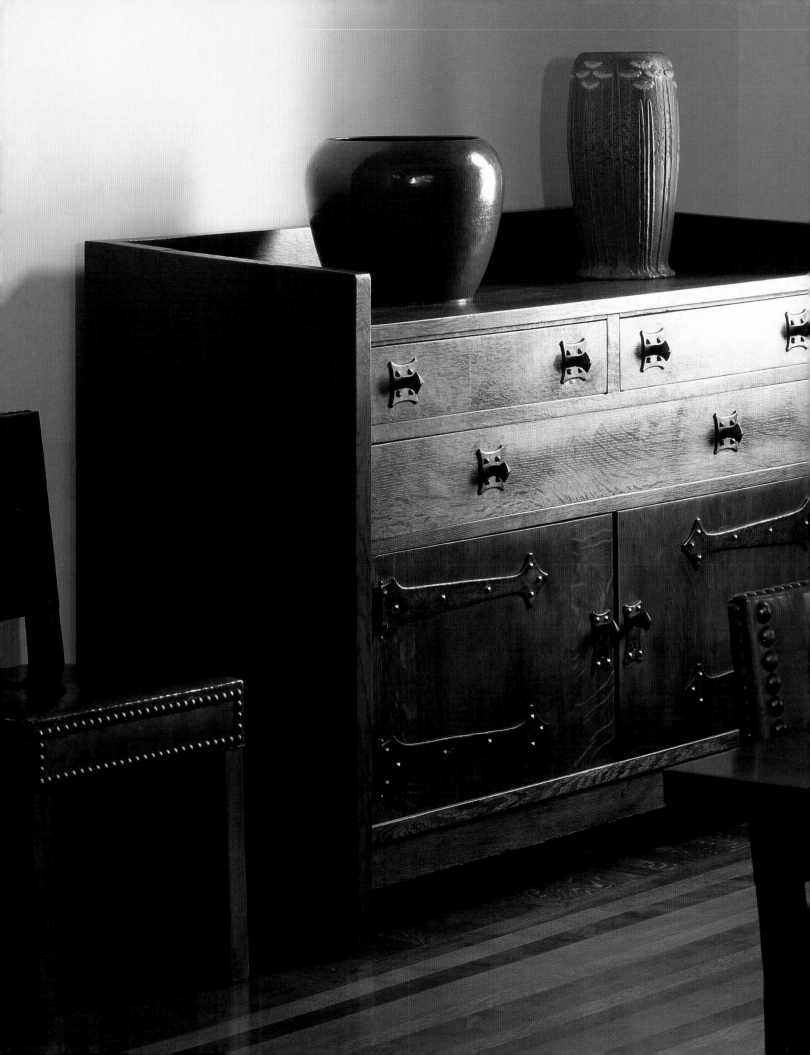

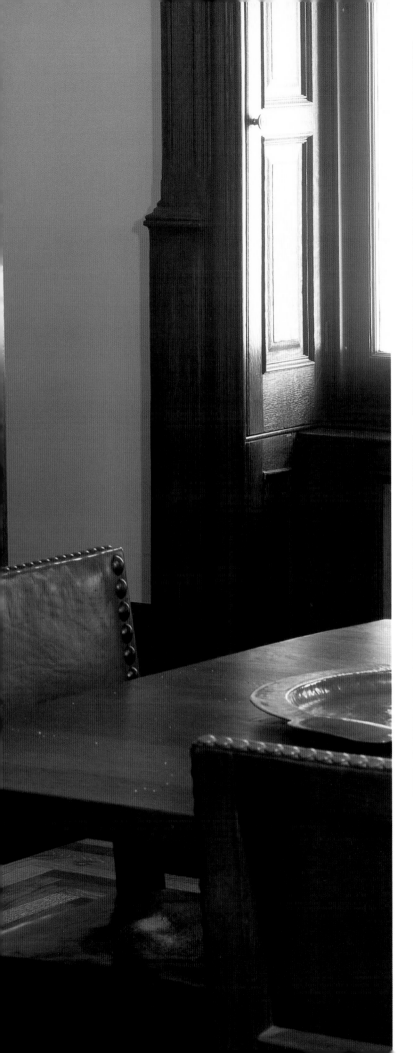

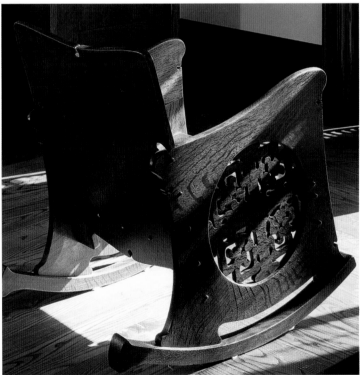

All the objects in the dining room (left) are "big and gutsy," from the Crafts-man sideboard, table, and chairs still covered in their original leather to a Dirk van Erp hammered-copper pot and a Grueby vase. Decorative pieces such as an iron head on a lamp by Samuel Yellin (top) and a Chinese-inspired rocker by Charles Rohlfs (above) lighten the overall feeling with bits of whimsy.

The Wright Kind of House

No one would mistake a foursquare Craftsman house for one of Frank Lloyd Wright's dramatic masterpieces. And yet Stickley, a furniture maker enamored of architecture, and Wright, a dominant architect of the same era who also designed furniture, worked within the same broadly defined tradition, their architectural ideas overlapping at many points. Both preferred houses with generally horizontal proportions and overhanging eaves and built of wood and stone, left as much as possible in their natural states. Both advocated free-flowing interior spaces and believed in the efficiency and structural beauty of built-in furniture. And both created freestanding furniture that relied on rectilinearity and geometric form. ▓ Stickley collectors seem universally to admire Wright, but few carry their admiration to quite the same extent as the owners of this southwestern house designed in the 1960s by Karl Kamrath, a Wright disciple and former Taliesin apprentice: one of the chief reasons they moved to the Southwest was to live in these soaring Wrightian spaces with their collection of Stickley furniture, metalwork, and American art pottery. Built on a site that rises slightly and then falls away, the

Stickley's spindle furniture, inspired in part by Wright, is at the heart of this living room (right and opposite). Fulper pottery balances on a rough wood beam like the ones Wright used. Stone walls root the house to nature, while glass walls bring the outdoors inside. When the sun goes down, Tiffany, van Erp, and Stickley lamps fill in.

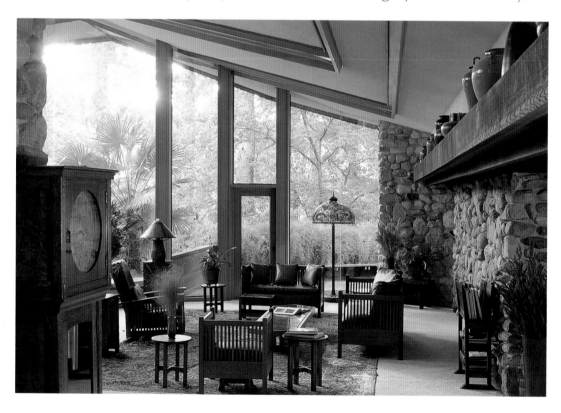

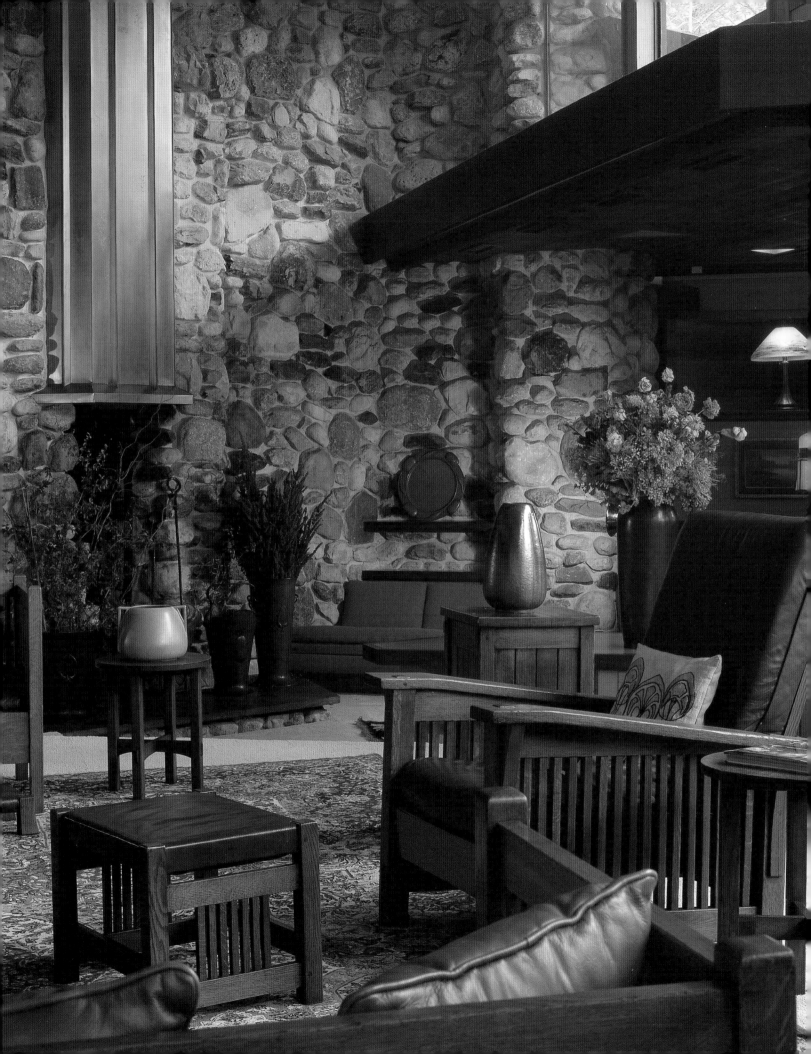

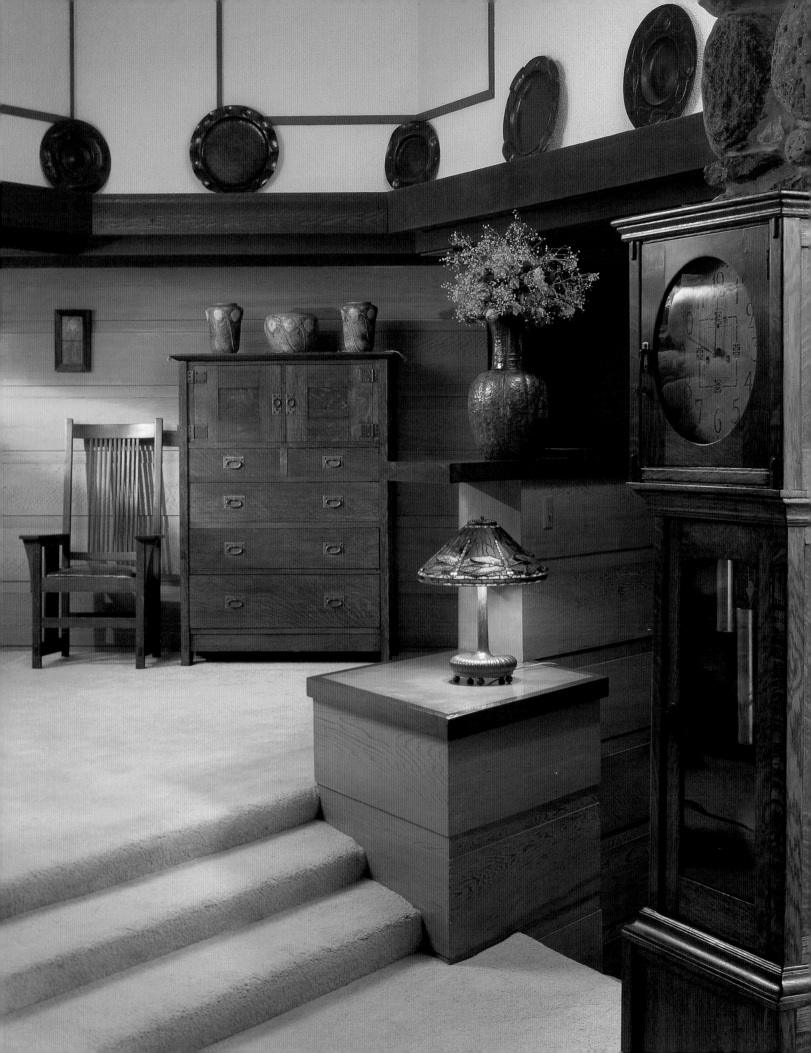

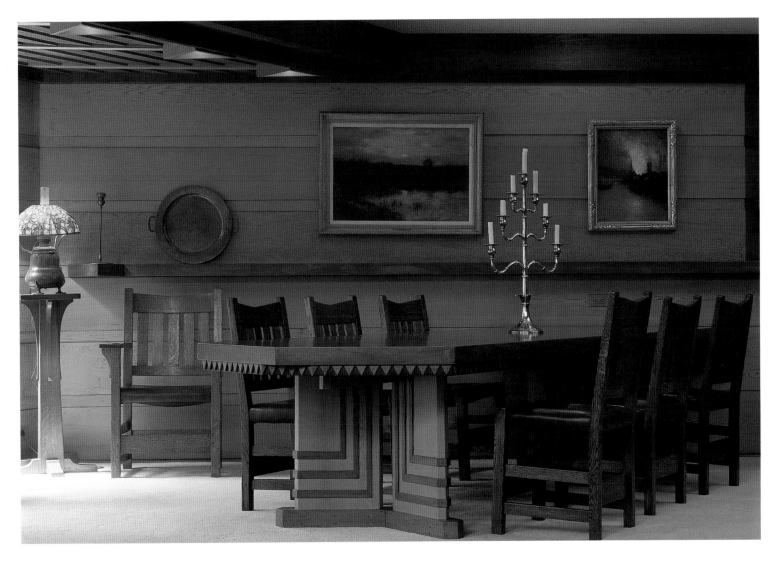

exterior presents a modest facade that contrasts with the spacious living area. Two-story windows at the rear open onto the surrounding woodland, while stone walls root the house in nature. The owners' Stickley furniture, especially the spindle pieces, works well in this Wright-inspired environment—just as Stickley furniture was sometimes fitted into Wright's Prairie houses in the first decade of the twentieth century. ▓ Wright began designing tall-back chairs with squared vertical spindles in the 1890s. A decade later, when Stickley first catalogued his own spindle furniture in 1905, he told his customers that it was "built on slender lines, tall, graceful, and showing . . . quaint refinement. The use of light spindles instead of broad bars in the backs of chairs and settles gives an effect that is rather more ornate than that of the heavier pieces." Stickley's spindle furniture shows the high level of sophistication Craftsman designs could reach, and its refinement echoes the larger architectural refinements of this spacious Wrightian home.

In the entry (opposite), a Craftsman chest and spindle armchair stand beneath an array of Stickley copper plaques. The house's triangular plan shows itself in the dining room (above), whose custom table seems at home with Stickley V-back chairs.

Details bring this collection to life. An L. & J. G. Stickley tall case clock (top left) greets visitors in the entrance hall. A silver candalabra (top right), made about 1910 by the Kalo Shop in Chicago, is the star of the dinner table. Near one of the soaring windows, a Stickley hammered-iron-and-glass lamp (bottom left) adds soft light. Art glass (bottom right) picks up the triangular Wrightian theme of the house. In the dining room (opposite), another triangle juts out from the plate rail as if pointing to one of Stickley's V-back chairs. On the shelf sits a candlestick by the noted Chicago artisan Robert Jarvie. A Tiffany lamp crowns an L. & J. G. Stickley pedestal.

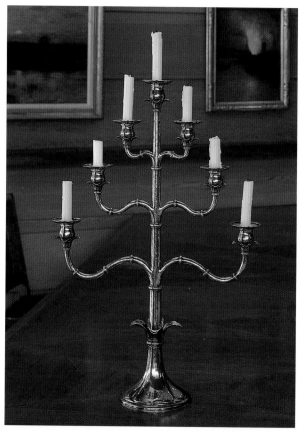

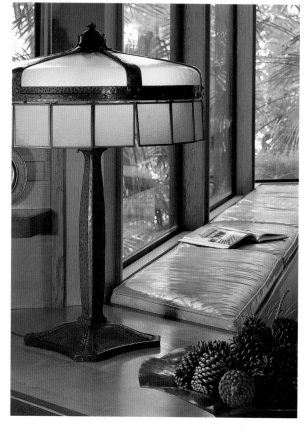

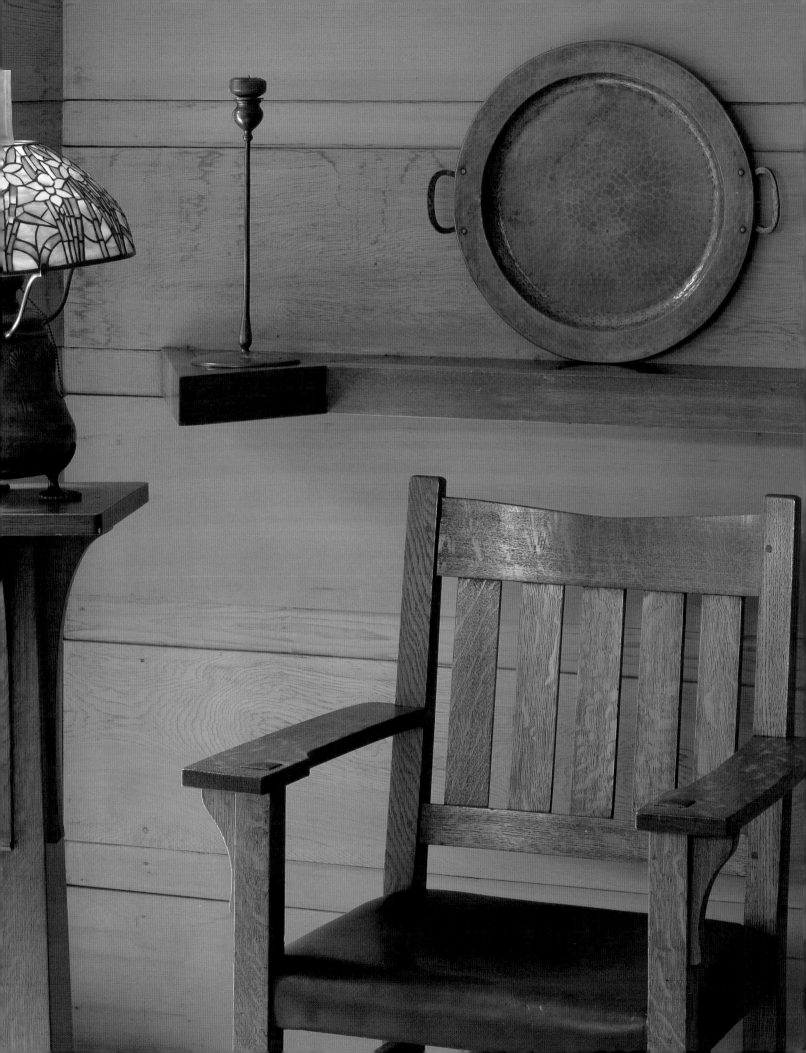

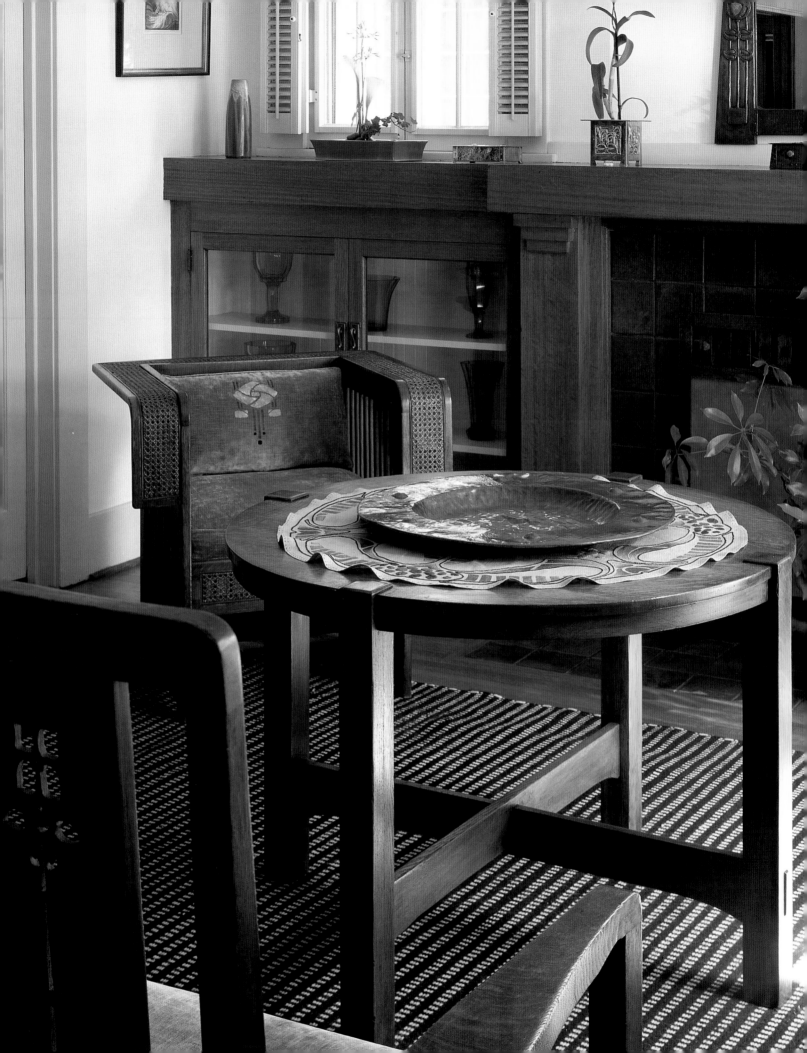

ALTHOUGH STICKLEY SAW HIS CRAFTSMAN FURNITURE AS DISTINCTLY AMERICAN—direct, honest, sturdy, vigorous—he drew inspiration from the international Arts and Crafts movement that had begun in Britain and spread to the European continent and the United States. This shared Arts and Crafts heritage—English, Scottish, and Viennese as well as American—is reflected in John and Heather Banfield's intermingling of American and European Arts and Crafts in their 1915 California bungalow. The Banfields first began collecting Arts and Crafts in the early 1970s, when they bought an 1899 brownstone in Brooklyn, New York, and decided to furnish it to reflect its era. Perhaps because they are English, they focused first on British Arts and Crafts, gradually adding American pieces that harmonized with their growing collection. ▓▓ The Banfields are particularly fond of the graceful lines, striking colors, and simplified

Transatlantic Bungalow

natural forms of the Glasgow style practiced around the beginning of the twentieth century by Charles Rennie Mackintosh and a loosely associated group of designers. Mackintosh's influence can be seen in the Craftsman furniture of Harvey Ellis, particularly in its colorful, inlaid motifs of tinted wood, pewter, and copper and its gently bowed sides, first used on Stickley's standardized production furniture in 1904 and continued as late as 1910. In addition, textile patterns derived from Mackintosh and other Glasgow-style designers were published in *The Craftsman* magazine during Ellis's tenure. ▓▓ The couple's California living room has many of the classic American bungalow features that Stickley admired most—a tiled fireplace, built-in bookcases, and a leaded-glass window—but its decoration is distinctly international. The richly inlaid sideboard is attributed to M. H. Baillie Scott, while the mirror over the fireplace is from Liberty and Company,

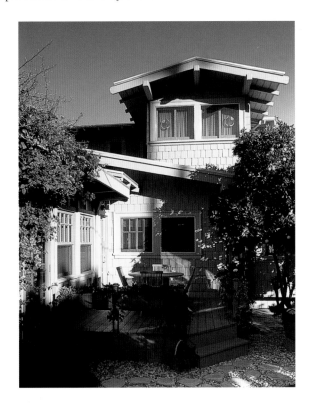

The round library table by L. & J. G. Stickley in the living room (opposite) is pure American Arts and Crafts, but the American-made chairs show the influence of progressive European design. The oak armchair, with sawn stylized plant forms, was inspired by the Austrians, as was the wicker chair, whose Glasgow rose was worked by Heather Banfield. With its strong gabled roofs and natural shingles, the owners' bungalow (right) speaks the Craftsman language.

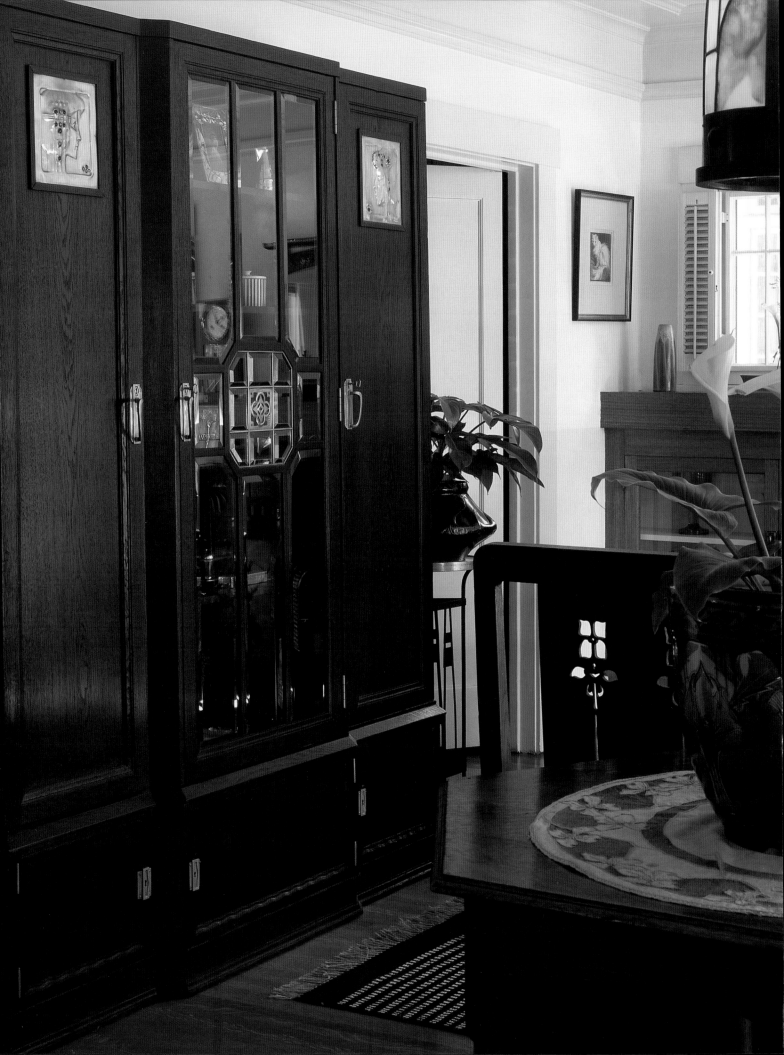

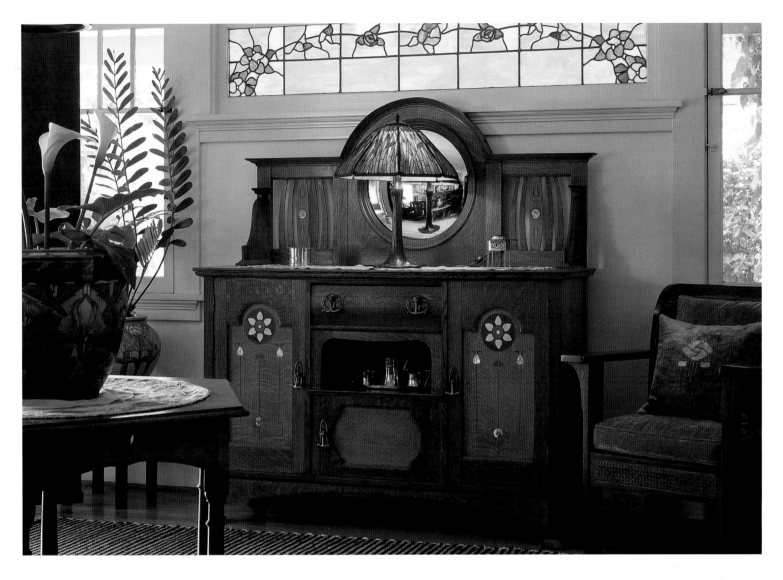

the London retailer that did so much to popularize British Arts and Crafts. Two library tables, a round one made by L. & J. G. Stickley and a hexagonal one designed by E. A. Taylor for Wylie and Lockhead of Glasgow, face spindle-sided wicker armchairs that suggest the advanced Austrian design of the Arts and Crafts era. ▪▪ Surrounding the black dining room table are four tall white-painted chairs, 1950s reproductions of Mackintosh designs (originally stained black) from about 1898 for Catherine Cranston's Argyle Street Tea Rooms in Glasgow. The leaded-glass light fixture, its rose motif typical of the Glasgow style, is attributed to George Walton. More leaded-glass roses grace the black-stained sideboard by E. A. Taylor, who also designed the side chairs for Wylie and Lockhead. In a Glasgow-style frame, Mackintosh in his flowing artist's tie presides serenely over a room filled with his own designs and those of his Glasgow contemporaries. ▪▪ By furnishing a California bungalow with American and European Arts and Crafts objects, the Banfields have created the kind of unified interior sought by Gustav Stickley and other Arts and Crafts–era designers on both sides of the Atlantic.

Set into the front of a tall Austrian cabinet (opposite) are nickel-silver panels inset with opals, garnets, and other semiprecious stones. The inlaid Baillie Scott sideboard (above) holds a U.S.-made Handel lamp and exquisite examples of metalwork by the Glasgow artisan Mary Gilmour.

The detailing of the
English sideboard
(top left) and the tall
Austrian cabinet with
hand-raised decorative
designs in nickel-silver
(top right) shows
Arts and Crafts artists'
contrasting styles. The
chair-like washstand
from Liberty and
Company of London
(bottom left) is a rare
find. Stickley supplied
the plain oak chest at
its feet. The silver clock
(bottom right), its pop-
lar motif reminiscent
of C. F. A. Voysey, also
came from Liberty. The
black-and-white dining
room (opposite and
pages 196–97) was born
in Glasgow. E. A. Taylor
designed the black side-
board and tall chairs
beside it. White Mack-
intosh-style chairs
surround a black table
under a leaded-glass
light fixture sporting a
Glasgow rose. Scottish,
English, Austrian—
all are at home in this
American bungalow.

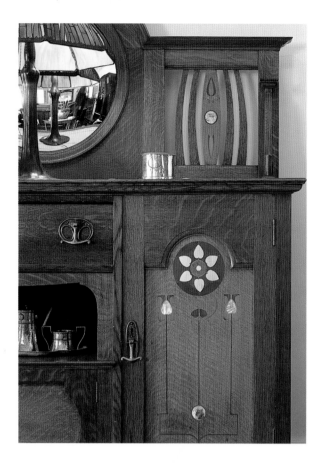

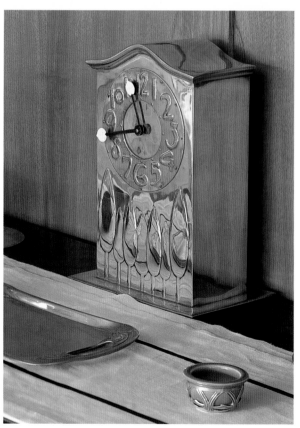

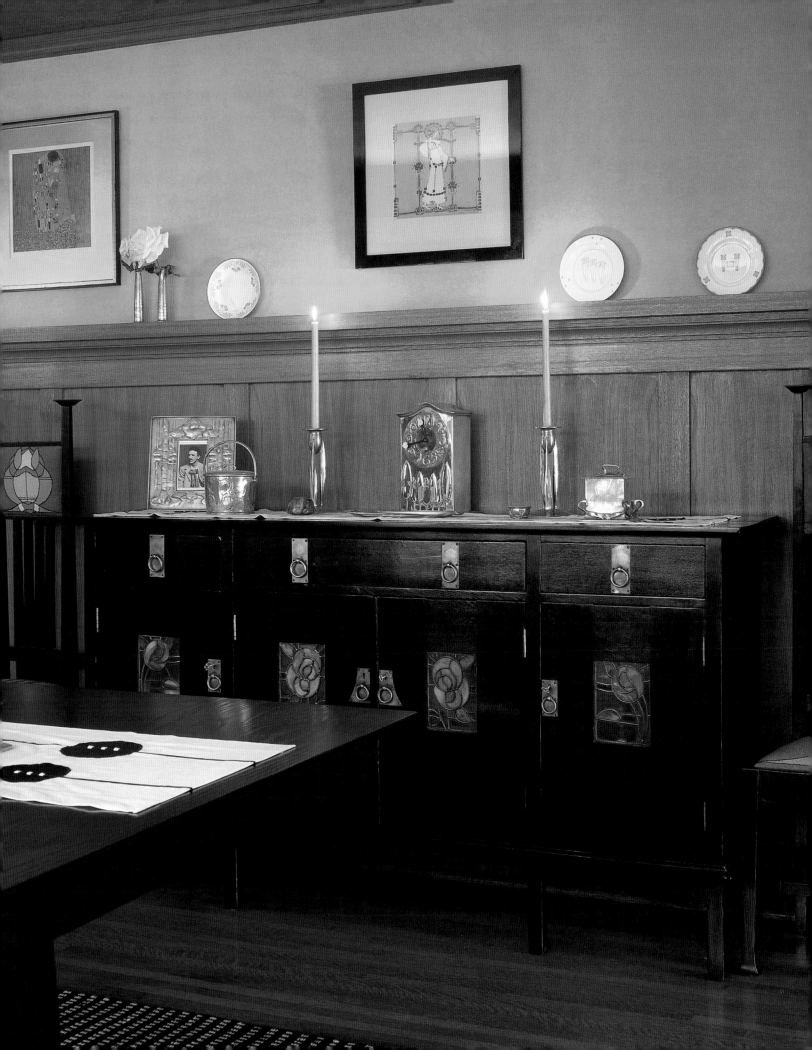

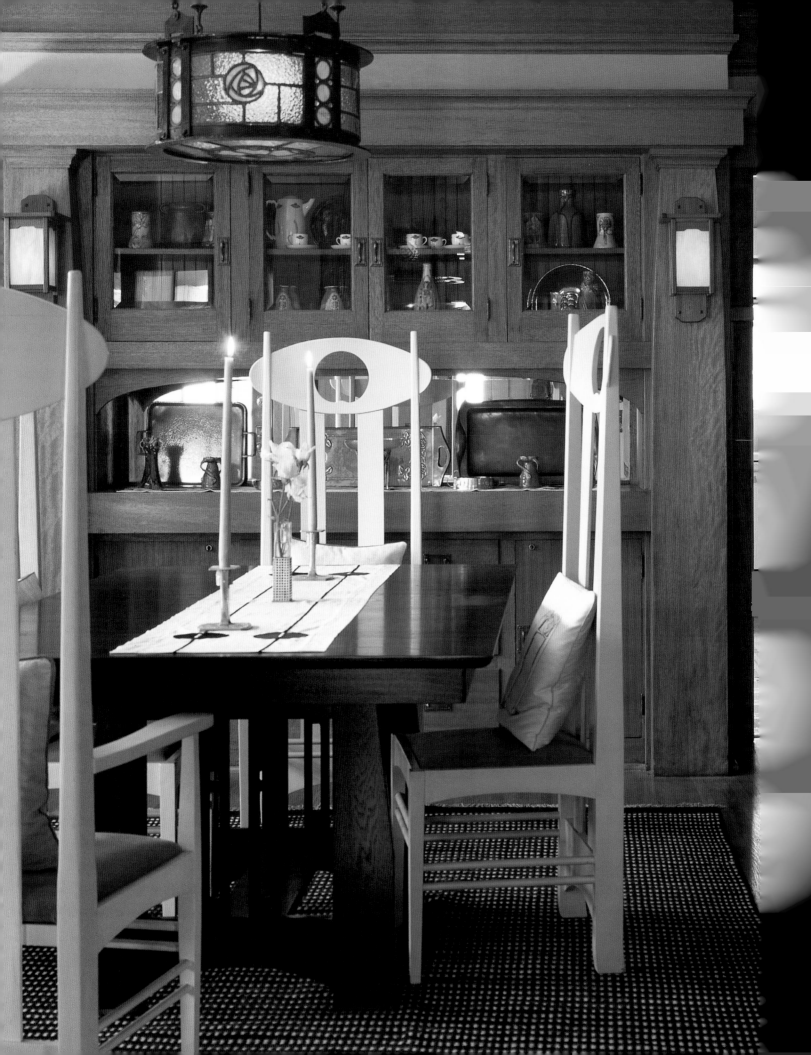

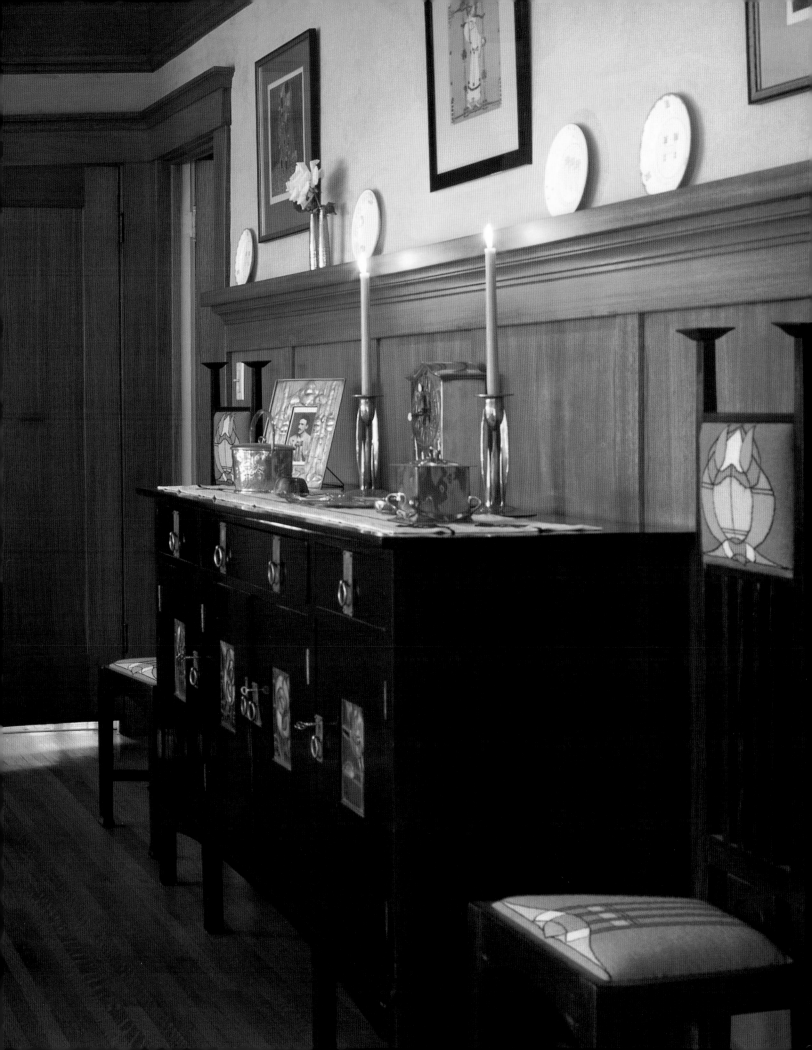

CRAFTSMAN FURNISHINGS FOR THE HOME

Reproduced from the Cover of THE CRAFTSMAN for September, 1912.

MADE BY
GUSTAV STICKLEY
THE CRAFTSMAN
INCORPORATED
WORKSHOPS: EASTWOOD, N. Y.
STORES:
29 WEST 34TH STREET, 1512 H STREET, N. W., 468 BOYLSTON ST.,
NEW YORK. WASHINGTON, D. C. BOSTON, MASS.

OCTOBER
1912

nd no aristocracy, the life of the plain people
the age must necessarily be the art of the
desire for show are only a part of the crudity
nd will not for many years; but as we grow
and to ch of life and
istakable m shams
merican g that he
y is all v o proving
reputatio re just as
e things t hings that
good inv d have no
merican are done.
oused wh he really
ble to fee d had the
trong is t that it is
merica an furniture
of simplic d conve-
he details of its construction can be readily
manent. We are not so many generations
e have grown entirely out of their way of
to think about them, but when we do our
e prevalence of cheap, showy, machine-made

STICKLEY

AT HOME

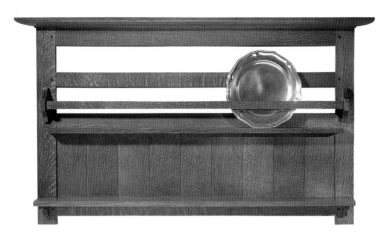

CRAFTSMAN PLATE RACK

Oak. 27 ½" high, 48 ½" wide, 5" deep. No. 89-811. L. & J. G. Stickley. A plate rack (top left) offers an appropriate way to display and store plaques and plates. Like most L. & J. G. Stickley furnishings, it is also available in cherry.

QUARTERSAWN OAK CABINETS

Oak or cherry. Various sizes. Crown Point Cabinetry. Handcrafted from solid quartersawn white oak, period-style kitchen cabinets (top right) have arched toe kicks and pyramidal wood knobs. All cabinets are custom designed to fit each kitchen.

TALL CASE CLOCK

Oak. 80" high, 27" wide, 16" deep. No. 89-86. L. & J. G. Stickley. An original L. & J. G. Stickley design from 1910, this flat-top clock (left) is an authentic reproduction with metal or wood knobs.

MANTEL CLOCK

Oak. 13 ¾" high, 8 ½" wide, 4 ¼" deep. No. 89-93. L. & J. G. Stickley. Gustav Stickley's 1912 rectilinear Craftsman clock (bottom left) is small enough to stand comfortably on a mantel.

CORNER CLOCK

Oak. 23 ½" high, 16" wide, 11 ½" deep. No. 89-82. L. & J. G. Stickley. A newly designed corner clock in the Arts and Crafts style (bottom right) is key wound and features an hourly gong.

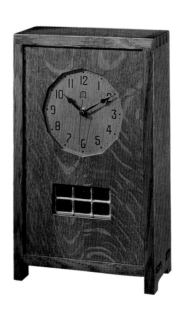

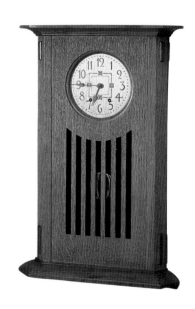

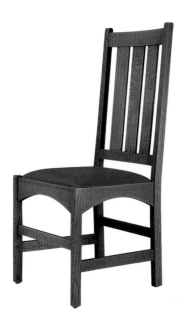

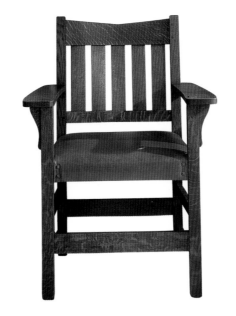

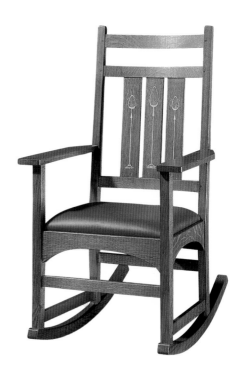

SIDE CHAIR

Oak. 42½" high, 19" wide, 21" deep. No. HS0120. Warren Hile Studio. This chair (top left) combines Stickley-like slats and a base in the style of Harvey Ellis.

V-BACK ARMCHAIR

Oak. 36½" high, 27" wide, 25" deep. No. HS0170. Warren Hile Studio. Styled after a Gustav Stickley original, this classic (top center) features a slatted back.

ELLIS INLAID ROCKER

Oak. 43" high, 25" wide, 31½" deep. No. 89-353½ R. L. & J. G. Stickley. Delicate inlays of cherry and maple are based on a 1903 Harvey Ellis design (top right).

CHERRY ARMCHAIR

Cherry. 42" high, 23" wide, 21" deep. No. NC-AC. Thos. Moser Cabinetmakers. Arts and Crafts elements combine with a tall back (bottom left) for a fresh look.

SPINDLE ARMCHAIR

Cherry. 43" high, 20" wide, 18" deep. M. T. Maxwell Furniture. This side chair (bottom center), a modern version of Stickley's spindle chair, has a leather seat.

SPINDLE ROCKER

Oak. 45" high, 28" wide, 31" deep. No. 89-376. L. & J. G. Stickley. Spindled sides and corbels in this rocker (bottom right) recreate the traditional Craftsman appearance.

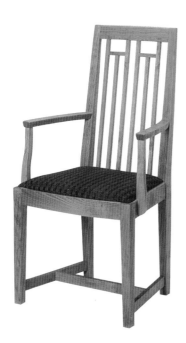

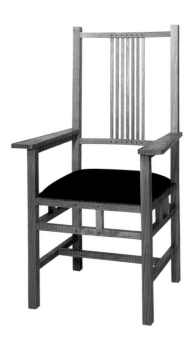

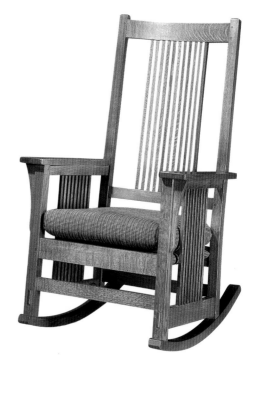

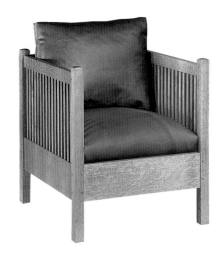

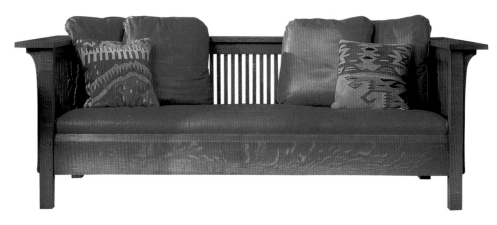

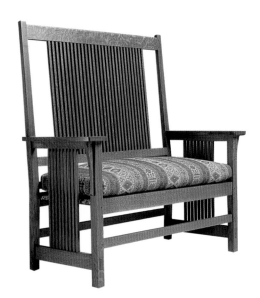

CUBE CHAIR

Oak. 29" high, 26½" wide, 29" deep. No. 89-391. L. & J. G. Stickley. An original 1905 Gustav Stickley design that refined the concept of a spindle chair (top left), this can be ordered with a choice of finishes and upholstery.

SPINDLE SETTEE

Oak. 49" high, 48½" wide, 24½" deep. No. 89-286. L. & J. G. Stickley. Spindles on the back and sides lend a structural elegance to this settee (left), based on a 1905 Craftsman design.

PRAIRIE SPINDLE SETTLE

Oak. 29" high, 84" wide, 37" deep. No. HS0050. Warren Hile Studio. This settle (top right) uses spindles and corbels for decorative effect, clearly showing the horizontal emphasis of the Prairie School. Other finishes and woods are available.

MORRIS ROCKER

Oak. 41" high, 32" wide, 35" deep. No. HS0030. Warren Hile Studio. An adaptation of the classic Morris armchair, this rocking chair (bottom left) has slatted sides and a back that reclines.

SLATTED SETTLE

Oak. 29" high, 76" wide, 34" deep. No. HS0060. Warren Hile Studio. This Craftsman settle (bottom right) features leather upholstery and mortise-and-tenon joinery that shows the construction.

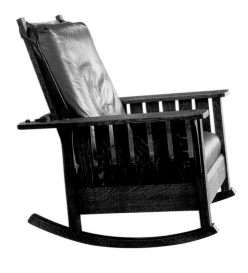

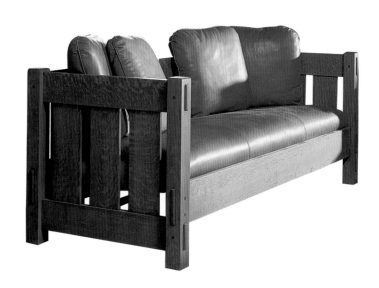

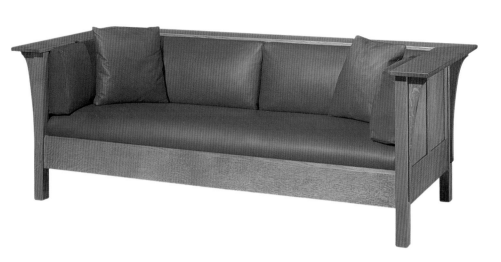

PRAIRIE SETTLE

Oak. 29" high, 84½" wide, 37½" deep. No. 89-220. L. & J. G. Stickley. The influence of the Prairie School is evident in this settle (top left) designed for Leopold Stickley by Peter Hansen about 1912. Several upholstery options are available.

BOW-ARM LOUNGE CHAIR

Oak. 39" high, 32" wide, 34½" deep. No. 89-2590. L. & J. G. Stickley. Gentle curves and bowed arms add to the appealing design of this long-popular lounge chair (top right). The back and seat are covered by leather cushions.

SPINDLE CHAIR

Oak. 29½" high, 42½" wide, 37½" deep. No. 89-417. L. & J. G. Stickley. Graceful corbels accent the broad arms of this spindle chair (bottom left), which can be paired with a spindle settle.

MORRIS CHAIR

Oak. 40" high, 33" wide, 37½–49" deep. No. 89-369. L. & J. G. Stickley. This adjustable chair (bottom right), a 1905 Craftsman design, has canted arms, spindled sides, and a footstool.

EASTWOOD CHAIR

Oak. 37" high, 36" wide, 32" deep. Cathers and Dembrosky. Designed by Gustav Stickley in 1901, this massive armchair of quartersawn oak (right) was a favorite of Stickley's. Every detail is authentic.

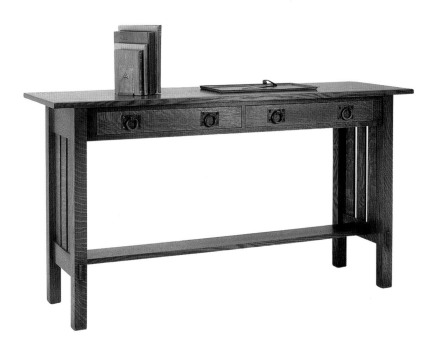

Magazine Pedestal

Oak. 63 ½" high, 18" wide, 18" deep. No. 89-80. L. & J. G. Stickley. A reissue of a Roycroft magazine pedestal featuring the original canted sides, keyed tenons, and shopmark (left), this distinctive storage piece boasts a secret compartment.

Sofa Table

Oak. 29 ½" high, 56" wide, 16" deep. No. HS0450. Warren Hile Studio. This solid oak table (top right) features slatted sides and two hand-hammered pulls on each drawer. It also comes in a spindled version and with a variety of finishes.

Stickley Library Table

Oak. 29 ½" high, 42 or 48" diameter. No. 89-407LT. L. & J. G. Stickley. This reissue of an original Gustav Stickley design from 1901 features arched stretchers and keyed tenons (bottom left). A solid oak top may be ordered instead of the leather shown.

Extension Table

Cherry. 29" high, 60–104" wide, 60" deep. No. NC-PTR. Thos. Moser Cabinetmakers. A modern interpretation that expands on Arts and Crafts design principles, this large round table (bottom right) uses squared spindles to dramatic effect.

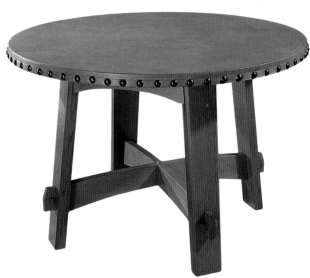

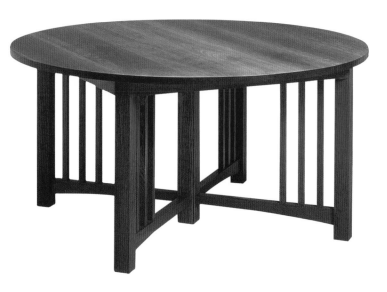

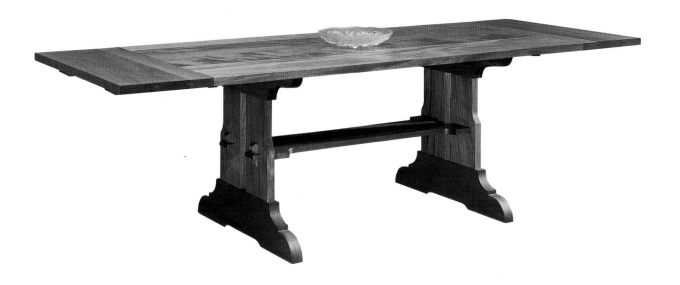

TRESTLE TABLE

Oak. 30" high, 76" wide, 38" deep.
No. HS0210. Warren Hile Studio. This
table (top) features keyed through-tenon
construction. It is available in three sizes
with the option of an extension leaf.

TRESTLE COFFEE TABLE

Oak. 17" high, 44" wide, 24" deep.
No. HS0444. Warren Hile Studio. Keyed
tenons add to the period look of this
trestle coffee table (right), which comes
in other woods and a variety of finishes.

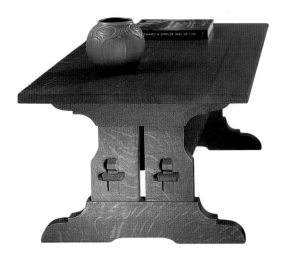

ROUND TABOURET

Oak. 24" high, 20" diam-
eter. Mack and Rodel.
Derived from designs by
Harvey Ellis and Gustav
Stickley, this tabouret
(bottom left) features a
delicate wood inlay.

CUBE TABLE

Oak. 22" high, 19" wide,
19" deep. No. HS0400.
Warren Hile Studio. This
table (bottom center) is
also offered with tiles
inset on the top surface
and a variety of finishes.

TILE-TOP STAND

Oak. 28" high, 13" wide,
13" deep. No. HS0430.
Warren Hile Studio. Slat-
ted sides, through-tenon
construction, and a tiled
top (bottom right) are
Arts and Crafts hallmarks.

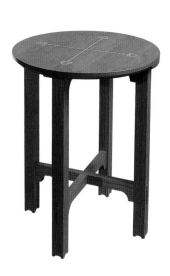

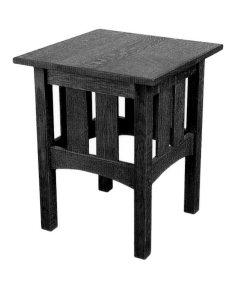

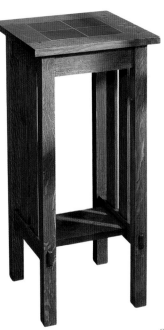

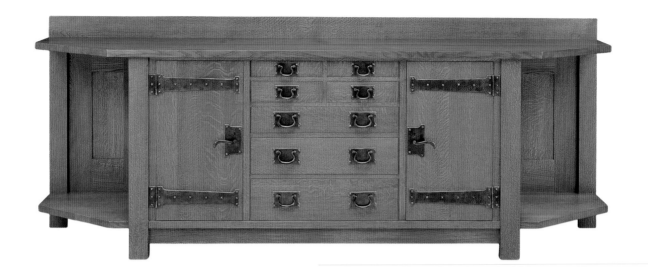

CHAFING DISH CABINET

Oak. 40" high, 32" wide, 19" deep. No. 89-55. L. & J. G. Stickley. A reissue of a Roycroft cabinet (left) features a locking door and an adjustable shelf. Leaded glass surrounds all four sides of the cabinet top. Only three originals of this rare cabinet design are known to exist.

DRESSING CHEST

Oak. 40½" high, 35½" wide, 18½" deep. No. 89-1927. L. & J. G. Stickley. This sturdy little chest (bottom left) is specially sized for children but still features Stickley's reliable and durable construction methods. It is also available with the option of wooden drawer pulls.

COLUMBUS AVENUE SIDEBOARD

Oak. 44½" high, 121" wide, 25" deep. No. 89-438. L. & J. G. Stickley. Designed for Gustav Stickley's own home in Syracuse, N.Y., this elegant sideboard (top) is available as a limited-edition reproduction. Like the original, it is crafted of quartersawn oak with copper hardware.

EIGHT-LEGGED SIDEBOARD

Oak. 50" high, 70" wide, 25" deep. No. HS0651. Warren Hile Studio. This reproduction of a Stickley sideboard designed by LaMont Warner (bottom right) features hammered-copper pulls and strap hinges. Handcrafted from quartersawn oak, it is available also in other finishes.

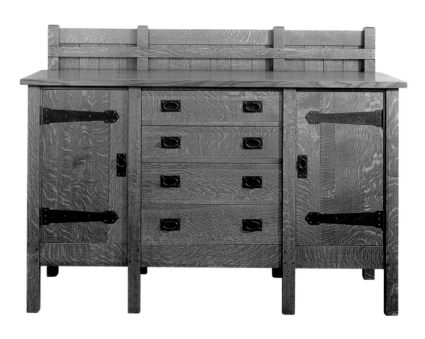

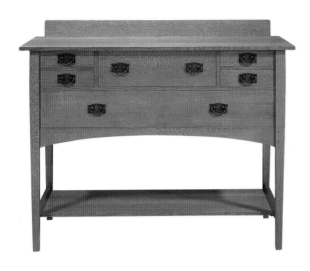

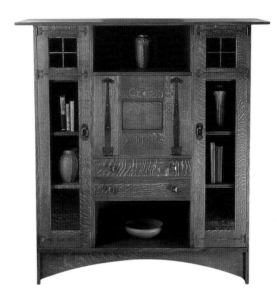

STICKLEY SIDEBOARD

Oak. 43″ high, 54″ wide, 21″ deep. No. 89-800. L. & J. G. Stickley. This sideboard (top left) is a reissue of an original Gustav Stickley design dating from 1903. The item features gently tapered legs and side-hung drawers with copper drawer pulls.

DROP-FRONT SECRETARY

Oak. 58″ high, 49″ wide, 18″ deep. No. HS0620. Warren Hile Studio. Based on Harvey Ellis's designs for Stickley, this secretary (top right) features a drop-front writing desk and hammered-copper hardware. Other finishes are also available.

FALL-FRONT DESK

Oak. 44½″ high, 36½″ wide, 15″ deep. No. 89-1729. L. & J. G. Stickley. An original Gustav Stickley design, this desk (bottom left) is crafted from oak and features solid copper hardware.

ELLIS BOOKCASE

Oak. 56″ high, 49″ wide, 15½″ deep. Mack and Rodel. An adaptation of a 1903 design by Ellis for Stickley, this bookcase (bottom right) is available with a variety of art glass options for the doors.

CHINA BUFFET

Oak. 82″ high, 68½″ wide, 18″ deep. No. 89-1730/1731. L. & J. G. Stickley. Leaded-glass doors, interior lights, and butterfly inlays add elements of distinction to this large buffet (right).

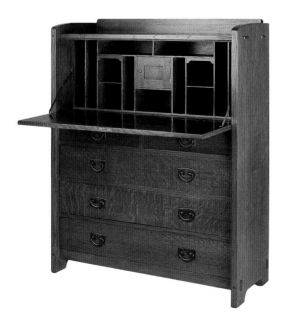

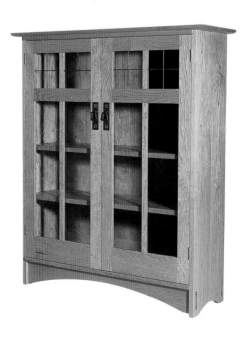

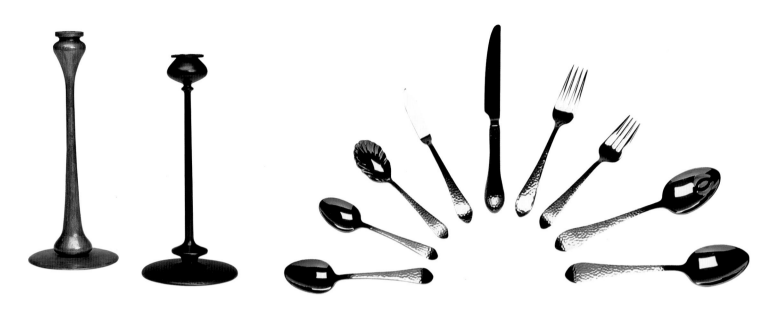

HAMMERED VASE

Copper. 9" high, 5" diameter. No. JCLR-14. Cobre. This hammered vase (left) is handmade using a traditional bonfire method and features the signature of the maker.

JARVIE CANDLESTICKS

Bronze. Kappa, 14" high; Beta, 13" high. United Crafts. These attenuated candlesticks (top left) are reproductions of Robert Jarvie's designs from about 1905.

HAMMERED FLATWARE

Stainless steel. Michael FitzSimmons Decorative Arts. The texture and weight of this flatware (top right), in two sizes, make it suitable for Arts and Crafts interiors.

LOTUS BOWL

Copper. 5" high, 13" diameter. Michael Fitz-Simmons Decorative Arts. This bowl (bottom left) is crafted by hand from reclaimed copper ingots and is seamless.

POMEGRANATE VASE

Copper. 4½" high, 3½" diameter. Michael Fitz-Simmons Decorative Arts. Each vase (bottom center) is crafted by arti-sans and is hammered and patinated by hand.

SEED-POD PLATE

Copper. 12" diameter. No. RM-1. Cobre. This unlacquered copper plate (bottom right), based on a Craftsman design, will age to a warm chocolate brown or deep red patina.

COPPER PULLS AND HARDWARE

Copper. Various sizes. Craftsmen Hardware. Drawer pulls, door pulls, and butterfly hinges (top row) are all hammered, crafted, and finished by hand. Pyramidal nails are shown here. A large variety of similar items is also offered.

CRAFTSMAN MAILBOX

Copper. 12" high, 9" wide, 3½" deep. FMG Design. This latticework box (right) features the rich brown patina of an antique. All mailboxes are made and finished entirely by hand. Custom orders are accepted to meet individual needs.

STICKLEY DRAWER PULL

Copper. 2" high, 3½" wide. Arts and Crafts Hardware. This drawer pull (below) is based on an original Gustav Stickley design. All pieces are finished to a rich dark brown patina.

ONONDAGA PULL

Copper. 1¼" high, 2¼" wide. Arts and Crafts Hardware. A reproduction of an L. & J. G. Stickley original (bottom), this hand-hammered pull features pyramidal nails and a coppery finish.

COPPER HARDWARE

Copper. Various sizes. Buffalo Studios. Handcrafted doorbells, stirrup pulls, and doorknobs (bottom right) are samples of this company's hardware. Both round and square screws are offered.

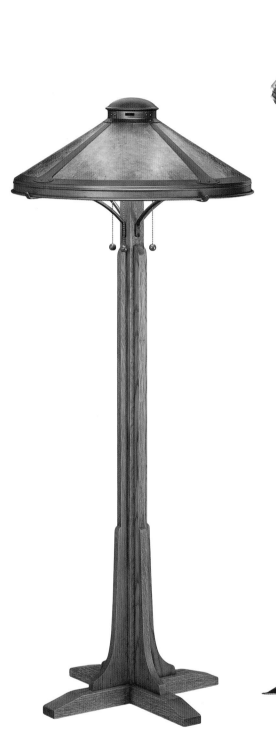

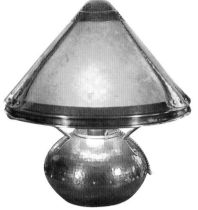

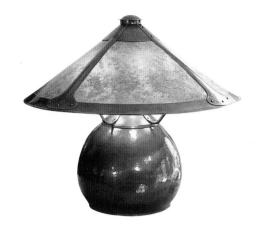

BEAN POT LAMP

Copper. 12" high, 12" diameter. No. 908. V. Michael Ashford. Finished in a rich dark patina, this table lamp (top left) is available with a mica, an art glass, or a frosted glass shade. All lamps are handmade; custom orders are welcome.

GOURD TABLE LAMP

Copper. 22" high, 24" diameter. No. 915. V. Michael Ashford. Crafted and finished by hand in the tradition of Gustav Stickley and Dirk van Erp, this rotund table lamp (top right) is shown with a shade made of translucent amber mica panels.

WOOD FLOOR LAMP

Oak or cherry. 59" high, 24" diameter. No. 051. Mica Lamp. A tall floor lamp (left) with a trunk and base of wood features a mica shade and separate pulls for each of the four light sockets.

MILK-CAN LAMP

Copper. 24" high, 23 1/4" diameter. Buffalo Studios. This table lamp (bottom left), with its mica shade and base of hammered copper, is a traditional Arts and Crafts lighting design.

RIVET LAMP

Copper. 18" high, 17" diameter. Aurora Studios. A Dirk van Erp reproduction (bottom right), this lamp crafted by Michael Adams consists of two copper pieces held together with thirty rivets.

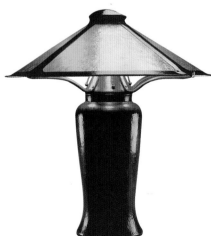

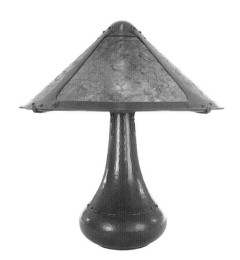

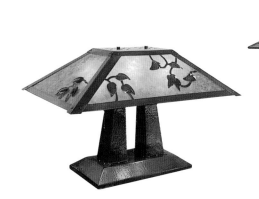

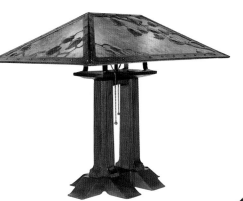

COPPER DOUBLE-PEDESTAL LAMP

Copper. 17" high, 22" wide, 15" deep. No. 902-A. V. Michael Ashford. This pedestal lamp (top left) is unusual in its use of a copper base. Various colors of art glass and frosted glass are available for the shade. Custom orders are accepted.

OAK DOUBLE-PEDESTAL LAMP

Oak. 19" high, 22" wide, 15" deep. Buffalo Studios. Crafted from a solid quartersawn oak base, this table lamp (top right) features a copper leaf overlay on the mica shade. Two lights with individual pulls provide ample light.

VAN ERP REPLICA

Copper. 17" high, 14" diameter. No. T420. Rejuvenation Lamp and Fixture. A replica of an original Dirk van Erp design, this lamp (bottom left) features bowed arms holding the mica shade.

TRUMPET TABLE LAMP

Copper. 20" high, 17 ½" diameter. Buffalo Studios. Hammered copper forms the base of this table lamp (bottom right), whose genuine mica shade releases a glowing amber light.

RIVET FLOOR LAMP

Copper. 65" high, 24" diameter. No. 1022. V. Michael Ashford. The traditional Arts and Crafts copper-and-mica lamp has been extended elegantly (right) to provide subtle accent light.

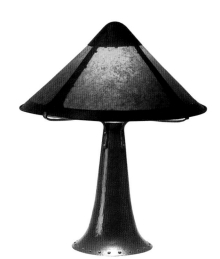

CLOTH CORD FIXTURE

Cloth. 36″ high. No. C100. Rejuvenation Lamp and Fixture. A carbon-filament bulb and covered cord reproduce the no-nonsense effect of period light fixtures (top left).

IN-LINE CHANDELIER

Brass. 37¾″ high, 28″ wide. No. BICH-6/3-WOP. Arroyo Craftsman. Distinguished by opalescent glass, three 6″ fixtures form this popular chandelier (top center).

LANTERN CHANDELIER

Brass. 36″ high, 16″ wide, 16″ deep. No. C509. Rejuvenation Lamp and Fixture. This chandelier (top right) features four lanterns (5″ diameter) in a square arrangement.

WOOD SCONCE

Mahogany. 16″ high, 4¼″ wide, 6½″ deep. No. BWS-GLD. Arroyo Craftsman. A mouth-blown gold art glass shade complements this wall sconce (bottom left).

LANTERN SCONCE

Brass. 14″ high, 8″ wide, 12″ deep. No. W666. Rejuvenation Lamp and Fixture. Suitable for use inside or out, this lantern (bottom center) also comes in other finishes.

CRAFTSMAN LANTERN

Brass. 9¾″ high, 5¼″ wide, 7¾″ deep. No. PA-6505-A10. Brass Light Gallery. Geometric styling and various finishes make this a classic period wall lantern (bottom right).

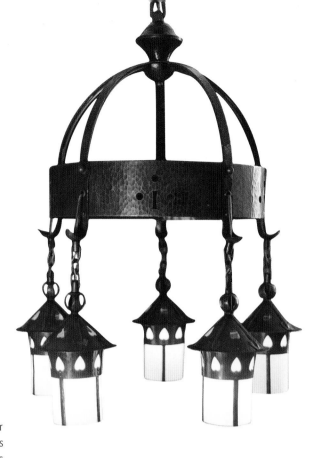

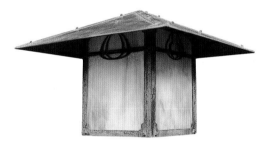

STAMFORD LANTERNS

Brass. 36" high, 28" wide. No. PA-6407-B16. Brass Light Gallery. Four lanterns make this a bright chandelier (top left). It is available in a two-lantern style as well.

HEART CHANDELIER

Copper. 40" high, 24" diameter. Aurora Studios. The five lanterns (9" high, 3 1/4" diameter) of this Stickley reproduction have slightly iridescent glass shades (top right).

POST LANTERN

Copper. 13 1/4" high, 19" wide. Buffalo Studios. Handcrafted from copper with iridescent glass, this lantern (right center) has an aged patina. Custom orders are also accepted.

WALL SCONCE

Brass. 13 1/4" high, 6 1/4" wide, 9 3/4" deep. No. BS-8RGW-AC. Arroyo Craftsman. This sconce (bottom left) is shown in antique copper but also comes in other finishes.

MICA-SHADE SCONCE

Copper. 11 1/2" high, 4" diameter. Buffalo Studios. A rich patina on this sconce (bottom center) is complemented by the square cutouts over the mica-shade panels.

YATES LANTERN

Copper. 12" high, 5" wide, 5" deep. Aurora Studios. This replica of a Stickley fixture from the Yates Hotel in Syracuse, N.Y., has hammered amber glass (bottom right).

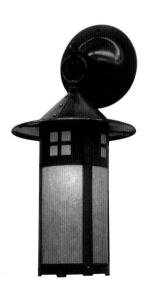

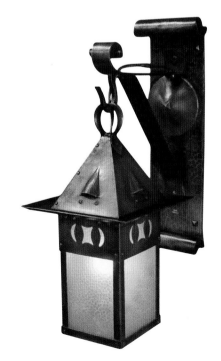

Iris Star Vase

Clay. 11" high, 5¾" diameter. No. 733. Ephraim Faience Pottery. An iris motif and an earthy glaze distinguish this vase (top left). All vases are made in limited numbers.

Bat Vase

Clay. 10" high, 6½" diameter. No. 823. Ephraim Faience Pottery. This vase (top center) features a glaze typical of Arts and Crafts pottery plus a whimsical motif.

Van Briggle Vases

Clay. Various sizes. Van Briggle Art Pottery. These vases (top right) feature the same hand-sculpted detail and distinctive glazes that Artus Van Briggle created.

Candlestick

Clay. 8" high, 4½" diameter. No. 824. Ephraim Faience Pottery. Subdued matte glazes typical of Arts and Crafts pottery have been used on an unusual candlestick (left).

Perennial Vase

Clay. 21" high, 10" diameter. No. 802. Ephraim Faience Pottery. Delicate flowers add depth to this vase (bottom left), which has been sculpted and glazed by hand.

Pinecone Stoneware

Dinnerware. Various sizes. United Crafts. These coordinated stoneware pieces for the Arts and Crafts table (bottom right) feature a pinecone motif on a matte green glaze.

CAMELLIA TILES

Stoneware. 4" high, 4" wide. Fulper Tile. These Arts and Crafts tiles are shown in Rose Matte, Cat's Eye, and Violet Wisteria (top row). Twelve glazes using the historic pottery company's original glaze recipes are available to choose from.

CARVED RELIEF TILES

Clay. 4" high, 4" wide. Tile Restoration Center. These tiles (right) are based on the designs of Ernest Batchelder. Represented here within a frame of trim tiles are, clockwise from left, Tuscan Wall, Cypress, English Cottage, and Seagull.

LANDSCAPE TILE

Ceramic. 8" high, 8" wide. No. 8820. Motawi Tileworks. This forest-scene tile (bottom left) is one of a set of two featuring a repeating pattern, which is also available in smaller sizes.

DATURA TILE

Ceramic. 8" high, 8" wide. No. 8835. Motawi Tileworks. Available in various glazes and sizes, this pattern (bottom center) and others are made by hand based on Arts and Crafts designs.

OWL TILE

Ceramic. 4" high, 4" wide. No. 4411. Motawi Tileworks. Another of Motawi's many nature-based designs is this decorative owl tile (bottom right). All tiles come in numerous glazes.

PINECONE MOTIF PILLOW

Linen. 22" high, 22" wide. Arts and Crafts Period Textiles. Available completed or as a kit, this pillow (top left) is based on a design from Gustav Stickley's Craftsman Workshops. The design also comes as a curtain, table scarf, or table square.

ROSE MOTIF PILLOW

Linen. 17" high, 20" wide. Arts and Crafts Period Textiles. Derived from the stylized rose design popular with Glasgow artists, this pillow (top right) also has a companion table scarf. Other color combinations are available as well.

VOYSEY RUNNER

Wool. Custom sizes. No. JV 4. Jax Arts and Crafts Rugs. The British designer C. F. A. Voysey provided the inspiration for this handsome rug (left) as well as many popular period textiles.

MEDE RUG

Wool. Various standard sizes. Nature's Loom. Handwoven in the Arts and Crafts tradition of craftsmanship, this tapestry-like rug (bottom left) comes in a wide variety of colors.

HONEYCOMB RUG

Wool. Various standard sizes. United Crafts. Based on a noted Gustav Stickley design, this geometric patterned rug (bottom right) is hand-woven to replicate the original tight weave.

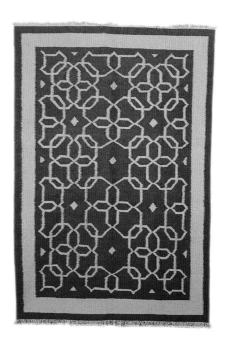

PICTURE FRAMES

Copper or brass. Both hold 4″ × 6″ prints. Michael FitzSimmons Decorative Arts. These picture frames (top left and center), crafted and finished by hand, are appropriate for displaying photographs in Arts and Crafts–style settings.

EUCALYPTUS SUNDOWN

Canvas. 6″ high, 8″ wide. Brian Stewart. Plein-air painting is a style that endeavors to capture a moment in nature on canvas. *Eucalyptus Sundown* (top right) is one of many in this style offered by the artist. All of his paintings are framed.

GINKGO WALLPAPER

Paper. 27″ wide rolls. No. GNK-001. J. R. Burrows. A ginkgo leaf pattern, a common Arts and Crafts motif, makes this wallpaper (bottom left) a good choice. It comes in celadon and pale gold.

KELMSCOTT FRAME

Oak. Various sizes. No. 20-20. Holton Studio, Frame-Makers. This frame (bottom right) features through-mortise-and-tenon joinery. Custom orders as well as mitered frames are also available.

LAST LIGHT

Canvas. 18″ high, 24″ wide. Brian Stewart. Each plein-air painting (right) is a unique work that has been created outdoors. All works come with a suitable frame selected by the artist.

Suppliers

ARROYO CRAFTSMAN

4509 Little John Street
Baldwin Park, Calif.
91706
626-960-9411

ARTS AND CRAFTS HARDWARE

3860 Ellamae Road
Oakland, Mich. 48363
248-652-7652

ARTS AND CRAFTS PERIOD TEXTILES

5427 Telegraph Avenue
Suite W2
Oakland, Calif. 94609
510-654-1645

V. MICHAEL ASHFORD

6543 Alpine Drive, S.W.
Olympia, Wash. 98512
360-352-0694

www.evergreenstudios.
com

AURORA STUDIOS

109 Main Street
Putnam, Conn. 06260
800-448-7828

www.artsncrafts.com

BRASS LIGHT GALLERY

131 South First Street
Milwaukee, Wis. 53204
800-243-9595

www.brasslight.com

BUFFALO STUDIOS

1925 East Deere Avenue
Santa Ana, Calif. 92705
949-250-7333

J. R. BURROWS & COMPANY

P.O. Box 522
Rockland, Mass. 02370
800-347-1795

www.burrows.com

CATHERS AND DEMROSKY

Arts & Craftsman
43 East Tenth Street
New York, N.Y. 10003
212-353-1244

COBRE

c/o Susan Hebert Imports
2018 N.W. Irving Street
Portland, Ore. 97209
503-248-0886

www.ecobre.com

CRAFTSMEN HARDWARE COMPANY

P.O. Box 161
Marceline, Mo. 64658
660-376-2481

www.craftsmenhardware
.com

CROWN POINT CABINETRY

P.O. Box 1560
Claremont, N.H. 03743
800-999-4994

EPHRAIM FAIENCE POTTERY

P.O. Box 168
Deerfield, Wis. 53531
888-704-7687

www.ephraim
pottery.com

MICHAEL FITZSIMMONS DECORATIVE ARTS

311 West Superior Street
Chicago, Ill. 60610
312-787-0496

www.fitzdecarts.com

FMG DESIGN

2601 West Farwell
Chicago, Ill. 60645
773-761-2957

www.fmgdesigns.com

FULPER TILE

P.O. Box 373
Yardley, Pa. 19067
215-736-8512

WARREN HILE STUDIO

1823 Enterprise Way
Monrovia, Calif. 91016
626-359-7210

HOLTON STUDIO, FRAME-MAKERS

5515 Doyle Street
No. 2
Emeryville, Calif. 94608
510-450-0350

www.holtonframes.com

JAX ARTS AND CRAFTS RUGS

109 Parkway
Berea, Ky. 40403
859-986-5410

www.jaxrugs.com

MACK AND RODEL

44 Leighton Road
Pownal, Maine 04069
207-688-4483

www.neaguild.com/
macrodel

M. T. MAXWELL FURNITURE COMPANY

715 Liberty Street
Bedford, Va. 24523
540-587-9543

www.maxwell
furniture.com

MICA LAMP COMPANY

517 State Street
Glendale, Calif. 91203
818-241-7227

www.micalamps.com

THOS. MOSER CABINETMAKERS

P.O. Box 1237
Auburn, Maine 04211
800-708-9703

www.thosmoser.com

MOTAWI TILEWORKS

33 North Staebler Road
Suite 2
Ann Arbor, Mich. 48103
734-213-0017

www.motawi.com

NATURE'S LOOM

32 East 31st Street
New York, N.Y. 10016
800-365-2002

www.naturesloom.com

REJUVENATION LAMP AND FIXTURE COMPANY

2550 N.W. Nicolai Street
Portland, Ore. 97210
888-343-8548

www.rejuvenation.com

BRIAN STEWART

5321 Xerxes Avenue
South
Minneapolis, Minn.
55410
612-920-4653

www.stew-art.com

L. & J. G. STICKLEY

P.O. Box 480
Manlius, N.Y. 13104
315-682-5500

www.stickley.com

TILE RESTORATION CENTER

3511 Interlake Avenue
North
Seattle, Wash. 98103
206-633-4866

TRC@Wolfenet.com

UNITED CRAFTS

127 West Putnam
Avenue
Suite 123
Greenwich, Conn. 06830
203-869-4898

www.ucrafts.com

VAN BRIGGLE ART POTTERY

P.O. Box 96
Colorado Springs, Colo.
80901
719-633-7729

www.vanbriggle.com

ACKNOWLEDGMENTS

Books like this one are necessarily collaborative efforts, and many people have generously contributed their time, expertise, and good wishes to *Stickley Style.* Thanks must go first to the private collectors who invited us into their homes and to the house museums that gave us access to their collections. We are grateful to John and Heather Banfield, Allen and Vonda Breed, Ann and André Chaves, Robert and Nancy Clark, Donald Davidoff and Susan Tarlow, the DeSimone family, Elaine and Robert Dillof, Lauren Gabor and Scott Goldstein, Lydia Jeffries and Bruce Johnson, Ted Lytwyn and Cara Corbo, Cindy and Tim McGinn, Dorothy and Geer McKee, and four anonymous collectors. Thanks as well to Alfred, Aminy, and Carolyn Audi and Mike Danial of L. & J. G. Stickley; Bruce Bland and Maryann Myers, co-curators of the Hubbard Roycroft Museum; and Tommy McPherson II, executive director, and Beth Ann McPherson, curator of interpretation, Craftsman Farms Foundation.

Thanks are also due to Beth Cathers and Nick Dembrosky; Robert Judson Clark, for many helpful insights; Marilyn Fish, for making available her latest research on Gustav Stickley's early life; Stephen Gray; H. Allan Knox; Coy Ludwig, for sharing his considerable knowledge of the Stickley family's life in Syracuse and providing the date of the fire at the Stickley house; Michele McHugh; Robert and Linda Preim; David Rago; Bruce Smith, for valuable help on Greene and Greene; Gladys LaCombe Stickley, for sharing anecdotes about the life led by her father-in-law, Gustav Stickley, in the 1920s and 1930s; Gustav Stickley III, for permission to quote from a 1983 interview, courtesy of the Joint Free Public Library of Morristown and Morris Township; Ray Stubblebine; Ann Wiles; and Ben Wiles Jr., for providing the quote on page 64 and for his unique, personal view of daily life with his grandfather, Gustav Stickley.

My thanks to Diane Maddex of Archetype Press, who conceived the idea for this book and guided its creation. She and her skillful staff, particularly Gretchen Smith Mui and Robert L. Wiser, deserve high praise for making this handsome illustrated book a reality. Thanks also to Constance Herndon of Simon & Schuster.

Alexander Vertikoff's magical photography is one of the true pleasures of *Stickley Style,* and my thanks go to him for his mastery of both "art" and "tech." And, as always, this book is for Susan.

—David Cathers

Photographing this book required me to spend a great deal of time away from home and could not have been done without the patience and love of Nora, Cole, and Carmen. I wish to thank Shaun Driscoll and Larry Battistello of Fuji for their expertise and generosity. Lastly, I wish to thank the many kind folks who made a stranger feel at home.

—Alexander Vertikoff

ILLUSTRATION CREDITS

Case binding: Courtesy United Crafts, Greenwich, Connecticut.

Front and back endpapers: *The Craftsman,* October 1905. David Cathers collection.

Pages 2–3: *The Craftsman,* October 1904. Courtesy Beth Cathers and Nick Dembrosky.

Page 10: Cover, *The Craftsman,* October 1901. Courtesy Beth Cathers and Nick Dembrosky.

Page 13: David Cathers collection.

Page 16, top and bottom: *The Craftsman,* December 1904. David Cathers collection.

Page 21: Courtesy H. Allan Knox.

Page 22: *The Craftsman,* October 1904. Courtesy Beth Cathers and Nick Dembrosky.

Page 23: *The Craftsman,* November 1905. David Cathers collection.

Page 27: Cover, *The Craftsman,* May 1904. Courtesy Beth Cathers and Nick Dembrosky.

Page 28: David Cathers collection.

Page 29: Courtesy Ann Wiles.

Page 30: Cover, *The Craftsman,* January 1904. Courtesy Beth Cathers and Nick Dembrosky.

Pages 34, 35, 36, 37: *Craftsman Houses: A Book for Home-Makers,* 1913. David Cathers collection.

Page 39: *The Craftsman,* March 1906. David Cathers collection.

Page 40: *The Craftsman,* April 1910. David Cathers collection.

Pages 44, 45: *The Craftsman,* October 1905. David Cathers collection.

Page 47: *The Craftsman,* September 1905. David Cathers collection.

Page 48: *The Craftsman,* October 1907. David Cathers collection.

Pages 51, 52, 55: *Some Chips from the Craftsman Workshops,* 1909. David Cathers collection.

Page 86, bottom right: *The Craftsman,* September 1908. Courtesy Beth Cathers and Nick Dembrosky.

Page 90: *The Craftsman,* December 1903. Courtesy Beth Cathers and Nick Dembrosky.

Page 198: *Craftsman Furnishings for the Home,* 1912. David Cathers collection.

Credits

Sources and Further Reading

CRAFTSMAN PUBLICATIONS

Gustav Stickley's Craftsman publications have been essential sources of information, especially his two books of house plans—

Craftsman Homes (1909) and *More Craftsman Homes* (1912)—and his promotional booklets: *Chips from the Craftsman Workshop* (1906); *Chips from the Craftsman Workshops: Number II* (ca. 1907); *Chips from the Workshops of the United Crafts* (1901) [an early name for Stickley's workshops]; *Craftsman Furnishings* (ca. 1905); *Craftsman Houses: A Book for Home-Makers* (1913); and *The Craftsman's Story* (ca. 1905).

The Craftsman magazine has also been a major resource, notably the following articles:

Burnett, Vivian. "Craftsman Gardens for Craftsman Homes." April 1910.

"California's Contribution to a National Architecture: Its Significance and Beauty as Shown in the Work of Greene and Greene." August 1912.

"Craftsman Farms: Its Development and Future." October 1913.

"A Craftsman House that Is Intended for Suburban Life in a Little Residence Park that Overlooks the Valley of the Bronx, Near New York." September 1908.

"The Craftsman Idea in Home-Building." April 1913.

Curtis, Natalie. "The New Log House at Craftsman Farms: An Architectural Development of the Log Cabin." November 1911.

"The Dining Room as a Center of Hospitality and Good Cheer." November 1905.

Ellis, Harvey. "How to Build a Bungalow." December 1903.

Howe, Samuel. "A Visit to the House of Mr. Stickley." December 1902.

"The Living Room, Its Many Uses and Its Possibilities for Comfort and Beauty." October 1905.

"Porches, Pergolas, and Balconies, and the Charm of Privacy out of Doors." March 1906.

Salmon, Lucy M. "Philosophy, Art, and Sense for the Kitchen." September 1906.

Stickley, Gustav. "From Ugliness to Beauty." December 1904.

"Telling History by Photographs: Records of Our North American Indians Being Preserved by Pictures." March 1906.

GUSTAV STICKLEY

Bartinique, A. Patricia. *Gustav Stickley: His Craft.* Exhibition catalogue. Parsippany, N.J.: Craftsman Farms Foundation, 1992.

Cathers, David, ed. *Gustav Stickley's Craftsman Farms: A Pictorial History.* Philmont, N.Y.: Turn of the Century Editions in association with the Craftsman Farms Press, 1999.

The Craftsman on CD-ROM. Every *Craftsman* issue, from October 1901 through December 1916. 8 disks. New York: Interactive Bureau, 1998. Available from Interactive Bureau, www.iab.com.

Davidoff, Donald A., and Stephen Gray. *Innovation and Derivation: The Contribution of L. & J. G. Stickley to the Arts and Crafts Movement.* Exhibition catalogue. Parsippany, N.J.: Craftsman Farms Foundation, 1995.

Fish, Marilyn. *Gustav Stickley: Heritage and Early Years.* North Caldwell, N.J.: Little Pond Press, 1997.

———. *Gustav Stickley: 1884–1900*. North Caldwell, N.J.: Little Pond Press, 1999.

Gray, Stephen, ed. *The Collected Works of Gustav Stickley.* Philmont, N.Y.: Turn of the Century Editions, 1987.

———. *The Early Work of Gustav Stickley.* Philmont, N.Y.: Turn of the Century Editions, 1981.

Hewitt, Mark Alan. *Gustav Stickley's Craftsman Farms: A Parable of the Arts and Crafts Movement.* Syracuse, N.Y.: Syracuse University Press, 1999.

Smith, Mary Ann. *Gustav Stickley: The Craftsman.* Syracuse, N.Y.: Syracuse University Press, 1983.

Stickley, Gustav. *Craftsman Homes.* Reprint, with a new introduction by Nancy Strathearn, New York: Dover Publications, 1996.

Stubblebine, Ray. "Stickley's Grand Designs." *Style 1900* 10, no. 3 (1997): 28–39.

RELATED TOPICS

Andrews, Jack. *Samuel Yellin: Metalworker.* Ocean City, Md.: Skipjack Press, 1992.

Baillie Scott, M. H. *Houses and Gardens.* 1906. Reprint, Suffolk, England: Antique Collectors' Club, 1995.

Cathers, David. *Furniture of the American Arts and Crafts Movement.* Rev. ed. Philmont, N.Y.: Turn of the Century Editions, 1996.

Clark, Robert Judson, ed. *The Arts and Crafts Movement in America 1876–1916.* Exhibition catalogue. Princeton, N.J.: Princeton University Press, 1972.

Cook, Clarence. *The House Beautiful.* 1877. Reprint, New York: Dover Publications, 1995.

Davis, Barbara A. *Edward S. Curtis: The Life and Times of a Shadow Catcher.* San Francisco: Chronicle Books, 1985.

Evans, Paul. *Art Pottery of the United States.* 2d ed. New York: Feingold and Lewis, 1987.

Goldstein, Scott. "The Theodore M. Irwin House, Pasadena, 1906—Living Greene and Greene II." *Style 1900* 11, no. 1 (1998): 72–79.

———. "What Happened to California?" and "Toward a Golden Age." *Style 1900* 11, no. 1 (1998): 8–12.

Hamilton, Charles. "George and Gladys ScheideMantel." In *Little Journeys to the Homes of Roycrofters.* East Aurora, N.Y.: S-G Press, 1963.

James, Michael L. *Drama in Design: The Life and Craft of Charles Rohlfs.* Exhibition catalogue. Buffalo, N.Y.: Burchfield Art Center, 1994.

Kaplan, Wendy, ed. *"The Art that Is Life": The Arts and Crafts Movement in America, 1875–1920.* Exhibition catalogue. Boston: Museum of Fine Arts, 1987.

Lancaster, Clay. *The American Bungalow 1880–1930.* New York: Dover Publications, 1985.

Ludwig, Coy L. *The Arts and Crafts Movement in New York State 1890s–1920s.* Hamilton, N.Y.: Gallery Association of New York, 1983.

Makinson, Randell L. *Greene and Greene: Architecture as Fine Art.* Salt Lake City: Peregrine Smith, 1977.

Rago, David. "Collecting Metal: A Visit to the Home of Ted Lytwyn and His Wife, Cara Corbo." *Style 1900* 11, no. 2 (1998): 72–73.

Via, Marie, and Marjorie B. Searl. *Head, Heart, and Hand: Elbert Hubbard and The Roycrofters.* Exhibition catalogue. Rochester, N.Y.: University of Rochester Press, 1994.

Winter, Robert, and Alexander Vertikoff. *American Bungalow Style.* New York: Simon and Schuster, 1996.

222

SIMON & SCHUSTER

Rockefeller Center

1230 Avenue of the Americas

New York, NY 10020

SIMON & SCHUSTER and colophon are registered

trademarks of Simon & Schuster Inc.

Compilation copyright © 1999 Archetype Press

Text copyright © 1999 David Cathers

Photographs copyright © 1999 Alexander Vertikoff

All rights reserved, including the right of reproduction

in whole or in part in any form.

Printed in South Korea

10 9 8 7 6 5 4

Library of Congress Cataloging-in-Publication Data

Cathers, David M.

Stickley style : arts and crafts homes in the craftsman

tradition / text by David Cathers ; photographs by

Alexander Vertikoff.

 p. cm.

Includes bibliographic references and index.

1. Stickley, Gustav, 1858–1942. 2. Architecture,

Domestic—United States—Designs and plans.

3. Arts and crafts movement—United States. I. Title.

NA737.S65A4 1999

728'.092—dc21 99-24774

 CIP

Produced by Archetype Press, Inc.

Diane Maddex, Project Director

Gretchen Smith Mui, Editor

John Hovanec, Editorial Assistant

Robert L. Wiser, Designer

Case binding: A linen ginkgo table scarf, handmade by United Crafts based on a Stickley textile motif.

Front endpaper: The prototype Craftsman living room, with a recessed window seat, exposed beams, wainscoting, and lanterns.

Pages 2–3: A Craftsman house published in 1904.

Pages 4–5: The chestnut-paneled dining room of Gustav Stickley's home in Syracuse, New York.

Pages 6–7: Grueby pots and a rare Dirk van Erp copper lamp in the collection of Robert Judson Clark.

Pages 10–11, 30–31, 56–57, and 198–99 (background text): Passages from Gustav Stickley's *Craftsman Homes* (1909).

This page: Gustav Stickley's insignia: His motto— *"Als ik kan"* ("If I can" or "As I can")—inside a joiner's compass.

Back endpaper: Posts and partitions in a Craftsman house separating the entrance from the living room.

A Note on the Typography

The display typeface, Florentine Old Style, was designed by Ludvig S. Ipsen in 1896–1903, based on lettering on a sixth-century Italian monument, and released by American Type Founders. The text and caption typefaces—Italian Old Style and Goudy Sans Serif, respectively—were designed by Frederick W. Goudy, one of America's best known and most prolific type designers, for Lanston Monotype. Italian Old Style, created in 1924, is based on early Venetian typefaces of the late fifteenth century. Goudy Sans Serif, designed in 1929–30, is a less formal alternative to traditional sans-serif forms.

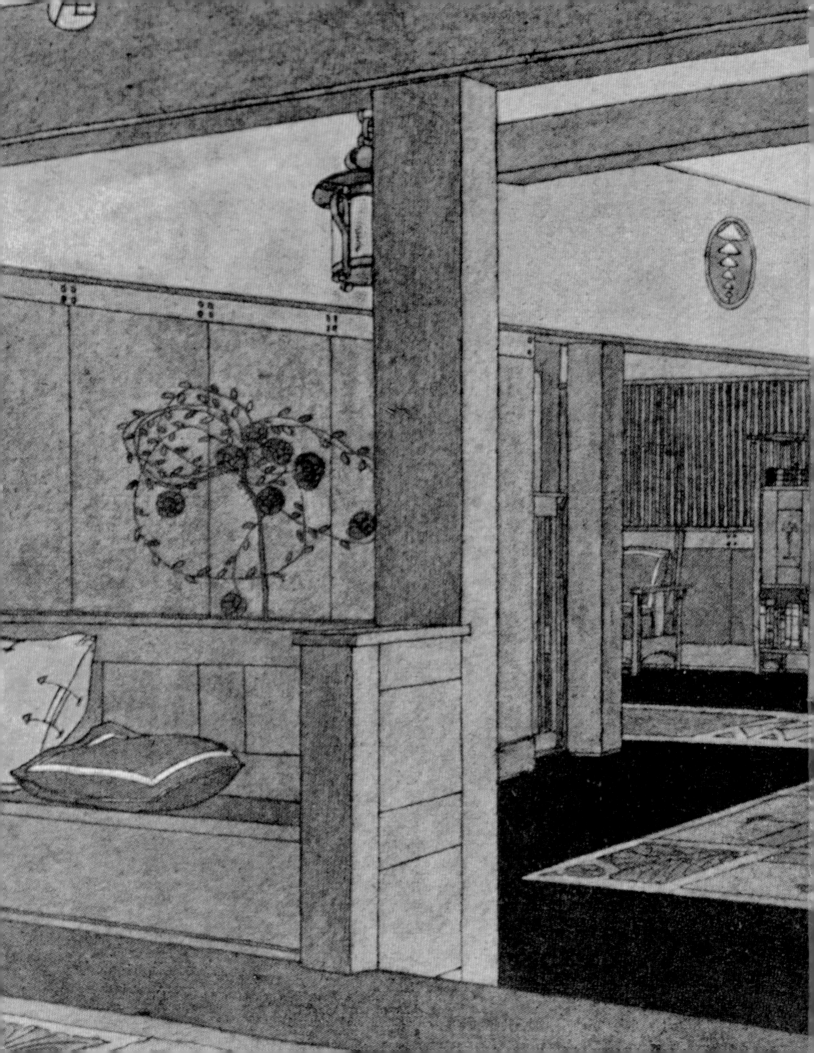